DRAWING

Second edition

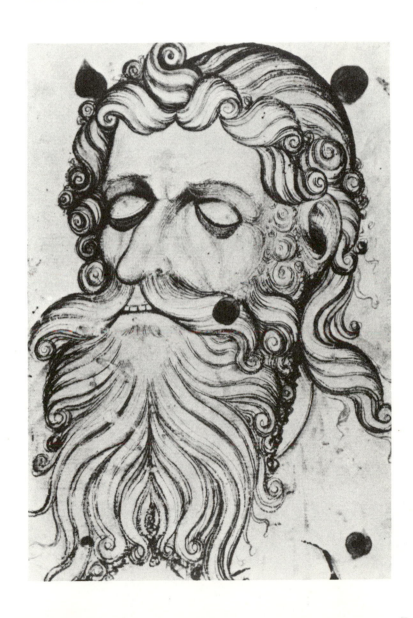

DRAWING / *Philip Rawson*

Second Edition

University of Pennsylvania Press • Philadelphia • 1987

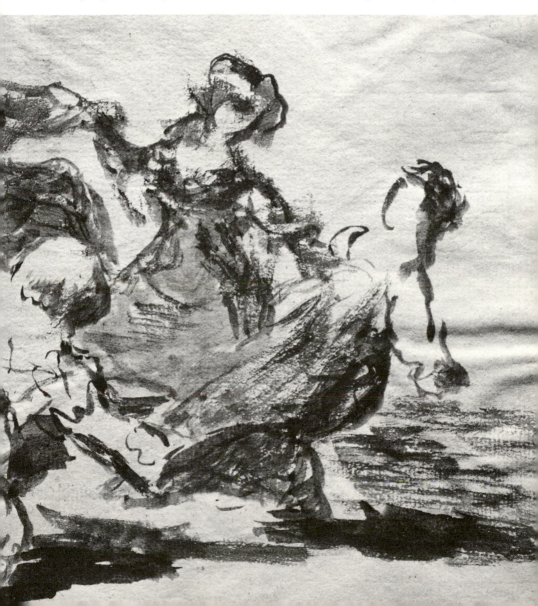

Revised paperback edition published 1987 by the University of Pennsylvania Press

First published 1969 by Oxford University Press

Library of Congress Cataloging-in-Publication Data

Rawson, Philip S.
 Drawing.

 Includes index.
 1. Drawing—Technique. I. Title.
NC735.R35 1987 741 87-10929
ISBN 0-8122-1251-7 (pbk.)

To Kurt Badt and Helen
with love and gratitude

There exists one great classic book on the art of drawing—*Die Handzeichnung: Ihre Technik und Entwicklung* by Joseph Meder, published in Vienna in 1919. It is a magnificent, thoroughly researched publication, and deals with many topics with which I have to deal here. It was based, however, upon a limited range of European drawing between the Middle Ages and the nineteenth century; and the greater part of its sources were Mannerist and Baroque academic ones. So Meder's conception of drawing was very much conditioned by the characteristic works of a single historical phase of art. This phase must seem to historians who study it closely to embrace an ample range of possibilities. But to a modern eye, accustomed to taking a far wider view of art than Meder's, his book seems to beg a large number of fundamental questions. I have therefore taken gratefully what Meder has to offer, but have at the same time treated some of his ideas in cavalier fashion. I hope this will be forgiven me.

The most important work on drawing, from my point of view, is contained in books by Kurt Badt. *The Drawings of Eugène Delacroix* (Oxford, 1946) is a fundamental study, as is the huge chapter on the artist's drawings in Badt's authoritative book on Nicholas Poussin, soon to appear in Germany. Other of his books contain important and relevant passages, notably *Raumphantasien und Raumillusionen* (Cologne, 1963).

The standpoint I want to adopt is not primarily that of appreciation; nor do I wish to take a brisk academic trot through different fields of drawing. Instead I shall be writing as it were from the other side, from the point of view of the maker of drawings. I hope this will also offer new insights to those whose interest in drawing is purely appreciative.

I have tried to avoid using the cant terms of criticism which are so often uttered glibly without any explanation of what they mean, such as 'organic relations', 'significant juxtaposition', 'pictorial logic', and all words that refer to subjective, unformulated emotional impressions. The terms I do use, while many of them may be unfamiliar, are chosen because they designate things that can actually be found in drawings by looking, and because they can be explained clearly and consistently. It may be quite difficult at first for the

reader to pick out the visual facts, because there is no traditional method of identifying them that I can use and no one has picked them out before. There are no accepted names for the facts of artistic execution as there are for the facts of musical language. What I hope is that this book may lay a kind of groundwork both for spectators to identify and understand the elements of style in any drawing, old or new, and for artists to explore the range of resources that lie open if only they can recognize them. At the same time I hope that it will help to bridge the abyss which has yawned during the last decades between what art students are learning to make as 'modern art' and the great art of the past.

Durham P.S.R.
June 1969

Preface to the 1987 Edition

This book explores the technical resources of drawing for their own sakes, as they appear individually or combined across the world's great historical traditions. Twentieth century drawing is little represented or discussed. This is because at the time the text was written it was essential at first to clarify the foundations of all drawing. I discuss many aspects of "modern" drawing in two further books, *Seeing Through Drawing* and *The Art of Drawing*. I am delighted that the University of Pennsylvania Press has decided to publish this new edition of *Drawing*.

Dorset Philip Rawson
1987

Contents

Illustrations

The figures in the right-hand margin of the text refer to pages on which relevant illustrations may be found

xi

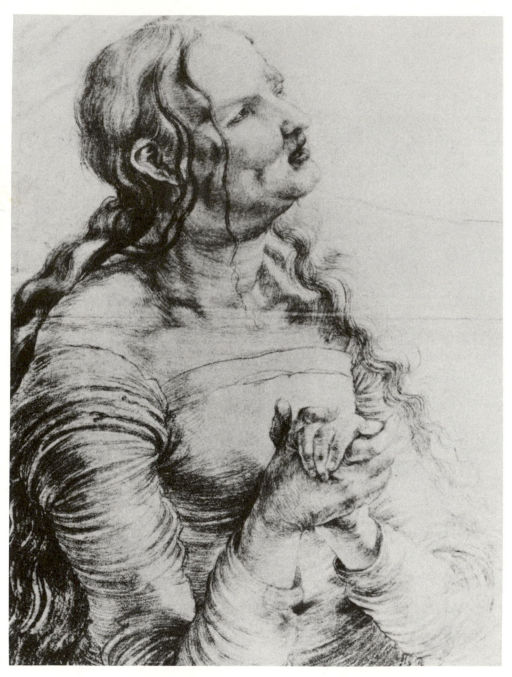

Mathis Neithardt-Gothardt, called Grünewald (*c.* 1470/80–1528), WEEPING WOMAN;
black and white chalk, 40 × 30 cm. *Collection Oskar Reinhart Winterthur*

The Theoretical Base

Definition of drawing Drawing I take to mean: that element in a work of art which is independent of colour or actual three-dimensional space, the underlying conceptual structure which may be indicated by tone alone. So I shall discuss many kinds of drawing, ranging from pure monochrome drawing in its own right to drawing as a structural element of the brushwork in painting or of the realization in relief sculpture or mosaic. Thinking like this it will be possible to say something about the drawing technique of art styles which have left us no instances of pure drawing; it is anyway very hard to draw clear lines of demarcation. For example, if we make special allowances for the qualities of media, the painting on archaic Greek pottery or the woodcuts of medieval Europe can give us an excellent idea of structural concepts belonging to the sphere of drawing which their makers held. In a similar way we can understand how forms or methods invented to suit some particular final medium have had a feedback influence on methods of pure drawing.

In a sense one can say that drawing is the most fundamentally spiritual—i.e. completely subjective—of all visual artistic activities. Nature presents our eyes with coloured surfaces to which painted areas of pigment may correspond, and with inflected surfaces to which sculptural surfaces may correspond. But nowhere does it present our eyes with the lines and the relationships between lines which are the raw material of drawing. For a drawing's basic ingredients are strokes or marks which have a symbolic relationship with experience, not a direct, overall similarity with anything real. And the relationships between marks, which embody the main meaning of a drawing, can only be read into the marks by the spectator, so as to create their own mode of truth. Certain kinds of relief sculpture, perhaps, like Donatello's *rilievo stiacciato*, may come closer to the symbolic self-sufficiency of drawing than work in any other media.

Scale of working The scale of a drawing is an important part of its meaning. This is one point at which the proliferation of book-publishing has had a disastrous effect upon people's ideas about art. And this book cannot escape adding its quota to the damage. For the size an artist has given to his work of art determines the way in which we receive it. But in

this book all the drawings of whatever size will be reduced to more or less uniform dimensions. Perhaps drawings will suffer rather less from this uniformity than pictures, sculptures, or architecture would, because the majority of these drawings are meant to be looked at virtually as a book is looked at—from close to. The attention of a single person is meant to be directed upon them, more or less at reading distance, and the spectator's environment is meant to be excluded. Drawings do not usually have to compete for attention with the distractions of architectural décor and with the events of actual life as other works of art may—frescoes or oil-paintings, for example. One usually approaches a drawing with one's mind focused down, ready to attend to the voice of the drawing alone. Drawings should always be exhibited in Museums so as to ensure that this approach is possible. But I point out later on that drawings are made up of strokes whose meaning is based upon our appreciation of their qualities of movement. And qualities of movement are affected very much by scale. The larger the original drawing is, the more will our response to a reproduction of it in this book be distorted. I cannot stress too much that looking at reproductions of drawings is no substitute for looking at drawings themselves. Obviously our appreciation of a big cartoon meant to cover a wall will suffer very much if we cannot meet it face to face on its own terms. There is another way also in which we can lose the meaning of drawings through the lack of a true sense of scale. We will not realize, for example, the intimate, contemplative quality of many of the late drawings by that hewer of colossi, Michelangelo, 54 drawings which are in fact very small. The fact of their smallness will not be apparent. After all, it matters very much whether an artist has made in his drawing an arm's length sweep or a narrow pull with his fingers. And so I must hope that with these considerations in mind the reader will make every possible effort to look at actual drawings.

'Art' as a term applied to drawing Drawings are works of art; and this word 'art' has two quite distinct meanings which are usually confused. It will be helpful to distinguish them at the outset so as to illustrate quite clearly the ways in which drawings *are* works of art. To begin with, I should like to suggest that one of the important meanings of 'art' is as a class term resembling 'language' and actually covering a very broad field, embracing a wide variety of activities, as 'language' does. All of these activities share the common factor of being conducted by means of visual symbols, just as verbal, linguistic activities share the common factor of being

conducted in verbal symbols. Language can be used to discuss an enormous variety of topics in all sorts of ways, by ordinary conversation, sermons, journalism, blue jokes, political commentary, scientific articles, or flights of lyric verse. All of these activities support, articulate, and enhance our awareness of the world we live in, and its meanings. In the same way anything made by the hands of men conveys to the eye a similar but visual awareness of the world we live in, of our relationship to the makers, and the world's possible meanings. This is done by the visual symbolism of forms. Anything made to be seen shows its maker's thoughts and intentions to anyone who can read them. The reason we may dislike the appearance of mass urban developments, Harlem slums, or advertising's female images with impossible clipped silhouettes, is because the meanings they convey as visual symbols include in each case contempt for man as a mere habitant unit, and in the last case a gross visual lie. The great nineteenth-century poet Coventry Patmore pointed out in one of his remarkable essays on architecture that if a house is built of massively laid stone and huge, pegged oak beams, and is obviously meant to last its inhabitants for centuries and keep its value, then that is an indelible part of its architectural meaning. If it is made of jobbed brickwork or factory-made units, that again is part of its architectural meaning.

It may well be that we need a subdividing class-system to distinguish the categories of art, just as we distinguish the categories of verbal expression from poetry downwards. For the whole world of made things can come to life for us if we become attentive to the vast range of topics and types available to artistic dialogue. Admittedly the normal British or American environment can get infinitely depressing as one grows more aware of its implied meanings. The expression of café tables, motel architecture, mass-produced fireplaces, of pantographed advertisement drawing, and fashion photographs with clipped silhouettes, conveys all too clearly what the makers feel about the consumers. And conversely it is precisely because of the high artistic quality which spreads throughout the architectural environment into all sorts of minor corners of visual expression that cities like Florence or Prague are so splendid. And the adjective 'splendid' is exact. They 'shine' with meanings addressed to the cultivated visual sense.

There is a second way in which the term 'art' is used, which implies an aesthetic value-judgement. This happens when we say that such and such an item is 'art' whilst another is 'not art'. We can say it of

poetry or music as well as of visual work. Such a dichotomy represents a kind of shorthand of aesthetic discussion. But it is not really correct to reduce our judgement of any work of art to a crude black-and-white distinction of this kind. There are many degrees of 'art' in this sense. Goudt was not a Rembrandt, but he did drawings worth looking at. And many eighteenth-century French engravers whose names are not at all illustrious produced work of value and interest, even if that value does not seem to be as high as that of a Watteau drawing. I want to suggest that among works of 'art' in the broad sense of 'visual language' there are works which we recognize as 'art' in this second sense, just as in the sphere of verbal language there are works of poetry and prose which belong to this second kind of 'art'. Thus there can be bad works of 'art' in the first sense which we would not recognize as 'art' in the second sense—for example, those café tables and pantographed advertisements.

When we discuss the 'art of drawing', the term 'art' has both these meanings. We are discussing something that is couched in visual, not verbal, symbols—an important point. And we are discussing things to which we give an aesthetic value, and admit to be art in this second sense. That is to say, they achieve something specifically 'elevated' within the general field of visual expression. The last chapter of the book will deal with the possibilities in some detail.

There have been innumerable theories as to what makes a work of art good in this second sense. I do not want to concern myself with them explicitly. I hope that the whole of this book will make clear by implication the grounds on which the aesthetic value of a drawing can be appreciated and judged. One obvious point, however, is that a work can be a work of art in the second sense, an aesthetically successful work, by virtue of the fitness of its symbolic language, of its art in the first sense, whatever the immediate occasion for which it was made. Neither Sir Thomas Browne nor Cervantes were bent on writing 'art' in the second sense. What characterizes those works which attain an aesthetic status seems to depend upon one particular thing which has not been directly noticed, as far as I am aware. This is the *numen* it gives its topic.

Iconography and artistic topic Later in the book I discuss the question of the drawing as a positive proposition, as communication. Speaking historically, and *pace* McLuhan, communications have a topic. This is not a plea for repre-

sentational art. It is exactly the opposite, as this whole book should demonstrate. For the topic of a drawing can be a most refined intuition. But such a topic has two aspects. First is the *tenor*, which is what promotes the extension of forms into space; second is the special meaning enclosed in the topic, which may not be an obvious direct product of the tenor though it may be 'hung on' it. An example will show what I mean. The tenor of the Michelangelo drawing on page 54 is: figures disposed in the given arrangement. But the figures are not the whole topic. The topic is something complex and remote which the figures illustrate and convey, something involved with the iconography, in which submerged Neoplatonic images and echoes of a particular historical response to the Classical are involved. The actual forms in which the drawing is executed are what convey this aspect of the topic. Nothing else can. The artist projects the image-containing forms upon the tenor, and hopes that we, his public, will be able to grasp his meaning from them.

The role of the tenor in a drawing thus resembles very much the role Ortega y Gasset suggested that the plot of a novel or drama has to play—rather like the tent-poles of a tent. They give the tent its extension in space, but are not themselves the tent. The tenor is not the whole, but without it there is no whole. Without the extension in space with its varied contexts, which the tenor gives, there can be no developed work. The tenor carries the work of art over its framework; and the tenor is the root of the topic. (The term 'tenor', derived from Latin *tenere*, to hold or sustain, comes from medieval musical practice, in which the tenor voice was called the tenor because it sang the main line of a familiar melody, whilst the other voices sang variations and ornaments around it.)

The forms of the drawing and the principles they follow are the key to what the draughtsman meant to say about his topic, and reveal his mind. The *meaning* lies not in the tenor, but in how it is treated. Iconography, of course, matters very much. But even icons can have many meanings according to how they are treated. That a Poussin drawing may represent a particular classical myth is certainly important. But it is important only as a beginning, a first step in the evolved statement. What actually conveys Poussin's unique meaning is the complex of forms with which he invests that mythical subject. Shakespeare's Macbeth is only to be found in Shakespeare's play, not in Holinshed's pale original image. Here is the nuclear idea behind this book.

Following Bernard Berenson, I accept that the ultimate iconography of a work of art—its true topic, in fact—does not lie in the merely given 'subject'. It lies far more deeply implicit in *how* that subject is developed. This can go so far, as Berenson pointed out, that the implied meanings of style and the conventional meaning of given subject-matter are in open conflict. A Christian *Virgin* may be treated with lascivious relish. And something similar had obviously happened when Veronese was called to task by the Inquisition for the manner in which he represented the Last Supper with 'jesters, drunkards, Germans, dwarfs', and a man with a bleeding nose. The Inquisitors did not mention the world-affirming luxuriance of Veronese's style—which was part of his true topic: presumably they felt it, and disliked it, though they had not the concepts to lay hold of it in their questioning. Veronese agreed to repaint. But his final solution was only to change the title of the picture to *The Feast in the House of Levi*, a subject to which the 'tone' of his imagination was not felt to be in such drastic opposition. This is a perfect example of the iconography of style conflicting with the iconography of given subject. Of course the optimum is when the two harmonize completely.

The point is that the topic of the work is something in which, whatever it may be, a special numinous power is felt to reside. This is characteristic of art in my second sense, and distinguishes it. The tenor is the notional subject or the bare skeleton of the visual idea which can provoke us if we are artists to project on to it, or if we are spectators to accept the projection of, the imagery and visual ideas into which is condensed our experience of what it is to BE. There is in it a total revelation of reality. A drawing, which is a conjunction and transformation of crude materials, shows us to ourselves as it were in a mirror at the heart of our own world of truth—truth not of abstract concepts but of visual conviction. Such a work is also an image of our own subjective experience of what it means to exist, an image taken not just at one moment but gathered together from long stretches of time into a sum which is outside any individual time, and becomes mythical time. The topic is the special place in which such a quality of *numen* can be experienced in its particular character natural to time, place, and people. We experience the forms of the drawing as an act of praise or celebration (Rilke's *feiern*) of the world which is the image of ourself, endowing it with positive truth and vivid reality which is symbolized by the density, wealth, and unity of the structure.

6

Obviously the accepted icons of religion have been one of the prime sources of tenor and topic. For it is their special function to crystallize such *numen* and make it visible. But even drawings which are studies from life or patterns for fuller designs share in the same impulse.

We may tend to think that many arts the world over have been primarily religious. In the European Middle Ages and Renaissance, ancient and medieval India, Egypt, and Central America, established religion always seems to have monopolized the *numen*-projecting power of the visual arts. In fact this is an illusion, due partly to the fact that nowadays we have a rather narrow idea of what is religious, partly because religious authority has always required its art to be made in the most permanent possible materials and has itself been the chief agency for preserving it in one way or another. We know quite well that all of these ages produced a wealth of art in relatively impermanent materials—not so carefully preserved once it became unfashionable—dealing with secular topics in which people experienced a powerful sense of the numinous, such as pageantry, costume, war, festivals, heraldry, the picaresque, romance, ribaldry, and sex. The Middle Ages, for example, were no less interested in erotic art than our own time. Byzantine courtesans had mosaic icons of themselves made. And elements of secular formal expression have contributed to the meanings of religious art. Indeed, in fifteenth-century Flanders and Burgundy the whole topic of contemporary man and his environment welled up into the field of religious painting, secular *trompe l'oeil* became a popular game for the religious artist, as the everyday world acquired a numinous dignity of its own.

In other epochs the numinous quality of officially secular topics is recognized quite openly. During the Renaissance a whole system of imagery devoted to an astrological Neoplatonism absorbed the energies of many artists and incorporated a vivid sense of numinous power. Later on Rubens, Boucher, Toulouse Lautrec, Degas, and Edvard Munch all devoted themselves to secular topics, even specifically anti-establishment and 'shocking' topics. In such topics, for different reasons, they found the presence of this numinous splendour which they could not find in the outworn images of religion. Nowadays, it seems, many artists have to search even further afield for images around which they can condense their sense of *numen*; and there is a tendency to identify *numen* with violent feeling or sensation —which it is not. Mere excitement without structure rates only as fantasy, not as art.

There is another reason too why we today may be prevented from accepting as valid tenors for artistic discourse many images which have served mankind for a very long time. In the past it was normal for artists to be able to use the same tenors over and over again as support for their topics—for example, Mother and Child, Cupid and Psyche, and a hundred other classical myths. But the graphic revolution, with its enormous and growing volume of bad, lying art produced during the last century, has debauched virtually all of the traditional topics. The noxious activities of commercial advertising have degraded most of the tenors which mean most to everyone by enveloping them in halos of falsehood and cynicism. When wild landscape is used to sell tweeds or cigarettes, mother and child to sell soaps or detergents by means of visual lies, associations with hypocrisy and graft are left in most people's minds which make it very difficult for good artists to deal with these topics, save with bitter irony or black humour. It has become virtually impossible to discuss deep erotic feeling in visual terms, or to offer sheep and cattle as images of delight —to us they are mere objects of use. The official 'great men' of a country or period may have a vestige of *numen*. But recently diagrams associated with the mystique of science have been most used as tenor, though it is often hard to see what topic and clothing of forms they support. Now, however, even optical sensation and cybernetic diagrams are in the process of being debauched. Many artists have tried violent expedients, committing visual acts of aggression against the traditional icons (Picasso and some of his followers such as Lorjou), to overcome the effects of this progressive degradation, and the very violence of the expedients has made them able to serve as a focus for a turbulent *numen*. The sensation of disorientation and irrational association was sought by Dada and its immense Surrealist progeny, especially in the USA. Irrational encounters have done yeoman service as tenor and topic. At present, violent undifferentiated sensation is the rising candidate for the vacant role of *numen*. Only, perhaps, in the art of children can one find the traditional tenors still being used as supports for art. With children familiarity and unwanted associations have not destroyed the validity of many objects and events of the natural world as vehicles for *numen*. The child's formal skills, however, may not be up to conveying *numen* very intensively in graphic symbols.

Two instances can serve to summarize this thesis concerning the tenor, topic, and *numen*. From Palaeolithic cave drawing we can 9

8

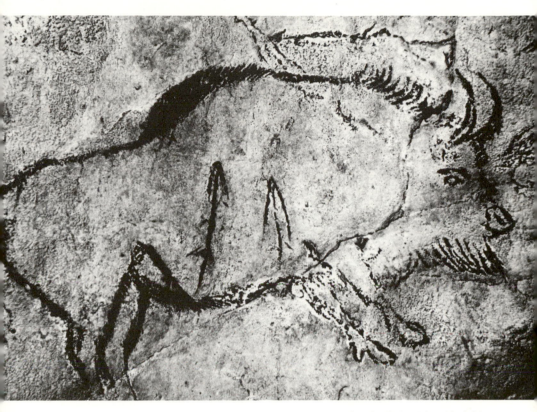

easily understand how the wild beast with which he identified his own existence and vitality, upon which he depended for livelihood, and around which his religion may have revolved, must have seemed to early man a natural focus for the projection of *numen* in the light of which he discerned his own identity. For in his beautifully formed drawings of the beast, with their interwoven enclosures, both positive and negative, he has condensed that intuition of splendour. The beast is the tenor, the topic its vitality, and the drawing a statement of the topic. In the case of the Rembrandt drawing exactly the same holds 198 good. For, as a matter of art-historical information, we know that Rembrandt was continually concerned with expressing the immanence of the divine in the everyday world, as if the world of the Bible was identical with his own here-and-now. And this Protestant intuition, centred without conflict upon tenors derived from his everyday experience, was the implied thesis of all his topics. In creating the image of his world man creates his image of himself. *Mutatis mutandis*

9

every good drawing will yield up its meaning to questioning on these lines.

One implication remains to be drawn from something which I said earlier concerning art as the class of all things made to be seen. It is that we must make inferences concerning the meaning of any drawing from all its visible attributes. Amongst these will even be the materials in which it is executed, and the way they are used. And if these are merely conventional, *that* is part of the meaning of the drawing. This will be discussed further.

Nevertheless it is commonly accepted that the essence of drawing is its use of monochrome marks to convey its meaning. Therefore the methods of drawing can be discussed as semantic methods, which can apply to a work of art whatever its topic—and that includes twentieth-century art. Certain particular topics have evoked particular methods from time to time; and special needs have given an impetus to the development of special methods. But the fundamental idea of this book is that drawing is done according to general principles of structure which can be discussed intelligently without the need for mystical jargon. Perhaps this may help to bridge the gap which yawns between what the art-student today learns to practise as 'art' and the real art of the historical past.

Communication *How* a drawing is treated can be discussed in terms of general methods or principles. For if one man is to get anything out of another man's drawn thoughts there has to be a common ground of some kind between them. And in so far as a drawing serves as communication it depends on the existence of a set of assumptions which must be recognized, perhaps unconsciously, by the parties to the communication. There must be points of reference, and an initial structure of general relationships commonly accepted. I do not wish to suggest that the substance, or thought, to be communicated is in some way distinct and separate from its methods—as I have suggested, the opposite is the case. But, to begin with, Wittgenstein's well-known analogy between communication and games can serve as a point of departure.

He suggests that any communication is like a game which only exists by virtue of the rules defining it, rules which the players agree to accept. When a woman says, 'I have a headache', she may really be saying, according to special, understood, rules, 'Take me away from this party!' 'Chess' is not 'fox and geese'. The rules are the

structural prerequisites for the game to take place; and each individual game played according to those rules represents an amplification of the structure of the game into realms of possibility that may actually be definite, but from the human point of view may well seem to be infinite. The possibilities are realized by the encounter between different players, with all their human and personal idiosyncrasies, and the rules. Incidentally it is the suggestive wealth of their rules that makes chess and 'wei-chi' (*go*) more interesting games than noughts and crosses. Exactly the same holds good with drawing styles.

For drawings to function as communication they must work according to visual principles accepted by parties to the communication. From now on I substitute the word 'principles' for 'rules', because the latter introduces a false meaning into my intended sense. 'Rules of drawing' have existed at various times, but it is not to them that I am now referring. The principles to which I refer have their expressive and structural functions, which can also be called 'methods'. Yet the analogy between games and graphic communication breaks down at a certain point. It is indeed true that the visual principles of a drawing-structure are in a way analogous to the rules of a game. But there is a kind of formal immutability about the rules of games which is not characteristic of the principles observed in art. For art seems to be continually at work revising and modifying its principles (rules), even whilst observing them. Communication must follow rules in some way constant and recognizable, or communication would not be possible. But the rules must also be capable of a kind of slow expansion or alteration, as the meanings which they serve themselves change. For in art, as in other human communication, intuited meanings override and modify the rules—a thing which seems not to happen with games. To pursue our now broken analogy, it is rather as though the rules of chess were to be gradually modified by every game of chess which was ever played, because chess-players were interested in getting their games to conform to intuited complete games, not only in exploiting the rules.

The principles of visual communication, analogous to the rules of games, which are the foundation of the methods of drawing styles change with the change of styles. Great draughtsmen may modify the principles as they draw, not as an act of arbitrary choice but because the topics they convey require it, and produce the changes from inner necessity. But the structural principles on which any individual draw-

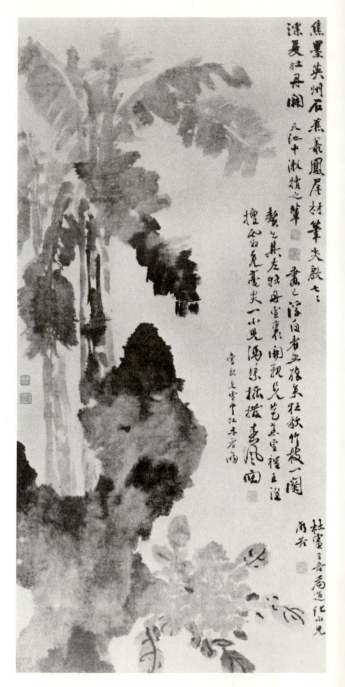

Hsü Wei (1521–93),
PEONY, PLANTAIN, AND
ROCKS; ink on paper,
120·6 × 58·4 cm.
Shanghai Museum

ing is founded are the rules we must accept and assimilate ourselves if we are ever to understand the intentions of the draughtsman. To some extent we can do this intuitively. Familiarity helps. But we would be wrong to imagine that we can understand every drawing style simply by looking at it. Before we can play the communication-game with the draughtsman we must learn his principles. In a sense we must learn the rules of his 'language game' at the time he made the drawing.

But there is one radical difference between the forms used in pictorial or graphic communication (perhaps musical communication as well) and those used in verbal, linguistic communication, a difference which makes visual artistic language easier to learn than verbal. It is this: verbal, linguistic forms have moved far away from any attempt there may once have been, back in the remote reaches of the human past, to render meanings by forms which have a direct resemblance to what they mean. Onomatopoeia in poetry is, perhaps, a vestigial trace of such a process. In fact the extraordinary wealth and freedom of expression which spoken and written language enjoys comes from linguistic forms having only a *conventional* relationship with the concepts they signify. The clicks, pops, buzzes, and squeaks that make up the mouthed sounds of speech claim no formal similarity with conceptualized realities. This does, however, carry penalties which are not always recognized by professional, verbally oriented philosophers.

With artistic forms it is different. The symbols used in drawing must have a direct resemblance with what they signify. Visually they have to be in some way analogous with the realities which give them their meaning. But note that THESE REALITIES ARE NOT THE SAME AS 'THINGS'. I shall explain this point in detail later, in connection with the concept of analogical structure. It is certainly true that graphic forms can become as conventionalized as verbal forms. Thus no one needs to recall, as he reads, that the capital letter 'A' once portrayed the face of an ox, V, now upside down. For convention is the essence of written script. The hieroglyph stands part way between picture and convention. And it seems probable that humanity's earliest known written scripts—Egyptian, Proto-Elamite, Indus Valley, and Chinese oracle-bone—were in fact associated with traditions of graphic decorative stereotypes which we know painted or incised on surviving pottery and bronzes. It is, however, the element of convention as against resemblance which distinguishes script from visual art.

Though there are indeed extremely interesting cases where both factors may be combined—as, for example, in Chinese calligraphy.

The kinetic basis of drawing Drawings are done with a point that moves. The point may be thin or thick. Europeans used fine silver point. Australian aborigines use their fingers. Japanese artists have used a wad of cloth, a bunch of straw, or even a bundle of old brushes dipped in ink. The essential feature remains that something generically classed as a point, a tool acting as some kind of surrogate for the hand with its fingers, has made a mark that records a two-dimensional movement in space.

Since such movement is the fundamental nature of drawing, the various styles and manners of representational drawing amount to techniques for crystallizing more or less strongly the implicit move- 14 ment of lines. In reality a line once made does not itself change or 34 move. It is fixed as a static mark. But there always lies at the bottom of every drawing an implied pattern of those movements through which it was created. A comparison with music may be helpful. Music takes on physical presence in performance. Its structure is properly conveyed only in time. Nevertheless the structure has an existence outside of time in the sense that one can, within limits, repeat it and comprehend it as a unit. We know that Mozart, like other composers, saw compositions complete in his mind before committing them to paper. The case with a drawing is precisely the reverse; it seems to have physical presence only as a static object. But its structure in fact is produced by actions carried out in time. Therefore in appreciating drawings, no less than in making them, one has to be continuously aware of the character and qualities of the sequences which went into their composition. To get at these one has to look into the drawing carefully to find the order in which its parts were executed. To some extent one may grasp them intuitively; but analysis can be a great help.

This quality of underlying movement is, of course, the special 'charm' of drawing which can never properly be carried over from drawing into a finished work of painting or sculpture. There have been a few great European artists, among them Rembrandt and Goya, who have succeeded in carrying over into painting the full quality of drawn movement, by means of a loose technique and careful preparation of a toned ground. But for thoroughgoing preservation of the qualities of drawing in painting one has to look to the Far East—or to Western 'action painting' based on Far Eastern ideas. More often the European painter, by going over the surface of his

ttributed to Wolf Huber
1490–1553), DER
RCHWEG; pen and ink,
6 × 159 cm.
ollection Göttingen
niversity

15

Georges Seurat, Study
for LA PARADE (1887);
pen and ink,
12.5 × 19 cm.
*Collection Robert von
Hirsch, Basle*

picture again and again, has obscured the movement pattern of any underlying drawing there might be, and has lost or destroyed important 'spiritual' qualities which he was actually able to capture in his drawings. Even in fresco paintings, which were in fact done at speed, the brushwork may have been so executed as to make the movement pattern of the brush invisible, at any rate from the normal viewing distance. But one of the most interesting things about some frescoes, such as Signorelli's great *Last Judgement* set at Orvieto, is that they *do* show an intelligible movement pattern on close inspection. The viscosity of oil-painting, however, is what has usually totally obscured drawn movement—so that the surface the picture presents does not allow underlying structure to be seen clearly. Loose 'brushwork' or 'handling', as one finds it in Rubens or Renoir, impresses us precisely because it can evoke a time-response like that characteristic of drawing, whereas in the art of Seurat one finds that both as painter and as draughtsman he has made strenuous efforts to obliterate any visible two-dimensional traces of graphic movement; that is, he tried to make his work present a static effect, as if one's eye were dispassionately taking in a visual field whole and entire at once.

This artist seems to have 'selected' his elements on the basis purely of silhouettes (which is *not* how the camera works). But I shall return to these points later.

It is, of course, well known that in all normal acts of visual perception the eyes do not observe the world with a blank, unmoving stare. On the contrary, they observe by continually scanning the visual field in a series of movements to and fro, and making continuous adjustments of focus. Without this optical movement, and the muscular sensations which accompany it, we should have no proper appreciation of space. And where drawing is concerned it seems quite clear that the movements suggested by the traces of the drawing-point ought actually to guide the motions of the eyes. The eyes must follow the original movements of the point—all of them, in due scale of emphasis—if one is to grasp the drawing properly. One adopts the mental scanning-pattern which the artist originally set down. One learns thus, by assimilation, advanced scanning procedures from artists whose own highly developed performances have been recorded by their drawing-points. So drawing is seen to be one of the most important elements in educating the eye and in developing visual perception—itself a matter of visual concepts and habitual structures. This fully justifies our belief that artistically minded people actually see (and so perceive and understand) more than the artistically uneducated. This again is one of the reasons why it matters so much for us to be able to discern in a drawing the original rough laying-out strokes by which the artist first located his image on the surface. They are an integral part of the scanning-pattern which will give to our perception the totality of the image. So sketches, first thoughts, have a genuine perceptual validity which traced-off or worked-over drawings do not have. In fact it is well known that excessive 'completeness' or 'finish' can be more injurious to a drawing than to any other kind of art.

For these reasons we can see that those sets of visual symbols which constitute drawing have an underlying temporal form. They demand to be read by scanning. For them to have meaning depends on our perceiving them in their kinetic nature. A good drawing can be as full of 'voices' or 'melodies' as a musical composition. But note that these 'voices' are not necessarily lines pure and simple—though they may be. If we read the drawing lazily and do not bother to follow out its structure, the loss is ours. We will not gather what the draughtsman had to say. His meaning will pass us by.

It is very probable that the growth of modern advertising art is responsible for most city people, who are besieged by posters and advertisements, developing a habitual approach to visual expression which cripples them for coming to terms with the best art of the past. This approach has also affected the artists who produce today's art. It forms the habit of expecting every piece of art to convey its whole impact at the very first glance. This is what advertising images have to do. They have to seize the attention, or even penetrate the unconscious levels of the mind, by an immediate visual impact. Busy people, even if they look at them consciously, will only be able to spare a *coup d'œil* for posters in subway or advertisements in a magazine. So posters are made to work that way. And it is easy to see that most people expect good works of art to deliver up their substance to the same kind of glance. Art galleries are always full of people walking past Rembrandts, Titians, and Rubenses, giving each of them the same casual glance they would give to a subway poster. Many modern works of art are made for exactly this kind of casual glance: indeed it is characteristic of them that they repel rather than invite prolonged attention. This was not so with older art. To recover a proper approach to the great art of the past is not a question of sheer knowledge. A potted biography of the artist delivered by tape machine or guide will not really help. One has to relearn habits of attention, and discover how to 'read' works of art which were made to be 'read' at length. Drawings are probably the best possible basis for this rediscovery.

Drawing and 'realization'

Perhaps the most important key to the meaning of individual drawings is this. In so far as any drawing amounts to a positive, affirmative statement, it both implies and illustrates the artist's conception of reality. The terms of the drawing are the terms which the artist has found for asserting the validity, or the 'actual presence', of his statement. However much an affirmative statement may be hedged about with conditions, it comes down in the end to saying: 'Such and such IS the case.' Drawing methods are a major part of the artist's means for stipulating the 'IS', attributing an affirmative quality to his topic; without them he can make no affirmation. And we may as well take the last jump and realize that, since this is so, implicit in every drawing style is a visual ontology, i.e. a definition of the real in visual terms.

In any drawing, therefore, the first thing to do is to decipher what are the elements of 'reality' that the methods seize upon and con-

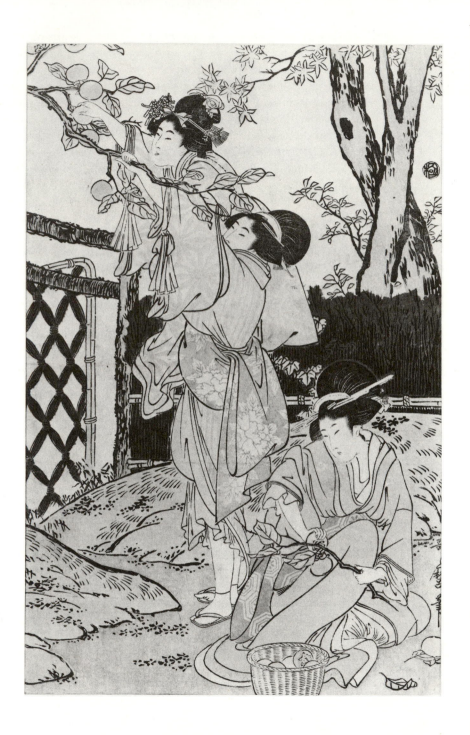

ceptualize. I shall analyse the possibilities later. But a single comparison will make the relevant point here. A Japanese artist such as Utamaro conceptualizes only the sinuous movement of lines across 20 his ground. These lines are derived each from the single edge of a thing. He does not conceptualize intelligible enclosures, nor plastic volumes, nor tonal gradations. In this, the artist's idea of visual reality is reflected. We know that in Japan the accepted idea of the real as a 'floating world' had its roots in a mixture of adapted Chinese Taoism and Buddhism, which denied any permanence, solidity, or absolute value to separate objects. Things existed for Utamaro as episodes in a process of shifting limits, not as separate, self-contained entities. And so he developed the linear language of the Far East in the direction of fluidity and elegance (which latter was also part of his purpose). In sharp contrast, an artist like Titian came in the end virtually to obliterate all trace of distinct lines in his drawings. In his late style all of his forms are converted into broad, luminous volumes, so solid that they seem eternal, but which emerge from an enveloping ground of shadow and undefined possibility. The methods of Titian as a 168 draughtsman are extremely subtle, and I shall discuss them in detail. But broadly speaking they indicate the presence of chains of objective bodies by means of tonal contrasts which adumbrate sequences of volume, with no edges or outlines asserted anywhere. This method reposes on a visual philosophy of Being which it would be pointless to try to identify glibly with a particular verbal philosophy. But it is one in which both the symbolism of light and the notion of eternal ideas informing the real play a leading part.

This comparison of the drawing styles of Utamaro and Titian shows how we must look at drawing methods with an eye to what the artists actually did to make their drawings convey affirmative conviction, or visual 'truth'. The old academic cliché that the draughtsman 'selects' aspects of a given 'real theme' must be set aside. The draughtsman may indeed 'select' in drawing. But he does not select by an act of conscious eclecticism. Nor does he pick items that he can actually see; for he makes up his drawings out of elements no one can see *in* any object. No one ever actually sees a black outline, for example, or the line which separates one plane from another. And I cannot stress too strongly that drawing is not seeing. It is one of the commonest fallacies, entertained by many people who ought to know better, that a work of art is a record of something seen. On the contrary, works of art are in fact, *made*; they are artistic constructs, based

21

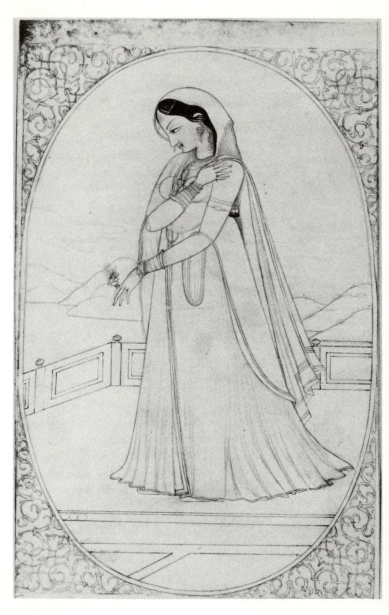

on ingrained scanning procedures. There is, of course, a correspond-ence between a work of art and the visual worlds of the artist and his patron. But it is by means of the symbolism of visual forms, not by means of direct imitation. A language of form or structure creates its own kind of reality. It may be a 'second nature' as Goethe called it, parallel and related to the first nature. But it *is* not the first. To talk of an artist's 'vision of the world' is misleading unless the terms are further defined. This word 'vision' does not mean that he sees the real world—so! but that he always makes an image of his world—so! The apparent concern of much Western art with the 'external world' or 'dead nature' is illusory. In fact the natural as such can never enter as a fourth term into the communicative process between man and man. What is referred to by artistic symbolism lies within the experi-ence of each party to the symbolism—though such experience may well be largely unconscious. Even if a drawing be purely topo-graphical in intent, it does not merely point at an external object.

A person's artistic language is the one in which he was reared, just as is his verbal speech. The structure of the artist's visual thought is what matters; and somehow or other it must be 'true', i.e. have a functional relationship to what artist and spectator accept as truth. It is certainly the case that from time to time the artist's notion of truth has involved an accurate paralleling of the visual field of tone by means of drawn tone. But this in itself reflects a specific, not an ultimate, philosophy of visual realization. How precisely an artist's conceptual forms relate to reality, and how they can be said to realize his intentions, is one of the fundamental issues in this book. The term 'selection' describes the process so inadequately that it is virtually useless.

At a simple level, where the representation of ideal bodies is in-volved, the idea of 'selection' of aspects can seem apt. For example: an Indian Rajput draughtsman never bothers to delineate and define 22 the complex of bone and muscle at the front of neck and shoulder, where collar bone and breastbone meet. To do so would be an artistic irrelevance, a totally unnecessary vulgarity. His 'truth' is a truth of feeling, where what matters is a continuum of sensual re-sponse to polished surfaces, conveyed by fluid lines running over unbroken, generalized areas symbolic of volumes. A Western draughtsman who was aware that in the history of his artistic language Leonardo da Vinci's work was fundamental might feel obliged to record the minutiae of the anatomy in order to demonstrate *en passant*

his grasp of an absolute, 'scientific' truth about the anatomy of human bodies. His own conception could thus never capture the unalloyed poetic consistency of an Indian drawing. But then he would never wish it to.

'Selection', however, shows its limitations as an interpretative concept when we enlarge our view of drawing to take in the drawing of all known traditions. We are then bound to adopt a more generally valid standpoint, and treat visual ontology under a complex heading of structure, method, symbolism, and visual analogy. No drawing, even the most representational, can ever convey a pure likeness, nor a selection of naturally given, objectively formulated visual data. It conveys a meaning. And it conveys that meaning not by a general similarity of surface but by a structure of symbolic elements which are formulated as method. At certain points the structure rests on a foundation of visual analogies between human perceptual experience both of graphic forms and of realities. Therefore the first thing to query in the study of any drawing is: To what features of experience do its basic visual elements ultimately correspond and how do they do so? What are the visual realities to which forms refer? And what, first of all, are forms?

Definition of form in terms of analogical structure
Orthodox logic has a definition of form which can serve as a starting-point for the study of artistic form. When we recognize and classify reality for ordinary practical purposes we do it on the basis of analogies that we perceive amongst phenomena. These analogies are partial similarities. Any such similarity is apparent to us because we recognize that two or more phenomena share a form, which suggests the analogy to us. Thus analogy and form are two complementary aspects of our normal, active perception of the world. For instance, a special form seems to be shared by tables, by which we analogize all tables into a class. Redness is a different order of form shared by all red objects. Number, qualities of density or movement, are other forms. The 'content' of such a form is the range or chain of analogized instances in our experience which offered that particular form to our analogizing faculty. The essence of such forms is that in a sense they are unreal, because the objects which possess them are not completely described by any one or more forms; thus each form is only a part of the truth about any phenomenon, and amounts actually to a mental index of relationship. But certain particular forms will have special importance, because for practical purposes they supply us with

a key to the use of the phenomenon—which is, broadly speaking, its primary meaning for us. Thus when we meet the 'table' form embodied in a new table—when, in fact, we make the analogy between a new phenomenon and memories of past phenomena—the important thing for us is that we can use the new phenomenon as we use a table and refer to it as such in conversation. It may also be either a 'weak, spindly-type' table or a 'rough, kitchen' table. These features could be important; secondarily perhaps, but we might have to warn someone about them. It may not matter much if it is a 'reddish-brown' table. The pattern in its grain may be of no significance at all save to an antique-dealer. But the point is that even though we may not take conscious note of these secondary forms, we do actually perceive them and register them unconsciously. And there will be many analogies which we make unconsciously between those features of our experience that we seldom recognize consciously at all, since they are features which cut across the categories of utilitarian form-recognition. In the case of our last examples, the colours of tables or the patterns of grain, they may suggest forms whose 'contents' do not consist of experiences of other tables. Their content may include features from our experience of widely separate phenomena, such as clouds, the skin on feet, and mud on river-banks. If we have no word tied in our minds to an analogized form, we will only be able to express it, if at all, by oblique references or by figurative speech. Or, most important, by artistic metaphor—verbal, visual, or auditory.

It is recognized that the human mind is endowed with a faculty of continuously analogizing its experience and classifying it in terms of the categories to which the analogy-forms are assigned. This analogizing faculty lies at the root of all human thought, and it never stops. At the same time the mind also seems to carry out a reflective activity, in which memories of analogized forms are further collated and analogized so that the mind also records analogies between analogized forms. Thus, it has a vast repertory of 'forms' and 'forms of forms' produced by its analogizing faculty and stored in its memory. Many of those forms will be visual, many kinaesthetic, many tactile or sensuous in other ways. But only for relatively few of them will there be words available. For fewer still will there be a noun, attributing to the form the quality of being an objective thing or even the property of a thing.

Words, the raw material of verbal language, have well-established conventional meanings because the categories of verbal language

have been refined and consolidated in use, so that the first 'meaning' of the forms indicated by verbal terms is a practical one. Our verbal language reflects our everyday life pretty comprehensively. But there is a huge number of other genuine, valid 'forms' of experience, produced by the analogizing faculty and therefore perfectly 'true' in any possible sense of that word, for which we have no conventionally associated words. They probably constitute a submerged 98 per cent of our actual, perceived experience. But they lie atrophied and inert in our minds, unless we can find ways of bringing them forward into consciousness. By vivifying them and vitalizing them we can make ourselves aware of that lost part of ourselves, our suppressed perceptions and memories. This is what the arts do. And that is why spokesmen for the arts always claim, quite rightly, to be operating beyond the reach of ordinary, utilitarian communication. That is also why the resolutely inartistic can never understand the point of art.

The marks made by the point in any drawing he looks at become part of the spectator's world of phenomena. His analogizing faculty sets to work upon the marks, their patterns and arrangement. They evoke analogous forms from his unconscious fund. Certain groups of marks will constitute references to everyday objects of use, i.e. will be representational. Others will serve structural functions according to the artist's usual principles. But the main bulk of the marks will not just refer directly to everyday objects but will 'qualify' them by investing them with analogous forms from quite other fields of experience. The represented objects of the tenor, serving as one term to the bridge of metaphor, will thus be endowed with a kind of metaphorical radiance shed on them by the experiences analogy associates with them from those other fields. Most of these visual forms have no immediate utilitarian sense, so their meaning can only lie in their contents, and in the feelings that are associated with the chains of instances composing the content. For most of the original experiences which supply the content of forms will have come originally into the mind charged with some kind of affect or feeling. So in an important sense our feeling-response to its proffered forms constitutes the ultimate meaning of the drawing.

The draughtsman's skill consists in being able to maintain contact with his own associations of form and feeling and to shape his marks and assemblages so as to evoke the appropriate analogy-responses from other people. This is where the 'rules of the game' come in. It should be obvious too that the faculty of response has also to be

schooled. In fact all the elements of the work should be shaped so as to evoke determinate responses—all the individual marks, the groups of marks, enclosures, implied structures of rhythm and other relations, and the whole assemblage itself. For the analogizing faculty cannot be turned off at will. Any resemblance which the work suggests, at any level, is inevitably part of the meaning. This fact has claimed penalties from many twentieth-century artists, who have unwittingly included ludicrous, infantile, or scatological meanings into the fields of reference of what they intended to be serious works. It can also mislead us severely in our response to works of other times and other places. For we may all too readily read, by association, into the forms of an exotic art meanings which do not belong there, meanings which only a modern man could bring to them. The scholar will take care to weed out where he can such unwanted responses. But one must not take the weeding too far. For it is only through responses of this kind that a drawing can mean anything to us at all.

The analogy-responses which graphic forms can evoke have a very wide range indeed. Logic and strict practical considerations usually demand that everyday speech confines the meaning of its terms to as narrow a field of reference as possible, so as to avoid ambiguity and mistakes of interpretation. It can be very important, for example, to know the precise, single significance of the word 'duck'. But in the case of all art, including visual art, ambiguity and multiple meanings may be of the essence. It is well known that, in poetry, puns, oblique allusions, metaphorical connections, all enhance the total meaning. So it is with visual art as well. Forms should have the widest possible scope of recollection. Just as the prismatic diction of poetry brings into the total image evoked by a poem oblique references to submerged realms of experience and intuition, so the forms of drawing can do the same. One could say that the concepts referred to by visual art should be inclusive, involving the whole 'content' of the forms, rather than reductive and abstract. Indeed the use of the word 'abstract' in connection with art may very well have done a great deal of damage to our appreciation of many arts which are by no means abstract, but precisely the opposite. On this point Chinese artists and aestheticians have written a great deal that is relevant.

Since Han times, 206 B.C.–A.D. 229, the Chinese have been profoundly interested in the techniques of graphic expression, particularly in the way in which the brush strokes of their calligraphy can convey intangible qualities of mind and allusions which are quite out-

衙齋臥聽蕭蕭竹
疑是民間疾苦聲
些小吾曹州縣吏
一枝一葉總關情

板橋

side the scope of the written text. They recognize that an artist–calligrapher, when he is inspired, can convey in the fluent movements of his brush 'resonances' of unuttered feeling. He can suggest such things as 'vapours rising', 'the plunging of great whales', 'vines trailing over a thousand-foot precipice', or 'boulders leaping down a mountain-side'. Indian artistic practice and aesthetic theory have consciously claimed a similar interest in metaphorical forms which convey deeply emotive impressions—the hip and thigh of a girl move like an elephant's trunk, her fish-shaped eyes glance like silver fish in a dark pool, her draperies flutter between her legs like ripples on a river between its banks. A similar case could be made for forms of central American and African arts. So artistic forms, including graphic forms, made with such a metaphorical intent, may be understood to depend for their meaning upon the linked chains of emotive affect they arouse; that is, upon their *content*. And this content belongs to the category of concrete, immediate experiences, associated by memory with emotions and sensation. Such an artistic method accords so closely with well-known intentions and methods of European poetry that one would be justified in assuming that it has some general validity.

The fallacy of 'abstraction' There is, however, one important strand in art criticism which seems to run counter to this idea. It is the generally accepted notion that art can and does deal in 'abstract form', and that therefore there is an 'abstract art'. It is certainly true that there are attributes of visual form which can be roughly, approximately, or figuratively described as abstract. It is helpful, though, to look a bit further into the precise meanings of the word if we wish to understand what this aspect of form really involves.

'Abstract' has an accepted basic meaning in logic and mathematics. Here it is applied to concepts which are mental, can never take concrete form, and because of their structural interrelationship single-valued. They are 'removed from' (*abs-tracta*) the realm of concrete reality into that of classes. The abstract concept 'redness', indicating the formal class differentia of things that are red, is not red itself, though its content may be all red things. Abstract concepts are thus applicable, mentally, to perceptual experience though they do not belong to the class of perceptions. However, even a mathematical diagram in a textbook is not abstract but concrete. It is perceived as a concrete phenomenon, but interpreted symbolically. Everything

29

possible is done to ensure that its meaning is 'purely' abstract, to slough off unwanted associative meanings, by reducing it to a grid of thin, inexpressive lines, by using on it the most conventional and 'colourless' symbols and figures. And because we recognize it as referring to a special field of abstract thought, we accept it as symbolic of an abstract idea. But in fact this symbolism is actually conveyed in part by the expression of those very 'inexpressive' qualities of the lines and symbols of which it is composed. The coolness, thinness, and stereotyped air of the diagram are what give it its validity as an index of the abstract. For suggestions of opulence, movement, violence, irregularity, and so on, have all been removed from the linear forms. Their 'content' as forms seems to be little more than the class of similar experienced diagrams—though it may be actually more. And the region of meaning to which they attach themselves is that of abstract concepts, which is a fully consistent world of its own, each part of which gives meaning to all the others.

It is clear that many twentieth-century artists have intentionally imported into their concrete works of art the visual qualities of the mathematical diagram (Max Bill, Albers, and many followers). In this way they expect their work to be taken as referring not to concrete, emotionally charged experiences, but to a self-consistent world of abstract visual forms which has the same internal coherence and the same remote reference to phenomena as have the forms of mathematics and abstract logic. They have made their surfaces cool, expressively thin, their shapes as schematic, generalized, and unparticularized—i.e. as diagrammatic—as possible. At present it seems that the internal, genuinely abstract consistency of this world of visible forms has not been demonstrated; though it may have affinities, which may one day emerge, with mathematical topology. Many artists are at present absorbed in combining and reconciling diagrammatic indices of abstract general forms—including both colours and three-dimensional shapes—with the deliberate intention of doing something similar to what mathematics has done, and exiling so far as possible any reference to the concrete emotive and the particular. Just as in mathematics three can be related to nine and eighty-one without referring to apples or people, so the forms to which these abstract works of art refer are imagined as lying in the mind, single-valued, self-consistent, unrelated to particular instances of form such as shells, leaves, or faces. Like mathematicians, these artists claim to live in a world of forms and formal relations, and their works of art

should be supposed to be only the incidental diagrams they need in order to communicate with each other by a true meta-language of form.[1]

The controversy which took place during the early years of this century among anthropologists such as Haddon, Stolpe, and Boas concerning the meaning-content which different primitive peoples attributed to the same 'abstract'-looking forms illustrates one thing very clearly. The available range of form-categories for visual communication, at their general level, is limited (possibly not, phenomenologically). So too, interestingly enough, are the general principles of humanity's games. But it was clearly shown by the controversy that what a primitive people *got out of* the generalized forms of their own traditional art was vastly more than any other people, including Europeans, could get out of them. And it was also shown that for all their apparent abstractness these general forms had in fact a content which was emphatically *not* abstract in the mathematical sense. It consisted of chains of emotionally charged memory-traces directly associated through analogy-systems with the concrete forms. What, in an African Yoruba carving of the female breast may look to *us* like an 'abstract' form, may read to a tribal African as a flat, hence often sucked, opulently flapping gourd-shape, evoking an endless chain of memories and feelings.

[1] I have suggested, however, that art is rooted in visual symbols, and that drawings take on meaning through analogized qualities suggested by their forms. It is therefore doubtful whether everyone at present could either make or understand such 'diagrammatic art'—which term, incidentally, seems to me far more apt than 'abstract art'. And it is worth mentioning that Cassirer has pointed out that even mathematics does depend upon 'concrete' perceptions for its meaning, whilst there can be little doubt that the artists who make these diagrammatic forms make them for emotional reasons of their own, and with the—perhaps unconscious—intent to inspire that same emotion in others by means of the qualities of their forms! There is as yet no means of purely visual communication so general and immutably conventional as number. This art is in the position of a mathematics with no language but ordinary words. Until a language of pure diagrams is developed for art, in so far as art deals in forms we must also accept that it deals in analogized emotive qualities. Meantime, just as mathematics is not the whole of language but only a specialized part, so diagrammatic art is only a specialized part of visual art. There remains to us—or should remain—the whole vast field of non-diagrammatic visual communication. And there is no reason at all why, just as writers of prose or poetry may also be mathematicians, so artists interested in diagrammatic form should not also be competent in other kinds of art.

Looking at the question from another side, we can see that representation is not something we may choose to do or not to do. It is the inevitable consequence of visual communication. For, as I pointed out, the formal constructs of drawing depend on our human faculty of recognizing continuously analogies of form between our various visual experiences, immediate and remembered. These analogies work as much for the broadest as for the smallest elements of form and structure. Moreover the faculty has to be continually alert if we are to read a drawing at all, and we cannot expect it to 'switch itself off' at some given stage in our reading. It will be there even in reading the whole drawing. We will recognize analogies of form between the whole assemblage of strokes on the drawn surface and other integral structures from our visual experience and reflection. One most important consideration is that *these other structures include other drawings, or other works of art.* Forms seen gain much of their meaning from the previous contexts in which they have been met. And drawings must therefore deal, in some sense, in general forms and in conceptual types (see pp. 183ff.). For the universe of discourse which draughtsman and spectator have in common is not mere designation of the object but a meeting of well-stocked minds. One must know drawings to understand drawing.

The relations a drawing purveys may seem primitive, such as mere 'separateness' in primitive arts dealing in simple enclosures. But the forms so defined by separation may represent extremely interesting conceptualizations, as in some subtly simple Japanese work. And a 282 drawing may be highly representational, as for example a Rembrandt, 312 and yet at the same time its whole assemblage will not look 'like' a factual piece of the world. It may gain part of its meaning from the relations of its internal structure to other similar structures, not from their relations to everyday percepts. It is only a pity that so many books on aesthetics starting from the principles of statistical psychology accept the grossly tendentious axiom that 'the naïve world' is composed of 'things'.[1] For to the truly naïve view, as to the artistic draughtsman, it is not. It is a whole. The 'things' which seem to be 'given' to perception are themselves a function of the perception, and of the linguistic communication-structure of the perceiver. As Benjamin Whorf has pointed out, it is impossible to match the *realia* of one language with those of another. This is what makes translation so difficult. For *realia* are not things, but general categories of thought

[1] For example, W. Kohler, *Gestalt Psychology* (London, 1966), and R. Arnheim, *passim.*

b

based on usage. The *realia* which drawings designate likewise may not necessarily correspond even with those of the artist's own verbal language. And so visual 'representation' works by formulating and distinguishing visual *realia* and their qualities according to general categories which are unknown to the pseudo-naïve perception of those whose perceptual ontology is formed by the utilitarian categories of verbal language. On this basis drawing styles can be distinguished from one another in that they represent each a different reality, a different set of *realia* related to each other by different types of structural function.

We must look further into the idea of the meaning-whole of the drawing. In a sense it will be the sum of the meanings of the parts, as I have mentioned, and such meanings are what is conveyed by the 'expression' of forms. Therefore, although it may seem to be representationally simple, a good drawing will nevertheless represent only what the spectator can bring up in himself to match with—analogize with—what the draughtsman offers at all levels. So anyone who believes that in identifying the 'subject' of a drawing (however iconologically complex) he has grasped what the drawing means, is wrong. There is far more to it than that. The wealth of reference given to the representation by the drawing methods, including the methods of creating overall unity or structure, are the real meaning of the drawing, whilst the final apparent image, or 'notional' objective reality, as well as being one amongst many of the possible unifying factors, can also be responsible for creating the internal tensions which give a drawing its force. This will be discussed in due course. But it is why so much extremely good art—especially drawing—has been produced around representational themes—tenors—which are apparently hackneyed, trivial, or indifferent.

As I have suggested, however, the forms of drawing do not carry meaning or 'significance' like a wagon carrying bricks. One form does not have one immutable meaning—or even one set of meanings. *Fig. 1* The meaning of any form is always a direct function of its context. This narrows down the possible references of the given form by demanding that it be consistent with its neighbour forms. It is at present a commonplace of semantics that meaning and context are synonymous. Context is a function of the topic and the topic itself is the tenor of the meaning.

But this idea must be extended for our purposes. For us, context has two aspects. First there is the aspect of context given by the

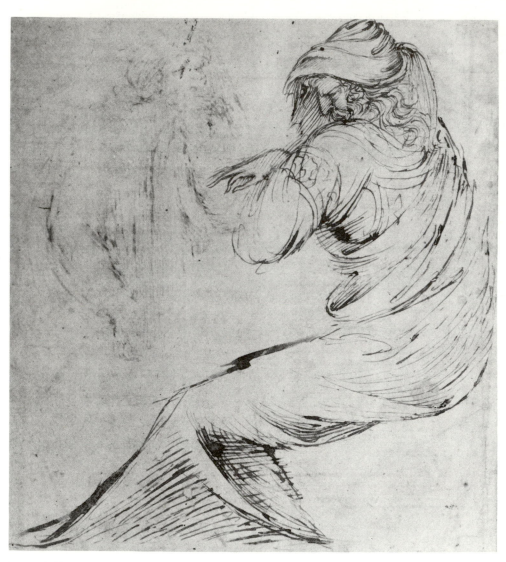

Stefano da Verona (1393–1450), A SEATED PROPHET IN PROFILE; pen and brown ink, 23·2 × 21 cm. *British Museum*

notional realities[1] in the work. This is of paramount importance. The same slightly asymmetrical loop may convey one meaning when it is located as the contour of a female breast, quite another when it indicates a table-top. The importance of this kind of context is most easily seen in primitive art, where the actual repertory of forms may

1 I use this term to indicate that which is depicted, portrayed, or represented: the apparent subject of the work, what it is seen as.

34

be quite restricted. Draughtsmen may use circles not distinguished by any special qualities for: the sun, the eyes, the breasts, a pool. Colour or plastic development might add further qualities. But intrinsically it is the context and the interrelationship which enables one to respond 'correctly' to the forms, to select the meaning which will link the circles into a structural unity with neighbour forms. Certainly there will be in the reponse to such circles overtones of the other possible but rejected meanings. That is one of the main points of my thesis. But from the point of view of over-all structure, which has its own claims to analogical life, to identify by notional context may be indispensable for further, broader stages of recognition. This is a point I shall be referring to again frequently and enlarging upon.[34]

There is a second aspect of context: the context in which the whole drawing itself belongs. This is very difficult to deal with and requires a sound sense of history, as well as the imagination to adopt the right mental posture in each case. To some extent it must depend on why the drawing was made, and who was meant to look at it where. Everyone knows that Michelangelo made highly finished drawings as gifts to Platonic philosopher friends. They were meant to be accepted as substitutes for sculptures with perfectly finished surface. Their forms were meant to hide their own inner structure. But a lot of Michelangelo's surviving drawings were a sort of shorthand for his own sculptural thoughts and were meant for no other eyes than his own. So their forms indicate only the inner structure without the surface. We may tend to like these best. And then Lafage, who was only a draughtsman, not a painter, made his drawings with their cursive lines partly because drawings were admired in a special way in the age of Louis XIV, and partly in order to exhibit a fluency of invention which would appeal to tastes formed by appreciating Bolognese drawings. They were meant to be seen in gatherings of the sophisticated, who would be suitably impressed and amazed.

Structure as relationship Perhaps the most important key, both to understanding drawings and to judging them, is this. Drawing is the creating of relationships which are themselves a function of the whole. A good drawing does not present a collection of separated items, it presents the unified whole: not the units but the system of connection. Any fool can draw lines round conventional objects. It takes an artist to relate them. And this system of relationship is the real subject of the drawing. In it is embedded the ontology to which I referred. All the distinctions

of method that I shall draw, all the categories of practice, are first of all an index to the visual *realia* of the ontology, i.e. not to things but to *visual* units, and these ultimately are a product of their own structural system. Unit and system are totally interdependent. In fact many great drawing styles expressly avoid bringing the everyday objects or recognizable elements of the day-to-day world into individual clarity, but focus instead on the bonding elements, on the forms which transgress the everyday thing-unit. Notable examples are the ink drawings of the Sung and Yuan masters of China, and of Rembrandt. And the conclusion which consummates this line of reasoning is that the structured complex whole is itself the most powerful symbol to which art can aspire. It is the image for that 'integrity' of self and world which justifies the artist's work.

Here is the essential function of that *general* aspect of form which is often mistakenly called 'abstract'. It enables forms to play their part in the structure of visual complexes by co-ordinating them through an underlying system of categories. I shall often have occasion to invoke the fact that all the forms embodied in drawing methods have to be seen under a double aspect. There is, first, their emotive and associational content as I have described it. But second, and equally important, is their structural function represented by the qualities they show which enable them to be related to one another at the level of generality and system, so as to compose an intelligible whole. These will be noted in due course. It seems to be this structural element of general artistic form which many recent theories have seized upon and emphasized to the exclusion of all else. But it does seem wrong to impose a system upon art as a whole which attempts to divorce structure entirely from content. For 'structure' is a genuine abstract notion without concrete existence, and the moment it finds expression in a concrete form, or is applied to forms 'notionally concrete' as in figurative drawing, it at once acquires a content. Thus, as drawing means making and reading material marks, structure and content must remain functions of form indissolubly linked to each other. And, furthermore, there is no doubt in my mind that as a matter of historical fact wealth and subtlety of structure have always been developed by those arts with the richest content of imagery. The challenge of the content has prompted and encouraged the development of the structure, which is manifested in continuous usage not in an ossified scheme.

Popular emphasis on each of these two poles of artistic form has

see-sawed in the history of art. During the twentieth century each pole has been more or less espoused as the only true doctrine by opposing schools of artistic thought, the Expressionist and the Constructivist, under various names. Constructivist criticism has claimed to find 'pure structures' in artists ranging from Cézanne to Piero della Francesca and the Dogon tribal artists; whilst Expressionist criticism has its own revered heroes like Grünewald and Maori carvers. Neither school can possibly lay a genuine claim to monopolize the *whole* truth about their patron saints. For Cézanne and Piero have a rich content of their own kind of 'expression', and the 'Expressionist' Mathis Grünewald has as subtle a structure in his own terms as Cézanne—but of a different kind.

So the drawing methods I shall go on to discuss will illustrate both aspects of the semantic process—content and organization. For I believe that neither can exist without the other. I make no claim that my survey is complete, but I hope it is a beginning. And I hope it will be a helpful guide to reading languages of form which we have learned to skip through in the 'Imaginary Museum' without realizing that they are definitely foreign, and that we are missing the message. For today, with regard to art, we have got ourselves into the position of exiles without a true mother-tongue of form; we are polyglots glib in the rudiments of many tongues but do not know any one really well.

CHAPTER 2 Supports, Materials, and Implements: Their Significance

Dark on light, and vice versa One point of quite extraordinary importance in drawing is never properly discussed. It is taken so much for granted that it has become 'invisible'. Books on drawing have been written which never even mention it. This is that drawing techniques all assume the use of dark lines drawn on a lighter ground. Only at a specific stage in the history of European art did the idea of drawing with white or light tone on a darker ground produce a special kind of drawing with its own principles, a factor which has been overlooked by Wölfflin, amongst others. Apart from this epoch in European art lines of light on a darker ground, where they occur, amount to no more than an occasional tonal inversion of normal methods of dark on light. For example, on Greek black-figure pottery lines incised into the black areas sometimes have white rubbed into them. Sino-Japanese Buddhist illustrations may be in light gold or silver on a dark-blue ground. There are woodcuts, Chinese and Japanese, where a technique of cutting lines as channels into the face of a printing-block results in a print of light lines against a dark ground. Eighteenth- and nineteenth-century European mezzotint and wood-engraving techniques, however, were a consequence of the special European light-drawing method mentioned above, which will be discussed in due course. The basic principle remains that drawing has usually meant dark on light; and the history of drawing has accommodated itself to this fact.

The nature and meaning of the natural surface as support The usual implements, materials, and media of straightforward drawing can be classified. First there is the ground or support on which the drawing is made. The character and qualities of this are very important, though they are often taken far too much for granted in this age of mass-produced papers; and we may easily be misled into thinking that this has always been so. The essential point is that the ground, whatever it be, is the underlying symbol in the drawing for the objective-as-such, for the *Gegenstand* which is set up facing us as the ontological basis of the communication. So it can never be ignored. Its symbolism is part of the symbolism of the drawing. And if it is a mass-produced paper, that is part of the drawing's meaning.

The ground may be a natural surface, such as the rock wall of a gully or cave. Aboriginal, Palaeolithic, and Negro peoples use such sur-

faces. Essentially this kind of ground is an actual piece of the real world. A part of the actual is used to serve as a symbol for the propositional truth of the drawing. This objectivity of the actual, as distinct from the objectivity of 'notional' space, is one of the inspirations of modern concrete–objective art, the art which attempts to create artificial works which are understood as pieces of reality.

The chief characteristics which such a piece of the surface of the real contributes to a drawing are: first, the irregularity and variety which are intrinsic to natural surfaces; and, second, the element of rhythm and regularity which may underlie the variety. This will be a function of the structure of the natural surface, such as the stratification of the rock. The drawing which is done on a rock will take account of or adapt itself to both these aspects. The first, the variety of surface, as well as giving an underlying conviction of reality through variety, will also offer the artist the chance to use actual protuberances or hollows in the surface to indicate the positive or negative plastic qualities of the whole subject, its convexities and concavities. This has been observed in many of the Palaeolithic cave drawings of Europe, and in the rock drawings of other peoples.

An interesting thing about rock drawings is that they lack a format. There are no co-ordinates given to the drawing by its edges. The only point of reference is the notional 'top' and 'bottom' which are given by the erect human posture before the drawing. Caves and rocks have no rectangular corners. And where such a drawing is done, for example, on a roof, there can be an almost complete disorientation of the sensibility. The artist may have had no points to which he referred his 'notional' object, and this is conveyed to us in his drawing. Thus the animals or people drawn by 'primitives' on open walls may seem to our eyes to lean crazily or to move as much up and down the wall as across it. For the right-angle, the joint concept of vertical and horizontal which deeply conditions the whole of our art, is a cultural achievement; and there have been, and still are, cultures or stages of culture in which it is lacking. There can be no doubt that a sense of disorientation, of liberty from the iron prison of the right-angled frame, is one of the things which sophisticated city-dwellers most appreciate in much primitive wall art. It becomes for them an emblem of freedom or naturalness. Draughtsmen such as Jean Dubuffet have attempted to capture the sensation in their tottering, 'irrational' figures, but unfortunately without being able to give up using the rectangular format completely. Roughly torn sheets of

paper might help, if they could be exhibited in a hall without level walls or right-angled corners!

There are other natural surfaces on which drawings have been made. Australian aborigines, for example, have often drawn on a 41 piece of the bark of a tree. Here again the bark surface has vigorous irregularities. It can not be flattened to what we should regard as a proper plane surface; and there are regular organic striations which offer a punctuating rhythm. Other natural surfaces, such as the animal skins used by American Indians, share these characteristics. But the moment we come to surfaces of limited size, such as ivory or bone, 143 we enter the realm of format. The dimensions and shape of the surface on which the drawing is done begin to play a role of overwhelming importance in the conception of the drawing. And it seems that the appearance of the concept of horizontal and vertical co-ordinates in drawing must be directly associated with the limited format. The purely rectangular format which we take for granted is in a sense always present, implied by invisible co-ordinates, even in those few drawings made inside circular or oval formats. There would seem to be room for a good deal of artistic exploration of the possibilities of an art of design which abolishes or transcends the co-ordinates—though, as I indicated, the whole environment within which these works were displayed would need to be sterilized of its own implicit co-ordinates, such as rectangular rooms and ceiling corners.

Adapted supports Next there is the class of support materials which have a secondarily 'natural' character. By this I mean that they were made by man, but not in the first place to be drawn on; drawing on them was a kind of afterthought. The most obvious of these are the Egyptian 'ostraka', pieces of potsherd. Thousands of ostraka bearing writing or drawing are known in Egypt from about 2500 B.C. right into the Christian period. Here again there would seem to be no obvious co-ordinates given by the support itself. But in fact there are co-ordinates in these works. For the art of Egypt had long been familiar with rigid co-ordinates on architecture and papyrus pages, as well as with writing inside a rectangular format. Their presence is everywhere implied in the drawings.

Old walls are another drawing support in which many people nowadays are much interested. *Graffiti* especially have interested artists such as Dubuffet and have been the subject of highly romanticized photographs, as those by Brassaï. Here again we find the sense of co-

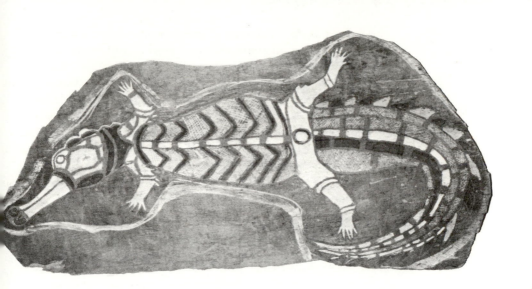

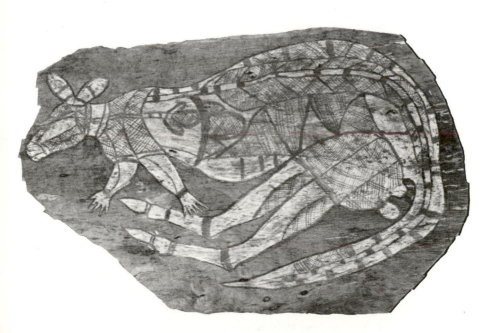

WALLABY AND CROCODILE, Australian; coloured earth and orchid juice on tree-bark, *c.* 20 in. *St Aidan's College, Durham*

ordinates weakened, although of course even old walls were once built according to co-ordinates. But the wall-scribblers have often worked in a hurry, carelessly, or lying down (in prison cells). The particular charm some people find in these drawings is due, usually, to three chief factors. First there is the obvious naïvety of the artists, which is itself an attraction to people disgusted with slick artifacts. Second, the fact that this naïvety is enhanced and extended by the irregularity of the material surface. A drawing point is blocked and skids to one side, and this does not matter to the draughtsman. A scratching point is diverted by a patch of hard surface and swerves away from the intended line. This too amounts to a concession to natural conditions, and a defeat for the over-assertive intellect. Third, the fact that the surface itself bears all the marks of its own history, and has usually been treated with public disregard or contempt. Together these three factors project that romanticism of the socially rejected, the fallen, and the decayed, which has been so fashionable. There is, however, another factor lying behind this aesthetic situation, which originated in the Far East and combines the qualities of these two last categories of support. This is the kind of drawing done on the rough, rustic surfaces of Japanese tea-wares. One could perhaps call it the aesthetic of agelong time. Modified and adapted, it exercises an immense influence on our present-day aesthetic ideas.

For many centuries—millennia, in fact—artists of the Far East have been obsessed with their vision of total reality as an infinite web of change, without beginning or end. It was called the Tao or the Dharma according to whether one's background was native Chinese or imported Buddhist. Aesthetic objects which served to symbolize immemorial age were highly revered, amongst them antique, corroded bronze vessels of the second and first millennia B.C., stones eroded into fantastic holed and hollowed shapes by the action of water, and ancient gnarled trees whose aesthetic impact could be enhanced by careful trimming. The pottery wares of certain Chinese and Korean peasant peoples, the forms of which were eccentric and the finish rough, were admired and collected during the later Middle Ages, especially in Japan, because they were held to express the same spirit of antiquity not spoiled by intellectual rigidity. The tea-wares of the Japanese tea-ceremony, originally a Buddhist ritual, were made between the fifteenth and nineteenth centuries in emulation of these earlier peasant wares. Their pot body was coarse, filled with roughly ground material. The forms were hand modelled, rarely

thrown. Their glazes were rough, too, of clouded colours, usually earth-colours, loosely applied, trickling and clotted, and they were fired in primitive types of kiln. The scanty designs drawn on the surfaces of these pots set out to be iconoclastic. Their irregularity was due to the hazards of material, and their sophisticated clumsiness was a rebuke to the slick designs of conventionally perfectionist wares. The few brush-strokes or scratches laid into the glaze were supposed only to bring out occult qualities implicit in the forms of the pot and its surface. The chance which produced the forms was never for these people *mere* chance; it illustrated the essential uniqueness of each piece, and the designs drawn on such a support could never be repetitions of a standard pattern. As no two pots could ever be the same, the designs too had to be unique, unrepeatable, on every individual pot. This aesthetic notion will appear again, repeatedly, in this book. Here I shall only point out that this type of support for drawing, like the decayed wall, offers to the draughtsman in every case a fresh, unique 'given', or *Gegenstand*, whose implications he has to capture and realize, allowing his intellectual formulations, his own idea or pattern, to be conditioned by the support. It must be added that this whole aesthetic only works if there actually is a minimal pattern whose subordination to the ground can actually be recognized.

In a sense such supports are a natural 'given'. Their awkward qualities show that they were not made just to be drawn on. Like a rock face they are something in themselves before they are supports for drawing. In the case of the Japanese pot the hazardous process of its manufacture duplicates, as it were, the processes of nature. Recently, however, many artists have tried to short-cut the natural processes of creation and devise quick and easy techniques for making surfaces which will offer them the same sort of opportunities for apparent spontaneity and chance as the natural supports already mentioned. Paper is crumpled and flattened again. Plaster or plastic is scrabbled on to a surface. However, as I have pointed out, all intentions show in the artifact; and here the spectator recognizes at once the lack of a true process of ageing, of a genuine history behind the formation of the surface. And his response is accordingly shallow.

Where, as often happens, a pot is the support for the drawing, and where the rugosities of its surface are not important but mainly its colour and texture, then a lot of other considerations come up. Some of the most magnificent drawings of the past survive for us on pottery 229 —for example, on that of early Susa, of Crete, Greece, and the Mochica 230

people of ancient Peru. And design on pottery is one of the most 146
interesting and artistically challenging aspects of art. 307

The most important aspect of pottery as support is the fact that it has a specific shape of its own and the surface it offers is three-dimensional. Interiors are concave, exteriors convex. And the pot surface itself offers an unequivocally objective ground upon which to 146 design. Drawing on this objective ground should always be related to the actual shape of the pot, and the three-dimensional implications of the form have always to be taken into account. The real achievements of such design depend on the thematic relationship between design and pot form. This will be discussed in detail later on. Here the 223 relevant point is that the pot surface gives an actual third dimension to the design, and any 'notional' third dimension, as in Greek pottery painting, must accommodate itself to this. The vertical co-ordinate of space is given, of course, by the vertical axis of the pot and the horizontal co-ordinate naturally follows, though it is highly ambiguous in that it is curved around the axis and blends into the third dimension. Second and third dimensions are thus aspects of each other. Cretan vase-design accommodates itself superbly to these 230 conditions by assimilating its undulant organic forms to the pot surface in such a way that their movement in the actual third dimension is entirely consistent with their movement in the 'notional' third dimension which the represented objects suggest. The same is true of the best Chinese pottery painting. Central American and Mesopotamian pot designs tend to eschew notional plasticity, and hence lack the notional third dimension to conflict with the actual. Early Greek pottery, by adopting the notional space-compression of the relief-frieze, was able to avoid conflict as well. The figures were adapted to differently shaped fields by means of stretching or contracting the base-line on which they stand. But on later Hellenic and Italiote pottery the surface of the pot often becomes, through the conflict of the three-dimensional logic, a dream-like, indeterminate arena in which figures float, notionally plastic themselves but not anchored into either of the possible three-dimensional modes.

An extremely interesting use of the pot surface is made when the design interprets the pot itself into the notionally three-dimensional body of the design. Pots made in Central America, and the Mochica 30 and Chimu wares of Peru, do this; Picasso has done it; and Indian peasants have done it with their Manasa pots, where the vessel is 45 interpreted into the form of a female figure in a sari.

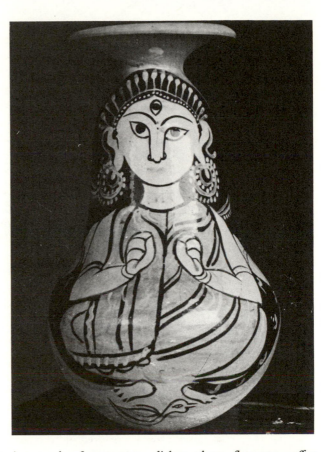

anasa pot, Eastern
dia, 20th century;
11 in.

The interior panels of openware—dishes, plates, flat cups—offer circular fields to the draughtsman. They may seem to lack obvious co-ordinates. However the true circle is a sophisticated form, usually associated with a stage of civilization in which a figurative art with built-in co-ordinates has emerged. The problem of organizing the designs of such spaces will be discussed later.

Obviously important for the significance of drawing on pottery is the surface to which it is ultimately fired. When the potter actually draws on the raw ware, dry or biscuit, he draws with suspensions of clay-slip or pigments in water on to the absorbent body. Generally speaking slip, being much thicker than glaze, produces more opulent effects of hazard.

One extremely common support for drawing has always been the plastered wall-surface, such drawings usually being a prelude to

45

fresco painting. There are notable instances of pure drawing direct on to such walls, amongst them works of Giotto, some of the mural art of India, and Ceylon. Here, of course, co-ordinates and formats are fully developed, in that the works are executed in architectural contexts.

Grounds prepared from natural materials A large number of natural materials, more or less prepared, have been used as a ground for drawing. In India, Ceylon, and countries of South-East Asia long strips of palm-leaf have provided an excellent drawing surface, probably for millennia, down to the present day. The part of the leaf used is that from beside the main mid-rib. Strips, about twelve to fifteen inches long horizontally by about two to three inches vertically, have been used to form manuscript books, strung on cords to preserve the page order. Such palm-leaf needs no preparation beyond trimming. It will easily take drawing with pen or brush, and can be impressed with the stylus so that pigment can be rubbed into the channels. It is usually partitioned vertically so as to provide panels of reasonable format.

Other leaves, such as the pipal, have very often been used for writing and drawing in these same countries, and it is reasonable to assume, both from the common usage of the term 'leaf' and from obscure references to classical oracles inscribed on leaves, that Western peoples have also used dried natural leaves. Indeed it would be surprising if they had not. However, no actual European drawings on leaves are known, and apart from palm-leaf, only a few examples of Indian drawings pricked on to pipal leaves seem to be available.

The most important plant material of the ancient world from our point of view is the Egyptian papyrus, from the name of which our modern world 'paper' is derived. Vast numbers of papyri are preserved, mainly from Hellenistic times, many of them adorned with drawings. Papyrus was probably the first manufactured 'utility' material for the draughtsman's use. It was prepared from strips of the pith taken from the stem of the papyrus rush. These were wetted and laid parallel beside each other. Several layers of strips laid alternately horizontal and vertical were pressed together, often with gum. The result was a fairly strong fibrous sheet, which would take penmanship easily with little further preparation save a rubbing down. Such papyri were always made with a definite format; indeed the material itself contained its own vertical and horizontal co-ordinates.

Wooden panels have been used for drawing on, of course. And

46

many medieval drawings, which represent the first stages of un-
finished paintings, were executed on sawn wooden boards the surface
of which was prepared with layers of fine glue mixed with fine chalk
or lime, and polished. But such wooden panels were naturally far too
expensive and difficult to prepare to serve as normal supports for a
continuous drawing activity. And so it seems that until well into the
sixteenth century, in most countries of Europe, the old classical
'tablets' were used by draughtsmen. These were small wooden boards
which were surfaced with wax coated with ground sepia and set in
little stiffening-frames, sometimes bound like the pages of a book on
loops or rings. The surface was protected by the raised frame. An iron
stylus was used to draw in the wax; the drawing could easily be
obliterated, and by gentle heating the surface could be prepared for
re-use.

Parchment was the principal drawing support of medieval Europe. 111
It was prepared from the skin of calves, goats, or sheep. It varied
much in quality, and this depended a good deal upon the skill with
which it was prepared. It was of course expensive, and old leaves, or
entire books, were often wiped off and re-used. Such palimpsests,
whose obliterated texts are read with modern scientific aids, have
yielded literature unknown in properly preserved manuscripts. In
fact the grain and surface of well prepared and rubbed-down parch-
ment is an excellent drawing surface, which takes ink very well.
Pieces of thick, strong parchment mounted on wooden tablets were
still used as sketching surfaces by artists of the fifteenth and sixteenth
centuries all over Europe. They could also, of course, be regularly
cleaned and re-used.

Generally speaking, parchment has always had attached to it the
cachet of being expensive. The religious texts, often illuminated with
drawings or paintings, which were produced in the European
monastic scriptoria of the Middle Ages, were regarded with reverence, 238
as treasures. The parchment of the most extravagant Imperial
Byzantine or Ottonian manuscripts, *codices aurei*, was often stained
purple and the script executed in silver or gold. When paper became
generally available after about A.D. 1400 parchment remained in use,
as it still is, for prestige purposes. State documents, royal warrants
and commissions, town plans, major architectural designs, coats of
arms and genealogies, and often miniature paintings, have been done
on parchment. From our point of view the essential thing about
parchment is that its traditional uses and its cost have usually con-

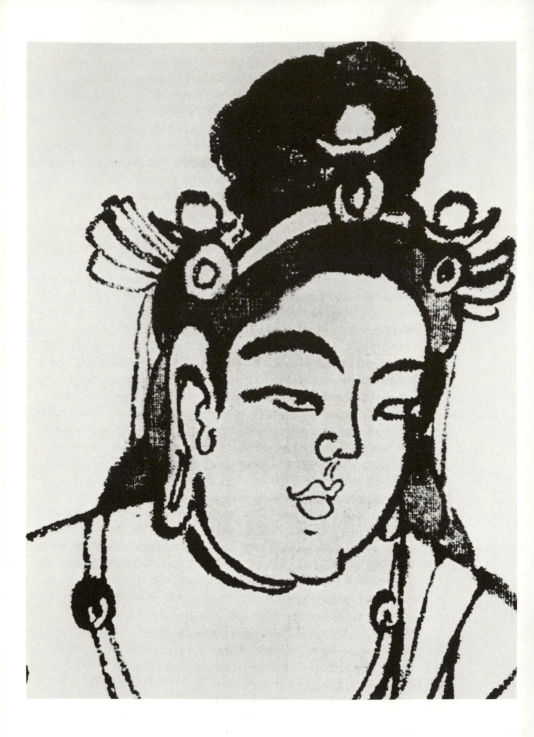

ditioned draughtsmen to a particular kind of attentive care in their work. The atmosphere of the monastic scriptorium hangs over it. Designs have usually been carefully prepared, sometimes by pricking, or with charcoal; and the final pen-lines have been phrased with a disciplined confidence. Dutch draughtsmen of the seventeenth century took to using parchment occasionally. The young Aelbert Cuyp, Gerard von Eeckhout, and others used it; and even Rembrandt has left one portrait drawing, a commissioned work in his earlier style, on parchment.

Fabric supports;
cloth and paper

The normal supports for drawing have been woven cloth and paper—usually, but not always, filled or prepared in some special way. We have no real means of knowing to what extent, say, cotton cloth has been used in tropical countries in the past, though it is very likely to have been used in ancient India, perhaps Central America, Mesopotamia, and undoubtedly in ancient Egypt. We have examples of painted cotton and even llama wool cloth from the first millennium B.C. in Peru. We know for certain that it has been used more recently, and still is, in India, Tibet, Africa, and Indonesia. Often its surface is prepared with one or several layers of fine white chalk or lime, mixed with glue. The surface is often then burnished.

Silk cloth has been used as a drawing-support extensively throughout the Far East and Central Asia. It will take ink from the brush when it is sized, and countless major works of monochrome art (as well as polychrome) have been executed on it. It has one particular significance which is important for the interpretation of drawings in general. Silk was always a precious substance in its own right. And in those countries which have chiefly used it, China and Japan, it has even served as a medium of financial exchange, a standard of value. A piece of fine silk spread out to receive the strokes from an artist's brush represented a special kind of invitation or challenge. It was not something which would be used up and thrown away. It was there to register and keep a precious record of the spiritual movements of a man of insight, someone prepared for and keyed up to an immediate peak of performance in painting or calligraphy. It is a fallacy, though, to believe that all Chinese and Japanese artists worked without preparation. Many used charcoal to prepare designs, and most of the greatest built up the density of their works by returning to them repeatedly over a longish period of time—months or even years. But

49

no mark once made was totally expunged, and 'pentimenti' were not recognized.[1]

The consequence of such a use of silk was that the picture's aesthetic value was reflected in its intrinsic value; the idea of financial worth was attached to the moral worth of the painting—which might, in actual fact, be an inferior one. For, whether it is on silk or on paper, only masters produce masterpieces! The idea of the 'valuable' support was, however, extended—especially in Japan—through the practice of preparing silk or papers by embellishing them with precious materials. Drifts of gold or silver flakes might be laid on beforehand, and their irregularity would suggest the placing of the design. (Over-zealous collectors sometimes had these drifts added afterwards; but this one can always tell.) Cut-out patterns of gold leaf in the form of rosettes, the heraldic emblems of the noble patrons, or herring-bone strips reminiscent of the backgrounds of old sacred pictures might be laid on. Papers stained with expensive red or blue might be used with these embellishments; and on them pictures might be executed in gold or silver. This was especially common with religious texts in the Far East, just as it was in the West with the *codices aurei*. Finally, the entire ground of silk or paper might be covered with gold or silver leaf as a support for the design—the *non plus ultra* of intrinsic value in the support.

If we recognize this deliberate involvement of financial value in the aesthetic image, it would be reasonable to expect that we might also find the opposite playing its part in an aesthetic complex. And, of course, we can. Much modern art has availed itself, deliberately, of despised, rejected materials as supports for drawing—wrapping-paper or old burlap, for example. But perhaps more interesting than this rather self-conscious use of a 'base' surface is the case when the artist is genuinely a poor man and incorporates his own poverty into his art, using humble materials because they are all that he can afford and because he feels at home with them. Such a case was Barlach. Many of his most impressive early drawings were done on pages from cheap school exercise-books, which were lined or squared out for children's use. His figures and their forms reflect that image of 'holy poverty' to which his whole art was dedicated, and with which the nature of the support is quite in keeping. The problem of

[1] Pentimenti are earlier, replaced lines. They may be still visible but they are not the final statement.

preserving these drawings intact will be a serious one for the museums where they are lodged.

Of course far the larger part of Western drawings have been done on paper of varying quality. Paper was in use in China by the second century A.D. In 751 the Islamic inhabitants of Samarkand captured some Chinese paper craftsmen, and by the ninth century there were many Islamic paper manuscripts. It was in use in the Byzantine Empire by the eleventh century and in other parts of Europe, including Moorish Spain, by the twelfth. The first mills in Italy were set up at Fabriano in 1276. Paper was being used in artists' workshops in Tuscany round about A.D. 1300; it was called *carta* by Cennino Cennini (1370–1440), and was regarded as a substitute for parchment.

Paper is made of fibres pulped in water, sometimes with an adhesive. A quantity of this is taken out on a kind of sieve and allowed to dry. The fibres felt themselves together into an interwoven texture as they dry. All kinds of fibres may be used from a wide variety of plants or trees, such as cotton, linen, bamboo, rice, or mulberry. Rags were commonly the source. Wood-pulp, which is now used everywhere, was introduced only in the mid-nineteenth century. Fine oriental papers were strengthened with cut silk fibres. The pulp is nowadays often bleached, reinforced with glues and white fillers such as chalk, and pressed between cold or hot rollers. In the Far East, however, in India and Persia, and in earlier times in Europe, the treatment of paper was usually confined to preparing the surface in various ways such as liming and burnishing. This was normally done in the artist's studio. But during the Renaissance in Europe industrial processes began to take over the job of preparation, and it became customary for different towns to develop special types of paper.

Most papers during the fifteenth to eighteenth centuries in Europe were of the natural faint beige or grey colour of the original dry pulp when untinted. But papers were developed into which colour was incorporated, such as carbon and sepia to darken it, blue (in which Venice specialized), faint or strong red, and *terre verte* (earth green). Most of these toned European papers were developed as a direct result of the techniques of chiaroscuro painting, and were designed to show the white drawing which supplemented the dark. For the normal method of chiaroscuro painting, from the days of the van Eycks (*c.* 1410) until virtually 1800, was to paint on a toned ground—grey, *terre verte*, or earth red—what amounted to two separate, interlaced designs, one in dark in the shadow, one in white in the lights. The

middle tone of the ground linked them, and transparent overlays of colour could then bond them firmly into a unity of continuous tone. Greater artists, such as Rubens or Rembrandt, might in their oil sketches short-circuit this method, but its implications were always there.

Toned papers provided an admirable support for preparatory studies towards such chiaroscuro paintings. Rembrandt, however, made little use of toned paper, although like Titian, he was chiefly concerned in his painting with the 'white drawing' aspect. In fact his drawings are mostly done on a light paper using a pure light-dark contrast that only a light paper can give. But there are a number of Rembrandt's drawings in which a layer of wash is applied so as to suggest a mid-tone against which the lights and darks are allowed to stand out.

Outside Europe paper was used in other ways. In the Far East fine, thin, absorbent papers were made on which to draw with brush and ink. These fine papers were imported and much used by European engravers and etchers for making prints. Their essential qualities are that whilst they drink the ink readily and virtually forbid second thoughts or redrawing, they do not allow the ink to 'halo' out from the central blot, and they keep their strength when wet. It was this latter characteristic which endeared them to the engravers. These papers can accept either a slow aggregation of touches of tone towards a final strong dark, as Mi Fu or Huang Kung Wang painted; liberal 'spilled ink', as Sesshu or Tessai used it; or vigorous wet and dry strokes, such as most of the Zen painters employed. Usually the topmost sheet of paper on which the ink drawing was being done would be backed by others to absorb excess moisture and give strength. When the ink was dry such fine papers would be strengthened from the back by further layers of paper applied with a very fine paste, and would thus be converted into a thick or thin cardboard. Very fine papers were much sought after and admired, so that they shared something of the *cachet* of silk.

Paper first became commonly used in Western India in about A.D. 1400. In India paper was most often used thick, prepared in layers like cardboard. For sophisticated work the surface would be treated with layers of glue and whiting, which would be repeatedly burnished in order to give the enamelled, jewel-like surface which Indians have always admired. The drawing would usually be done with the brush.

Paper, of course, has become the common utility material for

drawing in most recent artistic societies. It is usually made in rectangular sheets, and in Europe has been standardized into format-sizes (based on book-printers' standards) for several centuries. Large sheets, when they are needed, as for cartoons, have been made by glueing together numbers of smaller sheets. Nowadays, however, the range includes the large formats familiar to most art students from Demy ($20'' \times 15\frac{1}{2}''$) through Medium ($22'' \times 17\frac{1}{2}''$), Royal ($24'' \times 19''$), Imperial ($30'' \times 20''$), to Double Elephant ($40'' \times 26\frac{3}{4}''$), and Antiquarian ($53'' \times 31''$). They are available in various weights. It is worthwhile remembering that until the seventeenth century, at the earliest, paper was by no means cheap. So that one finds great artists like Michelangelo using up every corner of both sides of a sheet of paper for sketches, plans, poems and the drafts of letters. Finally, one important quality of many good papers is the rough, granular surface which is given to them by the sieve in which the pulp was collected for drying. This has been used to great effect particularly by draughtsmen working with chalk. Nowadays there are various standard surfaces available, such as 'hot pressed' (very smooth) 'not' (i.e. medium, not hot-pressed), and 'rough', the only one which preserves the natural surface.

The importance of the format; co-ordinates We now come to one of the most important theoretical aspects of the ordinary rectangular support, which for convenience I shall suppose to be the sheet of paper. This is the influence on the drawing of the actual format itself. I have mentioned that the support represents to the draughtsman the objective, the *Gegenstand*, which supplies him with the reality-basis for his work. Manufactured supports always have a format.

There is one way in which the drawings of sculptors, and of a few painters whose work has been much influenced by the sculptor's way of thinking, differs in its use of the sheet format from that of the true painter. Until the *Quattrocento* in Italy no European sculptor was supposed to be able to draw. The only medieval sculptors who did draw were those who followed as well professions where two-dimensional design was needed; such were goldsmiths and their descendants the engravers—amongst them the great Nürnberg sculptor Veit Stoss. Most medieval sculptors, if they wished to have a drawing of a proposed design—say an altar-piece—to show to a prospective client, employed a draughtsman to make a drawing. The point here is that when sculptors did begin to make drawings, both for their

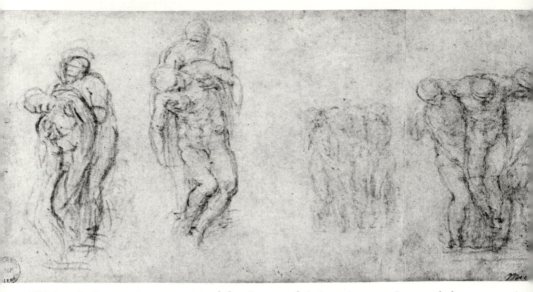

Michelangelo Buonarroti
(1475–1564), Row of
figures for THE DEPOSI-
TION, *c.* 1540; black chalk,
10·8 × 28·1 cm. *Ashmolean
Museum, Oxford*

own use and for the use of their assistants, they tended to approach
their sheet of paper in a special way—that is, without regard to the
format as frame. Michelangelo is an excellent example, even though
he was a painter and did make a number of specially finished drawings
as gifts for Platonic philosopher friends later in his life. But it is easy
to see how in most of his sculptural drawings his single figures or
groups of figures, even when they approach the complete idea, are
treated as independent, self-related unitis, placed virtually anywhere
on the page without any specific relationship to the edges of the sheet.
The horizontal and vertical co-ordinates are contained within the
figural design itself, and the whole principle of unity lies inside the
group and is not related to the format as frame. The sheet of paper
outside the design represents a kind of negative, valueless space. This
is also true of most architectural drawing. In the work of painters on
the other hand one usually finds the drawing divorced from the
format only on scribble sheets, where the figures are no more than
suggestions.

For painters, with their pictorial outlook, tend to treat the format
of the sheet as if it were a frame to which the figures drawn stand in
some intelligible relationship. In fact the format is often one of the
thematic elements of the design—but this is an issue I shall discuss
later in more detail. It is true that there are many painters' drawings
in which the relationship is relatively casual, particularly in the case of

detail or auxiliary studies. But the elements of a drawing which is in any sense a pictorial composition are closely related to the sheet format, or at least to a format drawn on the sheet around the composition by the artist himself.

This distinction, although it may at the moment seem to be without great significance, is nevertheless extremely important when one comes to the point of actually reading the expression of drawings. For much of this depends upon the relationship of graphic elements to one or other type of given co-ordinate system. One reads a sculptural drawing in relation to co-ordinates contained within the 'notional realities' (e.g. the figures), a painterly drawing in relation to external co-ordinates given by the frame.

Accepting that the format-frame has a role to play in the meaning of pictorial compositions, we can make some preliminary classifications of the ways in which graphic elements, and especially the notional realities such as figures, buildings, trees, etc., are related to the format. This question will have to be covered more thoroughly at a later stage in connection with the problems of space.

First, the format-size is normally related to the customary viewing distance between eye and sheet. In the case of drawings this is usually the same as reading distance, about 18 inches, though the quality and touch of the drawing may suggest longer or shorter distances. For in principle even monumental painters have made drawings on a scale which permits them to oversee and control the whole of their drawing surface within the scope of a single glance. Of course drawings which 'aspire to the condition of paintings', as many modern drawings do, will have been conceived as drawn and viewed from much further off. Many Far Eastern drawings, however, do use a format which at nor- 184 mal viewing distance does not permit the eye to take in the whole in one glance. But such special cases do not invalidate the general principle that the relationship between the size of any notional objects and the format will suggest a sense of closeness or remoteness to the spectator, as if the format were a window-frame through which the spectator was looking at his notional reality from the given distance. A draughtsman who sets out to draw from any actual motif adjusts 273 the format of his sheet to his distance from the motif and the 'cut-out' 312 area of the motif he intends to cover. It was this kind of adjustment which the drawing machines used particularly in the sixteenth and seventeenth centuries in Europe were devised to produce mechanically.

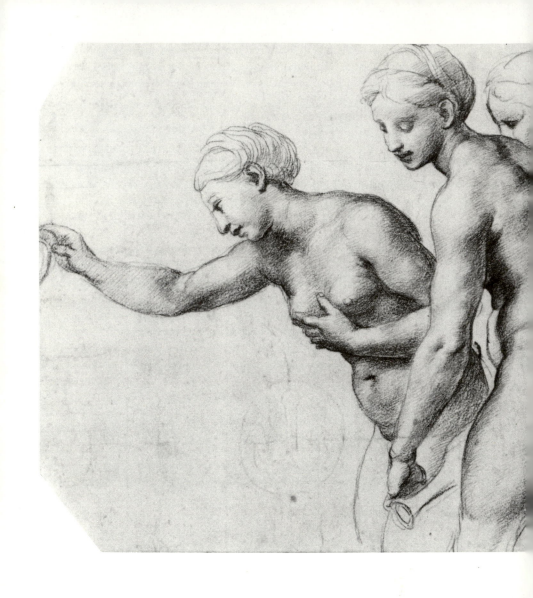

The format thus acts as if it were a window, of the size of the sheet, set at the viewing distance from the spectator and opening on to the required field of the motif. So if only part of a single notional object 98 fills the format closely, the spectator is given the sense that the notional reality is overpoweringly close to him, like, say, his own reflection in a small mirror. It can even seem to be within touching distance. If several human figures are accommodated comfortably full length within, say, half to two-thirds the height of the format, as in many Rembrandt drawings, the sense is that the figures are about twenty to thirty feet away—an innocuous, contemplative distance beyond the scope of binocular parallax. If buildings and trees are small, and figures smaller still in relation to the format, the natural sense is of remote distance.

One of the most important expressive resources of drawing is to create some special relationship, even one of strong conflict, between the expected sense of distance as suggested by this relation of format to notional realities, and the actual method of treating those notional realities. Here is one of the many places where figurative drawing scores heavily over non-figurative. For example, in many early Flemish drawings of the fifteenth century notional objects, which the format declares to be distant, are treated with a minute attention to surface detail which is appropriate only to a very close view of such objects. The converse is far commoner today: in drawings by Rouault, say, one encounters bust-figures which are declared 'close' by the format but are treated by very broad units of form and tone as if they were untouchably distant, like stained-glass windows. At the opposite end of the scale, in the drawings of Seurat, the suggested 16 distance for the figures is yet further increased by the handling so as to eliminate any sense of human contact. In many drawings of Raphael, especially the preparatory drawings for the mid and later *Stanze*, 56 figures which belong in the comfortable middle distance are actually treated with a close attention to the surface of the flesh and garments which is only proper to a very close, even an 'intimate' view. This Leonardo frequently does as well. In contrast the drawings of some of the seventeenth-century Dutch domestic painters, like Terborch, create their sense of bland tranquillity partly by adjusting their treatment closely to the suggested distance. Precisely what 'treatment' involves is, of course, a very difficult matter, and will emerge in due course.

European drawing formats have usually been limited to a group of

orthodox printers' and paper-manufacturers' formats, their halves and quarters. Even for landscape long, horizontal sheets have not been much used. This may also have something to do with the influence of drawing machines in Western art. In the Far East, however, other very interesting formats have been extensively employed, which give the draughtsman a much wider range of expression via format. Perhaps the most important is the long handscroll. This is a continuous sheet, usually some 12 to 18 inches in height, and perhaps 40 or 50 feet long—though it can be far less—which is kept on rollers, and unrolled from right to left about 2 or 3 feet at a time to be looked at. The drawing thus offers a continuous sequence of visual events, given a vivid kinetic value by being seen as an unbroken whole. The vertical view is compressed within the vertical width, but within it all degrees of closeness or distance of treatment are possible. This will be discussed in the section on Space (pp. 199ff.).

The second Oriental format is the vertical hanging scroll, which varies in the proportion of its horizontal width but is always much longer vertically than horizontally. It is meant to be seen as a unit, not continuously unrolled. But its vertical emphasis means that it gives scope either for creating a vivid sense of the presence of a single standing figure, or a sense of immense distance and depth in landscapes by the use of a high horizon line and a mixture of very long and short rhythmic intervals. One special version of this was much cultivated in Japan. This is the very tall, narrow 'pillar print' format in which 'close' figures are cut off by the edges of the frame so that their movements and relationships become charmingly enigmatic. Again the Far East has challenging formats in the shape of drawings made for fans, often by major masters. The two principal shapes are

 and The first can be filled more or less conven-

tionally; the second may often involve distorting the ground into a curve with the features of the composition, close or distant, radiating from the centre. Extremely interesting spatial effects can spring from this when the shape of the format is allowed to condition the conformations of the notional space in which represented objects stand. This is an aspect of format which Western art has never developed to any great extent.

Now I must discuss briefly the implements used in drawing. At the outset a most important point to remember is that the draughtsman's hand is *not* normally seeking to make a fine, perfect line. Such lines *may* be the draughtsman's objective; and if they are, that fact has a specific significance. But at bottom the drawn line represents an encounter between the shaping hand and a given surface. And in the encounter the special qualities of the substance which the hand applies to it play as important a role as the surface itself. For the hand learns to incorporate into the image offered by its drawing all those irregularities and accidents which the substance promotes and which the surface brings out. For example, slip brushwork on pottery, or Japanese 'sumi' (ink) on absorbent paper, will add special qualities to the drawn image. Thus a fine, 'perfect' type of line is only one among the many possibilities, and depends on specific types of drawing-point used on specific kinds of drawing surface.

The hand may apply some substance directly to the surface. It may smear on with the fingers, palm, and edge of the hand a paste made of ochreous earths, lamp-black, chalk, or powdered wood, perhaps mixed with fat or the juice of plant—such as the orchid juice used by some Australian aborigines. Usually the hand which draws in this way will make deliberate gestures which produce an 'additive' line made up of separate touches; for the fingers cannot carry enough of the drawing pigment, nor can they apply it freely enough, to make a long, elaborated stroke. Thus the linear form will be thorough-invented. Many modern draughtsmen seek without great success to imitate the blunt, accumulative strokes of primitive finger-drawing in fine modern media on bland modern surfaces.

But finger-drawing is not used only by primitive artists. It has formed part of the technical equipment of many highly sophisticated draughtsmen. Chalk and charcoal have been rubbed out into pools of shadow with the finger-tips (Grünewald, Marées). Wet strokes of ink have been spread into streaks of dark (Rembrandt). Ink has been used to draw with the finger-tips, so that dabs of the finger-ends or accompanying streaks made by the nail can be seen (Chu Ta). Rubbing and spreading are nowadays often done with a twist of folded paper, which is harder than the human finger-tip and is more effective in rubbing out the harder chalks.

There are three principal ways of holding any drawing-point in the hand. The first two are those familiar in the West (including Islam) and the Far East. In the West we hold any point which has a long

shaft—our usual type—within a downward and forward pointing cluster of the tips of thumb and first two (or occasionally three) fingers, whilst the shaft may rest on the flesh of the ligature between thumb and first finger. We hold it in this way even when we draw with an unsupported hand. Usually we hold the shaft slanted at an angle to the drawing surface with the hand resting on the support, or steadied in some way. So, because of the general direction of the action of the finger muscles, which is reinforced by our muscular habits derived from calligraphy, we tend to make repeated small downward pulls with our fingers alone.

In the Far East the brush is usually employed vertical to the drawing surface, which lies flat. The upper end of the shaft is held between the thumb and middle joint of the first finger, which together act as a kind of swivel. The wrist and unsupported heel of the hand are angled down towards the drawing surface, and the lower part of the shaft of the brush is held between the tip of the second finger and the tip of the upper (or nail) side of the third finger. These two fingers can then make pulls in many directions, not only downwards. This is indeed far superior to the Western custom in the freedom of direction it offers. However both these methods, despite the free arm of the Far Eastern method, are in fact dedicated to the finesse of finger-tip movements, and tied very much to calligraphic customs. And if the drawing implement needs some pressure, as a carbon-pencil does, the artist naturally favours those pulls in which his finger-muscles are strongest.

The third method of holding the drawing-point, between the bunched finger-tips, demands that it be not held in a shaft; it must be short enough to tuck in under the palm. The primitive earth knob, chalk, charcoal, and the ink-dipped rag will all serve. The special virtue of this way of holding the point is that, although it cannot be controlled to the minute finesse of the finger-tip touch, it eludes the calligraphic schooling of the hand. The free movements of the arm can execute a far wider variety of strokes in response to visual ideas than can the fingers, with their favouring of the strokes in which they are strong.

From the basic hand technique two families of drawing techniques have evolved. The first involves holding a piece of drawing material in the hand and rubbing some of it on to the surface. One might call such a piece of material the most primitive drawing-point. Possibly the oldest of such drawing substances, in use in Palaeolithic times, must be a lump of ochreous earth or clay coloured by iron oxide, such

as occurs naturally in many parts of the world, especially in volcanic regions. For the commonest colours are varieties of red or yellow, though blacks are known. Primitive men have attached symbolic meaning to red ochres and therefore used them for ritual purposes. They also used manganese ores of a dark purplish-brown colour. With such drawing materials a free, long line can be executed. The natural shape of the lump, its uneven faceting, and its tendency to wear away quickly into flat faces, will help to produce an easily identifiable 'natural' quality in lines which no shaped and manufactured chalks can imitate.

Charcoal is another 'natural' material which must have had a long history, from the time of humanity's earliest fires with their charred sticks throughout those long periods of history when it has been carefully produced on an industrial scale by controlled slow combustion in stacks which are never allowed sufficient air to burst into flame. Nowadays it is produced inside ovens with controlled atmospheres, and willow is the favourite wood. But twigs of many other woods have been used in the past, notably vine. Unlike the nodules of earth charred wood has the general shape of a point-tool, and it therefore favours the drawing of relatively fine, long lines. It has, however, the special quality of dryness, so that it easily rubs off a surface to which it is applied. This has made it very useful to artists the world over as a medium for preparatory drawing. It was used for this in China and the Islamic Middle East, as well as Europe. For when it is no longer needed it can be erased easily by blowing, rubbing, or flicking. The same quality makes it easy to rub into pools of dark, and at the same time prevents its being used to build up depths of dark; for it will not accumulate thickly. Because it is naturally porous charcoal can, however, easily be turned into a truly adhesive drawing chalk. It will soak up linseed oil, wax emulsion, or any plant juice, and thus will get over one of the greatest disadvantages of the dry drawing substances —the need for fixing.

Charcoal, of course, is black; and there can be little doubt that it is the oldest of those long generations of black drawing substances which are still with us. For black has a special symbolism. It has what may be called 'negative value'. Where a black line is drawn a division is established which is colouristically and emotionally neutral. It can be used in gradations to indicate the *absence* of light and colour, i.e. shadow. It can be used in combination with any group of colours without setting up a specific colour key. It can be used as 'grisaille'

underpainting in shades of grey without radically affecting the colour system of the transparent overpainting. (Much late medieval painting used *terre verte* underpainting beneath transparent overpainting in warm, reddish tones, which would with the green produce optical greys.) Black can also be used emphatically in pictures and drawings in such dense body and broad strokes that its negative value becomes overt and aggressive, so as to suggest death, anxiety, and despair. Rouault uses it thus. But in medieval stained glass the leads, for all their blackness of appearance in printed reproductions, are in reality merely tracks where the coloured light, which is everywhere else translucent, is absent. Only in some tropical countries, India for example, does black have positive emotional overtones suggesting the grateful sweetness of shade and the erotic warmth of black hair. In China and Japan the black of ink has a special significance which I shall discuss later.

On similar lines it is possible to account for the continued survival of red chalks based on the traditional ochreous earth. Red, especially the vivid orange-red of many iron oxides, is far from being a material of negative colour value. Its significance is overwhelmingly positive. It lies at the very centre of the 'hot' side of the colour circle and is the colour which symbolizes the highest pitch of feeling. When it is used not only to draw outlines but to indicate shadow, as with Watteau, Boucher, Renoir, and Maillol, it adds a peculiar dimension of feeling to the forms of the drawing. When, as often during the seventeenth and eighteenth centuries in Europe, red chalk is combined with black, or warm brown, to provide the deepest grade of dark, particular effects are produced.

We have no information as to when the kind of black chalk was introduced which became a standard drawing material in Europe throughout the Renaissance down to the end of the eighteenth century. There do survive a few late medieval drawings in which it was used, and Cennino Cennini refers to it in his technical manual. It was called *carboncino*, and it had a wide range of quality and texture. A fine variety was known as *pietra dura*. It is a natural carboniferous slate, which was usually sawn into small rods of square section; modern manufactured chalks preserve this shape. Its impurities made it adhesive and though it really needed fixing to survive properly, it could serve fairly well without. It could be rubbed out into shadow tone, and strokes could be laid over each other to produce a dense black. Almost every well-known European draughtsman of the

period used it, and there are indications that it was used in the Islamic world as well.

The various shades of ochre, especially the reds, were almost as widely used in drawing from the fifteenth century onwards. Fundamentally this is the same material as the primitive nodule of haematite earth. Italy's volcanic regions produced an abundant supply of such haematites, coloured by iron oxides, of many different textures. These too could be sawn into sticks for convenient use. But they did need fixing. Leonardo da Vinci was perhaps the first draughtsman to use such red chalk extensively but, as I have indicated, it was later used very widely, especially during the eighteenth century when painters in oil often imitated its hot effect with a tonal underpainting of ochre. Hans von Marées, living in Italy, used it during the nine- 296–7 teenth century.

White crayon usually consisted of chalk or gypsum. It was first used in combination with black during the fifteenth century in Italy, and it played a special role in drawing which I shall discuss in detail later on. By about 1540 artists were using the three crayons, black, white, and red, in combination on a tinted or tan paper; and Rubens, G.B. Tiepolo, and Watteau all became famous for their 'three crayon' drawings.

All these crayons, or chalks, could be used so as to turn the texture of the drawing surface to account. The grain of a paper would give a luminous quality to their strokes. That is to say, since the face of the paper was granulated each stroke would show a pattern of untouched surface through the pigment. This is in contrast to the overall blackness of pen- or brush-strokes. Rubbing tends to obliterate it but hatchings of all kinds preserve the luminosity. The 'softness' of the crayon touch is its special virtue, and the eighteenth century found a way of reproducing its effects in engraving by using a special roulette on a plate prepared with etching ground. G. Demarteau (1722–76) in Paris, who became famous especially for his work after drawings by Boucher, was the doyen of engravers in the 'crayon manner'. He used two plates to imitate in his prints the effect of drawings in two crayons, sometimes more. The development of this kind of engraving reflects the special enthusiasm for drawings in eighteenth-century France. It is possible, by using the side of a piece of chalk or charcoal, to produce a broad, rectangular area of crayon tone. This technique has been much used by twentieth-century 'realist' draughtsmen. But it introduces a note of vulgarity, and it was not used by earlier artists.

The only draughtsmen of the highest quality who have used it successfully have been the great sculptor Charles Despiau and the painters Henri Matisse, H. Dunoyer de Segonzac, and Raoul Dufy.

Alongside the black crayon made of carboniferous slate another type of dark point for drawing was used during the Middle Ages and early Renaissance in Europe. This is usually called 'silverpoint', after the most popular metal for making the drawing tip. Briefly, the technique is as follows. The surface of the vellum or paper is coated with opaque white and the drawing is done with the tip of a thin rod or wire of the metal, held usually in a wooden holder. The pale lines this produces are indelible, and are naturally fine. Thus the style produced by silverpoint drawing is usually deliberate, its contours are 'slow' in movement, and it has little capacity for heavy shading. As well as silver, gold, copper, and lead have been used as points, and lead was sometimes cast into narrow leather tubes, thus making a passable predecessor to the 'lead' (but actually graphite) pencil.

Graphite as a drawing material was first produced after the opening of the graphite mines in Cumberland, England, in 1564. Thereafter it was exported first into France under Louis XIII and then all over Europe. Wooden holders like those used for silverpoint were adapted to take the heavier thicknesses of graphite. During the seventeenth and eighteenth centuries graphite was used for drawing in a way very similar to that in which the black crayon was used, and even supplanted it in France. The modern graphite pencil evolved directly from this. In 1792 the graphite pencil trade between France and England was interrupted by war and M. Conté was prompted to develop his well-known crayons, which were used instead of Italian crayon by an increasing number of artists and were extensively imitated by many commercial manufacturers of drawing chalks and modern carbon pencils.

What Conté did was to adapt the already established principle of the pastel—which was, in effect, a manufactured crayon—and enclose a length of pastel in a cedarwood jacket. The crayon element was made by bonding with gum a dry mixture of the age-old clay and colour—carbon for black, haematites (iron oxides) for reds, yellows, and browns. This mixture would rub off against a paper surface with a quality not unlike that of the traditional natural crayons, but without their slight natural adhesiveness. Such Conté crayons, like pastels, need fixing if they are to be at all permanent. The leads of modern carbon pencils are made of a mixture of clay and graphite—the more

clay the harder the lead. They, too, need fixing, as their strokes are easily smudged.

Fixing is necessary for all dry drawing materials which are likely to rub off. It is done by spraying the drawing lightly with a liquid containing some binding material. These materials are usually the traditional binding media of painting. Skimmed milk, for its casein content, and real beer have been extensively used. So have dilutions of animal glue in water and of resins in evaporating oils or alcohol. The juices of certain plants have been used, and so has diluted white of egg. Gum arabic has been much employed, and nowadays synthetic resins in solvents are practically universal. Precisely when the insufflator for spraying fixative was first invented I cannot say. But there are fifteenth-century charcoal drawings in existence which do seem to have been fixed by some sort of spraying. Sprinkling can hardly have served, nor can spraying from the mouth. Nowadays, of course, we have the aerosol can. It is worth mentioning that natural fixatives have helped to preserve Palaeolithic cave drawings. For many of these are overlaid by a skin or sinter of calcium carbonate or silicate which, suspended in water, has leaked through from the rock behind, dried, and set over the surface of the pigment. The presence of such a silicate deposit produced over a long period of geological time helped to convince nineteenth-century archaeologists of conservative mind that the cave paintings discovered in Spain and the Dordogne were not forgeries.

One solution to the problem of the adhesion of drawing crayon was, as I have mentioned, to soak charcoal in a drying oil and draw with it before the fluid dried. It is quite possible that this technique was employed more widely than has been realized before. It may even have extended to using charcoal soaked in any of the traditional binding or fixing media. Other crayons may also have been fixed in a similar fashion. But the most familiar kind of incorporated vehicle is the waxy grease used in lithographic crayon, and the wax used in modern wax crayons. Here the black substance, usually a lamp black, is mixed with the vehicle and cast into sticks. Strokes made by these sticks dry into a paper surface and adhere well. Lithographic crayon has been used with great effect by many nineteenth-century draughtsmen, both on the stone or plate, as the medium for lithographic printing and for direct drawing on paper either *as* drawing or for applying to a printing stone. Amongst twentieth-century draughtsmen who have used it for pure drawing the German Käthe Kollwitz is out-

standing. Wax crayons, colourless, white, or coloured, or even paraffin wax candles, have been used by other twentieth-century artists, e.g. Henry Moore, for a technique of resist drawing. The wax crayon is used for drawing first on the surface, and wash is then laid over it. Where there is a patch of wax the wash is rejected; it takes only on to the parts of the surface which are free from wax. Technical games of a similar kind can be played with other modern materials. And of course it must be remembered that straightforward drawing, including colouristic effects, can be executed in many modern varieties of coloured crayon or pencil (Toulouse Lautrec; Egon Schiele).

The pen and brush; their influence on calligraphic habit The drawing materials we have discussed so far are substances which are held in the hand—or in a holder—and which rub off on to the surface. The other major family of techniques involves dipping an implement into a fluid substance and trailing it on to the surface either by dripping or by direct application. Everyone now knows it is possible to draw simply by pouring a coloured liquid on to a flat surface. Jackson Pollock has amply demonstrated that the rhythmic movements of a pouring hand can readily produce interesting designs, many of them belonging rather to the category of texture than to invention. And any stick dipped in any liquid or paste can make a drawing. But generally speaking two kinds of dipped drawing-point have been used by draughtsmen—the pen and the brush. And these two kinds of point produce characteristic kinds of strokes.

The pen is a shaped stick. It can be made of wood, such as a reed or twig of bamboo, or of some other natural object, far the commonest being the quill—a long wing feather of goose or swan. And, of course, it can be made as a metal nib. The quality of a pen depends on the way it is cut or shaped. The shaft is usually cut in a hollow diagonal section, with or without a shoulder. The quality is determined by two chief factors: first, the breadth of the drawing tip, both absolutely and in relation to its thickness; second, the flexibility of the point, in particular in relation to the depth of a possible centre slit which allows the two segments of the point to separate and produce a stroke far wider than the point itself. Calligraphic pens usually have their points cut to a chisel-section wide in relation to their thickness, either at right-angles or on the slant. A reservoir may be added. The pens used for Islamic calligraphy may have no centre slit at all, and the qualities of such calligraphy depend upon the fact that the chisel tip, unvarying

in width, of a stiff, inflexible point is held always at the same angle in relation to the horizon of the format, whatever the curve or stroke which is being executed. Thus the varying widths of stroke are the product entirely of the direction in which the tip moves in relation to its principal width. This effect is often imitated in Persian drawing actually executed with a fine brush, probably because of the immense prestige enjoyed by calligraphy in Islam as the vehicle of the Word of God.

This kind of effect is only sought in the West in pure calligraphy, for which stiff, chisel-cut pens are used. Italic writing (invented in Italy in the sixteenth century and used as an administrative hand) demands a stiff chisel point, and the flexible point used earlier in the Middle Ages and again in the eighteenth and early nineteenth centuries is frowned on. Today Italic script with its stereotyped letters has become a popular cult, so much so that it is very hard to find a flexible nib for a fountain pen. As a drawing implement, however, the Italic nib is not at all responsive. Its strictly formalized curve is objectionable to our aesthetic. Its centre slit is only there as a channel for the smooth flow of ink, not to allow spreading. However, most of the great masters of European pen drawing used their cut quills as 312 flexible instruments—especially Rembrandt. But even masters like Michelangelo or Titian sought a free, flexible touch from their points. 242

The reason is, of course, that the European draughtsman does not hold his pen as does the calligrapher, at a constant angle so as to repeat identical shapes, with his hand resting on the paper or a support. He draws his point in many directions and imparts varying pressure to it according as plastic or tonal emphasis requires. Thus it is true that calligraphic habits do have an influence on style, as we shall see. The style of pen drawing which prevailed in the Middle Ages and was formed in monastic scriptoria was quiet and disciplined, incorporating only the standardized flourishes of current manuscript ornament. It is, however, one of the great virtues of Matthew Paris's drawings that they elude the stereotypes of the scriptoria. But with a great master such as Michelangelo the loops and hatchings of his pen style can only have been produced in direct response to an imagination unconditioned by the detailed formulas of calligraphy. Many artists of the *Quattrocento* in Italy and the North (e.g. Rubens) used the quill pen without demanding more of the implement than the workaday calligrapher was accustomed to demand. With Rembrandt it was different.

Rembrandt's use of the pen was the most highly developed, free,

and inventive of any artist before or since. He used a quill, obviously cut *ad hoc*, and in several different ways. He often began a drawing with a fresh, fine point and destroyed the point by violent pressure in the course of the drawing, so that he finished it with a bent and blunted tip. He is also said to have used a reed pen; but many of the drawings which are said to have been done with the broad-cut reed were, I believe, actually done with a quill bent, split, and worn to a rough, broad tip. In addition it is obvious that Rembrandt very often— especially in finishing off a drawing with the last broad touches—used the butt end of his stripped quill dipped in ink. As well he often used his fingers to smear a wet stroke out into an area of tone. In Rembrandt's hands both ends of the quill pen were capable of all sorts of strokes which orthodox penmanship never envisaged.

What might be called his 'smear technique' was actually invented by the great artist Elsheimer, who died young in Rome. Elsheimer's free pen-drawing style bore little relation to his painting style, which was meticulous and even minute. But his drawing must have impressed many artists of the early seventeenth century. Even Poussin was influenced by it at one stage of his career. Elsheimer evolved a very free use of rough pen-strokes; but it was Rembrandt who developed his intuitions and dissociated these strokes decisively from outlines, turning them into notations of tone which at the same time convey a sense of plastic form.

The use of the pen has far more commonly been restricted to drawing contours from the days of ancient Egypt until the present day. For the pen's relative rigidity has been best adapted to tracing lines. Hatching, of course, has been possible. During the later nineteenth century a number of draughtsmen in Holland and Germany (Israels, Liebermann) attempted to revive elements of Rembrandt's pen technique. They were, however, not able to do much more than to produce variant forms of often decorative tonal hatching. But in the hands of van Gogh the stick-pen was capable not only of producing a considerable gamut of lines, but also a variety of texture-marks. Very frequently, of course, pen drawing has been combined with wash or tone; and it has also been used to give final definition to a drawing begun in chalk or charcoal. For the dark clarity of pen-strokes easily overrides the softer strokes of chalk or charcoal.

The brush is potentially far the most flexible member of the second family of drawing-points, though it has not been used in European drawing as much as other implements, save to lay washes. Indeed

am Elsheimer, CHRIST
RRYING THE CROSS,
600–10; pen and ink
tch from the Frankfurt
ebook, 164 × 184 mm.
delsches Kunstinstitut,
nkfurt

many people in the West have a feeling that work executed with a
brush is more properly called painting. The most primitive form of
brush, still used by village artists in, for example, India and Africa, is a
fibrous stick, the end of which is hammered so that its structure
breaks down and only the fibres are left. Sophisticated brushes are of
many types. They can be of flat section or, more usually, round. They
can have long or short hairs; the hair may be stiff (pig, goat), medium
(cow, badger), or soft (squirrel, cat, rabbit, hare, sable). It is essential
that the hairs retain their own natural tips and are not trimmed. But
most important of all is the construction.

Many modern European paint-brushes are made simply of a bundle
of hairs of roughly equal length bound, glued, and set into a tubular
metal handle. Near the root such a brush-tip tends to splay out a little;
and so water-colour brushes made like this carry their load of wash
in a belly part way down the hairs which trails and spreads behind the
stroke, giving the characteristic boneless tapered quality of the
European wash touch. In earlier times in Europe a quill or reed would
be used as handle and more care was given to the assembling of the
hairs, so that a nucleus of stiffer hairs would be surrounded by a
jacket of softer hairs. Traditionally the brushes used by Persian artists

69

were very fine, and the bundles were carefully assembled so that the natural curvature of the individual hairs formed the taper of the brush tip. Normally Persian brushes were so fine that the loaded belly caused little problem. But it has been in the Far East that most attention has been given to brushes, and a range of highly sophisticated implements has been developed which is becoming progressively more widely adopted elsewhere.

The Chinese have written with the brush since at least the third century B.C.—possibly earlier. There is no accurate information as to the history of the brush in China, or even later in Japan. But the essential construction of the Sino-Japanese brush is as follows. The nucleus of the bundle of hairs is provided by a carefully assembled cone of short stiffish hairs. Around this is gathered one or more jackets of longer hairs bound on to the nucleus. The nucleus gives body to the root of the brush, and the thickest part of the brush is at the root. The charge of ink or wash lies in the open reservoir between the nucleus and the jacket, and does not trail behind as the brush moves. The tip even of a large brush may be very fine, and with varying pressure may narrow or spread with the rhythm of the strokes. The tip of the brush is expected to travel in the centre of the stroke, forming its 'bone'. But eccentric strokes, for example with the slanting brush, can be made.

There are varieties of Far Eastern brush for different uses. Some are very wide and soft and will carry a large load of wet ink, others are narrow and long, and the standard type, with a tip resembling in shape a sharpened pencil comes in various sizes. As well, Far Eastern artists have used various eccentric types of brush, the purpose of which has always been to enhance the element of uniqueness in the encounter between brush and drawing surface. Worn-out brushes are popular. Bundles of old brushes may be used as if they were a single brush. Brushes may be made of straw. In Japan, amongst the Zen-inspired artists, a mere bundle of straw or a bunch of cloth dipped in ink would be used. Nowadays in the West felt or plastic fibre is often used as a drawing tip.

The ways in which brushes are used vary widely, of course, both from culture to culture and within any given culture. In the Far East the resources of the brush-stroke have been most intensively explored, as we shall see. In Islam the search for the perfectly executed, long, formal curve dominated brushwork—though in many Islamic drawings one can often find that the strokes are built up from, or

reinforced by, a multitude of miniscule touches from the point of the tiny brush favoured especially by Persian miniature artists.

The brush has been used in Europe for drawing. During classical times it was obviously used, in Greek vase-painting for example, to draw clear and sharp 'first-time' lines, carefully phrased. They were executed free-hand over a preliminary design either scratched on the pot surface or drawn in plain water on the drying clay. We know little of the brushes used by later draughtsmen until the Middle Ages; though it is clear from Roman wall decoration, and from early Christian wall-painting, that good brushes were made, capable of broad clear lines. The lettering of Roman inscriptions cut in stone suggests that broad, chisel-shaped brushes were used to draw them, probably resembling modern oil-painting flats. During the Middle Ages, however, the very fine brush was much used. It imitated the lines of pen-strokes pretty closely, and its small touches were used to assemble lines and to produce graded 'shading' which indicated not shadow proper but plastic recession, and was a function of the contours. All through the *Quattrocento* in Italy and Flanders one finds draughtsmen using the brush in this way. Perhaps the most interesting drawing in this vein is the superb study in the Louvre by Signorelli of a nude man, seen from the back and carrying another man draped across his shoulders, in which the tiny brush strokes of dark and light follow out in woven sequences the undulating surface of the body. This anticipates Michelangelo's use of a similar technique. It is interesting that a reproduction of this drawing was pinned to the wall of Cézanne's studio in his latter years.

With the development of 'wash-drawing' after about 1500, especially by the chiaroscuro specialists, the brush gradually came to be more freely used. Substantial brushes for laying wash, probably much resembling modern water-colour brushes, were used by Tiepolo, Poussin, and innumerable others. Rembrandt made direct drawings entirely with the brush, as well as using it for applying areas of wash. So did others, notably Goya and Constable; and many draughtsmen used brushed wash over chalk under-drawing, particularly during the seventeenth and eighteenth centuries (e.g. Fragonard). Nowadays, of course, many artists use the various available types of brushes for drawing, including oil-colour and decorators' brushes, primarily for the sake of the textural effects they produce.

k and its symbolism The ink used with the pen or brush cannot, of course, be neglected.

Although the Egyptians used an ink of carbon mixed with gum, the Chinese have for many centuries manufactured the world's best black carbon ink. Because this ink reached Europe through the intermediary of the East India trading companies it has acquired the generic name in the West of 'Indian ink'—which it is not. Ancient Egypt and the classical world seem both to have used a most important natural ink, which is still in use today under the name 'sepia'. Sepia proper comes from the ink-sac of the octopus, which discharges it as a cloud into the water to cover the animal's retreat from an enemy. All over the Mediterranean world octopus ink has been collected and marketed. When it is used thick it is almost black; watered it has a cool, yellow-brown tinge. Thus a drawing in sepia contains colour transitions of a sort. It is relatively permanent. A poorer substitute for sepia is bistre, which is supposed to have been made from a certain kind of wood, charred and steeped.

Another ink used in Europe from at least early medieval times onwards is oak-gall ink. This is made by boiling oak-galls in water, and boiling off some of the water. The colouring agents here are oxides of iron, which are not particularly light-proof. In addition the ink is slightly acid, and when applied thickly to paper can erode it. A number of old drawings have holes burnt in them where the ink was densest, and many have faded. This ink, too, would water down fairly well into washes, and its brownish colour makes it hard to distinguish from sepia. (The scientific identification of inks seems to be still somewhat unreliable.) Most modern fountain-pen blue-black or black inks are, or have been until recently, manufactured from ferric oxides, and are very much subject to fading. So too are most of the synthetic inks of coal-tar derivation. Carbon black remains the only truly permanent light-proof ink.

Carbon ink is sold today under many names, including 'Indian', and is mixed in various ways. The waterproof type contains a dissolved resin to form a scale, and the fountain-pen types need to have their carbon ground to an extreme fineness. The original Chinese ink, used in India and the Islamic world as well as Europe, was in effect a pigment. It consisted of the soot from the combustion of resinous woods collected on the underside of slabs of stone or metal sheets, which was scraped off, carefully mixed with glue, and moulded into sticks or cakes. Various woods produced various qualities of ink. Pine was long regarded as the best on account of its resinous content. When required for use the stick or cake would be rubbed in water on

a roughish surface—stone or pottery—then diluted to the required density. Europe and Islam, with their dipped pens, have always been accustomed to having their ink ready mixed to a single density in a receptacle; and so ready-ground carbon inks have always been sold. The Far East, however, has been prepared to draw direct from its ink-stone or mixing dish in a variety of tones and textures; and so it has usually sold its ink in stick form. In addition, the East has usually drawn with the brush.

The reason why the East has paid so much attention to its ink is that the black substance was identified in the minds of the calligraphers and artists with the root of all colours, the root of all forms, the un-differentiated substance of which the world consists. In drawing with ink they felt they were engaging in an activity that brought them close to the ground of visible being. They therefore experimented widely with the densities and textures of their material, building up structures which depended on vivid contrasts of ink-quality for their effects. A brush scarcely moist with very black ink produces a very different stroke from one thoroughly soaked in pale ink. A black pro-duced by a single dark wash has a completely different quality from one made by building up layers of paler touches. A single area of tone may change quality from place to place. And so on. How the blacks were used will be explained later.

In European wash-drawing a different principle was followed by the major masters. The washes were prepared in containers in a fixed range of tones—usually three or four, with the pure ink the darkest. This gave the tonal system a scale and intelligible order of its own. The washes were then applied so as to indicate areas of shadow of the different densities. This was the method of Poussin and Claude. Other artists like Goya or Constable used a single tone of ink or water-colour with the brush, and executed drawings which contained generalized effects of light without fully ordered system of tone. This is one of the chief points of contrast between Claude, whose drawings were based on a tonal scale, and Turner, who when imitating him had no clear set of tonal intervals.

It does, of course, go without saying that any of the pigments nor-mally used as water-colour can be used with the brush for drawing, or even with the pen. Very often, as with Goya, the effects of using a red colour for brush drawing can be most striking. It is, besides, normal practice for artists to add small quantities of water-colour to their black inks to give them particular quality; vermilion and *terre*

Orrisan drawing, *c.* 1700; stylus on palm-leaf, 6 × 2 in. *The Oriental Museum, Durham*

verte are often so used. Interesting effects can also be obtained by drawing directly with a damped cake of water-colour.

Last, there must be mentioned the various printing inks which are nowadays very popular with artists. These consist of carbon—lamp black or animal carbon, for example, from charred bones and hoofs, as well as mineral carbon—combined with oily vehicles.

The stylus The stylus must briefly be considered as a drawing implement. This consists of a smooth, blunt point of metal or other hard material, which is used to impress a line into the drawing surface. It was used in classical times for drawing on wax, and in Europe during the Middle Ages to lay out preliminary designs on prepared grounds. It was used most extensively and successfully in India for drawing on palm-leaf, when pigment was later rubbed into its indentations. The 74 fine Orissan style of palm-leaf manuscript illumination by stylus still survives. The pressure necessary for drawing with such an implement in this way means that the kinetic quality of its lines is usually slow, its curves tend towards deep, formalized loops, and the lines are often made by repeated separate indentations.

Scratching or incising with a sharp point is, naturally, a very com- 126 mon primitive method of drawing. But one related drawing technique which has become especially popular with commercial artists working for mechanical reproduction is scraperboard. This is executed with an edged scraping tool, which cuts away the black surface of a white card previously prepared with a coat of Indian ink. This is in fact the one technique amongst all drawing techniques which works essentially as white on black. The artist has to cut out his white areas or lines, and black drawn lines play no part in the design. In fact the technique as it is known is intimately related to the techniques of wood-engraving and even mezzotint, though as yet far less sophisticated than they.

One auxiliary technique must be mentioned which is being steadily developed and already plays an important role in modern graphic art. This is monotype. Entire works may be executed in monotype, or only bits of a single work. Its essence is that a single print is made from something drawn on another surface, e.g. a sheet of glass, by pressing the other surface and the drawing ground together. The most primitive form of this is a print of the hand dipped in medium. Many primitive and Palaeolithic cave hand-prints are known. Nowadays drawings may be amplified or textured with prints from leaves, cut potato, broken machinery, etc. The pressure printing ensures that an effect of hazard is added to the design.

Technical Methods

This chapter will be concerned with the various formal methods which are available to the draughtsman. It will do this by breaking them down into categories. For they have to be isolated and reduced to conceptual forms if we are to discuss them at all. But in practice they are not encountered in isolation divorced from their particular meanings and contexts. It might be argued, therefore, that it is not right to treat drawing as if it were a dead language. But this is not what I am doing. In the sphere of spoken or literary language it is no barrier to good writing that the writer should understand his grammar and syntax in a conceptual manner. And neither appreciation nor higher criticism would be possible without such understanding. So to have a developed and critical knowledge of the range of possible forms of expression in drawing seems to be an asset not a handicap.

I do agree, however, that it is quite out of the question to rest content with turning drawing techniques into dead concepts. The transcription I make will, I hope, be entirely practical. It is meant to open up technical resources. The artist has to look critically at his work as he does it, trying to discover what more it needs, where it has gone adrift. The spectator too has to know what to look for to get the most out of what he sees, and he has to know what visual faculties to develop in himself. He also wants a means of assessing a draughtsman's creative achievement, and real clues to distinguishing good from bad. Mere 'liking' or 'disliking' an artist's work is not enough for making judgements. For different people may like and dislike the work of a good artist, or of a bad one. A knowledge of the principles of drawing-structure can help to provide an agreed basis at least for judging the technical wealth and structural density of a drawing, so that discussion can be made more fruitful. The survey of methods which follows offers them as open possibilities—potential weapons in the draughtsman's armoury.

In analysing the technical aspects of drawing it is necessary to break down the methods into artificially isolated techniques. But one has always to remember that great draughtsmen have been those who have known how to handle many of these methods simultaneously, and who have shown themselves able continually to develop fresh ways of using them. Thus in fact a method is rarely if ever found in isolation, but each one appears as an element in a rich tissue of combined resources. It is, however, one of the characteristics of much

modern art that each artist tries to restrict his methods as much as possible, exploring their possibilities to the limit. In the past this was not so much the case, and the quality of older drawing depends very much on its amplification of many resources at once. The greater artists cultivated the ability to manipulate symbolism covering a wide range of visual categories. Rembrandt, for example, was always ready to learn lessons in draughtsmanship from alien styles, as his drawn copies of other people's works show.

The composer Arnold Schönberg said: 'In a real work of art it is like this: everything looks as if it had come first because everything is born at the same time. The feeling already is the form, the thought already is the word.'[1] Elsewhere he wrote: 'Schemes of musical arrangement, even if they exist *a priori*, should only be discovered after they have been used.'[2] This is indeed true of drawing. But it is not the same as saying that one should not study the theory of structures. In fact Schönberg spent much of his life studying and teaching the theory of musical structure. It must be added that Western music, like Eastern, has benefited for centuries from the existence of a body of basic principles recognized by all musicians. In visual art, on the other hand, even the ABC of theory has been lacking. Before 'everything' in a drawing can be 'born at the same time', much effort and practice has to be devoted to the processes of conception, gestation, growth, and birth. One can only progress by gaining such command over the elements that their manipulation becomes second nature and they take deep root in the unconscious mind. Here traditional arts score heavily. For though sheer intuition may carry an isolated artist forward for years, there usually comes a time when neglect of method takes its toll, intensity is lost, and his work runs the risk of lapsing into banality. In fact the principles and methods which I am obliged to lay out and discuss in sequence here must appear in actual drawings to be simultaneous, 'born together' in Schönberg's sense. The whole is always of overriding importance and the sole justification for the parts. These things must be felt and understood also by the observer if he is to approach the drawings of great artists with a just and apposite appreciation.

The principles of variety and tension In any drawing style of distinction variety is an important principle. In a sense it is a direct function of precision of thought—and by this

[1] Quoted in Merle Armitage (ed.), *Schönberg: Articles between 1929 and 1937* (1937).
[2] In 'Kompositionslehre', *Die Musik*, May 1931.

77

I do *not* mean perfectionism or tightness of finish! All the drawings of the great masters, however rough or cursory they may appear at first sight, are distinguished by the variety of their strokes and forms within the ordered structure. Without precision in formulating the elements there can be no true variety. For it is only possible to recognize variety and variation if distinctions between the forms are made quite clear. And there can only be variety within an ordered structure, or else differences are simply chaos and not variation. Variation implies a substratum of norm-units which are varied. To supply this is the special role of those general type-categories to which I refer in analysing the various graphic methods. It is also one of the reasons for the thematic structure of drawings.

This principle of variety and variation will be found at work amongst all the elements of a good drawing—in the inflexion of lines, enclosures, surfaces, in the spacing of elements, the calculation of rhythms, and the counterpoint of design. It is the life-blood of drawing, an essential index to its truth. Some draughtsmen, like Rembrandt, invent freely varied forms and groups at once. Others—like, say, Carpaccio—may begin with a fairly schematic idea, and introduce variation only in the course of the evolution of their design. Lively variation of form is one of the principal marks of a first-class artist, and lack of it one of the commonest defects of poorer artists; for it is extremely difficult to achieve. It is all too easy to compose what looks like a drawing out of idle lines and unformulated repetitions. A comparison between the varied foliage forms of the great Rembrandt and the monotonous ones of Gainsborough will show at once what I mean. Variation is only valid if at the same time the structure of the drawing is strong. And genuine variety is only achieved by variation upon those germinal categories and thematic forms within the drawing which I shall be discussing. At present I want only to emphasize the importance of variety as such, and stress that a large part of the effort of any draughtsman is devoted to varying his given units of form, whatever they may be.

If variety can only be defined in terms of norm-units, as I suggested, in every drawing there will be recognizable categories of form which carry the weight of the invention. What these are, and how they are related to the 'notional realities' in any drawing, largely determines the style. In the course of this section I will indicate examples of what these units may be. To a certain extent they are the ready-made repertory of the drawing, and there may be more than one kind of unit

in a drawing. They may be, for example, conceptualized flat areas of dark overlaid by linear forms, as on the archaic Greek black-figure vases; they may be shadow glyphs and rhythmically spaced strokes in Rembrandt, or open, undulant contours in Far Eastern drawing. Such units of form are analogous to the basic phrases of verbal speech. (They are not analogous to bricks or prefabricated units in architecture, which are not capable individually of being modified but can only be added together.) Their relationship is analogous to grammar and syntax. Their meaning is a function of their usage in larger syntactical structures, but they do represent the irreducible units of sense upon which the whole structure ultimately rests. And they define the minimum scale of detail in the drawing, naturally suggesting the distance at which the whole is to be seen. They are thus the chief element in that 'treatment' which relates the drawing to its own format. The analysis which follows will trace the formal elements of drawing from the basic units upwards towards the more complex syntactical elements of structure and meaning.

One final general point remains to be made. It is that in most of the world's best drawings a very large part of their vigour and expression derives from a kind of tension or conflict between the two-dimensional and the three-dimensional. The methods which follow will include those which have as their purpose the development of the two-dimensional aspect, of the three-dimensional, or of both together. My point here is that in those drawings which are universally recognized as masterpieces there is a vigorous conflict between a highly-developed two-dimensional surface unity, and a highly-developed three-dimensional plasticity. The higher the point to which both are developed, the stronger the drawing. I am aware that this is nowadays a most unfashionable view; for it is everywhere treated as dogma by critics, and, following them, by artists, that only the two-dimensional surface is of any real interest. However I must take a long view here, looking across the centuries. For even Cézanne, who is often quoted as the father of the twentieth-century flat picture-surface, was actually obsessed with means for creating a three-dimensional plasticity of forms within his flat unified surface. The overwhelming impact of his art comes from a vivid tension between the two aspects.

Of course an equality of balance between the two sides has rarely been achieved—only by Poussin, Veronese, and a few other major masters. Usually one side or the other tends to predominate, but one

is never allowed to swamp the other. Nowadays that 'modern academic' type of drawing, which never has the slightest suggestion of three dimensions, gives to an eye accustomed to the drawing of the masters an unwanted impression of watery blandness and prettiness, no matter how wild or hard the handling may be. Although there is no doubt at all that a dense, flat structure appears in all good drawing, there is equally no doubt that unless such a structure is challenged by a strong three-dimensional counterpoise, it remains wall-paper. And I am afraid the horrid implication here is that this third dimension is produced only by the appearance in the drawing of notional *bodies* of some sort. One cannot rape and seize abstract space, but only suggest it. This may be why, as has sometimes been said, a return to the Surrealist world of objects irrationally juxtaposed may be a profitable way out of its present impasse for any art which aims higher than the pages of the mass-circulation colour magazines.

I am only too well aware that what I have to say here will be treated by a very large number of 'modern academicians' as the rankest heresy. For there is a whole art-education industry based entirely on the assumption that works by the masters of the past can and should be reduced to flat diagrams (which never *really* fit them) or 'analysed' into flat areas of light and dark. This may accord very well with contemporary prejudices. But it is a monstrous solecism when such processes are applied to the works of great artists, most of whose effort was spent trying to create vivid bodies in the third dimension as well as a taut surface, and who expressly wanted their darks to have a double value, both two-dimensional and three-dimensional.

The blob The blob is a mark in which chance plays the dominating part. It may be possible to read, for example, from the general shape of a blob that it was produced by a splash from a given direction; more often one can read this only from a chain or sequence of blobs. But the appearance of the blob intrinsically represents the element of hazard in drawing technique. Some styles exile hazard and the blob completely. Others may cultivate it expressly. For example, the 'po-mo' technique of the Chinese ink-painters of the Sung dynasty, and later Chinese and Japanese epochs, cultivated 'spilled ink' as a stimulus to invention. 80 Literal 'puddles' of ink would be teased with the brush into suggestive shapes. J. R. Cozens's blot landscapes also began the same way. Jackson Pollock and many other Abstract Expressionists elaborated the use of the blob into a system.

sshu, Spilled ink land-
ape in *haboku* style,
95; brushed ink on
per, 149 × 33 cm.
ational Museum, Tokyo

81

The blob derives significance from a number of possible considerations. First comes the mere fact that it is allowed to be there, emblematic of chance, of the unrepeatable event in the unrepeatable instant of time, the product of converging processes in the tissue of reality. It can thus symbolize the unique individuality of the moment at which the artist's mind was in a special condition of enlightenment or inspiration; the appearance of the blot can indicate the historical concreteness of the inspiration. It also serves to inject the element of variety into any style. If a style incorporates substantial numbers of unmodified blots, these can symbolize the artist's abdication of directing conscious will in favour of hazard, his accommodation to the spirit moving him at a given moment of time. An exclusive use of unmodified blobs probably indicates a disgust with the limitations of an intellectual method, which the artist has found wanting in stimulus to his invention. And this is usually because the intellectual methods in question have been misunderstood, are inadequately developed, or have an air of staleness and exhaustion for the artist.

On other occasions a blob may be attached to an intended line—usually a pen or brush line—and be left unmodified. This commonly happens when the artist is trying to make an emphatic dark with an overloaded point. Rembrandt and other artists of the smear technique invented by Elsheimer have done this. The blob then simply serves to reinforce the general density of the stroke. These same artists often converted the blob, whilst still wet, by rubbing it out into a stroke with a dry finger so as to create a streak of shadow. In some styles of drawing, again the smear technique and Far Eastern techniques, blobs happen where a number of strokes from loaded points converge, so as happily to emphasize the convergence.

Of course blobs even more than other graphic symbols depend for their meaning upon the spectator's being ready to read into them associations to which the suggested context gives rise. Blobs belonging to an art which does not emphasize intelligible contexts will depend upon a purely subjective response on the part of the spectator to the suggestive forms of the blob without benefit of the conscious intelligence—a response resembling that evoked by Rorschach test-blobs. The latter, however, are usually folded so as to give them a symmetry suggesting an organic creature. When the context of a blob is other blobs and some non-representational lines, one must expect that the responses to each blob will be, as it were, filtered by its connection with the responses to related blobs. Thus a context of un-

conscious meaning can actually be developed without the benefit of recognized, conscious context. This is a field in which many modern artists have worked (for example, Frankenthaler, Japanese calligraphers).

Blobs are thus an important element in what one might figuratively call the graphic principle of indeterminacy. In representational art they may be found especially when the artist wishes to avoid a tight definition or limitation of a form by his contour. The Chinese brush or the European quill pen can both spread towards the blob so as to baffle the reading eye as to the precise limits of a form; though, of course, such strokes will have their own kinetic and structural significance. In the two arts, the Far Eastern brush style and the seventeenth-century European chiaroscuro style, the blob will have different psychological roles to play. In the Far East tonal density usually indicates strength of immediate presence—the darker the more affirmative, dark emerging out of paler undefined regions. Such presence may equally well be due to mere closeness, darkness of local colour, atmospheric clarity, or actual tonal darkness due to cloud-shadow (in landscape). In the Western seventeenth-century chiaroscuro style tonal density is related to shadow, and one would always expect a tonal blob to be intimately connected with a 'shadow-hole' in the surface of the drawing.

English draughtsmen of the eighteenth and nineteenth centuries used blobs in an idiosyncratic fashion which was related rather tenuously to the traditional Western chiaroscuro technique. I have mentioned J. R. Cozens, who is known for his 'blot landscapes'. He was both a professional painter of picturesque scenes and a teacher of drawing. The kind of landscapes he drew were based principally on tone as outline and as a substitute for local colour, not as true chiaroscuro. Dark bunches of trees in black ink sit on outlined areas of terrain. Following suggestions by Leonardo he developed the custom of scattering blobs on paper in order to stimulate his invention of possible landscape motifs. The landscapes he then drew were conceived as a logical explanation in three-dimensional terms of the flat relationship between his given random blobs. This technique he recommended, as a teacher. Hazard was to be used to stretch the tired imagination of the hack draughtsman. At the same time the practice suggests that Cozens conceived his artistic responsibility to be to produce an indeterminate picturesque item, rather than to develop a dense tissue of meaning.

The line is a trace left by a moving point. Its essence is that it has directional value in relation to the co-ordinates of the field. If the point is an inflexible one, like the silverpoint or stylus, its line will be a trace without many qualities other than its direction and track. If the point is a flexible one, using a fluid medium such as ink, then all sorts of qualities may be suggested at different parts of the line's track by different kinds of pressure on the point, changing its angle, rolling it, and so on. All these variations of touch will combine with the line's qualities of direction to enhance its expression. I wish to emphasize as strongly as possible that the word 'line' as I use it here *does not just mean 'outline'*. It means any kind of directional mark used for any purpose whatsoever, including outline.

Semantically, the significance of any line will arise from the way it awakens echoes in the spectator's mind of experiences connected with similar vectors both actual and drawn. And both its form and its significance will be bound up with its relationship to the co-ordinates, and to left and right. Its meaning will depend, for example, on whether it sweeps down and then curls up; whether it does this leftwards or rightwards; on whether it rises smoothly *with* the natural sweep, say, of a pen over a rounded top or runs 'savagely', stabbed into the paper in the reverse direction. It may indeed be possible to get something from a drawing without paying any attention to this kinetic element, treating it simply as a static picture. But to assimilate its meaning fully one needs to look in detail into the kinetic structure of all its lines. It is, I am afraid, impossible to prove this point, to which I return repeatedly. The proof of this pudding is only in the eating.

Even if a line, for example an outline, has been repeatedly gone over, as many lines of Raphael or Ingres have been, one is still able to understand the directional sense of the line without too much effort. Inferior artists are, however, inclined to kill their lines by excessive overdrawing, which obliterates the kinetic sense. As I have already suggested, specific drawing-points tend to favour the production of certain particular kinds of line, and of lines made in particular directions. This will help very much in the reading of lines.

Drawings by European artists who are right-handed always have a kind of 'watershed' at the top left-hand corner of every major feature. From this watershed strokes run down the left side of the feature, then across to the right and perhaps finally upwards, and/or across from the watershed rightwards and down its right side. The watershed is usually covered by a small concealing line or set of lines, and

most commonly the upper left side of the main feature is the part to be first developed after the initial nucleus of the drawing. Left-handed artists like Leonardo da Vinci exhibit their watershed at the top right. But always the tendency of the European draughtsman, accustomed to handling a pen for his own kind of handwriting which is based on the formula of reading from top left progressively to bottom right, is to pull from the top left slightly left and down, and from the top left across right and down. Even though one may find in a work by such a master as Rembrandt strokes which seem to override this principle, the majority of the strokes in any drawing will nevertheless still conform to it. And of course it is well known that hatching strokes used to make shadow or indicate volume tend to follow a slant from right down to left with right-handed artists, the opposite with left-handed ones. It is worth bearing in mind as well that all such tendencies to construct and read in a given direction will be reversed in woodcuts, engravings, etchings, and monotypes, though a second reversal may be found in counterproof prints, which are struck from the print of an engraving whilst it is still wet.

Other peoples have other graphic habits, derived from their customary manner of reading a page. Pure Islamic drawings, which were always executed by draughtsmen trained in the Persian script, follow that script in its general tendency from right to left, from top right to 86 lower left. At the same time Persian script penmanship is full of left- 87 ward strokes, curves and upward loops made by the *pushed* reed pen cut broad without a slit. The Islamic draughtsman, therefore, tends to execute curved lines which originate on the right upper side of the sheet, and includes many lines which are drawn curving upwards from below. This gives a distinct quality to all Islamic drawings.

No less important and interesting are the graphic habits of the Far Eastern countries, China, Korea, and Japan. The scripts of these countries are written downwards, in vertical columns. The Far Eastern draughtsman thus always divides up his motif, approaching 280 each section from the top. And the linear features of his composition —be they landscape, human, animal, or vegetable—are always conceived as structured around their topmost contours. Hills and rocks have tops, from which they hang, but often no bottoms. Men and animals are constructed downwards from their heads and backs, their feet always looking like concluding appendages uncertainly placed on the ground. Even where groups of hills or rocks have base-lines, they are usually cursory cut-offs rather than fully

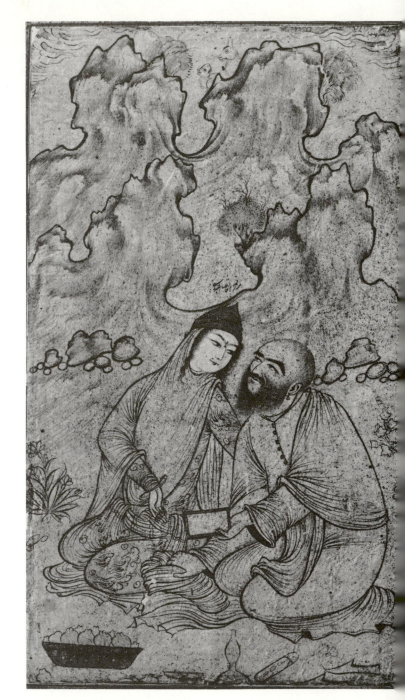

SAGE AND GIRL IN
LANDSCAPE, Persian
style, 17th century; pen
and ink on paper, 33 ×
25·5 cm. *Musée des Arts
Décoratifs, Paris*

formulated conclusions. This approach is responsible for part of the ethereal 'floating'' effect that we can feel in so much Far Eastern drawing. In the hanging scrolls of long vertical format this effect is most pronounced. In the long handscrolls of the Far East, which are unrolled from right to left to be looked at, the emphasis upon right to left movement is marked in all aspects of the design, but especially in the lines. No handscroll, or section of a handscroll, can be understood unless it is read from right to left as well as over the topsides of the objects.

And then, of course, there is the drawing of peoples who have no script tradition in our sense at all. In such works, especially those done with the fingers or a stick, one feels an equal directional stress in all the lines. They seem to have been made with a remarkable freedom of touch. Nevertheless, the left–right difference, which will be discussed later, may still be felt.

A most important factor in sophisticated drawing is the way in which the implement is held. Most Europeans, including artists, have a tendency, which they carry over from their handwriting habits, to

rest both their elbow and their hand on the surface of the support. One of the first things a student has to learn is not to rest either. It is difficult even to do without the support of the little finger. Literal copying and mechanical accuracy can make it seem indispensable. But these are not true drawing. Fully formed kinetic impulses can only flow down an arm into a hand which are both free of any impediment. The Chinese recognized this, and both Chinese and Japanese artists always wrote and drew holding their brushes well up towards the top, with no more than an occasional support for their fist. The Chinese explained their reason figuratively: they believed that the spirit of an artist inspired by the Cosmic Movement could only flow down an unobstructed channel.

Such liberation of the hand will not abolish the directional habits of thinking I mentioned above. But it will enable a draughtsman both to invent and to execute a far wider variety of stroke-forms than otherwise he could. Some of his constrictions will be relieved. He will not make strokes with the limited pull of his fingers, but with his whole arm. Most Western artists have had to learn it with difficulty. Some— Hans von Marées for example—have deliberately adopted a very large format and a long holder for the implement, which compel them to draw every single stroke with an unsupported sweep. There can be little doubt that one of the reasons for the modern pursuit of the grandiose in art, as well as the cult during the forties and fifties of working with drips on the floor, represent an unformulated yearning for the liberated hand.

There are four general categories of linear inflexion in terms of which any line or linear continuity can best be understood. These general categories, like the other categories of form which might be figuratively called 'geometric', represent the basic principles underlying structural variation; they are what makes the basic unit of drawn form a unit. And any line, in so far as it is a clearly conceived form, must fall under these headings. This is not to say that any one line does, or is obliged to, exhibit these general forms as 'pure' or 'abstract' uninflected types. Nor do I mean that lines must be broken up into sections each one of which corresponds to one of the categories—though this in fact is often done. As I have often pointed out, the expression of graphic forms involves suggestive ambiguity. And every individual concrete line is bound to differ from every other. But the underlying elements of structure are present in each case as normative units. And the greater masters of drawing have been those

Fig. 2

who have been able to combine the strongest structural clarity in these terms with the most individual expression.

These categories are: the straight line; the equal, arc-like curve: the angle-curve: and the unequal, or exponential-type curve.[1] Varia- *Fig. 2* tions and combinations of all these categories occur in every drawn line. For example, a ripple curve may pass through several of the categories in turn. One of the distinctive features of any drawing style is how it combines its linear segments into 'melodic phrases'. This will be discussed later. Structural strength in a drawing is partly a product of the intellectual clarity with which the lines are phrased into a measured series of varied categories. For without precision of this kind true variation is impossible. Without such categorized phrasing not even the most 'resembling' contour is of value, nor can the most 'abstract' forms be made interesting.

There is one primary distinction between these types of lines—straight and curved. Straightness implies a fixed sense of direction, *ab initio*, which cannot be deflected. It also establishes a claim to an absolute and necessary rightness and validity, as in mathematical diagrams or in architectural drawing. It establishes too a kind of [16] certainty in art, and is much used in the stylization of contour for the sake of the conviction it lends, for example, to advertising art and comic strip, which would otherwise demand more effort and invention than they are worth. The school of rectilinear painters and sculptors use it for the sake of the moral support it offers, cutting out the need for thinking about all those aspects of linear development that depend upon curves and linear connections. It is thus greatly employed by artists working to appeal to the immediate glance or *coup d'œil*. It is also used as an extension or displacement of the picture frame by artists who are thus enabled to dismiss from consideration all those problems of direction and change raised by curves and linear inflexions and continuities, and concentrate on pure proportional

[1] If these are treated as strict logical categories, they are not the same in their mode. The first, the straight line, represents a norm from which any individual variant can only depart. No actual line is ever ideally straight anyway. The second, which can include an infinite variety of degrees of curvature, is characterized by its symmetry and implication of a centre. The third and fourth can cover an infinitude of instances unconditionally. However, as I point out later, all of these are only general headings or abstract norms for lines. No logical significance attaches to them, and there is no suggestion that they constitute a logical system. Here art and topology emphatically part company, just as poetic language and algebra do.

relationships (or colour). Employed as an invisible but operative element in design, for example in the ordering of a sequence of points across the surface of a picture, by the projection of a contour or axis, or in the evolution of architectural leading lines, it lends the same sense of established rightness to the position of elements. Perhaps its most important artistic function is as axis; vertical, horizontal, diagonal, or as the fictional axis of rotation of a centred form running into the depth of the picture. In the art of ancient Egypt the vertical and transverse axes were established by the height and shoulders of a figure, the third dimension in depth by the axis through the hips. The same basic axes, with additions, were used in the elaborate *contrapposto* of figures in Italian Baroque art, and the use of the fictive axis in depth was developed in Italy in connection with foreshortening and rectilinear, fixed-viewpoint perspective. The special kind of shading known as 'bracelet shading' was ancillary to the fictive axis. Finally, conceived as pure direction, the straight line, either implied or directly stated, plays an important role in the system of gamuts discussed later.

The curved stroke, the variety of which is immense, is based upon the concept of change; for a curve is drawn by an instrument that is continuously changing its direction across the ground. The qualities of curves, and their content of experience of change, are one of the most important sources of artistic vitality, for they extend the meaning of the drawn forms via the suggestion of change into the dimension of time. They are symbolic of life, suggesting the contours of fruit, flesh, organic substances which are full of sap, juice, blood, and they are capable of movement, in contrast to the inorganic, lifeless, and crystalline immobility of the straight, the flat, and the equally faceted. In most good drawings there appears a kind of dialectic between curve and straight, living bodies favouring curves, rocks and buildings favouring the straight—though, as we shall see, the two interpenetrate as well. When one or the other greatly predominates where it 'should not', as curves may in Chinese landscape or flat facets in some European figure-drawing, we must be prepared to accept the emotive implications of such observation.

It is always worth looking particularly at the quality and variety of the curves that go into the construction of a drawing. The endless repetition of a single-graded and flattened curve was one of the evil tendencies that afflicted many draughtsmen of post-Renaissance Europe from Bandinelli down to Flaxman and Fuseli. Only the greatest imaginations were able to overcome it. Used as virtually the sole

resource of the art, as curves are, for example, in much Japanese art, their expression depends greatly on our recognizing where each begins and ends. Its actual course across the field needs to be followed, and if a complex structure of such open curves is to be read, the relationships between the end of each one and the beginning of the next are of prime importance. Sequences, repeats, or opposed curves which were made as united groupings must not be missed. Thus even the reading of a single figure composed of curves—a Sotatsu demon, for example, or a Koryusai girl—may demand of us—though perhaps not of a Japanese, to whom its patterns will be familiar—a great deal of study and rehearsal if the drama of its strokes is to have its full impact. This means that such art can never be understood at a single glance. Here is the point too where much Abstract Expressionist art —though not perhaps the best of Pollock—breaks down. For its brush-strokes usually present superimposed layers of fresh starts which have only the sketchiest structural relationship to each other.

Curves make temporal transitions visible as process; so that art which uses virtually nothing but curvilinear transitions is really expressing an ontology which views reality as fluid and constantly changing, without true static forms. In fact, however, very few arts do actually deal in such purely fluid forms. Most use curves as one aspect of their expression, and combine them with other types of form. In addition all curves as they appear in drawn contexts seem to have an underlying tendency to resolve themselves into 'straight' directions or facets. I do not mean to suggest that all curves must be made up of straight sections: far from it, but since good drawing demands that all the component strokes be related to each other, and since many of the relations will be *across*, not *with*, the direction of the line, some of the crosswise relationships will be based on an assumed single direction, a kind of quantum of direction, for each part of a curve. For this reason pure arcs are both uncomfortable and unpleasant elements in any drawing which is not diagrammatic. They refuse to be integrated crosswise with anything but their own circle. Many Western artists today find themselves unable to cope properly with curves because they are not aware of the double aspect they can be given. Some highly linear drawing styles, such as the Ukiyo-e style, even require that, to have any expressive validity, a line must embrace at least three different principal reaches of direction, and all leading lines a recurve. Needless to say, to draw such lines firmly and clearly demands—as well as an unsupported hand—a sustained act of

concentration of a kind which is not natural to Western artists. Western lines tend to be short-breathed, and to play their part in an over-all structure across the direction of the lines. As an example of a Far Eastern technical ideal we may recall that the great Japanese painter Kano Eitoku (1543–90) is said to have drawn free-hand, with a straw-brush and ink, on a wall of the audience room of a castle, a single stroke 40 yards long representing a tree trunk.

The uses of lines I have mentioned that the meaning of lines depends very much on their kinetic suggestion in relation to the co-ordinates and to the direction of drawing. To take the simplest examples: lines may 'rise', 'swoop', 'plunge', or 'float'. All these figurative verbs suggest possible qualities of linear movement in relation to high and low, and right and left. But they are no more than approximate descriptions of what lines can do. For the conceptual language of lines does not cover the same ground as words. There are lines for movement-concepts for which there are no words. Thus it is impossible to say in words what any line does, though it is perfectly possible for the artistically educated to 'understand', in the fullest sense of the term, the meaning of the line. For such meanings are composed of experience-contents of vector-traces which given lines call up. And, as I showed in Chapter 1, all such vector-traces belong to a category of experience not connected with verbal experience. A complex linear form such as, for example, a Far Eastern 'ravelled hemp' brush-stroke refers to a rich visual reality-experience which cannot be reduced to any other terms. The meaning of any single line is further clarified both by its context of other lines, with which the mind has to relate it, and by its context as an index to a notional reality, for example, the edge of a robe, or hair, or a rock face. It is here that the question of artistic 'realization' mentioned in Chapter 1 comes to be considered. For we can postulate that what a drawing style does with its lines gives the key to its visual ontology.

European drawing, and the drawing of the peoples of the Americas, has tended to play down the purely kinetic expression of lines in the interests of other kinds of expression. There are various degrees in this balance of interest. On the one hand some masters of the Art Nouveau epoch such as Munch, Gauguin, and the young Maillol (partly under the influence of Far Eastern art: Cézanne referred contemptuously to Gauguin's 'Chinese pictures' without volumes) attempted to use cursive lines as their principal expressive forms. On

the other hand a draughtsman like the old Poussin eliminated all the ¹⁸² kinetic brio he could from his lines, as also did Titian and above all Seurat, who worked his drawings over carefully with this end in view. In fact, of course, the lines that even the most determined anti-linearists employed *were* made by a moving hand in a particular pattern of stroke and direction. It may be quite possible for a spectator to enjoy a drawing without bothering about this kinetic pattern—which may sometimes be very difficult to decipher. But it is my contention throughout this book that both observer and artist can gain a great deal by becoming as far as possible aware of the order of strokes that make up a drawing. I hope to demonstrate later how this can be done, ²³⁴ in reference to a drawing by Dürer and one by Poussin. ¹⁷⁸

One can say that Western draughtsmen do often attempt to establish a kind of eternal validity for static shapes marked off by lines, and for the closed static structure established by patterns of lines, related to each other across their directions. This does not abolish the need to read lines kinetically, but adds a further dimension to their interpretation. For their significance is shifted from an image of pure change to one of an extended present. Ontologically this shift may be associated with that type of Platonism which accords prime reality or substance to the abstract concepts represented by nouns and immutable class-relation systems. Once again only very general philosophical parallels can be suggested and they must never be pressed too far, as they sometimes have been. Much work needs to be done. But it remains a fact that the *visual* ontologies of different artists may be perfectly clear, if we know what we are looking for, without our knowing of any actual verbal, philosophical parallels. Indeed there is no reason to assume that there will be such parallels in any given period. For visual ontologies can have a validity quite independent of verbal philosophizing. Great artists like Poussin and Rembrandt have a status as ontologists quite independent of and superior to that of academic philosophers.

The greater part of my later discussion of lines, enclosures, and volumes will be devoted to the kind of visual concepts used in addition to the purely kinetic expression of lines. But, as I pointed out, even in drawing with the most static intent there *is* a kinetic pattern. So that in reading the meaning of enclosures, say, and in understanding their place in the whole context of a drawing, it can matter whether the lines which compose them were made in one or another pattern of directions. The element of time and change can scarcely ever be

banished completely from the expression of drawing. Nor should it be, if truth is to be served. And in drawings by the mature Rembrandt, 31 for example, the dance of the pen-tip over the surface is essential to the image.

Definition of terms applied to lines Before continuing with further discussion of the uses of line it would be as well if I defined three words which I intend to employ with a precise if slightly arbitrary meaning. First: by 'contour' I mean a line which marks off a part of a positive body from something else and gives it some shape—a kind of shaped edge. It is essentially a line which is not closed; so that there can be, for example, a group of contours overlapping each other which together enclose, say, the shape of an arm. A contour may define the only visible undercut edge of a fold in drapery which elsewhere is visually continuous. Secondly: by 'outline' I mean a closed line which runs virtually all the way round a feature or round an enclosure which does not necessarily correspond with a single object, such as an area of empty space. Thus a series of joined contours could compose an outline. Thirdly: by 'silhouette' I mean the complete closed outline of a single, whole object which is intrinsically devoid of three-dimensional significance. As we shall see later, both contours and outlines can have a pronounced three-dimensional significance.

There are five major categories of linear function distinct from the outlining of enclosures. First: the line may serve as demarcation or limit between areas or volumes. This is perhaps the most primitive function of line. Secondly: the line may be developed for its own sake as a fluent, two-dimensional expression. Thirdly: the line may form itself according to a standardized linear concept or pattern, such as the spiral, squared hook, or S-curve. Fourthly: the line may be developed in special ways either to indicate three-dimensional volume (plasticity) or to indicate the shapes of surfaces moving in depth. Fifthly: the line may be used as a piece of tonal substance for the sake of its dark or light. Two or more of these categories may be combined in any style, though particular styles may attempt to confine themselves to one only. And all of them are in some degree conditioned by the fact that lines are usually dark on light. Some drawing styles, especially those which use rough, abrupt strokes like Rembrandt's, when they seem to be doubling or modifying a first contour by a second, may actually be doing two or three things at the same place, which a single line alone would never do. And some styles, such as the sophis-

ticated styles of Gothic, fourteenth-century Europe, carefully distinguish the ways in which lines are used in different parts of the same composition, using them in one way in one section and in another way 275 in another.

There is one term I must define by means of a simple musical analogy. Just as the executive musician 'phrases' the shape of his melodic material, so too does the draughtsman 'phrase' his lines. He shapes them by means of rhythms, subtly varied, by inflecting them, breaking them, and causing them to spring one from another. This conception of linear phrasing is extremely important for the understanding of all drawing.

Two-dimensional *nitations of the line;* *d means to overcome* *them* Since the essential fact about the line is that it is a two-dimensional trace on a plane, it has *in itself* no three-dimensional value. When a line is recorded on a flat drawing surface the mind always accepts it first as functionally a separator. Its tone is taken for granted, and it is understood simply to mark off one side of itself from the other. A completely closed line, such as a circle, separates the area it encloses from the area that lies without. At bottom, lines represent limits, borders. And when they are applied to defining notional realities such as human figures, animals, or trees, they are used to establish the two-dimensional limits of the objects. This seems to be what happens in the most primitive art we know. (In contrast, to use lines as the axes of intrinsically solid forms, as in 'pin-man' drawings, is a relatively sophisticated process.) The effect of drawing continuous, unbroken outlines round any notional object is always to bind such an outlined object closely into the plane of the picture surface, turning it into a two-dimensional silhouette. (Many modern artists wish to do just that.) But every drawing style that seeks to go further has to evolve some procedure to deal with the fact that all lines are intrinsically two-dimensional separators. Even the most sinuous line cannot escape the fact that it is really a two-dimensional phenomenon. And every edge-line which is to be developed as the contour of a body needs to be contrived so as to give more than simply a section of the elevation on a two-dimensional plane of the notional object it delimits. The 'life' and independent volumes of notional bodies are, as it were, in bondage to the fact that lines on a plane surface can only ever present some form of two-dimensional cut-out. This means that to achieve a three-dimensional sense in drawing it is not enough simply to give continuous outlines to objects the drawing represents.

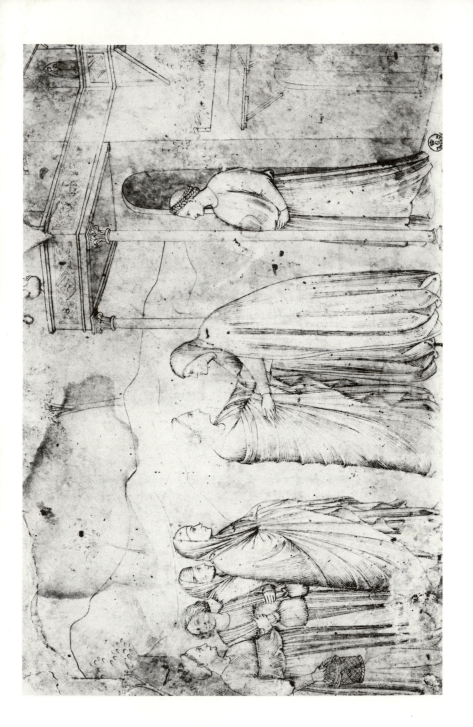

Anonymous Florentine, THE VISITATION, early 15th century; pen and ink, 22 × 34 cm. *Uffizi, Florence*

Something more is always needed. There are many possibilities; and most of them represent some means for driving the eye away from the outline towards the centre of the outlined form.

There are styles of drawing that accept the basic integrity of the silhouettes of objects which appear to be sectioned clearly through by the plane of the drawing surface. The intention of such styles is to present their subject-matter as calmed, disciplined by an unbroken 96 outline, and subdued to the surface. Outstanding examples are Giotto and Fra Angelico. It may seem that such art actually preaches discipline as a virtue, and it is associated with the social ideal of discipline. Such completely integrated silhouette outlines are characteristic too of drawings associated with those styles of sculpture whose aim is the complete integrity of a sculptural surface which isolates by silhouette each single figure. And such drawing styles are associated with special techniques for developing the plastic volume of the bodies forward into the third dimension, from the silhouette towards the eye. Certain of the techniques will be discussed later. Some of these drawing styles are those associated with much Graeco-Roman sculpture, most 164 medieval Indian sculpture, and the sculpture of South-East Asia, as well as the more restrained styles of Italian Romanesque. All these sculptural styles seek in their plastic thought a close integrity of the 'skin' of the surface and a clear separation of figures. This requires that, from the main viewpoint at least, all of the sculptured surface, from one side of the outlined figure to the other, shall be visible without 'dead ground', however deep the recessions may be. (Channels, actually undercut, may be incised in patterns into the surface so long as its integrity as a surface is preserved.) Thus the contours used in the sculpture, like the outline of the related drawing styles, represent the most distant receding edges of the objects united into silhouettes. But each object is conceived as three-dimensional within its silhouettes. The sculptor Maillol, for example, drew by means of con- 98 tinuous contours, and strove for exactly this kind of plastic integrity in his sculptures. Giotto's drawing style is the best indication of the importance for his art of the traditions of Tuscan Romanesque sculpture. More will be said of this topic in subsequent sections, when it is explained how three-dimensional plasticity can be given to such notional objects. However, there are many examples of work by sophisticated draughtsmen who have fallen into this two-dimensional constriction *without intending to*. Many of the later admirers of Raphael, for example, made their contours of human figures so smoothly con-

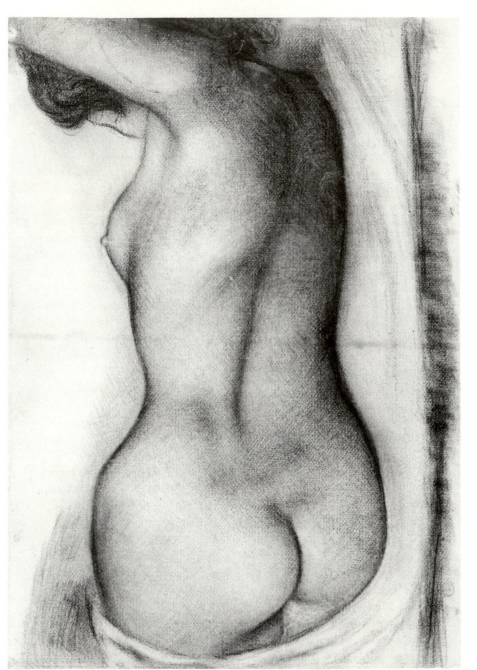

Aristide Maillol (1861–1944), RECLINING NUDE, c. 1931; red crayon, 28.6 × 77.8 cm. © 1987 *The Art Institute of Chicago. All Rights Reserved. Gift of William N. Eisendrath*

tinuous over all the members that the three-dimensional quality sought elsewhere by other means was too emphatically negated. In the works of the great Bolognese masters following the Carracci the carefully cultivated, fluently undulant contours applied to human figures and landscape—the much-admired Italianate *disegno* derived from Raphael—can militate against plasticity, despite the careful elaboration of the shadow-modelling in the forms.

Fluent linear expression The artistic culture which has devoted most thought to the line as two-dimensional expression for its own sake, and which has elaborated its types and functions most carefully, is the Chinese. The Japanese assimilated and developed the Chinese methods. Thus Far Eastern draughtsmen using the flexible Chinese brush have been able to produce an extraordinary variety of stroke-forms and stroke-qualities. The habitual practice of calligraphy has instilled into people who have learned to read and write Chinese a vivid sense of the possible varieties of lines. A first-class Chinese or Japanese draughtsman is able to create long sequences of extended, meaningful lines of a kind which is quite outside the capacity of any Occidental draughtsman. (Of course this entails the sacrifice of other artistic resources.) The ability to formulate such extended linear sequences has long been recognized in the Far East as the mark of the superior artist—not least because it calls for an intense discipline of the capacity for sustained concentration. And Far Eastern ontology conceives reality to be predominantly an infinite process of unique movements and never-repeated change. (Chinese is a language especially rich in verb forms.) The normal Chinese training in calligraphy develops the ability to produce lines of immensely varied inflexion. The inflexion, of course, varies with the styles, from Six Dynasties Buddhist Paradise reliefs through the major masters of calligraphic monochrome in China and Japan down to the Japanese masters of the Edo Ukiyo-e (the popular print style). And, of course, the meanings of all such different linear expressions are themselves different. Much work needs to be done on distinguishing such qualities of purely formal meaning. Here I can only offer a general indication of where the problems lie.

Such extended calligraphic rendering of movement could only be achieved by the sacrifice of those static enclosures and volumes and the objective solidity which most Western drawing has striven for. Indeed the momentary accidental effects of hazard are deliberately sought by Far Eastern calligraphy—and every stroke is intended to

represent a unique, unrepeated, and intrinsically unrepeatable pheno-
menon. It must be based on norm-units and general qualities, of
course, or it could never be understood, and these are recognized and
classified in calligraphic theory. But it is part of the Chinese view of
life that each phenomenon stands at a unique nexus of conditions in
time.

To give an idea of the wide range of the qualities of lines recognized
in the Far East, here are a few of the types listed according to their

descriptive, metaphorical names. Lines may suggest: willow leaves; angle worms; water-whorls; series of date stones; series of olive stones; wasp-bodies; ravelled hemp; iron wire; broken brushwood; nail heads with rats' tails; axe-cuts; broken weeds; bamboo leaves; orchid leaves; and so on. Dots may be of many kinds, and to make a single dot the brush may be moved in as many as three different directions. In drawing lines it may be trailed or rolled and twisted; it may be used slantwise to give a fat rough stroke or upright to give a fine one. The touch may be soft and wet, hazy, harsh, or dry. All such lines gain their significance by the way in which they rise and fall, cross and dip, in relation to the co-ordinates of the sheet.

Many of the figurative names for lines given above are derived from a particular Far Eastern method of treating the smaller elements of the notional realities represented in the art. For it was customary to represent, say, bamboo leaves, twigs, or orchid leaves each by means of a single sophisticated stroke of the brush, creating an organic 28 correspondence between the object and the graphic symbol. Longer lines could be made by assembling strokes, say, of the 'bamboo leaf' type, into chains. Rhythmic pressure on the brush tip would punctuate the line to suggest 'bamboo leaf' qualities. Such a parallelism will produce a homogeneity of touch between the small items in a drawing and the larger notional objects drawn with bigger lines. In the execution of large drawings the artist controlled the multiplicity of the small elements of reality by deliberately reducing leaves, say, to a specific number, symbolic of 'many'. In the freer styles of Chinese drawing groups of dots or small graphic shapes would be noted in clusters 314 without any close individual description.

In seizing the larger elements of reality the Far Eastern style at its best created chains or sequences of contour-edges, none of which was actually closed so as completely to delimit a single object. Thus a clothed figure would be composed out of open-ended assemblages of two-dimensional contours, each indicating part of an edge, none of them claiming to be the complete edge or to establish a definite outline. A mountain or rock in a landscape would consist of broken ranks of overlapping edge-lines, none of them laying claim to enclose any 211 single definite thing or item of reality—though in some styles (Wang 280 Meng, 1308–85) rather generalized volumes corresponding with elements of the landscape are enclosed. The spreading of the brush and varying density of the ink can suggest that such lines are no more than shifting borders in a continuum of 'the real'. It is interesting to

recall in this context that Rembrandt, according to Hoogstraten, told his pupils never to enclose any form in a single pull of the pen. Chinese critics pointed out that a mountain enclosed in a single line would not seem high, and that a section of river or pathway completely outlined without interruption would 'resemble a worm'. Such an open conception of drawing must symbolize the 'unlimited' aspect of the notional reality, permitting it to elude compression into two dimensions by dogmatic outlines, and is connected with the particular mode of space cultivated in the Far East (see pp. 201–4).

In this kind of linear style there is usually found as well a device for suggesting the 'fullness' or multiplicity of reality without labouring to define details which would distract attention from the calligraphic expression. This device appears usually as a multiplicity of small touches not corresponding one for one with actual details. The Chinese use 'wrinkles' scattered over the rocks and hills in clusters to 18 suggest a general broken or rough effect, or scarcely decipherable 28 bunches of little strokes paling into the negative area of the surface to 21 suggest scrub. Such small touches only work in the aggregate; and they are laid with sufficient irregularity to suggest the diversity of the detail of 'the real'. They may, by creating a dark rim inside a contour, suggest a generalized three-dimensional quality too. Though they may not be meant to be read as units, since they may lie below the distance threshold for optical identification of the individual touches, they add powerfully to the effect.

Stylized lines In a number of drawing styles there is a tendency, more or less strongly developed, to stereotype contour-lines into recognizable, generalized patterns. It appears in different degrees in different styles. This is often called 'decorative' stylization. For such shapes are usually those characteristic of decorative art, and the nearer the lines approximate to the general linear pattern the more decorative they may seem. In principle such stereotyping of lines tends to emphasize the flatness of the forms delineated. But it is also true that, for example, in such Indian drawing as that of the Orissan palm-leaf manuscripts, stylized curlicues and spirals are included in a style which is closely linked to a vividly protuberant style of sculpture. It should be emphasized that such patterns are not the same as the general categories of line mentioned earlier, but are composed by means of them as are all lines.

The kinds of stereotyped linear forms that may be used are, for example, the pronounced S-curve, the spiral, the squared hook,

Fig. 3

Fig. 4

Fig. 5

Fig. 6

the palmette, and the key-pattern—any of the fundamental motifs of Fig. 4 the world's decorative art, in fact. It is their generality which makes Fig. 5 the linear shapes decorative. (In fact, the categories of line mentioned Fig. 6 above appear in this type of linearism in their most obvious forms.) And it must be admitted that such decorative stylization plays an overwhelmingly important role in much twentieth-century painting —the linear right-angle in flat pattern Cubism, the segmented circle in Orphic and post-Orphic drawing, for example. They are probably used in this kind of art especially for their flattening affect.

Other styles which have made use of such linear stereotypes are: the art of early China—Shang, Chou, and Han, where it is possible to trace the evolutionary change of stereotypes, especially the squared hook; the Maya art of Mexico, which also used the squared hook; Celtic manuscript illumination; the soft International Gothic style of 220 about 1400 in Europe, which made much use of the double spiral and 154 a looped S-curve in its decorative drapery forms; the pen-drawing 14 styles of German art in the early sixteenth century (Dürer, Burck- 108 mair); much Italian and Italianate academic *disegno*, which treated the 234 S-curve, flattened, as the essential 'line of beauty' (Hogarth); William Blake; and the S-curves of Art Nouveau.

From these examples it will be clear that it is possible to combine such stereotyped lines into styles which use other linear methods as well, and even to incorporate them at suitable points in a fully three-dimensional realization, for example in Gothic sculpture of the early fifteenth century. Furthermore, it is even possible to produce sculptural forms on the basis of lines which are themselves very close to a general pattern, by means of the process called 'development'.

In the art of drawing, however, one finds many instances where the artists tend to formulate at least some of their lines according to pre-established decorative patterns. (These, I should like to point out, are not the same thing as visual types.) Indian draughtsmanship, for example, always tended to use lines which were strongly patterned, so that one can say that the artist knew precisely what course his line was to take before it set out because he had made the same line at the same place many times before. Persian calligraphic line cultivated 86 extreme perfectionism in the execution of a wider repertory of standard linear forms which are not, perhaps, so rigidly patterned as Indian lines, though the draughtsmanship is just as repetitive. Indeed the Persian artist studied his craft by learning to execute with un-wavering accuracy a repertory of standard curve-forms with a minute

brush; and his accurate finesse was regarded as a measure of his closeness to the ultimate calligraphic patterns, which were believed to partake of the eternal validity of the divine. Indian drawing of the sixteenth to nineteenth centuries combined the qualities of Indian and Persian linear styles.

The aesthetic basis of this kind of decorative line-drawing must be connected in some way with concepts of superhuman value. For such patterns can best be understood as ideal units, the property not of individuals but of the whole human race. Thus they may seem to have a 'perfection' or 'beauty' transcending the limitations of merely human invention. (Kant, as I have mentioned, attributed ultimate beauty to the arabesque.) And for this reason drawings which include or base themselves on such forms acquire a kind of transcendant worth. This idea can throw light on the meaning of the styles mentioned, most of which were producing religious icons, whilst the Italianate styles were producing Platonic ideal forms.

The phrasing of lines Every drawing of high quality, however, bases itself on a true understanding of the two-dimensional limitation of the line, and develops techniques for transcending that limitation. The danger that lines may remain mere separators, without any unifying function, has also to be overcome. These techniques are universal. Generally speaking, any emphasis upon the expressive quality of the line as such, as in Chinese drawing, or upon the decorative pattern, as in Art Nouveau, tends to emphasize the flatness of the cut-outs; and so those styles of drawing which are interested in an independent three-dimensional plastic presence have tended to play down both the immediately expressive and the decorative quality of their lines in favour of two major linear resources which I shall describe. By means of these two linear resources alone it is quite possible to create a strongly plastic presence, though they are usually reinforced by methods of tonal gradation. Amongst great draughtsmen Poussin, for example, in his developed style always treats his outlines as being without any purely linear expression. So that in his latest drawings, when the trembling of the hand with which he was afflicted makes his contours no more than shaky limits, his forms are still beautifully clear.

The first linear resource, used by some Far Eastern artists as well as by all post-medieval European draughtsmen, is to phrase the contours of notional objects in a particular way. This involves treating each section of outline as a sequence of contour units, usually curved

Fig. 7

and most but not all of them convex. Such contour-units will be con- *Fig. 7* nected in different ways. They may be continuous with one another, each representing a fresh act of conceptualization but linked by the fact that the drawing-point has not left the paper. The lines may break 242 either with a gap or so that one line emphatically crosses, often at an exaggerated angle, the springing point of another, suggesting a strong recession between the 'foremost' line and the 'rear' one. They may 159 cluster in various ways which I shall describe. And all such techniques of phrasing create rhythmical figures by means of continuous series of linked contour-units, giving them fresh starts, breaks, and calculated overlaps so that lines seem to end and begin again, some lines springing from behind or in front of other lines, and ending behind or before others.

In such phrases each contour-unit which is actually two-dimensional presents us with a cut-out or slice of undefined, varying, but nevertheless intelligible depth, and the phrasing suggests the way in which the slices are piled one above the other. The clue to the notional depth of each slice is partly given by our knowledge of what part of the notional object it corresponds to, partly by convex curvature of the segment of contour, and partly by its place in the phrase. Each linear edge thus stays in its own notional two-dimensional plane, whilst the plasticity of the whole notional object is created by an accumulation of suggested slices depicted by elevation-sections of the object. So strong can the effect of phrasing be that it can create the impression that a continuous contour linking a series of depth-slices actually runs 158 back into depth (for example, in the pure line drawings of Gaudier Brzeska). As well, each segment of such a phrased contour, each contour-unit or curve, will have its special quality emphasized both in its individual character and in its general category. In really strong drawing each segment and each chain of segments will have a pronounced two-dimensional movement. In some styles a slice is only suggested by one of its sides (Far Eastern drawing; occasionally in 28 Rembrandt), and no enclosed area or volume is suggested. But in most Western drawing each contour-segment is so phrased as to suggest the elevation section of a unit of volume of which it is only one edge. Further, as will be explained in the section dealing with enclosures and volumes, each contour-segment may be deliberately interpreted as the contour of an intelligible volume either by being related to another one complementing it or by means of tone. One finds in drawings by artists such as Ingres considerable confusion of phrasing in this sense.

It is very interesting to observe that many academic life-drawing teachers in this century have gone out of their way expressly and perversely to deny the validity of the overlapped phrasing of lines— although its presence and value can be seen on display in the work of countless major masters, including Mantegna, Botticelli, Signorelli, Tintoretto, Michelangelo, Rembrandt, and Boucher. It is also the basis of the beautiful linear styles of the fifteenth-century medieval woodcuts, which succeed in creating expressive linear sequences which are yet plastically firm (this is, no doubt, because the leading art of the Middle Ages, with which the imagination of every draughtsman was intimately familiar, was that of the sculptured relief, either shallow or deep, with its clearly defined overlapping edges). And drawing founded on linear overlapping remained the basic method of Renaissance *rilievo stiacchiato* (very shallow relief), of which Donatello was the outstanding practitioner. (In full, deep relief, of course, unlike drawing on a plane surface, the edge-lines would be given an actual three-dimensional movement.) The overlapping of 'slice-edges' is very evident in the figure-, fold-, and mountain-drawing of the Far Eastern countries; though here, as I have suggested, the development of intrinsically expressive lines, combined with the lack of volumetric enclosure methods, tended to eliminate any strong sense of mass and volume. Even the residuum of mass-drawing which had entered China with Buddhism from medieval India was effectively suppressed in favour of the extended line.

Lines which display three-dimensional sections of forms The second linear resource for developing three-dimensional meaning by lines is as follows. Certain key lines are drawn in such a fashion that they lay out in two dimensions the three-dimensional plan-section of the volume to which they are attached. The section of the plan is presented, as it were, tilted round towards the eye. This was done notably by the Greek vase painters and the mediaeval woodcut artists, and became common practice with innumerable post-medieval draughtsmen. For example, when the edge of a circular bangle which cuts across the wrist should be rendered from the point of view of pure optical accuracy as a straight line, it is actually shown as a deep curve whose ends vanish behind the outlines of the wrist. The outlines of eyelids are nearly always drawn with a far deeper curve than they show optically, and the deeper curve can suggest the forward bulge of the eyeball. In Greek red-figure vase paintings the

Fig. 8

outline of the pectoral muscle of the male nude, running from the armpit to the centre of the chest, usually shows not the optical, two-dimensional fact but the three-dimensional section. Another very common instance of its use is found in those linear sequences which link up the bottom edge of a series of drapery-folds in medieval and Renaissance drawings, or the outline of a rocky shore in sixteenth-century Flemish landscape. Here it may resemble the section of a complex architectural moulding. The planning of the placing of the feet of groups of figures may also follow such a pattern. Barlach uses it often to indicate the faceted volumes of the drapery of his figures where it is cut off short at the bottom edge. There are countless instances in the art of Europe. When chains of such three-dimensional sections are linked together they can suggest a very strong movement in and out of the depth of the design. *Fig. 8* 124 135

This resource is what justifies certain of the techniques of architectural drawing, perspectives or isometric projections, where one continuous straight edge is intended to look as if it runs backwards at an angle into space. In fact the three-dimensional effects such lines achieve depend upon the angles or curves at their corners, which suggest the three-dimensional plan of the whole angle. Without angles or curves no straight line on a plane surface can suggest recession. And if, in an architectural projection, any straight line gets itself stretched too far away from its corners, or if it is divorced from any corners at all, it will at once cease to have a genuine three-dimensional significance and become flattened into the two-dimensional plane. This needs to be understood by all architectural draughtsmen. It is interesting in this connection that pure engineering drawing has accommodated itself to the realities of the plane surface far more successfully than architectural drawing by developing its concepts far more as a series of changing pure sections. 202

Perhaps the most interesting and familiar development of this resource is in the style of 'bracelet shading' which was taken up from the work of fifteenth-century medieval draughtsmen like the Master E. S. and Konrad Witz, developed by late fifteenth- and sixteenth-century German draughtsmen, and which later became the standard equipment of all European engravers. This was largely because Dürer and other of the German artists were themselves great and influential engravers. German drawing was always predominantly linear. Its leading concept was the deeply curved line, most commonly done with the pen. Dürer, and even more his great contem- 136

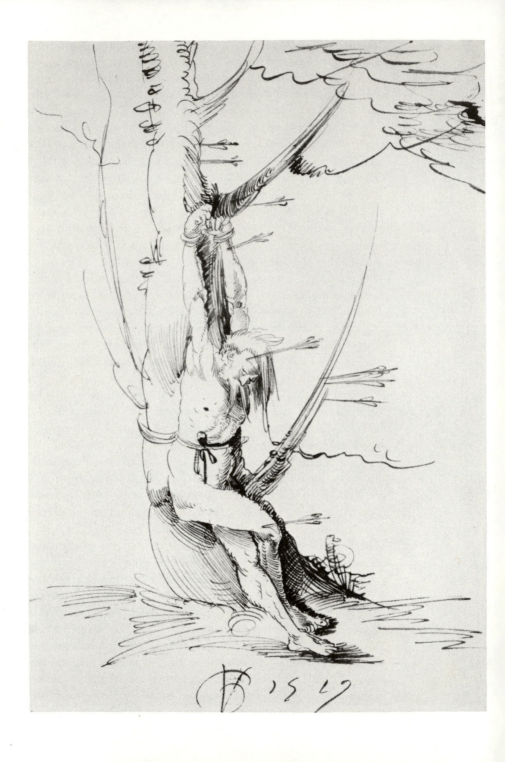

Urs Graf, SEBASTIAN
1519); pen and ink,
31.8 × 21.3 cm.
Oeffentliche Kunstsammlung
Basel, Kupferstichkabinett

porary Mathis Neithardt-Gothardt, called Grünewald, certainly did
both use pure tonal shading to achieve plasticity. Grünewald adopted
the method from his master, the painter and engraver Schongauer,
but Dürer most elaborately developed the use of ranks of curved lines 234
which occupy the correct place for shadow whilst having an emphatic
three-dimensional effect, as if they were visible edges of sections
through the form canted up so as to exhibit the sectional outline of
the form's three-dimensional surface. In a sense these 'bracelet
shading' lines are a functional product of the contours, in that they
may spring from one of the major edge-sections, developing it for-
ward into the third dimension. In the drawings of the Danube artists
like Wolf Huber, of Urs Graf, Hans Sebald Beham, Cranach, and ${}^{14}_{108}$
Burckmair, the florid two-dimensional linearism was developed by
means of bracelets, some of them deeply curved, some only very
lightly curved, into a linear exploration of the third dimension. Such
shading was often inverted in tone and drawn in white on toned paper
to suggest the plastic projection of forms by rendering the light falling
over one side of them. From Dürer both Leonardo and Raphael 110
adopted bracelet shading. And copying Dürer's engraving technique
Europe's engravers abandoned older Italian parallel hatched shading
for a tonal version of the bracelets. Indian draughtsmen of the atelier
of the Mogul emperor Akbar adopted the technique from the Euro- 262-3
pean engravings they copied. And one French engraver, Claude
Mellan, developed in the seventeenth century a version of the bracelet
style which even dispensed altogether with contours.

Dark line treated as
tone; chiaroscuro

As I have mentioned, drawing is usually done with dark lines. In
many drawing styles the darkness of the lines is without significance
in itself; it remains a neutral element in the design, and only the shape
of the line matters. But in Europe, in Graeco-Roman art and then
again after about 1350, and in the Far East, the darkness of lines be-
came a factor in drawing, treated in different ways.

In much surviving Graeco-Roman painting and in many surviving
medieval European drawings one finds the dark tone of the outlines 111
extended by shading in towards the centre of the forms, paling as it
goes. This is usually done by means of many small strokes which
repeat the direction of the main outline of which they are a function,
though during the fifteenth century this method was combined with 196
accumulations of bracelet shading. The meaning of this is clear:
the dark of the contour is accepted symbolically as the ultimate degree

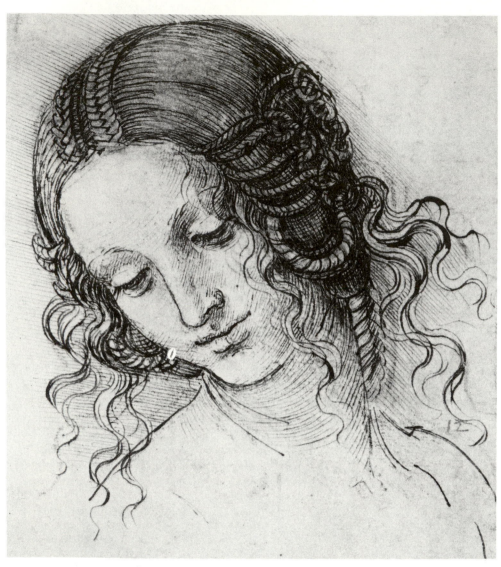

above
Leonardo da Vinci (1452–1519), HEAD OF LEDA; pen and ink over black chalk, 177 × 147 mm. *Windsor Castle, Royal Library. By permission of Her Majesty Queen Elizabeth II*

right
The Master of the Parement de Narbonne, AN ARCHER DRAWING HIS BOW; brush drawing in black on vellum, 26.6 × 16.2 cm. *By permission of The Governing Body, Christ Church, Oxford*

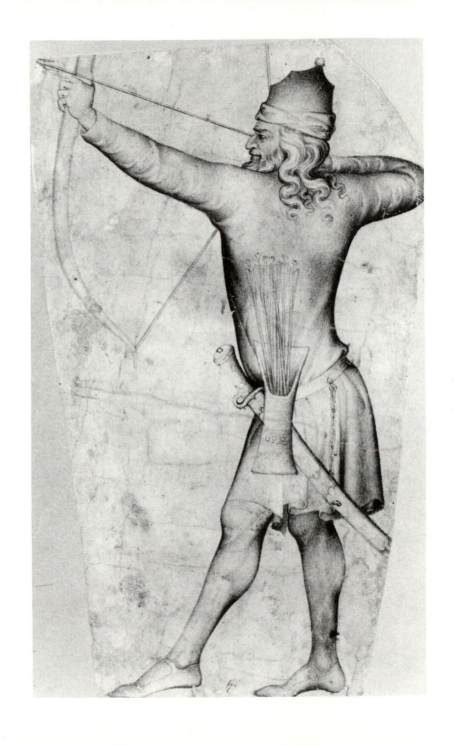

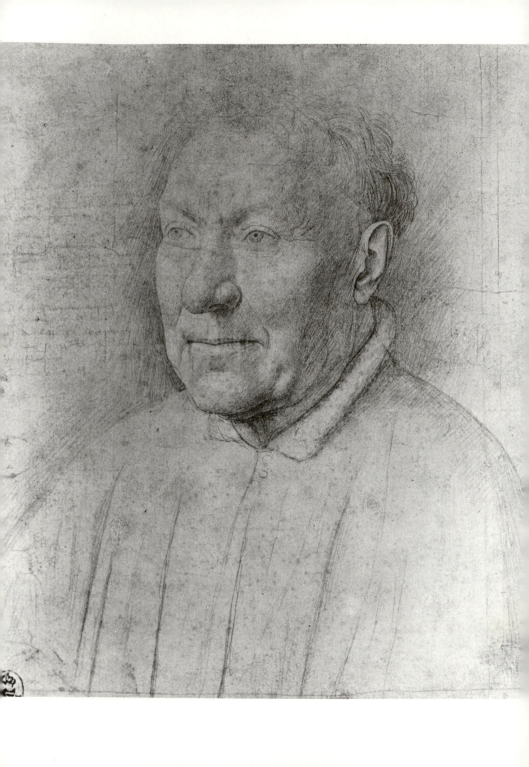

of the form's recession from the eye, the limit of its turning away; so strong can the impression be that it can even suggest that the surface turns back behind itself. The graded contour-shading thus represents the graded recession of the surface towards its edges. Nylon stockings emphasize the form of female legs in the same way; the weave is open and the tone light on the facing plane of the surface; as the form turns away towards the edges the weave darkens. This technique is used especially in styles which are dominated by a sculptural way of thinking and is related to the united contour I mentioned earlier. For it naturally tends to isolate the individual figures with which much sculpture primarily deals. It does not set up a 'pictorial' bond between objects. Indian painting of about A.D. 400–700 uses the technique; while among modern artists Renoir employed it extensively, and the sculptor Maillol made it the basis on which he de- 98 veloped forms in his drawing style. Vestiges of it survived in Chinese art until about A.D. 1300, for it had been carried across Central Asia from India as one of the standard methods of Buddhist painting. In India itself, as in China and Central Asia, it survived into medieval times in the form of a ribbon or band of toned colour a little lighter than the contour itself, following the inside of the contour. Such a band may also carry distant reflections of the side surfaces discussed further on.

In Europe, however, this technique was gradually eclipsed with the development of chiaroscuro painting after about A.D. 1400, first in Flanders and then in Italy. In drawing lines were still used with a linear value and a 'separating' significance. (Only Titian really superseded this, before Cézanne.) But at the same time it was gradually realized that the tone of lines must also be assimilated into the chiaroscuro structure of drawing. At first, it seems, in the drawings of *Quattrocento* artists in Italy only the contours on the dark side of any form were thus assimilated into the chiaroscuro. Flemish artists of 112 the fifteenth century who followed the van Eycks began to distinguish between the tone of contours drawn on the dark side of a form and the light side—those on the lit side being drawn lightly in pen or faintly in chalk, those on the shadowed side being drawn more heavily and stressed. This was a most important element in later Netherland techniques. But it was in *Cinquecento* Italy, in Venice particularly, that draughtsmen completely broke up the contour on the lit sides of forms so as to suggest that the contour's own tone represented tonal properties of objects represented behind those forms, thus

establishing a link by tonal contrast between the lit forms and the rest of the environment. Even Leonardo da Vinci, much interested in chiaroscuro as he was, always preserved strong, clear, dark outlines for the lit sides of his objects, separating them sharply from the rest of the visual field. And the Florentine style generally remained wedded, as is well known, to the firm, factually delimiting contour. The results of this attachment were not altogether happy. And even in the late eighteenth century William Blake fulminated against Venetian and Rubensian 'slobber' in the name of the dead, often decorative and hence unintentionally flattening and isolating engraver's contour which did so much to spoil his own art. Many artists, even the greatest, have found it impossible to dispense altogether with the separating function of the outline in drawing, perhaps using it only as a support for refined tonal definitions in their more developed painting styles.

Line as 'touch' Here I must mention one important distinction in the way that lines are treated which has not been noticed before. It is this. On the one hand lines can be drawn so that the scope of the line as it is traced in its curves and inflexions corresponds exactly with the contour of the 108 form. This means that drawn curves, for example, denote curved surfaces of the same curvature as the line itself; the movement of the drawing-point shapes the form and coincides with its contour, embracing it and defining it. On the other hand lines can be drawn so that no single touch or stroke alone claims ever to embrace and define a form; each touch is smaller than any unit of curve or form in the notional subject. The actual phrased line which emerges in the agglomeration of touches is thus an invention in its own right, and 267 did not happen as a consequence of a comparable phrasing of the hand's actual movements. The effect of this technique can be a softness or gentleness which must never be mistaken for weakness. It marks the styles of the old age of certain great masters, such as Michelangelo, Titian, Corot, Renoir, and the Chinese Li Cheng, Mu Chi, and Kung Hsien. It implies that the form is allowed, as it were, to 54 speak with its own voice and is not subjected to a dogmatic and emphatic contour. Of course it demands that the form be genuinely conceived: for strength in this method depends on the strength of the mind's conceptions alone and not on any established routine of the hand.

The first method is characteristic of an enormous number of very successful masters of drawing who take a natural pride in the skilful

movements of their trained hands, among them Raphael, Leonardo, 110
the Caracci, Rubens, the Chinese Liang K'ai, and Shih Tao, and the 314
medieval Indian wall-painters whom tradition describes as enjoying 165
great esteem for their free-hand drawing of life-size figures. At the
same time some of the great masters who came later in life to use the
second method began by using the first. The classical example is again 129
Michelangelo. But many artists who were painters as well as draughts-
men came in the act of painting to eliminate the dogmatism of outline
shown in their drawing by the touch of their paint-brush. Rubens is a 278–9
good example. There have, too, been artists who have drawn by the
second method most of their lives. Carpaccio is an example, as are
some of the Flemish landscapists such as Ruysdael and van Goyen.

There is one particular kind of line which often occurs, even in the
purely linear drawings of the European Middle Ages, and of China
and Japan where it may seem almost an *hasard voulu*. It is very com-
mon in post-Renaissance European drawing where it is made inten-
tionally with heavily pressed chalk or a loaded pen. This is the
occasional line which gives the impression of cutting into the surface
of the paper where a deep shadow naturally lies. In the European
Middle Ages and the Far East such lines often appear where there is a
deep, narrow and hence very much shadowed cleft between two
drapery folds. Later in Europe they appear in similar places but more 234
often, as where a sitting posterior meets a seat, beneath the edge of a
robe, or where a line springs from an armpit. Rembrandt's famous
brush drawing in the British Museum of a sleeping girl wrapped in a
blanket contains a high proportion of such strokes.

Tonal hatching and However, the tonal use of line has generally speaking been associated
the line first of all with one or another kind of hatching. The typical pattern
is found in Leonardo's left-handed clusters of slanting lines, applied
with delicately controlled tips and tails, placed as shading to illustrate
the plastic volumes of his carefully outlined forms, the white paper
serving as the light. Such shading within already established contours
became the academic method *par excellence*. Raphael used it in most
of his drawings, though he combined it with a version of the bracelet
shading I have described above, and most of the engravers who
worked from Raphael's designs combined the two techniques.

At its earliest appearance in Flanders soon after 1400 chiaroscuro
shading was a derivative of the medieval edge-shading technique,
which had come to be accumulated on the dark sides of lit forms. The

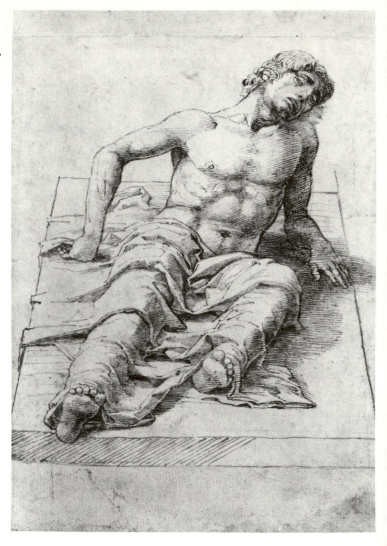

Andrea Mantegna (1431–1506), MAN ON A STONE SLAB; pen and brown ink over traces of black chalk, 16·3 × 14 cm. *British Museum*

van Eycks established all-over shading on the same side of all the objects in a composition, which thus implied a uniform source of light, as a normal part of the technique of drawing. Other Flemings, notably Rogier van der Weyden, developed the use of the hatched cast shadow, the edges of which had the same sort of three-dimension sectional value as the lines described on pp. 106–9. They can thus illustrate in two dimensions the three-dimensional volumes of the

forms on which the shadows are cast. This has remained one of the most important aspects of tonal technique.

Parallel hatching as a means of illuminating form was a marked feature of the drawing style of Andrea Mantegna and of the numerous 116 influential engravers who derived inspiration from him. With Mantegna the special virtues of this technique at its most elaborate are apparent. He seems to have recognized the tonal implications of every one of his most diversely phrased and sectional contours; and he attached parallel hatching to whichever side of the contour was the darker, thus making each lit side stand up sharply against the shadows indicated by the hatching. At the same time the equal texture of the *Fig. 9* hatching, all over a drawing or engraving, gave to the whole that unity of surface we value so much today. The counterpoint of surface and plasticity is by this means much enhanced. The method reached its apogee in some of the big etchings of Rembrandt, where large masses of dense and varied tone were laid in with diagonal hatching.

Lines may develop into tonal significance in yet another way—when they abandon their function as edges without abandoning their linear significance. This happened as a consequence of their imitating the brushwork of the painter in setting down areas of shadow. One might call this linear chiaroscuro; it was the invention particularly of the Dutch landscapists and flower painters of the seventeenth century, 118 and was much used in etching by Rembrandt, Ruysdael, and others. They drew by means of a kind of compendium of contour-shading and bracelet-shading, which divorced itself from edges. It results in mobile sequences of loose lines, following and branching, now denser, now sparser, defining the shadow-paths around which the drawing is built. The lines do retain their directional significance and some lines are included which do set the limits to the extent of objects. One can best liken this method to trees (or dendrites) of dark, spreading and branching across the ground. One of the leading exponents of the style was Goya. It is interesting that he in particular included in his 124 system of darks not only shadow but the tones of colour-areas. This is the basis of that style which Wölfflin called pictorial, for it does not define separate contoured objects, but the paths of dark tone that can be found running throughout a field of objects. In a sense it is the logical consequence of attempting to draw entirely by tone as against contours.

Eighteenth-century artists in France, with their affection for the 192 Dutch landscapists, adopted and stereotyped this technique, though they too were reluctant to abandon the dark contour as limit; Watteau

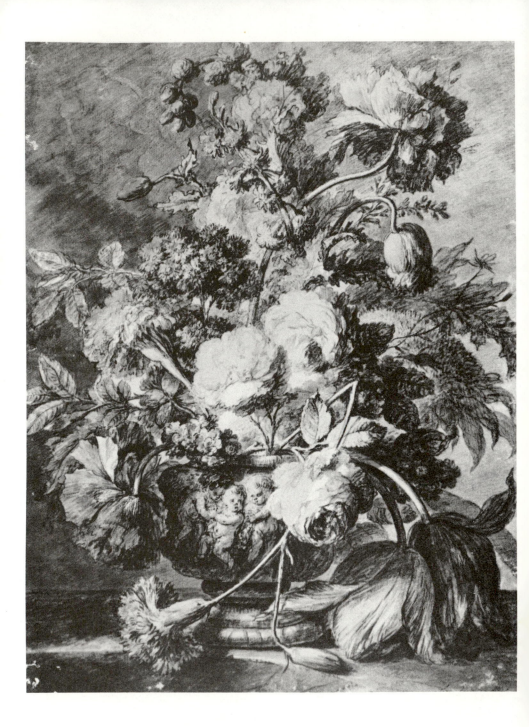

and Fragonard perhaps went furthest in relinquishing the contour. But the greater 'free etchers' or engravers as well, like Cochin *fils* and Gravelot (though *not* Saint-Aubin), succeeded in turning their works into accumulations of defining tone organized rather loosely into shadow-paths.

The ultimate conclusion of this use of lines was the drawing style of Cézanne. In this he owed a distant debt to the Dutch landscapists 120 which is not often enough recognized. As he achieved his own personal style, Cézanne ceased to employ dark lines as in any sense contours. All of his lines were tonal marks with a direction—notes of the location of a tonal contrast, attached only to the shadowed parts of all volumes indifferently. The basis of all Cézanne's drawings is the evolution of carefully structured shadow-paths. He is quite prepared to ignore contours when no tonal contrast is visible. These shadow-paths Cézanne amplified by means of strips of hatching, which amount virtually to broad, short lines of tone with form-defining value in relation to the volumes to which they are attached but structurally integrated into the system of shadow-paths on which he built his art. The directional significance of his lines, and their crosswise relationship, will come up for discussion later. But, as mentioned in connection with Mantegna, uniformity of hatching adds a surface unity to the major areas of his picture surface—though the direction may vary from area to area!

Into this complex of tonal definition belongs the streak of ink rubbed by the finger-tip, and the thick stroke of ink applied by the brush as used by Rembrandt and by Constable, to select two examples whose styles otherwise differ. Rembrandt's organization of his 312 shadow-paths was very firm and interesting, and his darks also had other significances. Constable's assembly of blacks was meant to 171 provide a cloud of darks without any edges on to which he could paint his coloured lights (not the slightest bit 'impressionist' as the cliché has it). But the organization is far less structured.

Last of the European tonal strokes is that which loses its directional identity as line and becomes a function of area and enclosure. Sometimes this may be a natural function of an assembly of strokes like those last discussed, as in many wash-drawings of Poussin. In the later drawings of Titian it can be the product of interwoven and indecipherable touches all following a wide variety of 'bracelet' implications, and gathered into 'pools' of dark on the surface from which the forms emerge. In reverse tonality such touches in white

Van Huysum (1682–
9), FLOWER PIECE;
and brown ink,
coal, and
rcolour, 408 × 318
, *Shawnee Mission*,
as. Mr. and Mrs.
on McGreevy

Paul Cézanne (1839–1906), STILL-LIFE WITH CANDLESTICK; pencil, 12.5 ×
19.6 cm. *Oeffentliche Kunstsammlung Basel. Kupferstichkabinett*

tones may cause lit forms to emerge. But this will be discussed later (p. 137). More commonly, however, washes, as in Rembrandt draw-¹ ings, or charcoal and chalk as in Grünewald, Titian, Marées, and ²⁹⁶⁻⁷ Seurat, may be spread by rubbing into connected pathways and 'pools' of tone, whose substance has no directional significance but can only be read in relation to the plastic volumes in connection with which they will be discussed. Here it must be pointed out that the *edges* of such areas will have a linear value working as three-dimensional section and as structural relation. Other functions of tone in European drawing will be analysed later.

Tone used for colour-density and chological emphasis In the Far East, however, tone is always in some sense a projection of line, and unconnected with the use of chiaroscuro to define three-dimensional plastic form. In Oriental art tone always depends on density of ink springing from a contour on one side or the other and most commonly ending without a firm, form-defining limit on the side away from the subtending contour. In much Far Eastern ink-drawing atmospheric distance is an important factor. For since mist is conceived as a symbol for one of the most important metaphysical principles, the Yin exhalation of the earth, it is always allowed full play. Therefore it is possible to recognize a scale which gives its rational basis to the Far Eastern use of tone and saturation of ink. This scale rests on a psychological estimate of degrees of focused attention. In the earliest Chinese and Japanese drawing pure linear contouring was used. By about A.D. 900 the scale in question was be- ²⁸⁰ coming established. Its scheme is as follows.

Those objects or elements which form the centre of attention in any picture are drawn with firm, dark lines which set off the bulk of the feature they contain as an enclosed area of strongly contrasted light tone. The eye picks upon these outlined elements as the focus of the work. Sometimes, for a subtle effect of reticence, the lines may be relatively light in tone. Then around them the other features are treated in a descending scale of darks, and of attention. A solid patch of strong dark, made either of brushed-out spilled ink (Sesshu) or of ⁸⁰ an accumulation of layers of ink (Mi Fu), is next in order of 'presence' —presence being unconnected with plastic projection. Then downward to the palest tonal areas, which shade off finally into the empty area of the surface. This scale of tonal values ensures that the spectator does not feel the open spaces in the picture as gaps, but only as the natural tapering off of his focused attention. ¹²²

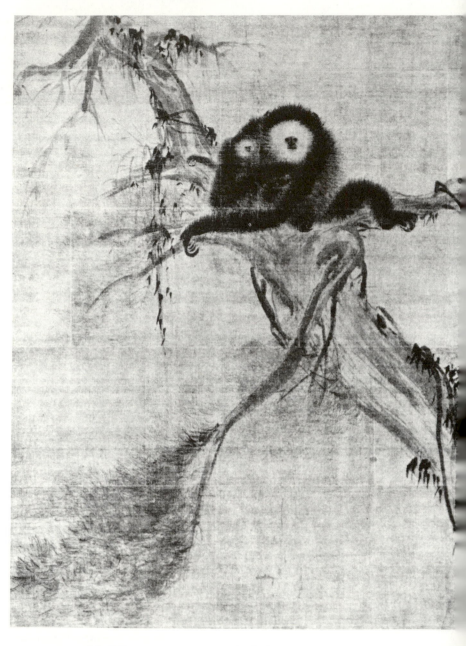

Mu Ch'i, GIBBON WITH YOUNG, detail of a hanging scroll, mid-13th century; ink on silk. *Daitokuji, Kyoto*

This use of tonality has no essential connection with shadow, either modelling or cast. It refers only to density of tone as a kind of local colour. Such colour-tone (as I call it) appears independently of shadow in natural objects, especially landscape in countries with a damp, light-diffusing atmosphere. It is due to the fact that some areas and some pigments reflect less light than others. For example, a ploughed field or a rock may appear much darker than a neighbouring patch of grass even though both are equally lit by the sun. Likewise a dark coloured pair of trousers may seem darker than a light shirt. At the same time a cloud-shadowed mountain far behind a nearer lit one may seem far more strongly 'present' than the other. Here the phenomenon is in fact due to relative lighting, but it has the value of colour-tone since the dark does not model the object. Many Western draughtsmen of the Baroque epoch ignored such colour-tone in favour of an abstracted shadow-tone, which indicated only three-dimensional form and pools of cast shadow. British artists of Italianate bent always find it very hard to distinguish properly between the two functions of dark, living as they do in a damp atmosphere that seldom projects the fully defined form-modelling shadows one sees in Italy. In colour-tone drawing dark coloured objects are shown as dark, light as light, and even patches of dense colour on a flower or bird are rendered as dark monochrome. And paradoxical though it may seem, it is also accepted that a saturated, strong colour will be more closely 'present' than a less intense one. And since it registers higher up the scale of attention, it may be treated as a stronger degree of dark. Distant objects, however, which usually have their colour weakened by the atmosphere, will only rarely rise high in the scale of dark.

The flat glyph One of the most important ways of handling such colour-tone is found in the drawings especially of southern Chinese artists. Whilst creating an expressive distribution of the attention amongst a group of objects (e.g. plants) all notionally placed at approximately the [18] same distance, these artists create out of their patches of tone expressive flat glyphs, areas which have a strong symbolic suggestion by reason of their shapes, which may 'gesture' to the beholder almost as if they were alive. Such patches of tone may be subtly mottled and graded to suggest variety and life. In later Japanese art, especially that of the woodcut artists of about 1700, one finds this scheme of tonal grading submitting to the exigencies of the line block, when its whole

Francisco Goya y Lucientes (1746–1828), DANZA DE MAJOS; brush and sepia wash, 244 × 352 mm. *Prado, Madrid*

scale is condensed into a pure black–white contrast. (It is interesting to speculate as to the extent to which European artists, working with areas of shadow-tone, have also been able to give to shadow areas a glyph-like symbolic expression.)

The oriental treatment of colour-tone has been used in the West, combined with chiaroscuro drawing and bracelet shading, in particular by Goya. In his ink drawings tonal patches may be read either as 124 chiaroscuro, or as dark colour, or as both. The artist himself clearly distinguished and combined the uses. And this helps to give his drawings their special character.

Finally, it must always be remembered that all the tonal linear methods described here can be, and have been, adapted simply by inverting the tonality from dark to light—using white or light-toned chalk or ink on a tinted paper—to defining the *lit* sides of forms, and the crests of projections. This is even true of the Far Eastern techniques, though the practice is far less common there and the light tints used were most often pale green and gold.

Fig. 10

Fig. 11

The logic of linear connectives

Arising out of the consideration of dark lines as units of meaningful form, there follows naturally the consideration of their structural aspect. First I shall discuss linear methods for relating lines to each other—the logic of linear connectives. Other methods will be looked at in due course.

A principal method for uniting elements in the composition of a drawing is by continuities. These are picked up across intervals or breaks, from one line to another. They are based on kinetic reading of 100 the implied vectors of lines across the intervals. Usually the picking Fig. 10 up will be direct; one line may pick up, and gather into itself, the projected vectors of more than one other line, and the projection of one line may be ramified into a number of other lines like a growing plant. Fig. 11 Quite often, too, the eye may be expected to pick up a continuity which has a step in the interval. All such continuities are most effective when they establish relations between what are, in the world of things, separate objects. For example, separate human figures may be joined by such continuities, or human beings may be linked with the elements of their environment. And obviously within the limits of the single human body separate members may be so linked. Considerable 126 linear chains, with a strong melodic expression, may thus be composed. Harunobu among the Japanese artists of the Ukiyo-e is especially strong in this aspect.

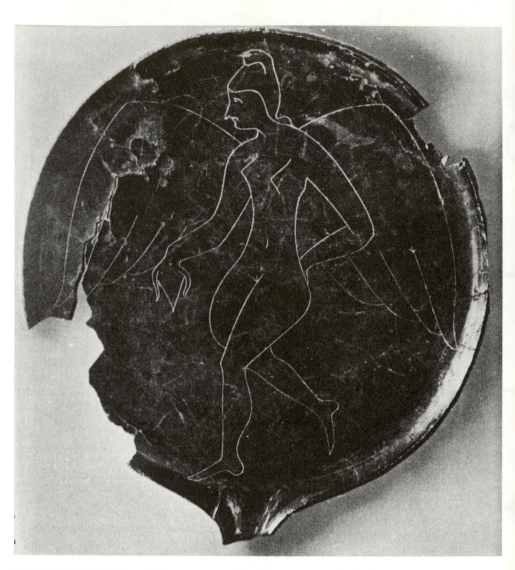

VICTORY IN A PHRYGIAN
CAP, Etruscan, engraved
on a bronze mirror, 3rd
century B.C.

There are certain further ways in which the network of linear con-
nectives can be developed. Some of the possible relationships are
these: (a) a line may take up the sense of another line by paralleling or
imitating its movement; (b) a line may relate itself to another line
by 'opposing' itself to it with a similar movement; (c) a line may
reverse its direction of movement and generate a fresh movement out
of itself reversed; (d) a line may take up with or assimilate to a line

126

a

b

c

d

e

Fig. 12

which is already 'going its way'; (e) a line may take up with part of a line to which its own projection connects.

In some designs such connections may almost seem accidental, though in fact they are not but are produced by the active constructing intelligence of the artist—possibly unconsciously—as he works. Such linear continuities can be carried by all sorts of elements in the design, though contours are the most obvious ones. In those arts which are most emphatically linear they are carried by single edges which do not form closed outlines. And usually, as with Japanese Ukiyo-e 20 artists or the draughtsmen of medieval Europe, certain elements such as drapery-folds are multiplied and exaggerated so as to offer a proliferation of long linear edges for the draughtsman's use. The lines they suggest can be elaborated and used to form a closely knit design. Of course where lines overlap the projected vectors of individual lines will be taken up so that the lines are related to each other only in the two-dimensional sense; and a two-dimensional linear continuity may very well bond elements which are widely separate in the depth of notional space. This, like all other flat connectives, helps to produce that tension between two-dimensional surface and notionally three-dimensional space which I have mentioned as one of the chief sources of expression in most drawing. The quality of the curves, deeply rounded or flat or angular, the proportion of each type, the relationship between convex curves over solid bodies and concave curves defining space between bodies, the kinds of connectives used and in what proportion, the degree to which the lines are consolidated into enclosures all help to determine the character of a style.

Continuities may be conveyed by other graphic elements of the design. Lines of hatched shadow may pick them up and transmit 159 them, or the shaped edges of areas of tone. Three-dimensional section 56 lines and bracelet shading, as in the work of Dürer, may both carry over intervals between contours and in doing so may bond areas of 128 surface into the two-dimensional unity. Many sculptors use this kind of continuity with particular emphasis, partly because they usually have no format-frame to give coherence to their designs so that the dense internal consistency they can achieve by continuities is most important to them. Painting styles which, like the medieval Indian, 74 are based on sculptural styles use it as well. Michelangelo is an outstanding example; indeed he developed an idiosyncratic method of hatching-strokes in imitation of his own claw-chisel marks in stone 129 carving, so as to run in linear continuities over a notionally three-

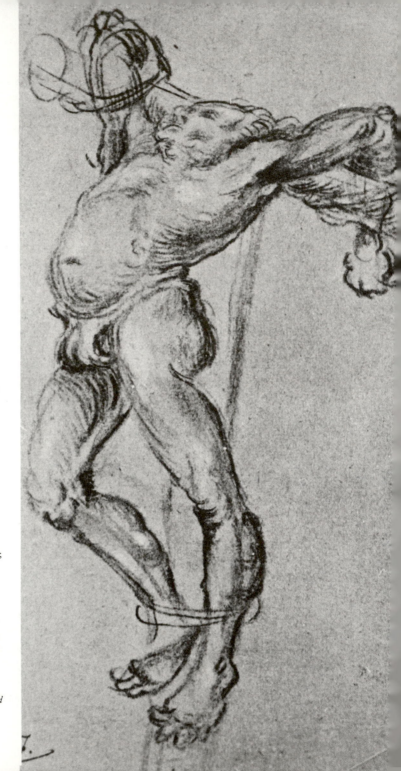

right
Lukas Cranach (1472–
1553), CRUCIFIED THIEF;
black chalk, 2·15 × 12·8
cm. *Kupferstichkabinett,
Berlin-Dahlem*

far right
Michelangelo Buonarroti,
NUDE MALE TORSO,
c. 1501–5; pen and ink
over black chalk,
26·2 × 17·3 cm.
Ashmolean Museum, Oxford

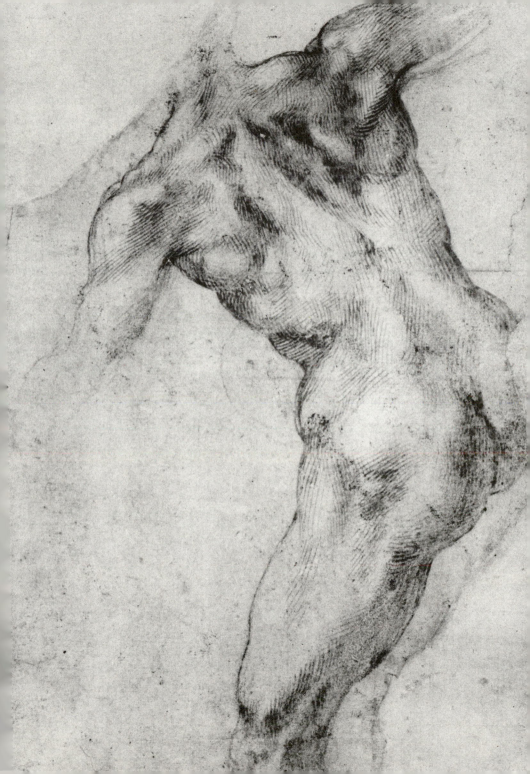

dimensional surface which was given its three-dimensional quality by versions of the ovoid enclosure. The hatching clusters in the hollows where shadows should lie (and where in a sculpture more chisel strokes would be needed) and becomes sparser over the lit humps. Two-dimensional undulation of the hatchings could also render the three-dimensional chasing of the surface by means of their 'sectional' suggestions. In this way Michelangelo symbolized the sculptor's chief concern, that continuous skin of intelligible surface which marks the ultimate success of his structural technique.

Generally speaking, the linear continuities which an art produces become what one could call the characteristic melodies of the style. They may be relatively 'free' melodies, that is they may rest within the sphere of purely linear significance, as they do in the Chinese Wei Buddhist style or the Japanese Ukiyo-e style. Or the continuities may be intimately linked with enclosures which prevent them wandering too far in the direction of pure line, and so limit their inflexion. One such is the most interesting version of the linear continuity which was developed first by Leonardo da Vinci and much used by Raphael in combination with other plastic methods in his earlier style. This was the technique of developing fluent linear continuities, which were conceived at the same time as loops and spirals in the third dimension and related to plastic enclosures. The outline of a shoulder would vanish behind a neck, to be picked up by the edges of a drapery fold which itself wound with suitable breaks round an arm. The disc-like folds and sleeve would compose an interrupted spiral, part of whose sense was that it vanished behind the bulk of the arm into the third dimension. This method, in a purely linear form uncombined with other three-dimensional methods, seems also to have been developed by Chinese and Japanese Buddhist artists and to have been preserved in the Ukiyo-e.

Transverse linear relations A major class of linear connectives is constituted by the various relations across the direction of the line. Hence I call them transverse relations. They at once provide the justification for conceiving the line under the four categories I proposed, in that unless a line is phrased into intelligible sections it is not possible to set up chains of transverse relations. Such relations are by far the most common in all the styles of the world's art, and are especially strongly developed in European drawing. The first, most obvious transverse relation is that of parallelism. One section of one line is parallel with a section of

Fig. 13

Fig. 14

Fig. 15

another line. Series of parallels may be accumulated in rhythmically spaced groups. Such parallelism can be seen everywhere in the work of Cézanne. A most obvious use of parallels, and one which produces an effect of tranquillity, suppressing the dynamic of life, is to make shading strokes run parallel to the contours as in Carpaccio's drawing. But here the function is not structural so much as a mere derivative of the placid contour.

Perhaps more important still is that class of transverse relations *Fig. 13* which I call 'radiating sequences', those which may run in inter- *Fig. 14* related groups in all directions over the surface of a drawing. These, too, are most clearly visible in Cézanne's work; and it is their requirements which often produce the 'broken' effect of what should be straight edges of furniture in many of his works. For one part of the edge may belong in one sequence, another in a different one, and the two may be linked indirectly by yet others. Rembrandt's later style depended largely much on such sequences, which were conveyed mainly in the strokes of dark tonality.

Both parallels and radiating sequences may be 'staggered' or offset, and apply as much to curved lines as to straight. Radiating sequences may actually touch at their apex, as they do so often when they represent the radiating folds of the neck of a kimono in an Ukiyo-e drawing. Or they may be spaced out very wide apart right 20 across the picture format, as in Rembrandt and Cézanne—in which case, as we shall see, they play a major role in creating a sense of deep notional space. In addition, in the case of volumetric enclosures based upon ovoids, the implied axes of the ovoids may themselves be related in the same terms.

One further most important linear relationship—it is not a true connective nor a transverse relation—is the right angle. A stroke in *Fig. 15* one part of a drawing will stand at right angles to another elsewhere; and one may well find that all the strokes in a drawing are related at right angles to one or other segment of the principal thematic idea. 116 Rembrandt very much made this method his own in his later years, 198 and it seems to be the principal element in his late 'classicism'. In 312 his landscape drawings, for example, the slant of a stroke indicating 135 the shadow of a distant tree-trunk justifies one of a pair of double lines or a slant in the drawing of a near bank. The same appears in Titian's use of rough chalk-darks, in Watteau, and in the drawing of Cézanne. In these, and other masters, the system is 'free'; that is, it is developed in relation to the topic only. In Cubist theory it was taken

over and schematized into a rigid, over-all conformism with the co-ordinates of the format.

Perhaps the most interesting possibility implicit in these sets of relations, the parallels, radiating sequences, and right angles, is this: in any drawing there will, in fact, be a limit to the number of angular directions which the lines follow. One might call the set of directions employed in any drawing its gamut; and it may suggest an analogy with the gamut of the musical scale. Some styles adhere closely to a limited gamut of, say, eight directions which can be analysed very simply. Other styles, such as the late medieval European, have a very wide gamut; and others, such as the Japanese Ukiyo-e, use a small gamut but 'slur' or inflect their lines so fluidly that they avoid any direct and obvious statement of any of the directions. The existence of an over-all gamut, wide or small, is one of the strongest means for relating disparate parts and separate linear inventions within the spread of a drawing. Poor drawings will have no sense of gamut, or one so simple that it can only be called crude. But where the system of right-angled relationship is highly developed this obviously has special implications for the character of the gamut in that its scale of directions will have an internal schematic pattern of right angles, which will add a further element to the whole scheme of two-dimensional unity in drawing. Specific gamuts of colour, tone, and plastic projection are used; but the linear gamuts are perhaps more fundamental. I have compared them with the degrees of the musical scale or mode, and this comparison can be taken further. Just as there are primitive types of music without actual modal gamuts, but with only specific note-patterns having no substratum of relationship with other such patterns, so there are arts in which individualized shape-patterns exist which are repeated but cannot be organically related with others of their kind. Examples are the figures in the rock paintings of the Dogon and of certain Australian aborigines. The development of the true linear gamut makes it possible for an art organically to integrate a multiplicity of forms and patterns through thematic variation and development. If we express a linear gamut as radiating lines at given angles, we can say that every line or stroke appearing in a composition across a visual field follows one or more of the given directions. From this springs the often observed multiplicity of parallels in well-constructed works of art, for needless to say each 'direction' or degree of the gamut usually appears more than once in each work. The character of the linear gamut helps to determine the

Fig. 16

132

effect of the whole composition. For example, if the gamut includes and stresses the horizontal and/or vertical co-ordinates, the work will produce an effect far different from that of one which excludes them. The quality of invention in a work of art may to some extent be judged by the consistency and variety of its directional system. If the directions on one side of the gamut are heavily outnumbered by those on the other, or if one side of the gamut is used far more than the other, strong specific effects will be created. And, of course, the gamut may even be reduced to the bare vertical and horizontal co-ordinates themselves, as in much flat rectilinear art.

The diagrams of the gamut I have given show the degrees represented by straight lines. In the actual practice of drawing the degrees of the gamut used *may* appear as virtually straight stretches of line, as in Rembrandt; but far more often they will not be so clearly displayed, especially in a style which is very much concerned with fluent linear connectives. One may have to interpret them carefully out of linear phrases. A musical analogy can help to illustrate what I mean. In Western music it is true that each degree of the scale is often held to be ideally performed as an inflexible note of unwavering frequency. In practice, save on the organ or pianoforte, it is not so. The phrasing of a good singer or instrumentalist always allows for curves on to and off the given pitch. In oriental music the statutory pitches of notes are regarded rather as the poles of intervals or as foci of inflexion. Often it is the intervals rather than the fixed notes that are sounded, *portamento*-wise, by varying the tension over the frets or sliding along the fingerboard on stringed instruments, or by over-blowing on wind instruments. Likewise, in oriental drawing the fundamental degrees of the linear gamut are not often executed as straight, unwavering lines. They are clearly discernible as *quanta* of direction, but the phrasing carries flexibly over from one degree to the next.

It is possible to distinguish characteristic types of motion between degrees and refine upon them. 'Conjunct' motion passes from one degree to the next as in Fig. 17a; 'disjunct' motion appears as in Fig. 17b. There are visual arts that cultivate clear, scarcely inflected degrees of the gamut (for example, Frans Hals). There are others that 135 favour the visual *portamento* and *glissando* (for example, Japanese art). 20 In much post-Renaissance Western art the degrees are used to establish the axes of the centred volumes; here the degrees are often deprived of conjunct linear continuity altogether, and thus to some extent of variety of phrasing. For in first-class works of essentially

a

b

Fig. 17

linear art each appearance of a particular degree carries an entirely different inflexion according to its place in the composition. It most frequently happens—as can perhaps be most clearly seen in the earliest Gothic woodcuts—that the leading invention in such linear work (often the face of the figure) was carried through with the most complex and varied refinement of 'melody' through the degrees, and as the development of the design progressed the linear inventions become less sustained until lines incorporating only one degree of direction are ultimately being added to complete the image. Extreme refinements of linear gamut with larger numbers of degrees were evolved in some oriental arts, especially Persian and Indian, which parallel the sophisticated and highly various monodic modes of oriental music with their purely melodic structure. It can also happen on occasion, though rarely in practice, that the gamut itself is altered in different sections of the same composition. When this occurs, the sense of related 'tonal regions' is set up, and the new gamut will share more or less of the degrees of the original gamut. One of the services rendered to art by the presence of notional objects with strong implicit directions, and also by the established forms of a script, is that they help to lay down a clear directional gamut for the artist's use.

In all figurative drawing it is a most important requirement that the *quanta* of direction in the lines, which are phrased following the gamut, should correspond faithfully to the planes of the surfaces of the notional objects. Hence the gamut may be amplified through the notional planes rendered in tone, as if the notional object *were* actually three-dimensional; whilst the linear sense of the tonal patches also remains within the flat gamut. This is difficult to understand, and few artists achieve it, though Michelangelo and Poussin did.

White drawing Out of all these types of linear continuity melodic chains of lines can be built up in the drawing. How the different types of continuity are combined and related, how they combine with the other elements in the drawing, which elements may not be used, or which predominates over the others, and so on—all this helps to constitute the style. Such relationships can, however, now be identified for the purposes of stylistic analysis. One can also find, it must be remembered, linear sequences carried out in white on toned ground in European drawing in the chiaroscuro tradition. Examples are many, but the drawings of the Lippis and Ghirlandaio include characteristic and easily understood examples. And this kind of white linear drawing has a special

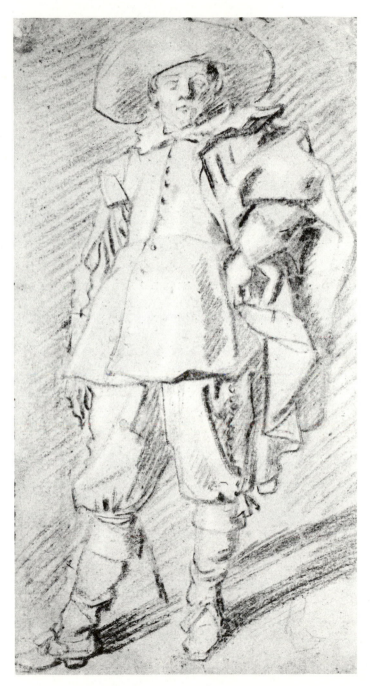

s Hals (*c.* 1580–
CAVALIER; chalk,
9 in. *Rijksmuseum,*
rdam

significance. For all chiaroscuro painting which was based on a toned ground, through the fifteenth to the eighteenth centuries, was actually realized by means of two interlocking drawings, each one with its own system of unity. The dark drawing, of course, usually supplied the fundamental structure. But afterwards there came a second drawing (either in white, which would be overglazed with tints as in so much of Titian, or in colours based on white as in Rembrandt and many others) which was a natural development from the forms of the underlying dark drawing, but was nevertheless bonded into a continuity at least in part by *linear* relationships even when the style was one of sophisticated plastic enclosures. 'White writing' has long been an integral part of the Western pictorial tradition. And linear sequences, as well as being extended in all directions across the surface, may also evolve as superimposed networks of touches, the earlier being legible through the later. This can be seen in the drawings of Rembrandt, the brush drawings of Goya, or the chalk drawings of Watteau, for example.

Calligraphy as art One most important but often neglected aspect of linear connectives appears in the art of calligraphy. Generally speaking, European calligraphy has devoted itself to assembling rows of letters which are formed individually as perfectly as possible; each time any letter appears, in whatever context, it is shaped more or less the same. The letterer, a descendant of the administrative scribe, has always aimed at legibility and formality. This kind of calligraphic art belongs to the realm of enclosures. For whereas distinguished lettering artists have usually estimated the interrelationships between letters in terms of spaces equalized by some esoteric principle of balance, in fact I believe it to be far more a matter of conceptualized 'negative enclosures', whilst rhythmic linear intervals are more important in Islamic formal calligraphy. But all cursive calligraphies should involve purely linear connections and rhythms. It is very interesting that Western tradition has always ignored the possibilities of cursive calligraphy as an art-form. This seems to be another facet of the Western tendency to take account only of forms standardized into static shapes.

ccht Altdorfer (*c.*
-1538), SCENE WITH
AN AND RIDERS;
nd ink with white
, 21·5 × 16·3 cm.
rstichkabinett,
-Dahlem

In the Far East, however, cursive calligraphy, which may be very difficult to read, has been developed into a high art-form. There the syllabic script of China has been adopted as a basis for writing in Korea and Japan too. The Chinese syllabic characters are each made up of a group of strokes, and have a clearly intelligible basic shape, so

that they can be written in standardized form for administrative legibility. But they do also contain within themselves an intrinsic kinetic element. For the strokes of each character have to be written in a definite order, and the individual strokes are always written in a specific direction. Thus any character has its own implied movement-pattern, different in the case of each of the many thousand characters, which embraces the intervals between strokes where the brush leaves the surface. So, in writing a column of characters from above down, the brush follows a continually changing path over the surface. The interest of the Chinese in these varied paths, combined with their metaphysical interest in individuality and change, led them, as I have mentioned, to develop an aesthetic interest in the expressive possibilities of the paths themselves. They came to regard it as a virtue in a cursive style that a character should be formed differently each time it appears, according to the different contexts of other characters in which it occurs. There is, in fact, no reason save clerical tradition and convention why cursive forms of European or other scripts should not be developed as art in the same way, if the principle of variation is accepted with all its implications. The alphabetic word-unit offers its own possibilities of expression.

'Invisible' linear *vectors* The final class of linear connective consists of invisible lines, whose presence is felt without being seen. For example, between the strokes, characters, and words in cursive calligraphy one can feel the directions in which the point has moved whilst it was lifted from the surface. But whereas to grasp the connectives in Chinese calligraphy we may actually know the order and directions in which the Chinese write the strokes, to read the invisible connectives in figurative art the spectator must trace out and interpret for himself the implied vectors of the lines in the drawing. Of course to read the linear connectives discussed earlier it was necessary to read gaps in otherwise continuous linear sequences. But one must be prepared to deal with sequences in which the gaps are, as it were, longer than the visible segments of line; whilst there *are* sequences in which no actual lines are visible at all, as when a group of similar objects, for example, flowers, is arranged along a straight, curved, or recurved line. (The characteristics of such group-formations are discussed on pp. 183ff.) This is very common in all drawing; here I may only mention particularly vivid examples found in the architectural design of the Baroque and Rococo, where the interrupted curves of architraves, vaults, and ornamental features

are composed as much of 'empty' vectors as of shaped bodies. This is also the case in the design of much of the geometric decoration of Islamic architecture, where the geometric patterns on which lines are based may be largely obliterated and only segments left visible. In the uppermost storeys of Michelangelo's façade to the Laurentian library the curved lines of the swags are carried on as invisible undulations through breaks in the mouldings of architraves and pediments. Such invisible lines will be found everywhere in drawing; but they are most easily recognized where they explain some 'distortion' in what would otherwise be a 'correct' optical image. They are also of quite outstanding importance in creating those sequences of bodies discussed on pp. 178ff.

Meantime, there is one particular use of invisible lines which is especially important for modern art, and is most useful in art-education. This is found in one of Klee's techniques of drawing long 140 mobile lines and subsequently simplifying out of them enclosures, a practice which he may have developed from Islamic example. His technique was to begin by drawing an extended and convoluted line, which curves back upon itself many times. Out of the large number of possible enclosures such a line offers he selects those which express his intention and 'fills them in', perhaps picking out as well short

139

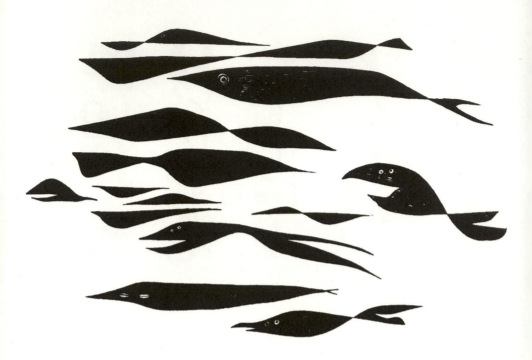

segments of the line for emphasis. All the rest of the original line is then obliterated, and the enclosures and segments are left standing in their own right. There may no longer be much visible linear connection between them—though there may be some. However, the mind grasps that there is an invisible unity, esoteric or 'mystical' perhaps, since it is not openly intelligible, bonding the enclosures together—the obliterated line. In very many of Klee's paintings the invisible linear bond is a loose 'chessboard' grid, the lines of which may be progressively developed as 'parameters'. Artists who have attempted to be influenced by Klee without understanding Klee's method have had to rely upon intuitive connectives which are never as impressive as Klee's own. The implications of this method for modern art, particularly when the basic line is developed by means of parameters, are immense. In a sense the method represents an inversion of the traditional methods for achieving two-dimensional unity: the linear connectives are invented first, whilst the notional reality is *ben trovato* afterwards; whereas in traditional art the connectives were developed by exploration of a notional reality. Klee's topic became, in fact, the logic of the connective and its implications.

Two-dimensional closures; three main types

I had better begin this section on two-dimensional enclosures with a definition of terms. By 'enclosure' I mean an area of the surface of a drawing the shape of which is in some way defined. It may be defined in several ways. First, by contours which are closed so as to outline the enclosure entirely. Secondly, by contours which are not completely closed but nevertheless give a fair idea of the intended shape, whilst leaving unstated one or more sides of the enclosure so that it may run continuously into its neighbour(s). Thirdly, and most important, by the fact that an enclosure of either of the two above types may, when it is understood by the mind, at once suggest either that as a whole it is an individual area falling under one of the general 140 basic categories of enclosure—the round, the triangular, the rectangular—or that it may be interpreted as an assemblage of parts all of which fall under one or other of those basic categories.

Enclosures define areas of the drawing surface; and the term 'enclosure' carries no specific suggestion as to the presence or absence of objective bodies. In actual practice enclosures may be used to define areas of void (early fifth-century B.C. Greek red-figure vase painting) 146 just as firmly as they may be used to define the shapes of notional bodies depicted as if physically present. And the various degrees of

geometric or structural tightness (close to the categorical forms) or looseness (distant from them), of open-endedness, of linear inflexion, of attention to the full or to the void, of relationship between the enclosures and the notional subject—all help to define the style and give it its characteristic expression.

Once more we have to remember that in relation to the coordinates or format, in relation to the direction of reading and to the notional objects in the drawing, two-dimensional enclosures actually *do* things which can be expressed by verbs. They can 'open', 'close', 'spread', 'divide', 'split', 'connect', 'bond together', 'condense', and perform many other unverbalizable functions, just as lines and other forms do. One can only read a drawing properly if one distinguishes and reads its enclosures with as much care as one would read its lines.

There are three main functional types of enclosure. The first two consist of enclosures which have an existential value in that they can be either positive (defining the full) or negative (defining the void). 14 That is to say, they may represent on the surface of the sheet either the *presence* of objective bodies or the empty areas between bodies. The balance between positive and negative is supremely important. This is to some extent a commonplace of academic teaching. But unfortunately it is one which seems immediately to be forgotten by the majority of students when they hatch out into artists. Negative forms must be even more vigorously studied in drawing than positive ones. It is normal for the physically present to demand definition, whereas the 'absent' needs far more effort to perceive and define. Anyone who has drawn from still life knows that whereas the actual shapes of bottles, baskets, or fruit remain more or less constant, and because of their familiarity can seem dull, the negative areas are always different and un-standardized; whilst even the slightest change of viewpoint can drastically alter the expression of the negative enclosures between the objects. Thus if one begins by drawing the negative areas without first diagramming the positive shapes, artistic results rather than inartistic must automatically emerge. This was a fact well known and always realized by the great masters of still life like Chardin. It is no less true, and no less important, in the construction of any composition based upon enclosures. Human and animal figures, microscopic reality, areas of concrete fact like torn paper, all find their most interesting definition through the relationships between them, ex- 1 pressed by the negative forms. And an important point about negative

Impression of a seal, Han dynasty (*c.* A.D. 1000); *c.* ¾ in. square

142

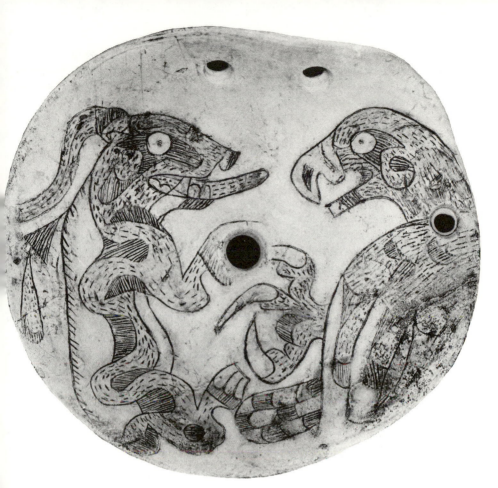

enclosures is that in two-dimensional art they are in a conceptual sense always and only flat. Only in the concrete actuality of sculpture fully in the round can they be given a three-dimensional value. Some draughtsmen may attempt a general three-dimensional effect for 'open' volumes, for example by creating a conceptual space between two lines of standing figures running into perspective depth. But little more than this seems to be possible.

Indeed it is easy to see that negative forms can only amount to 'pure relationships'; for they define no object. From this characteristic of theirs it should be possible to draw the inference that, actually, even the *positive* forms denoting presence must also in essence be statements of relationship between one part of the drawing field and another, and never mere descriptions. In sculpture, because the technique of direct

carving demands that the negative areas of material to be removed must, in the removing, be clearly conceptualized, many sculptors find stone- and wood-carving far more satisfactory than modelling. For carving techniques impose this method for producing relationships even upon an artist who may not consciously be aware of it or capable of it. If he were, he should be able to introduce it into his modelling, as most great sculptors of the past have. One can also discover that even in a kind of design which otherwise is not usually good, individual pieces of high quality can emerge when the technique in which they happen to be executed demands that material be removed (and not added), compelling the designer to think of his negative shapes. Examples of this can be found among the numbers chiselled from thick brass panels for nineteenth-century locomotives. It must be mentioned in passing that if negative forms are to have a real value in drawing, they must not be composed entirely of concave contours. If they are, their functional integrity is damaged.

There is, however, one further type of enclosure, in addition to the positive and negative enclosures which indicate full areas and void areas. This third type is the enclosure which does not correspond either with any body or with any void space. Instead it can embrace areas of both full and void. For example, one may find that the left-hand contour of a human figure may form a clearly shaped enclosure along with the right-hand contour of the trunk of a tree to the left of which the figure stands. The top of the enclosure may be made by the contours of foliage on the underside of the tree, the bottom by a strip of ground. Thus the enclosure in question would embrace two solid bodies, the human being and the tree trunk, as well as the void spaces between and above both. Such enclosures, which are purely conceptual, overlap the positive and negative enclosures which have an existential reference to the 'full' and the 'void'. They may also work on a smaller scale, within the limits of positive or negative areas, linking the contours of drapery folds or the flat shapes of a group of muscles. How they link up across the ground, interpenetrating and subdivided, and how enclosures of this third type relate to the two types of enclosure with an existential value, are matters of prime importance in reading the meaning and expression of any style.

Fig. 18

F.

Qualities and uses of graphic enclosures; the logic of areas Perhaps the most primitive type of enclosure, in terms of drawing technique, which is yet capable of considerable development, is the soft, amoeba-like positive morph enclosed by a single, continuous

undulating line—the kind of shape on which Jean (Hans) Arp based *Fig. 19* his style. In an enclosure of this kind, as well as the purely linear expression and the formalization of the bounding line, the interplay of positive enclosed areas and the negative ambient areas is most important. One can see here, perhaps, the principle of variety at work in its most exposed and obvious form. For a skilful artist will make sure that both the 'promontories' and the 'inlets' of his enclosure are varied in shape, and do not simply repeat themselves or each other. As well he will ensure that the negative areas of ambience running up to the edges of the format are clearly conceptualized. As long as this is done, good 'placing' is not a matter for occult intuition. (This principle is equally important in three-dimensional work.) Because young children are uninhibited by considerations of resemblance, the expression of simple amoebic forms in many of their drawings shows a quality of life which in the works of older children and adults is not present.

Fig. 19

All calligraphic styles of drawing are bound to produce enclosures of some sort simply by virtue of the fact that their curved and angled lines inevitably embrace areas of the ground. Those styles which cultivate the freest and most fluent calligraphy tend to produce enclosures which are incomplete, open on one or more sides, perhaps only contained within a single deep curve or an acute angle. Such enclosures can run and blend into each other quite freely, so that their characteristics are never completely defined. Often areas will be marked off by lines which refuse to formulate conceptualized enclosures at all. In these styles—that of the Japanese Ukiyo-e, for example—the meaning of any enclosure is purely a product of the enclosing lines, and the enclosures themselves may have scarcely any independent significance. As they are defined only by their edge-lines, their characteristics as enclosures elude definition by the structural categories mentioned earlier.

The calligraphic enclosures characteristic of Persian art, though 147 they may be closed, are nevertheless rarely conceptualized structurally, and scarcely ever defined by the third type of enclosure. Once again they are characterized by recurved lines which frame them, and it is very hard to relate them to any intelligible plastic entities save recognizable objects. However, when the Persian style of drawing was deliberately combined at the court of the Mogul emperor Akbar (1542–1605) with native Indian plastic drawing, a new group of styles developed. They amalgamated fluent Persian linearism in varying 262–3

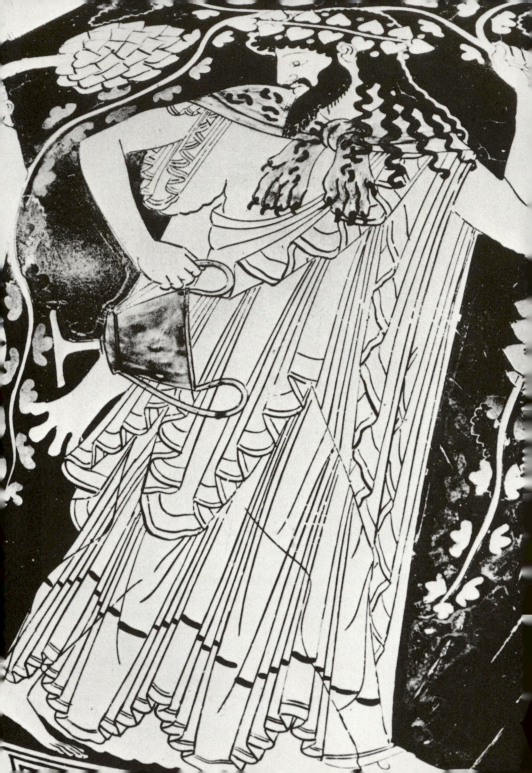

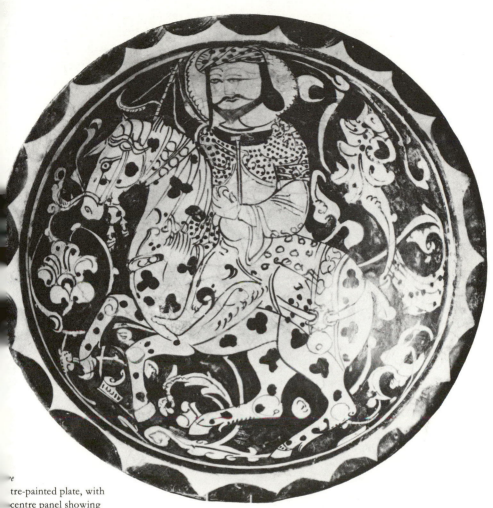

degrees with the Indian system of conventional conceptualized en-
closures, with the emphasis on the positive. As well they assimilated
influences from European art, especially engravings.

What I here call the conceptualized enclosure, absorbing into itself
the expressive qualities of its bounding and defining contours, has
provided the basis for a great deal of the world's art. One of its main
functions is to withdraw attention from the *outline*—which designates,
after all, the most distant part of any object—and focus the mind on
to what lies inside outlines, the primary existential units. This it does

partly because our minds can make the jump and recognize areas as units, or accumulations of units, by virtue of their corresponding with certain general type-categories. In the same way as it is possible to define a set of fundamental shape-categories for lines, one can do the same for enclosures (and for areas of tone). I have briefly indicated their nature above. But again one must make the proviso that these categories are only the class-*differentiae* or 'headings' by means of which we are able to recognize basic formal units composing any area. So that we must expect to find them realized concretely only in modified and combined forms. The basic categories are the circular, triangular, and rectangular. They appear in all their modifications and combinations. On one hand these enclosure-forms may be actually symmetrical. Symmetrical basic enclosure-forms give a special character to a drawing style. The forms may be used so that each one individually is virtually symmetrical, as in much Central American drawing. Or enclosure-forms individually asymmetrical may be used in opposed pairs so as to complete a symmetry, as in much primitive drawing. Then symmetry of either of these kinds may be present but subtly broken by calculated breaches, as with a turned head or gesturing arms. Finally, units of enclosure which are in themselves symmetrical may be combined in a free disposition and asymmetrically shaded, so as to encompass the variety of natural appearance within their system; this is especially characteristic of an enormous amount of Renaissance and later Italian drawing.

On the other hand in many styles the actual realization of each enclosure, of whatever kind, will be modified by its inflected contours and by its junctions with other areas or enclosures, whilst no single enclosure will actually be symmetrical. Concave or convex edges given, say, to a long triangle will modify its meaning, as would one convex, one concave, and one straight edge. In most styles the circular will almost always appear as some kind of oval, whilst forms may appear as functional combinations of two or three of the basic categories, symmetrical or asymmetrical; for example the fan-format = a section of the circular + a section of the rectangular; in Fig. 21 another combination is shown.

The numerical preponderance of one or other category, their blending, and how they are combined in either or both positive and negative enclosures, help to determine the character of a style. For example the Tiahuanaco style of Peruvian, and much Mexican pre-Maya design, are dominated by proportional modifications and combina-

a

b

Fig. 20

148

tions of the rectangular, tending towards the square, amplified by curvilinear formulas based on categories of stylized curve. In these styles the enclosure tends to be represented complete, each enclosure being juxtaposed in an additive way with the next or joined with it so that its integrity is preserved and its whole area remains clearly distinct, whilst long chains of positive or negative enclosures are not made. The style of the great Reichenau manuscript illuminators, 150 however, deals mainly in elongated, straight-sided enclosures—rectangles and triangles, both positive and negative, a few with curved sides, especially in the positive forms, whilst versions of round enclosures are used chiefly for head, halo, and hands, though they do occur elsewhere. The enclosure-forms are dovetailed together, superimposed, or elided into each other, positive and negative sequences being kept sharply distinct. Indian drawing, on the other hand, has always employed a high proportion of opulently rounded positive enclosures, most of which are convex with very few concave contours, whilst its negative enclosures are usually—but not quite always —feebly conceptualized. The most striking examples of an art of mutually balanced positive and negative enclosures, very varied and executed with the slenderest possible resources, is the Palaeolithic cave drawing of Europe. A single rough contour can subtend most 9 beautifully structured sequences of both types of existential enclosure.

Perhaps the most interesting style based on the purely two-dimensional enclosure is that of the archaic Greek black-figure vase. 152 It is interesting because the figures are laid out separately, frieze-like on the negative ground, and the technique is therefore visible with particular clarity. Here the draughtsmen developed a strikingly balanced blend of the positive and negative conceptual categories of area, combined with a sophisticated linear articulation. The functions of both classes of form, the line and the enclosure, were clearly distinguished in the drawing. Rectangles, triangles, ovoids are coordinated, combined, and varied with the greatest freedom, but at the same time we are aware of a clear, intelligent discipline which is represented by the strong sense of structural categories. More particularly we can read the extraordinary continuity with which the positive enclosures are joined, articulated, and interwoven by the linear inflexion of their contours, not merely added together. The emphasis on the two existential categories, especially the positive, gives a strong sense that a sculptural idea with its internal continuity informs the whole of each and every figure. For this to be achieved it

a

b

Fig. 21

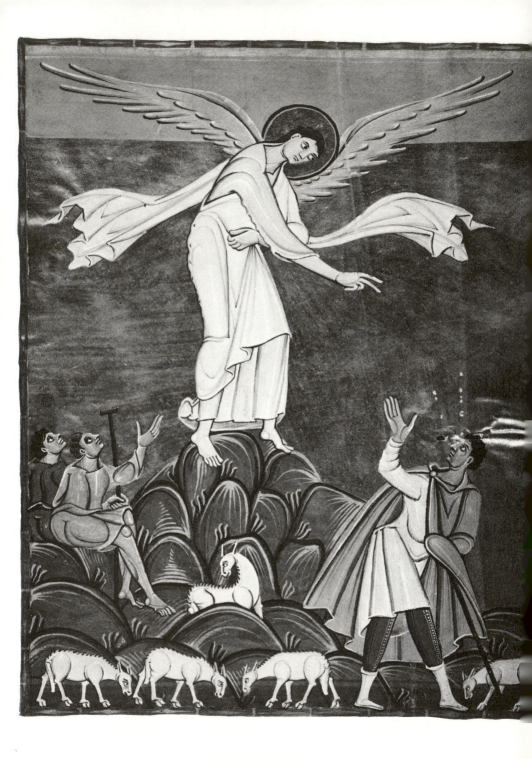

is necessary that each enclosure, even if it be indicated only by two of its edges, shall be contained completely within the outlines of the notional positive body. None must ever be cut off incomplete; the defining edges of each shall be allowed to consummate their enclosure-implications within the limits of the whole notional body. In this style, too, one can see the particular value of the human figure, the notional object, as context. For both the frieze-like arrangement and the generalized appearance of the figures throw the whole burden of expression on graphic elements alone. The basically simple resources are used with sophisticated skill. The human figure as context supplies the rationale for the diversity of forms.

One can easily read in this style the expressive qualities inherent in the graphic enclosures which designate thigh, thorax, or knee, precisely because the responses are ready to hand like stock epithets in verse. One knows what a Greek felt about the strong thigh of Achilles and its meaning to the warrior; about the thorax, seat of the dry and wakeful consciousness, the thymos; about the knee, whose sinews were the first to be loosed in death and whose synovial fluid was cognate with the fluid, seminal psyche, and divine unction. *Mutatis mutandis* it should be possible, granted some research on fundamental attitudes, to read the metaphorical qualities attributed by their forms to the notional realities represented in other drawing styles. Indian and Chinese art theory has made some very acute analyses. This is a point where there is room for a great deal of further research. For such emotive effects do not depend on vague surges of generalized feeling, but upon fairly precise responses to graphic metaphors.

One of the most important issues in the whole question of graphic enclosures is this: many art styles, particularly those usually called primitive, make their units of enclosure correspond exactly with those units of the notional world for which there are spoken names. Thus the enclosure-units composing the human body correspond in most primitive arts with terms like 'hand', 'arm', 'body', 'leg', 'foot', 'face', 'nose', and 'eye'. In Haida Indian design the thunder-bird has 'beak', 'head', 'eyes', 'wings', 'claws', 'body', each defined by a single enclosure. In less primitive styles the enclosures defining the human body correspond with further named units: 'forearm', 'chest', 'thigh', 'cheek', 'chin', 'beard', and so on, the recognized units of visual sense corresponding with more refined recognized units of verbal sense. And the inflexion of the forms of the units gives

151

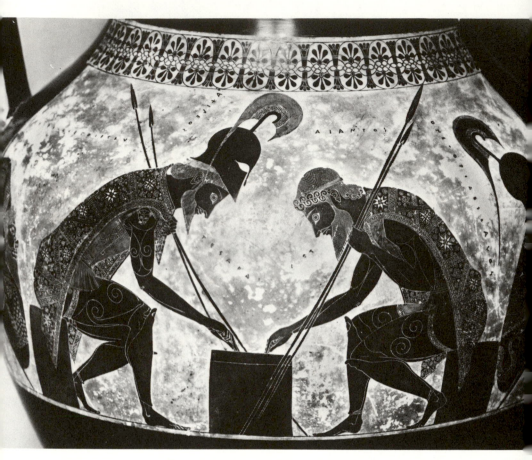

AJAX AND ODYSSEUS
PLAYING DICE, from the
Attic amphora by Exekias,
c. 530–20 B.C. *Vatican
Museum, Rome* (photo:
Mansell/Alinari)

to those units their qualities by metaphorical analogies. As individual
art styles develop, however, we find that the area of the notional world
designated by particular enclosures slips progressively further out of
correspondence with named things; so that the enclosures refer to
entities which are purely visual phenomena—for example segments
of a leg which correspond to no named muscle; one of many possible
elements in a structure of folds; a piece of shadow; a form jointly
embracing one man's leg, part of another man's robe, and the contour
of a tree-trunk. In the most sophisticated styles all the enclosure-units
define elements of visual sense which lie beyond the reach of words.
It is most striking that in this respect the Palaeolithic art of the
European caves bears no traces of the primitive definition by names.

In this connection it is interesting to note that drawing of an

anatomical bent can represent a regression—in my opinion most undesirable—to a primitive enumeration by enclosure. For each unit of enclosed form may be made to correspond with a muscle named in the anatomical code. As scientific description this may be all very well, but in practice it can destroy the artistic value of the drawing since it represents a false and banal primitivism. Even Leonardo da Vinci's carefully studied anatomical nudes suffer from this regression in a way which Mantegna's or Botticelli's nudes do not. Leonardo's art of drawing was a great art in spite of its descriptiveness, not because of it.

One of the most important and sophisticated ways of treating enclosure-forms emphasizes the third of the functional types of enclosure mentioned above. It creates interlocked, overlapping, and interlinked chains of enclosures which may greatly preponderate over the positive enclosures composing notional bodies, and the integral negative areas visible between bodies. Instead, each single intelligible enclosure is composed by the contours of a group of elements which are not plastically continuous with each other—the edges of folds far apart, of a ground line, the edge of a building, and a human figure. Each may include both full and void areas. Of the other enclosures which interpenetrate with it, some do not necessarily use any of the edges of the first given enclosure, whilst others may be subtended by the same edges. The notional bodies produced by such an art do not have an emphatically existential quality, but seem interfused with each other and with their ambient space. Such interpenetrating enclosure structure is especially characteristic of German Gothic art, and even of later Germanic art—especially Klee. Picasso, too, has made much use of it. It is partly responsible for the strongly 'mysterious' or 'mystical' effect which is sometimes claimed for Germanic art in contrast to the decorative extraversion of French art, which tends to adhere closely to a structure of positive bodies corresponding closely with notional realities.

Something may always be said about the types of enclosures favoured by different arts. There are so many possibilities that they cannot even be summarized here. However, a pair of contrasted general examples will show what can be looked for. Gothic design allows for, and employs, enclosures which may differ widely in their length and breadth. Thus single items may be defined which are very long in relation to their breadth; though this does not mean that other kinds are excluded. In contrast, the drawing of the Renaissance

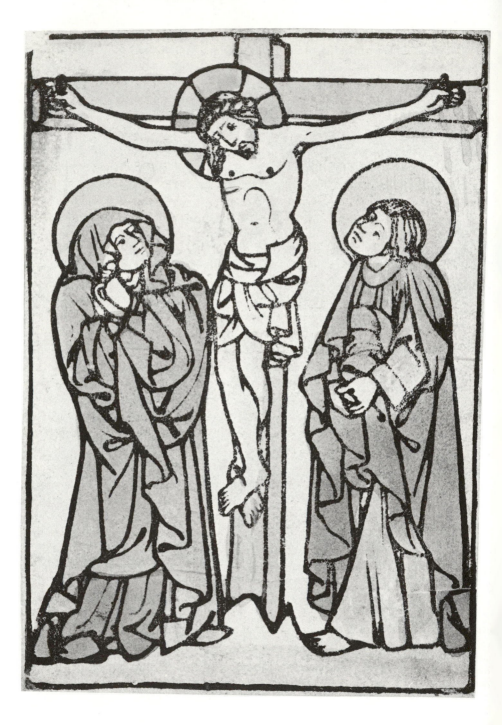

always attempts to make its enclosure-units approximate as far as possible to the isometric forms of circle and square. Short units are also favoured in post-Archaic Greece, Rome, and India. This contrast of unit-types is related to the two modes of space discussed on pp. 201ff. For elongated units obviously tend to use space as an environment, whilst isometric units tend to enclose it.

Enclosures as
depth-slices

At this point I must refer back to the concept of outlines being phrased so as to present 'slices' or sections through the notional object, a matter which was discussed under the heading of lines. For of course these slices usually came to be formulated into enclosures in European drawing styles; though, as I have mentioned, most Far Eastern styles preferred to extend the overlapping edges lengthwise, leaving their enclosure-implications open. Those drawing styles which unite into a continuity the entire silhouette of each object naturally produce enclosures which tally with whole objects; and so for the moment I shall leave them aside. Those styles which, whilst dealing in forms which do not tally with named pieces of reality, yet suggest clear enclosures by means of outline alone show the next method in its essence. For enclosures which are assembled in these styles into plastic notional realities are usually defined by three or two of their sides only, one or two of the sides being left open to elide into neighbour enclosures, where it is necessary to preserve the sense of a continuous plastic entity. In fact where the contours of a body are phrased so as to suggest a chain of positive enclosures, the depth-slice segments of the contour do not need actually to overlap one another so long as they are phrased so as correctly to define the successive enclosures. The artist of the Niaux bison does this beautifully. But 9 perhaps the most complex example, which uses all three types of enclosure, is the first-class northern woodblock print of the fifteenth 154 century. However, we must remember that in this last case an element has been added to the design which would not be present in a straight-forward drawing with the point. This is the set of conceptualized enclosures which appear as the white areas between roughish black lines. They were created with the chisel as hollows in the face of the woodblock, and do not correspond precisely with the enclosures indicated by the lines drawn on the block. They enrich and enhance the point-drawn design, without simply repeating it: at the same time they have a unitary system of their own. We can see clearly in such a design how pairs or triads of contours relate to each other across the

surface so as to suggest slice-enclosures, without necessarily being 'joined up' to make a complete, outlined enclosure. The mind may have to take in each enclosure-construct imaginatively according to its form-categories, whilst its ends are kept 'open' for the sake of plastic continuity. The lines framing the slice-enclosures may retain some purely linear expression, whilst many of them at certain places may complete enclosures by acting as contours with a strong suggestion of three-dimensional section.

It is particularly important to realize that in this style, as in many other linear styles of enclosure, the lines follow patterns conditioned by contemporary conceptions of sculpture, which was then the leading art. They follow what would be the channels a sculptor would carve into the masses of his block to define the forms of outstanding features, such as folds or the step-intervals defining overlapping edges.

There is one further important device characteristic of the linear-slice style which was used continually right through to the end of the eighteenth century. This is creating by a line one side of a 'slice' in such a fashion that it makes enclosures with more than one other line; and those other lines are the overlapping edges of still other slices of depth. Thus for the first line a strong three-dimensional depth will be suggested, since it is obliged itself to embrace the series of depth-slices suggested by the multiple lines to which it relates. The first line may also be one of those lines which illustrate a three-dimensional section of form.

Most Gothic art, when it came to developing enclosure systems in depth, concerned itself principally with the folds of robes which according to medieval ideas of sumptuary symbolism signified celestial glory. When it did treat the nude human figure it virtually always enclosed it within a united enveloping contour, which did not allow the body to be broken up into depth-slices. A splendid example of this in sculpture is the great *Mary Magdalen* by Gregor Erhart in the Louvre. Only during the fifteenth century, the *Quattrocento* in Italy, did draughtsmen begin to break up the nude type into depth-slices; and the fact that this was done must be attributed to the growing influence of the late classical sculptures which were being found and eagerly collected by wealthy connoisseurs and artists during that period. For such classical figures always show the body as delimited into well-defined areas of three-dimensional surface. However, there is one further element of that style, the ovoid plasticity, to be discussed

shortly, which was not immediately recognized by the *Quattrocento* draughtsmen.

The surviving Pollaiuolo drawings, for all their deliberate adoption of classical subject-matter, show that extended linearism related to the *Trecento* type was still in the ascendant; for the multiplied linear overlaps of the Pollaiuolo contours were not developed as depth-slices into thoroughly conceived enclosures. In the drawings of the great master draughtsman Signorelli, however, we find fully fledged a phrasing not only of the contours but also of the inner modelling lines of figures into positive enclosure-slices of well-marked and strongly differentiated enclosure-form. Not only that, but areas of shading were used to help to define enclosures. So that an enclosure could be indicated not only by two or three lines, but by sections of phrased contour in combination with edges of shadow— or even by areas of shadow alone. The great virtue of Signorelli's drawings is that these enclosures are wonderfully varied in shape.

Mantegna reveals similar qualities in his drawing. And the works of other *Quattrocento* artists after the mid-century such as the Lippis have similar features. But the most significant aspect of the graphic development of the period was in the use of tone by all these artists to bring forward and define with some precision the actual plastic depth of the enclosure-slices by means of shadow. Shadow became not simply an adjunct to the contoured form but an enclosure-defining phenomenon in its own right, frequently picking up the vector of a contour to form a linear continuity, or combining with contours to define enclosures on either side of itself. And during the second half of the century the practice seems to have become more common of assisting the plastic relief of the enclosure-forms by means of lit surfaces indicated by white drawing on tinted paper. At the very end of the century, as I have mentioned, a few artists, notably Leonardo da Vinci, adopted the Germanic method of bracelet shading, probably from Dürer's prints, as an aid to bringing forward outlined enclosures into a suggested third dimension. The young Raphael also adopted this technique, combining it with the diagonal shading more characteristic of the *Quattrocento*.

158

159

116

240

110

300

Development of three-dimensional volumes from two-dimensional enclosures

Positive enclosures of the most varied shapes are readily converted to indicate three-dimensional forms. The most obvious way of doing this is by adding to the contours inner lines suggesting the facets of an intelligible three-dimensional volume subtended by the contours. *Fig. 22*

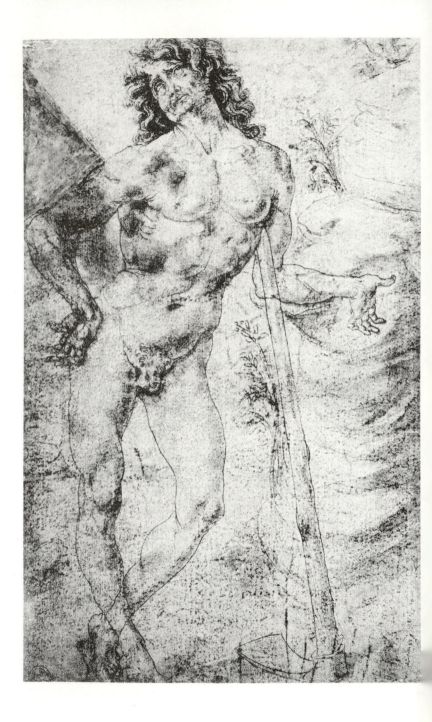

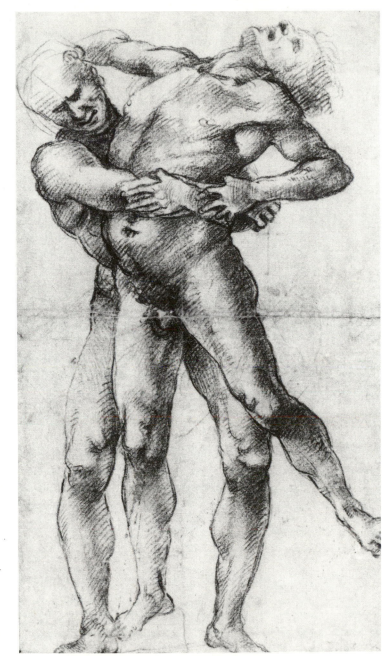

o del Pollaiuolo
–98), ADAM; pen
ack chalk and
28.5 × 18 cm.
(photo: *Alinari*)

gnorelli (? 1441–
HERCULES AND
us; black chalk,
163 mm.
Castle, Royal
By permission of
ijesty Queen
h II

Fig. 22

Such inner lines may be called 'shed-lines', as they indicate as it were the watersheds dividing the facets of surface. They may very often be disguised as the edges of an area of shaded tone. But in Rembrandt, for example, a dark pen-line can serve as an adequate clue to reading the crest between two facets. The positive volumes indicated will be those readily extended from positive enclosures. The principal artistic aim is to shift the viewer's attention away from edges to frontal faces, so giving a vivid sense of presence to the forms. Far the most common type of plastic enclosure develops areas of flat surface into notional volumes of a rounded three-dimensional quality, usually ovoid.

It is very difficult to discover the point at which the classical technique of ovoid stylization crept into the *Quattrocento* system of enclosure-slices. It appears fully fledged in the mature drawings of Leonardo, and seems to have been half-understood by his master, Verrocchio. It is a technique which also reached India, probably via late Hellenistic exemplars, and greatly influenced Indian drawing styles thereafter. It is found well developed in the fourth century B.C. in styles of red-figure Attic vase painting. And it appears in the drawing of some of the Roman frescoes at Pompeii—most important, in the famous fresco called *The Aldobrandini Wedding,* which exerted such an influence on seventeenth-century Baroque drawing. Once adopted by the artists of Italy it was transmitted partly through Dürer—who understood it only imperfectly—to the Low Countries and the north. The Flemish artists of the last half of the sixteenth century such as Martin de Vos, with the engravers who worked from their designs, transmitted the technique to Rubens and others. Knowledge of it then faded for a while—though Boucher knew it well—and it was 'rediscovered' and developed by Delacroix on the basis of hints from Baron Gros. From him Cézanne and Renoir took it over.

Briefly described, the technique is as follows. The contours of enclosure-slices are so phrased as to give convexity to all positive forms; at the same time the outer contours of notional bodies are not related directly to each other, but each is related first to an equal and opposite line which lies within the contour, so as to suggest a complete ovoid or ovoidal cylinder. The lines are then related to each other by the plastic surfaces so implied. Such pot-like volumes always refer the mind primarily to their content of space, rather than to the outer surface alone. This technique indicates a fundamental discovery concerning the manner of symbolizing the convexity of the surfaces

of positive bodies. And I should point out here that Cézanne, in his famous letter to Émile Bernard of 1904, which is so often barbarously misquoted by apologists for Cubism, suggested that Bernard 'treat nature by the cylinder, the sphere, the cone'—all convex curved forms; and as he had no interest whatever in drawing hard, clear edges, there were no 'cubes' at all! (Cézanne was by no stretch of the imagination a 'Cubist', nor an 'Ur-Cubist'.) It should also be pointed out, perhaps, that one of the effects of this ovoid technique is to weaken, and make very difficult to rationalize, the system of negative enclosures which are so important for the two-dimensional structure of drawing. For the ovoids are all purely positive enclosure forms, which naturally tend to give all the adjacent negative enclosures concave contours. This presents a great problem in finding the true place and quality for contours which are compelled to have a double function. Perhaps the most successful reconciliations of the demands of this technique with the technique of negative enclosures is found in the work of three of Europe's colossi, Titian, Veronese, and Poussin. It is partly because of this that they *are* colossi.

As will easily be seen from my mentioning Titian, the way of rendering these ovoid convexities went far beyond the use of contour alone. We may profitably trace the evolution of the method from its beginning in pure contour to the point where it was achieved virtually by pure tone, without adhering too closely to a strictly historical sequence.

When Delacroix explained his rediscovery of the ovoid method to Jean Gigoux he first referred to it in relation to a piece of sculpture which Gigoux showed him, questioning whether it was genuinely Classical or a Renaissance piece. Delacroix decided that it was Renaissance, because 'the Classic artists grasped things by their centres, the Renaissance by line'. He then demonstrated by drawing that what he meant by 'centres' (*milieux*) was ovoids. As we have seen and shall see, his distinction was not wholly true; for some Renaissance and late Renaissance-Mannerist artists did indeed have a good grasp of the *milieux*. But in so far as 'Renaissance' meant to him *Quattrocento*, he was broadly right. And 'classic' certainly meant to him Hellenistic-Roman sculptural art. This is another way of expressing the fact that truly classic forms are convex in all directions. Their convexities being given life and emphasis by the variety of their implied facets and by the various ways in which they melt and resolve into one another.

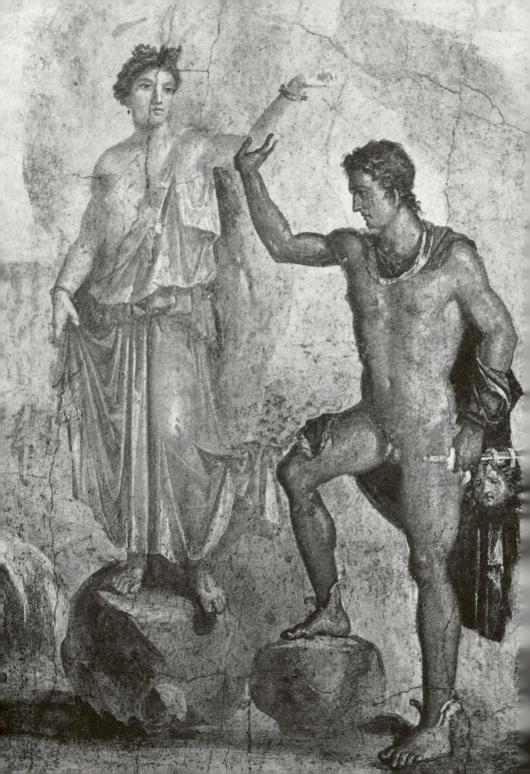

Delacroix, of course, was talking about a sculpture; but he demonstrated the technique in drawing. And his own drawings show it 180 splendidly developed. He used abrupt, 'unfinished' strokes and a mixture of diagonal hatching, bracelet shading, and directional hatching to bring out his forms in a painterly manner. Unfortunately we have no drawings from the classical epoch which would relate to the kind of sculpture in question. The nearest approaches can probably be found in some (not all) of the magnificent Lekythos drawings of the 232 late fifth century B.C., one or two mosaics from the third century B.C., and in some of the Pompeii and Herculaneum paintings. In all of 162 these the ovoids are executed in some sense by means of lines. Often 164 the ovoid or cylindrical volume is contained by a pair of contours, either so that each volume and each item of the notional world, for example, a forearm, have a one-to-one correspondence, or so that at least a part of each section of the notional world is enclosed as a completed volume, for example, an arm or the calf of a leg. Such 116 forms will always have implied axes, and such axes will always play 165 an important part in composition. They will be especially useful in creating the notional depth of foreshortening by seeming to be tilted into the third dimension. Bracelet shading can also play its part in suggesting the axes of forms around which it 'revolves'. Surfaces so defined can be regarded as 'functions of revolution' (to use a mathematical term) of the contour line about the axis—like a pot. If the contour lines are slightly different from each other, an inflected surface, developing from one into the other, will be suggested. This was highly characteristic of Indian draughtsmanship up to about A.D. 1200.

However, this variation of surface ceased to be possible when the ovoids had to be stereotyped towards pure versions of the category-forms. This happened because it became customary to suggest the ovoids by indicating only one, not both, of their contours. It can be found even in the phrasing of some of the Greek Lekythos drawings 232 of the late fifth century B.C. In the later Renaissance drawing to which I have referred shading was used to 'help out' such phrased contours. In the art of some Mannerist painters (Vasari) and of the Flemish sixteenth-century engravers such shading completing the ovoids became so routine and emphatic that figures, especially nudes, may look as if they were composed of dense clusters of oval bubbles, or like cauliflowers. It is worth mentioning that it was precisely this aspect of Italian drawing routine that Rembrandt rejected so violently, pre-

SEUS AND
ROMEDA, from a
co at Pompeii, mid-
century A.D.

163

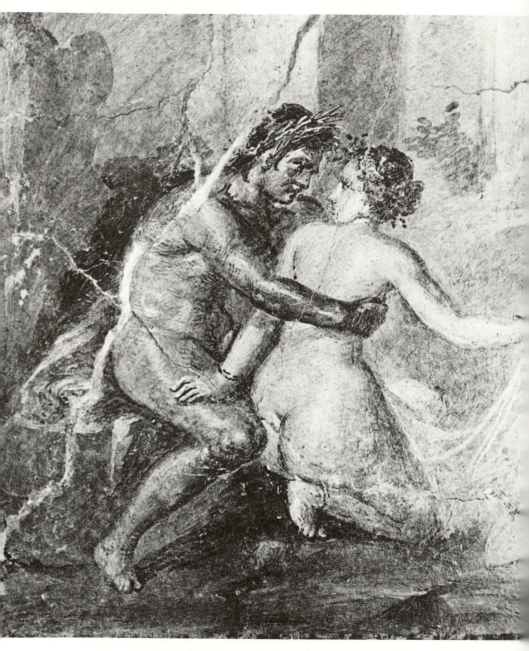

NYMPH AND SATYR, from a fresco at Pompeii, *c.* A.D. 70; 43·5 × 37 cm. *National Museum, Naples*

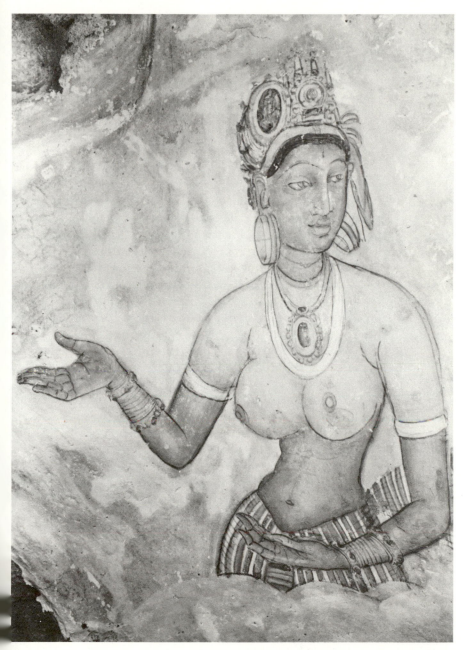

AN APSARAS, from Sihagiri; painting on plaster, half life-size. *UNESCO Publications Department*

ferring to recover certain earlier Italian virtues, as will be seen. Rubens, however, succeeded in forging a distinctly personal style out of that very method, inflecting his contours and shading into suggested ovoids whose implied surfaces meshed into a bonded notional surface with absolute consistency. He preserved most clearly the linear value of his contours assembled into outlines, building his compositions upon it. In this he differed from his chief Italian mentor, Titian.

Although Titian was an artist of an earlier generation than Veronese, in some ways he went much further than Veronese in his abandonment of contour. Veronese, however, developed one special function of the ovoid-contoured enclosure to a very high degree. He did not attempt to preserve the linear value of the continuous contour; but he gave to each ovoid segment of contour a multiple reference. That is to say, to each segment of contour with an ovoid inflexion not one but many other opposing segments can be found which will suggest complete ovoids: such ovoids belong to my third type of enclosure. The opposing related segments may be quite far away across the surface of the composition; and so the ovoids they suggest will be big volumes of plastic space. Thus the positive, full ovoids of the bodies are intimately wedded to their ambience. And at the same time Veronese was able to give to his clearly conceptualized enclosures a flat sense, both negative and positive, bonded by ovals of the third type. And so although his drawings do not usually combine all these graphic features together, his finished pictures present a dense conceptual structure in which the tension between the plastic and the flat is admirably stressed.

Titian ended by creating his ovoids entirely out of tone. His earlier drawings illustrate how carefully he developed the volumes of his figures as assemblages of outlined ovoids. The beautiful sketch usually called *Jupiter and Io* shows him assembling his volumes. The rough outlines of these ovoids, however, were meant to vanish into an over-all unity of tone (his *sfumato*), which by its inflexion suggested the mesh of volumes without ever stating them as enclosed and limited entities. This technique, of course, is conceived on the assumption that an overriding plastic unity will be provided by the white tonal drawing of the lit surfaces of the bodies, inflected to suggest both their oval elements and the transitions between them. It takes the eye away from its hypnotic attachment to edges, and focuses it on the centres of volumes, the surfaces nearest to it. It can then move over

these, from centre to centre, in a due hierarchy of order and emphasis which offers a true psychological scale of attention. For in perceiving anything real one does not look at its edges but at *it*, at its middle (whatever some schools of statistical psychology of perception may assume).

This last aspect is perhaps Titian's greatest contribution to the art of drawing—one in which few have been able to follow him. It gives a kind of hierarchy of plastic presence to the elements in his work. The basis is his network of conceptualized areas, into which shadow 'holes' are cut, whilst clearly formed negative areas defined in dark tone rule the placing of the lights. The plasticity of half-lit bodies is suppressed into the *sfumato* or over-all half-tone given by the toned ground (with only a glaze or two over it in painting); but the lights then emerge to form those continuous chains of lit surface whose altering inflexion suggests the plastic presence of bodies lying beneath them, not any line or single-valued linear sequence. Hence they appear 'calm', 'magnificent', 'opulent', and 'static' for all the dramatic quality of the illumination. The essence of his drawing is that his loose, dark strokes always make allowance for the presence of the continuous lit surface which indicates the central faces of bodies lying most present to the eye. Even when they are pen-strokes, and in his earlier drawings state necessary tonal contours, the dark strokes are always drawn with the idea in mind that the prominent lit surface is there first, already present on the paper before the tonal strokes were laid on. Where non-tonal preliminary strokes—siting strokes or defining contours—have actually been set down as dark they are easily discounted by an eye accustomed to reading his style.

iaroscuro in relation to both two- and three-dimensional structure

Drawn tone will always relate itself to the tone of the surface on which it is laid, once the eye has come to recognize the drawing substance as equivalent to tone. Dark tones on light (or white) paper can be treated in such a fashion that they define the areas of paper left light only as the lit parts of the visual field. But this is a relatively unsophisticated thing to do. In the drawings of Rembrandt, for example, there are many other more sophisticated drawing methods involved, all of which involve the use of the drawing substance as tone. For example, dark contour-strokes are used to 'lift' the tonality of a lit body set against a dark mass, to which the contour-strokes attach themselves; or a pair of strokes linked by rough hatching can indicate the shape of a shadow which moulds volume. But in fact Rembrandt's drawings are

167

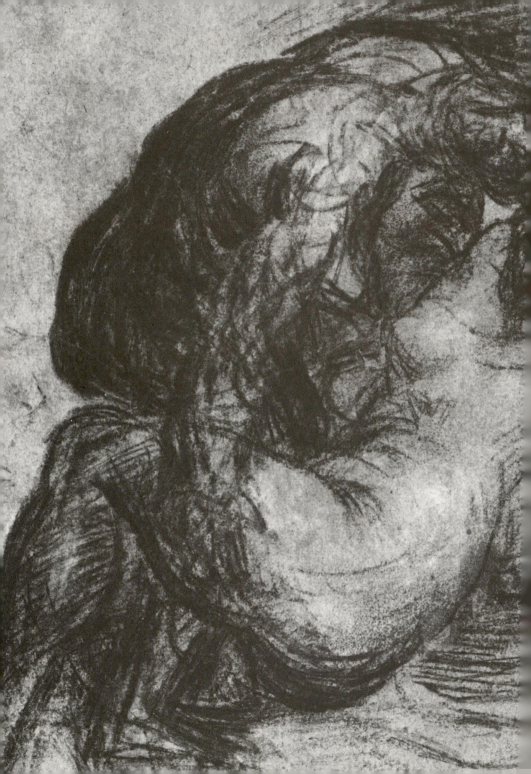

Titian (Tiziano Vecelli) (*c.* 1477–1576), A
MYTHOLOGICAL COUPLE IN EMBRACE
(?Jupiter and Io); black chalk on blue paper,
$9\frac{15}{16} \times 10\frac{1}{4}$ in. *Fitzwilliam Museum, Cambridge*

constructed in such a way that the function of finally defining the lights as bare paper is left to the half-toned wash which he sometimes applied. The half-tone wash acts as a surrogate for the toned ground of a painting, on which the lights would appear as a fresh invention. Thus, as I have mentioned, a painting by Rembrandt (and by others like, for example, Titian) can be thought of as at bottom two inter-related but tonally distinct drawings, one in dark, one in light, laid on a half-toned ground which, glazed, links the two.

On a light ground, however, some draughtsmen have set out to exclude and reduce with their tone all but the lights. The intention is to offer the eye a similar sort of over-all visual field to that of painting, denying to some extent the special 'spiritual' nature of drawing which I mentioned at the beginning of this book. Seurat and Constable (in some wash-drawings) are good examples. Seurat's use is the least sophisticated tonally (not in other ways). He drew mainly with a stipple and rubbing technique, treating shadow tone and local colour alike as drawn tone. He was interested in suppressing plasticity and emphasizing by means of tonal contrasts only the silhouette, which he tried to make as static and non-kinetic as possible. This he did by refusing to allow the lines of demarcation between tones any implied vectors. The relationships he allowed them were only those of measure and rhythm *across*, not *with*, the direction of the lines. Each segment of line is reduced to its most colourless 'mathematical' linear expression. Nevertheless this *is* expression *sui generis*. The tonal grada-tions are shaded into each other, without any ordered distinctions, thus creating a tonal continuity from one side of the format to the other, the light tone of the paper taking its proper place. No doubt in this procedure the similarity to the toned surface of the photograph was part of the image.

Constable's use of tone in his free, single-wash drawings, was similar only in this one respect of aiming to define the white of the paper as the light. However, he avoided clear, formalized edges, and did not blend together a tonal scale but drew freely with the brush areas of dark, almost black shadow (such as also formed the basis of his paintings; but in his oil landscapes opaque light colours added the lights to the picture). In his looser drawings the flecks of white un-touched paper shining through his darks suggested the flecks of light pigment he scattered through the shadows of his paintings to give them life. (Incidentally, this is not at all an Impressionist method.) But the principles of arrangement Constable's wash-drawings follow

John Constable (1776–1837), TREES AND WATER ON THE STOUR(?); brush and sepia wash, 8 × 6¼ in. *Victoria and Albert Museum. Crown Copyright*

are not very firm or interesting, but are casually related to an appearance, without many defining forms, glyph images, or sequences save a modest gamut of stroke direction and some group arrangement. In contrast Claude Lorrain, in his drawings with an over-all toned surface, created finely linked chains of well-defined tonal patches suggesting objects which run through his compositions, as well as considered stepped gradations of tone.

A most interesting tonal method related to Titian's *sfumato* is used to draw on a light ground by, for example, Claude, Hans von Marées, and even Grünewald (it is one of the characteristics that made his style unique in his time). This entails developing extensive areas of dark, actually a half-tone related to a dark painting-ground, which indicate the 'lost' or negative region of shadow out of which emerge the positive, lit and defined forms, and into which are laid the deepest darks. Such tone may indeed be stippled or rubbed out into a 'pool'. The limits of this pool of shadow are, however, not vague, but give vital help in defining the surfaces of the forms which emerge from it. In its historical context this method has striking ontological overtones, in contrast with the method of total plastic definition by tone. For in implying that the creation of a closed and comprehensive system of visual reality is neither possible nor desirable, and so suggesting that an appearance is not a thing in itself but a modification of that divinely symbolic substance, light, into the image of body, it actually undertakes to *draw* the region of the 'lost' as the pool of tone.

In a sense the technique of mezzotint engraving encouraged a base version of tonal drawing with light—base because the artists who employed it had not Titian's sense of full and varied underlying volumes. Their work lacked both linear precision and plastic vigour. But the art of the mezzotint exercised a considerable influence on the history of European art from the mid-seventeenth century on. Draughtsmen attempted to reproduce its soft effects, and distinguished painters were not immune to its charms. It is most probable that many other artists—among them Mortimer, Fuseli, and William Blake, who detested it—were counter-influenced by the popularity of the works of Joseph Smith, Earlom, MacArdell, and others into a vigorous re-affirmation of outline.

I have mentioned shadow 'holes' in the drawing of Titian. These are, of course, an extension of a tonal idea which had been germinally present in earlier drawing styles. But after Titian they came to play a more important role in art. Cézanne certainly was aware of the idea

172

Claude Gellée, called 'Le Lorrain' (1600–82), THE TIBER ABOVE ROME; brush and wash drawing, 188 × 270 mm. *British Museum*

173

of 'cutting holes' in the canvas of a painting (and no doubt in drawing) as an aspect of his 'shadow-path' technique. For in his drawings his shadows seem to have been developed from nuclei of dark spaced out 120 over the surface. And the story of how he acclaimed with ironic obscenity his young son's achievement in 'cutting holes' in the canvas with a palette-knife is far too exact technically to be just *ben trovato*. Many artists of the Baroque and Rococo were aware of this method. Outstanding among them was Bernini, some of whose sculptural drawings use an extraordinary technique of shadow-path and 'hole' drawing that reminds one very forcibly of what Cézanne did over three centuries later.

Tone and the sculptural science of surface

Chiaroscuro is, of course, based on the assumption that light falling from a single (or multiple) source upon plastically projecting bodies can be represented by shaped flat areas of dark tone which show where the light does not fall. Artists such as Titian, Rembrandt, and Watteau were not concerned with defining bodies precisely as if they were entities that had already been given sculptural form. That is to say their methods were pictorial methods related to the format, and the meaning of their forms did not include conceiving their bodies as if they were classical sculptures before they were painted images. Of course Titian especially, but the others as well, were perfectly familiar with a great deal of classical art of one type or another. Titian's pictures include both representations of relief sculpture and references to classical prototypes in the conception of his own figures. But there is one most important sculptural technique which was not included in his drawing style or that of the other 'pictorial' artists, although it was of the utmost importance in many other great drawing styles, especially that of the Florentine and Roman *Cinquecento* and of Poussin. (Later French classicizers like David and Ingres never under- 17 stood it.) It is not possible to explain the use of shading and chiaro- 18 scuro in this last group of drawing styles without reference to it. And it helps to justify the claims of the Florentine party in the Mannerist squabbles between Florentine 'draughtsmen' and Venetian 'colourists' that the Florentine kind of painting included all the virtues of sculpture. Though I must point out that as a *sculptural* technique it has been known and used in Archaic Greece, India, Cambodia (superbly), China, Korea, Japan, Africa, and Central America. Perhaps it was in Greece and pre-Khmer Cambodia that it was most highly developed and centred on the nude or semi-nude human figure. The *Cinque-*

a

b

Fig. 23

Fig. 24

cento artists and Poussin adopted the technique through their intimate study of classical sculptures.

For want of a better name I may call the method the science of the continuous side-surface. For the purpose of explaining it, it can be broken down into aspects. One can say that in order to look deeply round in section a body must first be square. For every body is interpreted as a stereometric volume, with a section intelligible as facets. AB represents the front plane of the body's volume, DC is its back, *Fig. 23a* CB and AD are its side-surfaces. DC is always longer than AB, and BC and AD are always rendered so that the whole depth of the side-surface is visible from the main viewpoint. On the surface C and D represent the location of the visible contours, A and B shed-lines. In the case of forms of triangular section, P represents the frontal edge, *Fig. 23b* Q and R the visible contours. Such triangular sections also appear when bodies of a quadratic section are seen at an angle. Seen in elevation the sections offer continuous modulated surfaces. Over this stereometric 'skeleton' is laid the 'clothing' of rounded volumes, *Fig. 24* given by the treatment of the subject. It will easily be seen that the various volumes enclosed by the stereometric faces can be interpreted 178 as a series of boxes. But the essential sculptural fact is that the surfaces are in fact continuous. For just as mathematically a line is the locus of a moving point, so a surface is the three-dimensional locus of a line. And if that line is a changing one, the volumes it can generate will depend for their intelligibility on the notional unit-volumes they offer within the continuous undulating skin of the sculptural surface. And because of the continuity of the surfaces the internal volumes of the sculpture will form a continuum of enclosed space.

Some drawings of Luca Cambiaso, popular nowadays because they can conveniently be claimed as Cubist, show an abortive understanding of this method. They are abortive because the side-surfaces of his figures are not properly united, nor are their facets adequately shadowed or lit; but the bodies are broken up into a series of separate boxes. As studies these may have been useful; that is all the artist *Fig. 25* meant them to be. But as art they do not achieve any great level of interest. Yet there is more to it than that. Masters like Michelangelo (a sculptor as well as painter) and Poussin (a learned student of classical sculpture) show in their drawings that they understood and manipulated their forms in terms of such stereometrically conceived facets, but with continuous side-surfaces (and top-surfaces as well).

It is possible to clothe the stereometric skeleton with rounded sur-

Fig. 25

Fig. 26

faces in many ways. In much highly disciplined sculpture the shed-lines between the front face and the receding surfaces are simply inflected towards each other and 'shed ridges' appear running up each side of the front face of the figure. Good examples are Archaic Greek monumental figures, and the pre-Khmer icons of Cambodia. Archaic black-figure vase paintings derive much of their quality from our 152 reading the linked black enclosures as in fact continuous volumes, and the superimposed curved lines as indications of undulant surface. The drawing styles influenced by later Hellenistic art with which we have to deal, however, allowed themselves more complex rounded surfaces based on ovoid enclosures, and a more diffracted stereometric pattern based on twisted postures with *contrapposto* in the figures so that different sections of the same body could offer a section scheme of this type. But the unity of the side-surfaces A, B, and C, though twisted, would be preserved. *Fig.*

Over the notional basis of such a sculptural conception and its given forms a very large number of Europe's greatest drawings have been made by means of one kind of chiaroscuro or another, on the assumption that a drawing can be composed as a lit group of sculpturally-conceived notional figures. The light gave an over-all unity to otherwise disparate elements. This assumption justified very many artists in using small stereotyped models of wax to help them in working out their compositions, placing them in a kind of theatre proscenium and illuminating them artificially from a single source. We have full descriptions of how Tintoretto and Poussin employed this method. And it is not likely that other and lesser masters failed to use the same well-known device. For in this way they were able to study the clustering and casting of clear-edged shadows which would not suffer from the confused reflections and refractions that appear in nature. And, of course, in this way the artist's imagination could find support and authentification for fantastic groupings, with flying and floating figures, such as he could never actually have seen.

It has been pointed out too that many Renaissance compositions were in fact strongly influenced by contemporary theatrical presentation ever since the days of Bramante, Serlio and Peruzzi, and Raphael, whose later designs for the *Stanze* in the Vatican were influenced by painted back-drops. And it may well be that the development of thorough-lit complex chiaroscuro compositions owes some debt to the dramatic extravaganzas of Mannerist Counter-Reformation 20 theatrical techniques. Certainly the language of gesture in art and in

the theatre exerted a powerful mutual influence. But since strong, un-diffused lighting from a single source only became possible in the theatre in the late eighteenth century, it is likely that the art of painting was regarded as improving on the purely visual resource of the theatre by being able to create a unity of illumination bonding together notional bodies of classical sculptural density.

The single source of illumination cast over bodies in complex postures with well-developed sculptural stereometry would give rise to shadows of great variety, but very well defined flat shapes. And such shadows could be used, as they were with supreme mastery by Poussin, to bond bodies and their contours into a vivid two-dimen-sional unity with their settings. Fundamentally these methods of shadow-bonding fall under the combined headings of linear con-tinuities and enclosure-forms—the expressive and structural en-closures being both dark and light. The figure-studies for Poussin's *Rape of the Sabines* at Windsor show admirably how conceptualized 178 shadow-forms run across, undivided, from body to body; how their edges pick up continuities and echoes from the contours. In other drawings of his shadow strips and patches are related to each other in groups of many patterns. And since all these shadows are intrinsically functions of unified light falling on stereometrically defined plastic forms, they will be immediately intelligible to the visual intuition. Here we must recall the point made earlier about the importance of a tonal scale in drawing. For in the shadows it is no less important to introduce an element of order, and hence the basis for variety, than in any other graphic element. Certainly, notable artists have left their scales vague. But their work has suffered from it.

Chains of bodies in Here we reach the point which represents the unique technical
'space' achievement of European art, the method of linked bodies in space. And only the greatest masters attained it fully. That they did so is a measure of their greatness. It would be very easy to fall into the trap of allowing catchwords about 'materialism' or 'literary content' to obscure its real significance. Because by a kind of inversion of logic this method of art, for all that it deals unequivocally with bodies, is the most transcendent or symphonic. It is easy to see or to grasp only when the perceptual faculties have been alerted to its presence. During the nineteenth century it was lost almost completely, and even so important an artist as Courbet never grasped it, though it would logically have consummated his own volumetric way of drawing. It

Nicolas Poussin (1594–
1665), Drawing for THE
RAPE OF THE SABINES;
pen and wash over black
chalk, 110 × 80 mm.
*Windsor Castle, Royal
Library. By permission of
Her Majesty Queen
Elizabeth II*

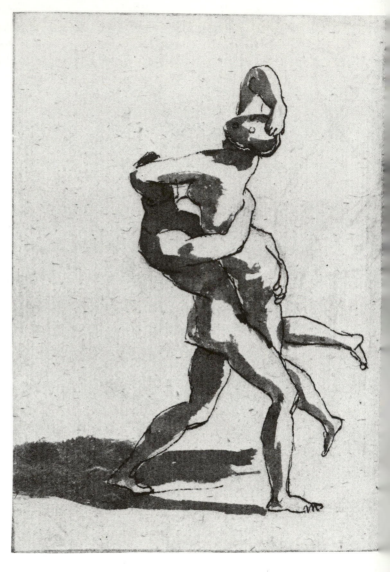

was intuitively recognized by Delacroix, but many considerab[l]
artists lived out their lives without ever laying hold of it. And the[i]
works therefore have a fragmented, 'bitty' look to an eye accustome[d]
to the method. I personally have the feeling that much of that disgu[st]
with the representational which launched artists of the twentie[th]

17

century into their retreat from likeness, their repudiation of analogy-correspondence between the pictorial image and the visible world, was partly due to the fact that this 'symphonic' method had been lost before artistic tradition had seized upon it as a thoroughly developed concept.

In a sense this method goes beyond the graphic symbols and elements which I have discussed up to now. But that is not to say that they are forgotten. Indeed they are so completely embedded in the tissue of the method that they never obtrude their presence or take precedence. And they are essential to it, though the method makes them virtually invisible. Indeed if they were absent, that sense of tension between the claims of surface and of plasticity which is so important an element in figurative art would be absent. But one has only to step, as it were, into the world of this method and flat art seems very flat.

In its origins it was classical. Certain Romano-Hellenistic stuccos and paintings—again not all, but only the best—first embody it. It appears uniting the forms of medieval sculptural compositions, and sometimes makes the best sense out of the designs of the medieval masters of woodcut and drawing. But its supreme exponents were some of the greatest of the Renaissance and Baroque masters, Titian, Tintoretto, Rembrandt, Rubens, Poussin—and the eighteenth- 278 century Watteau. Two further great masters, who are usually quite 182 astonishingly neglected, belong in this company, Jacopo della Quercia and Paolo Veronese. Perhaps surprisingly the relatively humble art of the sixteenth-century woodcut book-illustrators in Venice captures the technique too.

The method is this: the visual field is so organized that all the positive bodies in it compose closely linked and interlinked sequences, with an inherent direction, over a basis of negative conceptualized areas in which the open space is treated virtually as 'substanceless body'. By 'bodies' I mean not only physical human bodies but all plastic entities, including human members, folds of flesh and fabric, bunches of foliage, rocks, clouds, and architecture. The links in these chains of bodies may be obvious continuities of body like hands hold- 180 ing folds, successions of arms, clusters, and groups of forms. They may be purely notional and 'abstract' links, such as the vector of a pointing finger or a glance bridging a wide interval, or through a pattern of feet. The chains may run through *like* bodies, for example, among the arms or feet of a group of figures, or through unlike, as

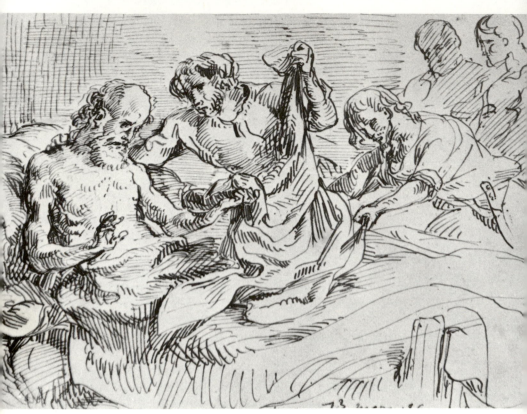

Eugène Delacroix,
JACOB'S SONS SHOW
HIM JOSEPH'S BLOODY
GARMENT (1860); pen,
140 × 210 mm. *Louvre,
Fonds Moreau-Nelaton*

through rock, man, and tree to goat. They may bond the forms of a landscape. A tenuous link such as a glance may be charged with almost the whole weight of a divided but weighty composition. The linear axes of volumetric forms thus play as vital a role as any of the other graphic elements. Most important of all, these sequences of bodies can have a vivid three-dimensional sense, creating links in and out of the notional depth of the composition; and magnificent undulating lines can be woven into the surfaces which are their functions.

Into the sequences that this method offers can be incorporated an immense richness and variety of rhythm and meaning. They will convey a vast number of analogical forms and metaphors from every region of reality, not merely as abstract categories but as emotive, concrete images. The sequences are actually present and intended; for they can never be read arbitrarily as different at each reading. Certainly our unskilled twentieth-century eyes may find them difficult to decipher and a painting by, say, Poussin, which is filled with

them, may offer us again and again new sequences we had not previously noticed. But once deciphered they are always manifestly present.

In fact one of the problems for artists in this mode was to know how to reduce such 'voices' to a manageable number. Titian and Rembrandt did it by veiling much of their picture field in tonal *sfumato* and 'painting up' only those volumes which compose the body-sequences in light tones with white, usually on a dark or bolus ground. In pure drawing without much *sfumato* this procedure is paralleled by a rigorous concentration on forms central to the sequence—as, for example in Rembrandt, around the faces, hands, occasional primary patches of garment—whilst the ambience is reduced to roughly indicative strokes which in a picture would be lost in areas of the lower tone.

Artists who do not use a technique of suppression by tone must solve this problem in other ways. For example the master of the stuccos of the Basilica Sotteranea at the Porta Maggiore in Rome, who was bound to the classical tradition of clear, objective statement, reduced the number of elements in his design by drastic, deliberate action. Even the feathers in the wing of the divine eagle are cut to the countable minimum that can compose a group. Jacopo della Quercia did it in the way habitual during his century. by filling the available framed space with bodies—all, as it were, 'foregrounded'. It might be mentioned in passing that Ghiberti, victor over Jacopo in the contest for the Baptistery doors at Florence, despite the esteem in which he was held by his contemporaries, never achieved the magnificent bodily sequences of Jacopo. His style, for all its fashionable perspective, remained one of assembling groups of swooping linear curves and undulating surfaces, with certain major links but nevertheless full of fresh starts—a kind of perpetual *cadenza* without Jacopo's over-all symphonic one-ness. This, in fact, is the principal point about this method—that nothing appears in a design which does not actually belong to one or other of the sequences. This was Poussin's particular difficulty, and the measure of his achievement. He was an heir to the Renaissance with its tradition of full compositions, and had a strong bent towards the classical. He therefore was unable to commit himself to techniques of suppression by tone like the old Titian's. He experimented for a while with a technique of rough 'smear-drawing' derived from Elsheimer's drawing style—a technique Rembrandt adopted completely—which involved tonal reduction; but he soon abandoned it. He could never allow himself to

Nicolas Poussin (1594–1665), Study for THE RAPE OF THE SABINES; pen, brush and bistre wash, 164 × 225 mm. *Devonshire Collection,*

suppress parts of what he considered visual 'truth'. And so he was committed to combining the multitudes of plastic bodily forms in his works into a far larger number, a more complex counterpoint of sequences, than any previous artist had coped with. He succeeded. His drawings chart the development. In certain of the sheets of drawings by Paolo Veronese where he is experimenting with a 'first thought', one can see him gradually building up ever more closely co-ordinated bodily sequences of the same kind.

One special and unique version of this method is found in the work of a few Chinese draughtsmen. Most Chinese art emphatically does *not* use it, but a few distinguished artists made it one of their resources. Most of these, like Huang Kung Wang, employed it spar- 184 ingly, but Wang Meng of the Yüan dynasty used it with abandon. It is called showing the 'dragon veins' and is related to the Chinese geomantic conception of 'Fengshui'. Accumulations of rocks are contour-drawn in such a fashion that there seem to be unbroken, sinuous, internal veins running through them and linking them together as if they were beads on strings. These 'dragon veins' may run very steeply back into the distance; and in Wang Meng's own work, especially his long hanging scrolls, the large number of rocks threaded on a single dragon vein running back up towards a high horizon-line may suggest an immense depth—which may then be negated, expressly, by a waterfall which drops straight from the summit into the foreground. In such cases the forms are not developed around directional axes and the possibilities of variety are not, perhaps, so great as in comparable European examples of the method. 'Dragon veins' obviously belong partly to the category of invisible connective lines. It must be remembered that in Chinese art the bodies linked by them are never closed, isolated units, but really elements in a single continuity of body.

Graphic groups as *ms; their types and* *characteristics* An important class of unifying elements used by draughtsmen is the group. Its importance is often overlooked, and some textbooks offer a very primitive interpretation of its varied uses. The essential point about all groups is that although the members are related by the group-entity, which is not itself a specific shape, once the group has been recognized the eye straightaway imposes its own categories of line and enclosure-shape upon the members. Thus once a group of, say, three blobs has been recognized, they will be seen to form the apices of a triangle; five blobs may lie on an undulant line; serial

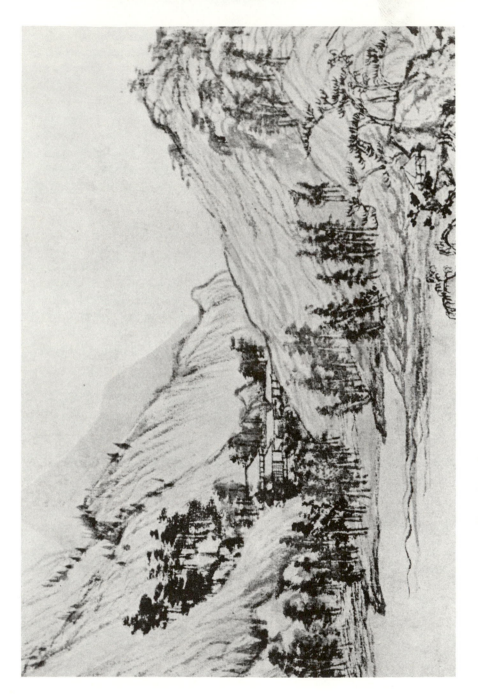

Huang Kung Wang (1269–1354), DWELLING IN THE FU CH'UN MOUNTAINS, section of a handscroll dated 1350; ink on paper, H. 13 in. *National Palace*

groups of objects may play a vital part in establishing linear depth in the notional reality; and so on. The recognition of groups is an essential prerequisite for many of the formal concepts of drawing. And so it will be seen how groups can, within limits, be the basis for 'forms' which are actually incorporeal lines or enclosures. Shape alone is not enough to establish a group entity without some other group-factors. This consideration will, I hope, dispose both of the theory which is still found in art-course manuals that groups are the product of patterns alone, and of that other theory beloved by art-historians that rigid diagrams of diagonals and triangles can 'explain' the compositions of masterpieces.

Generally speaking groups of three to five members are the most easily grasped. Groups of more than seven tend either to become 'lost', or to be seen as mere texture. This fact is recognized explicitly in the theory of Chinese painting, where five is usually given as the maximum for a recognizable group. On this aspect experimental research, if it were properly conceived, might bring useful results. Groups will, of course, virtually always overlap each other, and so set up quite a complex counterpoint of associations between their various members.

Groups can be analysed under the following headings, the simpler first; all group members may or may not fall under one or more of the other group-headings as well.

1. A number of similar notional objects may be seen as a group. For example, a group of hands, feet, or heads may emerge from a welter of notional objects and support a shape-concept.

2. Objects similar in size or scale may form a group. For example, human figures of a similar apparent size will be grouped and will indicate, say, a given region of distance in notional space, as for example, a 'foreground'.

3. Things similar in shape may form a group. The things in question may be notional objects which are normally similar in shape anyway; so that this grouping may often reinforce group type 1. But the similarity in shape may, more subtly, work amongst purely graphic elements, such as linear or enclosure forms.

4. Things similar in tonality form groups. Obviously the points of highest light or of deepest dark in a drawing may form one or more groups according to how they are placed on the surface. Where there are too many dispersed patches of a tone—for example, a mid-tone—they are not easy to assemble or recognize as grouped. It is not acci-

dental that many of the most conscious craftsmen in tone amongst draughtsmen, such as Rembrandt, have cut down the number of deep darks in their drawings into small manageable groups. In their paintings they have done the same with the chief highlights.

5. Things of similar colour form groups.

6. Things of similar plastic projection form groups. This is most common in sculpture, especially relief. But in drawing which is based on sculptural conceptions one can find reflections of it.

7. Things of similar texture form groups (texture is discussed on pp. 187ff.).

8. Groups containing the same number of things form groups. For example, a cluster of three heads, one of three hands, another of three feet, may form one group.

9. Things, even disparate things, which are physically close to one another, and either separated from other things or surrounded by an enclosure of some kind, will form a group. There are innumerable variants of this type of group.

10. Things disposed as a sequence at recognized intervals in space will form a group, as for example, the rungs of a ladder or, more subtly, the rhythmic elements of a design. This type of grouping will be discussed as well in the section on rhythm and space.

11. Occasionally the prominent suggestion of a linear pattern such as a triangle or a curve can suggest a group amongst elements which have no other common group-factor.

The following group-types are all amplifications of Nos. 4 to 10, substituting serial progression for affinity. Some are, admittedly, both abstract and rarely recognized.

12. serial progression of size: as, for example, amongst elements in a perspective design

13. serial progression of tonality

14. serial progression of colour, either along a scale of modification of one colour into another or along a spectrum-band scale

15. serial progression of plastic projection (cf. No. 6)

16. serial progression of the number of members composing the clusters that make up the group, for example, 1.2.3 or 2.4.8.

The last two are of extreme importance, but their main features have already been discussed in connection with the gamut. Things (17) parallel to each other or (18) in serial progression of direction will form groups.

Texture and touch Texture plays a different role in different styles. As I have mentioned, the texture of the ground is important because it promotes qualities in the strokes applied to it. But in general texture has not been considered as material for investigation until quite recently. Draughtsmen have remained content with a single acceptable texture in which their whole drawing has been carried out. And the weight of graphic invention has been laid on the invented forms. The essence of texture, however, is that its marks are the result either of chance, or of a special independent process by the artist not intrinsically related to form or subject *in detail* to the artist's control. He may work with a particular type of texture; he may indeed use the general direction of its strokes; he may be responsible for the general pattern of marks as it emerges, because he executed the strokes that made it. But those strokes are not related as individuals to the whole structure. All too often critics confuse invented forms with textures. The draughtsman does not *draw* texture, he *produces* it. Its actual marks are not part of the structure of his design, just as the rustications chiselled on the surface of stones used in Renaissance architecture are only significant in the mass, not individually.

In recent years artists of all kinds have become interested in textures, very much as musicians have become interested in sonorities. And many draughtsmen have developed methods of producing novel and interesting textures. They have used versions of monotype printing from various natural objects like leaves, burlap, typewriter ribbons; they have crumpled paper, mixed on to the surface all kinds of already existent materials including newsprint, broken glass, old leather, shells, and sand. Surfaces have been filled with repeated shapes. Draughtsmen have run, streaked, and combed areas of tone, and mingled techniques to produce a surface previously unfamiliar. This is all part of the twentieth-century pursuit of the new for its own sake. What matters artistically is what is done with the textures, not that they merely exist.

There is no doubt that various textures can evoke associations and echoes of past experience; and these experience-traces may have a valuable contribution to make to an artistic structure. But as with any of the other elements of drawing (or of any other art), it is not enough simply to stimulate the traces. They must be integrated into a conscious image if they are to make any permanently valuable contribution to the spectator's personal life.

Texture is the characteristic of an area, and emphasizes the physical

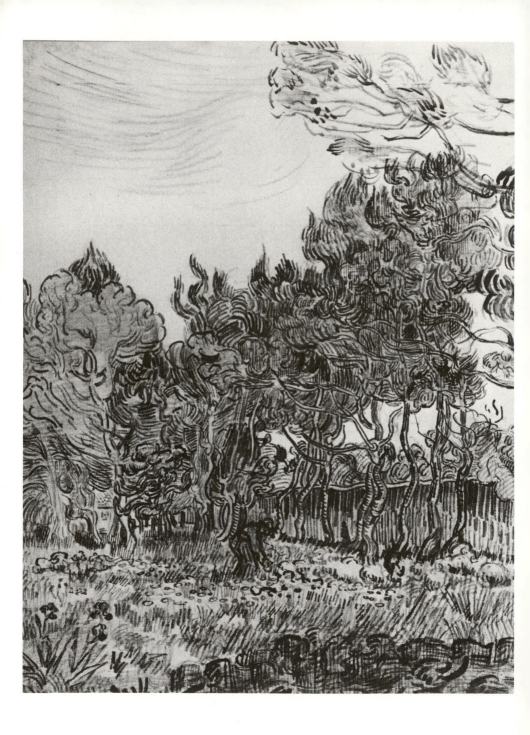

presence of the drawn surface. In fact one of its chief uses in much modern art is to prevent the spectator looking 'through' the surface of the ground into a notional space. This means that modern texture drawings which are at all figurative must work primarily with flat glyphs. Texture is always grasped by being understood as a segment of surface imbued with an emotive quality, very much as colour is. In general smooth textures have a 'cold' quality, implying remoteness and, perhaps unexpectedly, repelling the sense of touch. Rougher textures feel 'warmer', inviting the hand; but much broken texture may be disconcerting. Others may be 'slimy', 'mechanically assertive', etc. And just as any flat area with its qualities can be used in a drawn construct, so too can areas of texture. Rhythmic sequences may be made with them, groups, enclosures of expressive contour, even lines of sufficient thickness. Finally, one must remember that even a conventional texture is a visual attribute of a drawing with a meaning of its own, namely that the texture is insignificant.

There are, however, two representational drawing techniques which have been used often in the past and are closely akin to texture, though they do not create the same emphasis on the plane surface as true texture does. The first is this. An area which is part of a notional reality, let us say a landscape, is treated with repeated small drawings of its salient feature, other features being suppressed. For example, a field of flowers may be indicated by a shaped area scattered with small symbols for the flowers (for example, van Gogh's *Garden at Saint-* 188 *Rémy*) or the area of a tree with symbols for leaves (Chinese drawing). 184 Secondly, it is also true that varied textures may make individual areas appear to advance or recede. This phenomenon usually has to do with the scale of the texturing in relation to the format, the broader, more varied, and denser textures appearing to advance before finer, less varied, and more open ones.

Woodblock printing may produce textures which add to the effect of the whole design (Munch, Japanese Kyoto prints). And the various techniques of ink-painting practised in the Far East have an element of textural significance. The Japanese, for example, sometimes sprinkled drops of plain water into an area of wet ink, giving spots of light. But an important use of textures in older art has been to suggest richness and value by means of burnished surfaces of precious metal, or by a fine paper surface which has been polished to a jewel-like finish. Many of the practices mentioned in the section on paper supports come into this category.

All textile design deals in textures. The substance of the dyed and woven fabric emphasizes the physical presence of the surface with its comforting softness and warmth. Thus many textile traditions use designs which are fundamentally two-dimensional (Peruvian, Persian), and one must never forget that no textile was ever meant to be seen stretched out flat, but always contains a three-dimensional ripple. However, there have been textile traditions which have compromised with three-dimensional imagery. European medieval tapestries allowed their three-dimensional designs to retain a strong flavour of the two-dimensional, by stressing the flat lines and enclosures of the design. But Flemish textile art of the sixteenth century began with a set purpose, to imitate the three-dimensional qualities of bodies and convert chiaroscuro drawing into bands of different coloured and toned stitching with some two-dimensional value. The process was carried to its high point in eighteenth-century France, both in wall tapestry and in elaborate flowered silk textiles woven on the Jacquard loom. In the case of the Flemish tapestries there may be a severe conflict between the intrusive texture of the surface and the strong rotundity of the modelled forms, which latter may have too little connection among themselves, so that the surface may seem to lack its pictorial two-dimensional co-ordination by line and enclosure. In the eighteenth century, however, the linear efflorescence of *rocaille* ornament restored a vivid two-dimensional value to designs even by artists like Boucher whose sense of plasticity was considerable.

It is arguable whether certain kinds of tonal hatching used in drawing should be regarded as texture. In fact the regular, slanting hatching used, for example, by Botticelli and Leonardo to model their lit plastic forms, and much later by Cézanne, actually had the function of helping to emphasize the two-dimensional integrity of the drawing surface in the face of strong three-dimensional plastic suggestions. Thus a careful pictorial balance was preserved. But in the sphere of printing textures acquired a very considerable importance by the eighteenth century. Connoisseurs of the print always seek rich, velvety blacks; and the various impressions of Rembrandt's great *Crucifixion* etching, for example, are valued for the special textures of their darks, which are created by multiple hatchings, repeated acid biting, drypoint burr, and varied inking of the plate. Here the textured darks work by negating the white surface and suggesting the grades and qualities of the abyss into which supernatural light is shed. This certainly is a graphic art of texture.

There is, of course, the question of notional texture—the texture attributed to real objects and materials which the draughtsman is able to suggest by the inflexion of his strokes and his tones. Rubens's silks 278-9 and Rembrandt's heavy fabrics are famous. At bottom this is a matter of formal representation, not of the 'sonorities' of the actual physical technique. And it is a grave solecism to pay attention to the pure surface texture, in my first sense, in the drawings of artists like Titian and Cézanne, to whom it was of no interest at all. However, there have been certain draughtsmen who often deliberately combined both kinds of texture in their drawings. The chief examples are among the artists of eighteenth-century France, notably Watteau, Boucher, and Lancret. Whilst the greatest of them were fully capable 192 of using their drawn lines to present contours, forms, and various kinds of shading with great skill and economy, they also developed the elements of their drawing methods so as sensuously to adorn the surface of the paper with textures. All the variations of touch, such as hatching in various directions, clusters of dots, bracelets, rubbed red chalk, groups of scribble, are used formally in their 'right' places, but at the same time multiplied and proliferated so as to appeal to the eye as an attractive surface. This is often at some cost to formal qualities. But from it springs the sensation of luxury these drawings produce. Renoir, who much admired the French eighteenth century, cultivated the same practice to a certain extent. Eighteenth-century drawing texture is certainly in the nature of a caress, sweet and gentle, and this is what appealed to Renoir—for it implies a positive attitude of acceptance and adoration towards the 'subject'. But, of course, such texturing can, at the opposite extreme, be violent and brutal in character, with those stabs and scratches so popular in American and Cosmopolitan art of the nineteeñ-forties and fifties. In this case it implies something like the opposite—an attitude of sadistic violence towards the 'subject'.

It is now apparent that from behind the issue of pure texture there emerges another intangible quality which contributes powerfully to the expression of any drawing. This is the quality of the touch in which it is executed. And, oddly enough, it seems to be best translated into words which have a kind of moral value—in the broadest and most liberal sense. It connects itself very closely with the 'mode' of a drawing. I have mentioned the implications of the touch of Watteau and Boucher, where it is applied to surface as well as to the subject. And Renoir is reported to have told an inquiring visitor that it gave

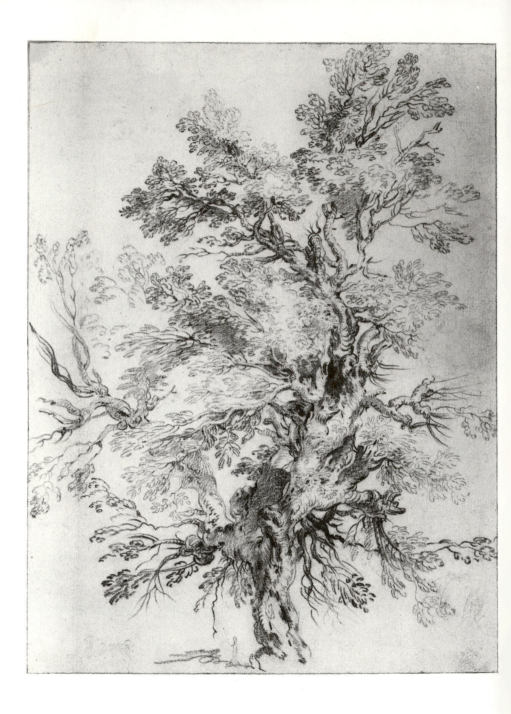

him great pleasure to caress the behinds of his painted girls with his brush. But there can be no mistaking the extreme tactile affection with which the touch of the old Michelangelo sets down and develops the 54 forms of his *Deposition* figures. Softness and gentleness are by no 267 means synonymous with weakness—they may be quite the reverse. Likewise with Titian and Rubens, one feels that the forms are so strongly conceived that the artist can afford to stroke them in with an undogmatic and freely roaming touch, which is yet totally accurate in terms of form. And here lies the point. *This* kind of touch is not the same thing at all as texture. It is a quality of the kinetic expression of the lines which the hand lays down in defining its forms.

One can read the varied qualities of this kind of touch in the work of all sorts of different artists; and because there are no objective criteria one's judgements are bound to be subjective—but they may be valid none the less. One may find intellectual vigour and *brio* in Dürer; in Poussin complete dedication to the 'other' in the object and absence of the artist's self-assertion; in Mantegna sternness and intellectual rigour; in the old Corot an extraordinary gentleness, behind which lies the Cézanne-like discipline of his years of early drawing; in Annibale Caracci a schooled and pleasing manner; and so on. One may call these responses mere feelings. Feelings they certainly are—and they may be very difficult or impossible to put into words—but 'mere' they are not: they can be of the essence. For in combination with his form—which will, of course, be clear and vivid in the work of a master—touch of this kind defines feeling *vis-à-vis* the idea of the drawing in an elusive but significant fashion. Above all, I repeat, this kind of touch must always be clearly distinguished from mere surface texture.

Rhythm and metre The aspect of drawing which comes up for discussion now is that which gives ultimate relationship and meaning to all those various elements of drawn form that have so far been mentioned. This is rhythm. It is unequivocally present in all good drawing and is itself a category of form. It is based on intervals of one sort or another, and the whole sense of pictorial space, both two- and three-dimensional, depends upon it. It is all too easy to talk of rhythm in the abstract as if it were either a kind of generalized swirl, or a pure measured pattern. But rhythm is a far more complex phenomenon; and though one can discuss it theoretically in terms of geometry and measurement in retrospective analysis, visual artists have always created their rhythms with the same kind of expressive freedom as all their other forms. Here, too, variety and life go hand in hand; and either rigid system or wide-ranging extemporization can be incorporated into the meaning of a particular art by its manner of developing rhythms. The expression of any drawing as a whole, and its quality of life, depend ultimately upon the sequences of varied but related rhythmic intervals amongst its other formal elements—lines, enclosures, etc. Such sequences are drawn from the human fund of kinetic images; the mere repetition of predetermined measurements that have no human reference can never convey an artistic impression. A routine or unplanned element of measure alone, for example in architecture, is not enough. The measure must have a meaning. It must symbolize something in relation to the building in which it appears. Yet, in spite of its apparent intangibility, as Raymond Bayer has suggested, rhythm does represent a factor in art both subjectively moving and—once its points of reference are recognized—externally measurable.

Rhythm has a double aspect. First is the element of unit measure, the equivalent to the musical time signature, by means of which the work is unified and made intelligible. Second come the particular shaped rhythmic inventions of the given work, riding over and through its units of measure. These aspects can be related figuratively with pulse and metre, or beat and phrase, but one should not, perhaps push the musical analogy too far. The two will have some natural relationship; but there is such a very large number of actual relationships possible that perhaps I may give one example of what I mean. The leading metric form may be, e.g. as in Fig. 27; AD will be the

Fig. 27

main unit of measure, whilst similar metric shapes may be evolved in which e.g. the actual unit AD becomes the shortest of the three measures. The unit is generally given openly in one of the principal, focal features of the drawing; as, say, in a Rembrandt by the length of the face from hat-brim to chin. In a Chinese drawing one of the nuclear stroke-groups may offer as unit of measure the square within which they sit—for the Chinese learn their calligraphy within a grid of squares. In Indian art the recorded theory recognizes over-all measure as based on the distance from hair-line to chin in a human type. In primitive art the basic unit of measure is usually very clearly exposed, and hence the rhythmic structure is most apparent.

The first thing to determine in any drawing is: Which elements carry the rhythm? It can work both along lines and across them. Undulant contours, segments of outlines, shadow-patches, the lit humps of oval volumes, white strokes of light on dark, may all carry rhythm in various ways incorporating both unity and variety. Any of the graphic elements so far discussed when arranged in sequence may have rhythmic significance—indeed the relationships between the elements making up practically all the graphic forms which have been discussed in this last section depend upon rhythm, among them the linked linear chains, the parallel segments, the echoing curves, the fluent lines, the group elements. And if those elements are not controlled by an imagination capable of creating expressive rhythmic figures or patterns, the design will collapse. In fact Cézanne's much-canvassed 'structure' is a matter primarily of transverse rhythmic intervals linked in interwoven sequences via the gamut. In music the tone intervals have in a sense a rhythmic form in two dimensions; so in visual art have colours and tonal gradations. And in any good drawing nothing which does not have a place within some aspect of the rhythmic system goes in for any other reason at all—resemblance, diagram, 'completeness', etc. Here the artistic 'tenor' is of great importance. For it is the tenor which provides the distribution and variety of punctuating points around which the rhythms condense themselves, and which suggests the graphic vehicles for rhythm and intervals. Many of them, of course, will correspond to the notional realities in the drawing; as for example the folds of a skirt or cloak or the widths of standing draped figures and the intervals between them or a combination of these. Face lengths and hats will serve in Dutch drawings, or trees, leaf-bunches, and folds in the ground. But of course all these things I have named as objects are indicated in

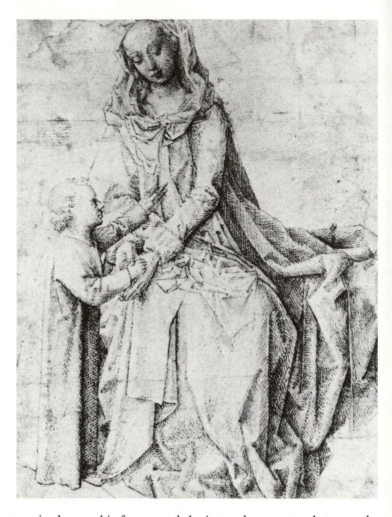

Hugo van der Goes
(1439–82), VIRGIN AND
CHILD; pen and ink on
paper, 209 × 155 mm.

practice by graphic forms; and the intervals are set up between the
graphic forms, and are not found as in some way 'actually present' in
the objects; though an artist working before a motif may claim to
'see' them.

Along the length of any line or linear sequence there will be rhyth-
mic punctuations. At their simplest these may be spaced undulations.
Klee even recommended that long lines should be drawn by means of
a series of little jerks of the hand, continual fresh starts as it were, no
doubt to give the line a rhythmic life it might not otherwise have. But
in fact all drawings of quality have shown an inner rhythm in their

lines. The long-breathed Far Eastern lines show it by means of variations of pressure on the brush and spread in the hairs as well as by changes of direction and sophisticated undulations. Western draughtsmanship has shown it in the phrasing, breaking, and chaining of undulant contour lines—smooth as in Italianate *disegno*, more turbulent in Rubens; broken as in much Netherlandish drawing; deeply inflected and growing one from behind the other as in German fifteenth to sixteenth-century drawing.

Lines which are discrete in nature, such as those which indicate chains of contained ovoids by a series of loose curves, will also offer rhythmically spaced sequences. Linear rhythms belong, of course, most especially to linear arts like the Far Eastern; and there they are most lavishly developed, largely because the sensitive Far Eastern brush makes rhythmic phrasing of a single line possible in a way which Western drawing instruments do not permit.

Rhythmic intervals across the direction of lines are universally 196 employed, and a major part of any artist's invention goes into them— *Fig. 28* though the spectator realizes this all too seldom. Sometimes a rhythm stated *along* a line will be picked up later by transverse intervals. This implies that in reading a drawing it is most important to *Fig. 29*

Fig. 29

scan the whole field of forms across the lines from one border to the other to grasp the internal structure. And in painterly drawings the edges of the format will certainly be integrated into the interval system in one way or another, whereas in sculptors' drawings the rhythms will tend to lie solely within the limits of the notional subject. In some drawings, such as many of Rembrandt's, the brusque, 'unrealistic', and 'unpleasing' lines prevent the eye wanting to read any descriptive or sensuous intent and force it to seek its satisfaction 198 directly in the intervals *across* the direction of the lines.

In any drawing the eye will find many sets and series of intervals of different kinds interwoven in the tissue of the drawing. And far the greater part of its meaning and its emotional impact comes from the

Rembrandt van Rijn, CHILD BEING TAUGHT TO WALK (1660–2); pen and sepia, 9·3 × 15·2 cm. *British Museum*

way in which the rhythmic intervals are read, and from the implications that are read into them, following recognized clues, by the spectator's educated responses. This is where the 'tenor' as 'subject' of the work plays one of its most important roles, as we shall see when we come to discuss the subject as such. A similar interval, for example, may be connected emotively with: a stretch of continuous form on a garment; a gap in the same plane of distance between the bodies of two people; a gap of two miles into depth; an infinitude of empty space between tree and cloud. This demonstrates that the question of space is indissolubly linked with rhythm and interval.

However, before we discuss this issue there remains to discuss one particular way of treating rhythm, measure, and space which prevails for the time being in much Western art. This involves eliminating notional space completely, compressing the entire symbolic reference of the graphic forms into the flat surface of the support, and squeezing the shapes into a close affinity with the rectangular format. This sometimes goes under the name of 'abstraction', though the artists who practise it do not see it as limited by such a term. The whole invention of such art is driven into the arrangement of more or less rectangular flat shapes, which would very easily become banal were their measure readily intelligible. Therefore, to create interest such artists, following Mondrian, devote a great deal of effort to producing more or less rectangular partitions which, of set purpose, elude the measuring eye. The artists work through a long process of continuous adjustment which gradually shifts, expands, and contracts the partitions and the area sizes, slightly distorting the angles of the grids, so that the areas are not controlled by proportions the mind can discern solely through looking. In this way, with a measure constantly altering from one part of the composition to another, no single rhythm runs through the whole, and variety is provided. The unity is provided both by the surface itself and by the fundamental affinity of the shapes with the format. The interest of this type of design, particularly when it is limited to the monochrome of drawing, is slender. For, however variable the rhythmic intervals may be, they must lack the vastly extended and abundant overtones suggested by a notional space-image which is invested with rhythmic structure.

Space and recession As I have suggested, visual rhythm and pictorial space are functionally interdependent. The one does not exist without the other. We have to remember that in spite of all the critical cant, space is not

a thing to be grasped as an object. 'Pure space' is only a noun, not a mystical entity. Space can be seen to exist only in and through relations produced by rhythmic marks: these work as signals in collaboration with our educated responses. And since our responses to actual space are formed by our experience of the objective world as a product of relations recognized between bodies, in drawing, too, notional bodies usually become the prime and most powerful vehicles of the sense of space. Thus the rhythmic elements of a drawing will demand that we read them as embracing both positive surfaces of body and negative voids of empty space. That we tend to try to do this even with the flat surface of a modern work is one of the reasons for the 'mysterious' effects some such art produces; for it may tease us with ambiguities about body and void. In this whole issue the handling and assemblage of lines is as vitally important as the knowledge we bring to the interpretation of the art. The seeming paradox, however, is that the most powerful sense of notional objectivity produces the most powerful 'abstract' forms and rhythms. And these can with some reason be called genuinely abstract, for they are in fact non-concrete, produced *by* the objects but not physically part of them.

There seem to be two chief ways in which the eye reads the depth of notional space, following the clues a drawing offers. The first of these is via the continuously receding surface; the second via overlaps, or discrete backsteps. The implication of both these terms is that to read depth the eye needs a frontal feature from which to start reading its recessions. The first way belongs properly to solid notional bodies, in that the eye accepts a suggested surface as running continuously backwards from a frontal plane into space, undulating perhaps through light and shadow, but understood as enclosing an unbroken chain of bodily volumes. For this to work the surface must be truly continuous; that is, there must not be places where the surface appears from the viewpoint to vanish behind a ridge, and its whole extent must be clearly visible. This is a fundamental technique in sculpture, and it has no doubt been adopted into Eastern Buddhist and Western drawing from the example of sculpture. It is functionally related to the technique of continuous side-surfaces, which has already been discussed (pp. 174ff.).

The reading of such a continuous recession requires a focal or central point, back from which the space is read. This is provided by the nearest points or faces of the whole volume. Thus contours lose their primacy as this method develops in a tradition; for the eye picks

first on the near point, and accepts the edges of volumes as more remote and less defined. A hard, clear contour becomes a solecism. Titian carried this way to its ultimate conclusion. I should mention that occasionally a single solid line may be identified with an entire, dark, continuously receding body, such as for example, a fence-rail in Rembrandt. It will then automatically step out of the depth-slice system.

The second way of reading notional space, by overlaps and back-steps, is by far the most common in the world's art, as it is the fundamental method of all linear drawing styles. Wherever one outline crosses another, the eye accepts a backstep. How deep this step is understood to be will depend on many clues. For example, steps between depth-slices of the contour of a human nude will be read as small; whereas the step between two overlapping buildings may be accepted as large; between mountains as larger still. In most linear drawings, therefore, overlaps play a vital part, and they are usually stressed by accentuating the angle at which the lines cross, and/or by leaving an interval in a line in front of which a fore-feature passes. Such overlaps and steps are functionally related to intervals in empty space between bodies. Therefore many drawings will combine both methods; and here the qualities of a notional subject will be able to add a great variety of 'flavour' to the rhythmic space-definition of drawings with a strong tenor.

Two modes of space The sense of space in a drawing is produced somehow in relation to the format of the work. And it seems that there are two principal ways of treating the format which artists have adopted. They correspond to those two modes of space which the French art-historian Henri Focillon invented to assist him in distinguishing the changes which took place between Romanesque and Gothic art. He called them *l'espace limite* and *l'espace milieu*, space as limit and space as environment. If we adopt these ideas as polar methods of constructing the rhythmic sequences of space in drawing, we can help ourselves to understand how the structures of drawings are created. I do not wish to suggest that the methods are absolutely mutually exclusive—in fact they are often combined—but they do represent a genuine distinction. Broadly speaking, art in the mode of 'limit' contains in its own forms all the space it creates. Everything outside that included space is of negative value, meaningless. Such art belongs to cultures which stress the value of the closed conceptual system. The mode of 'en-

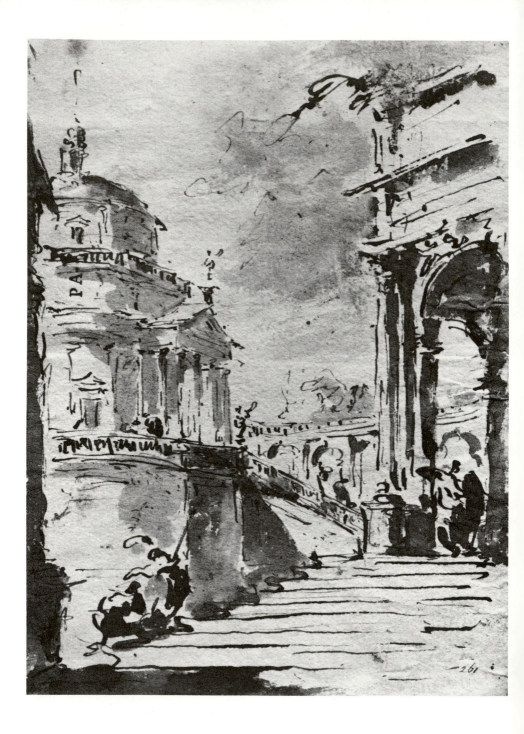

vironment' creates forms which move freely in an undefined environment without specified limits. And this environment can extend into, or blend into, our own actual space.

These modes can be understood best if two drawing styles, each of which exemplifies one of the modes most strongly, are compared. 165 Indian medieval drawing follows the mode of space as limit; Far 74 Eastern drawing of about the same period that of space as environ- 280 ment. The distinction between the two lies mainly in the way they treat the format of the drawing sheet. The question of theme, variation, and development is deeply involved in the methods; but for the moment this must be left out of consideration.

Indian drawing begins by accepting the format as an established and given area, which it then subdivides by means of features such as buildings, doors, and windows, or symbolic, outlined mountains, trees, and spaces. All are defined as completely intelligible spatial enclosures. The subdivision is done on the basis of a rhythmic design. Within the nuclear spaces so established may be set the leading formal inventions, usually as figures. But these figures, for all their fluent linear contours, are still conceived as linked assemblages of containing flat enclosures. Every point on the drawn surface is conceived as lying within one or more defined enclosures. In this type the rectangle of the format usually plays a major role in the development of the thematic forms, since its proportions suggest a basic metrical unit.

In contrast, Far Eastern drawn designs are based upon a few nuclei scattered over the open surface of the format. Starting from these points the design evolves outward into the negative, undefined area of the surface, never enclosing it all or defining it, implying always that it extends without a break beyond the limits of the format. Certainly the evolved forms may include enclosures; but they are not usually asserted as dogmatic entities. The emphasis is upon the way in which the lines and chains of forms move about within the arena of the open space. The chains of forms evolved from the nuclei may approach one another and articulate with one another, but they need not. In such a style the unresolved space may gain a sort of notional definition, and be identified as mist, sky, or water; but this is not essential. The mind is prepared psychologically to accept the undefined region as in some way an essential part of visual truth.

In both modes the means of representing recession include certain of the same elements. Space as environment may not emphasize bodily volumes, but one is always expected to read the intervals be-

tween overlaps as having a step-back in space intervening between bodies of some sort. In fact, the principal way in which *deep* space can be conveyed in any drawing in either mode is by suggesting intelligible series of receding intervals—measured steps back from centres in the foreground of the design. This is the real meaning of perspective (post-Renaissance peep-show perspective is something different again). In fact, this back-step process only elaborates the method of depth-slices discussed earlier, continuing the slice-principle on into deep space. But depth is functionally related to rhythm, and we are expected to read all the intervals in a drawing as having a wide and lively variety of depth-implications. Further, these steps suggested by overlapping bodies will combine with all sorts of elements in the design to form rhythmical sequences in the two-dimensional plane. The artist offers us the co-ordinated overlapping of figures, trees, branches, buildings, and mountains as intelligible clues to the complex dimensions of his design, upon which he and his public are agreed.

The 'floor' as index of space An important part of a drawing for conveying a sense of depth, especially in Western art is the 'floor'. This is the ground surface which, the drawing suggests, rises into the format from under the spectator's own feet. The chief key to depth construction on such a floor is the placing low or high on the floor of the 'feet' of all figures and objects. Low = near; high = far. The nearest of all may even have their 'feet' cut off by the lower edge of the format. The most primitive version of the floor is the base-line upon which figures stand—and the base-line may also be the bottom edge of the format; this is common in many primitive arts. But when notional figures and objects leave the base-line and move up into the picture space, the artist is bound to decide how to treat his floor.

Usually in the drawing of western Europe the floor has been emphasized by means of a continuous, rhythmic succession of features. Its undulations are defined; the nearer have a plastic emphasis; the further offer silhouetted overlaps. The ground on which the spectator himself stands runs up into the arena of the format. Even in drawings where only a quarter- or half-length figure is shown one feels that the floor is present; it is there as an invisible support for the frame in which the figure is set. The *veduta*, or view out of an enclosed picture area through a wall on to a distant landscape, so common in *Quattrocento* art, is not there merely to give a sense of visual libera-

tion (as Francastel suggests). It also re-establishes our contact with the 'floor' of nature. In Islamic drawing the horizon-line is usually very high, and the ground which runs up to it is often given continuity and presence by an unbroken sequence of scattered, even-patterned features such as little plants—like a sprigged brocade. But the most sophisticated user of the floor as leading element in the creation of space was Degas. In many of his drawings no 'horizon' is 206 included in the format at all; it is as if one were looking on to the subject not merely from high up, but also from so close that it is necessary to look down on it. The patterns formed by groups of dancers' feet or domestic objects on this floor can create a space which needs no wall or ceiling. At the same time the way close elements on the floor are allowed to run out of the bottom edge of the format, and be cut off by it, only serves to emphasize that this floor is continuous with the one on which the spectator himself stands.

It is characteristic of the 'wonder-working' styles of many Counter-Reformation Baroque artists, like Rubens or Pietro da Cortona 278–9 (who in this followed Correggio), that their compositions, whilst in the foreground apparently accepting the floor, came in the grouping of their figures expressly to negate it. The figures pile themselves into overlapping and involved assemblages, seated on thrones or raised without intelligible support in space, so as to contradict one's expectations of the logic of standing-places on the floor. The space occupied by the figures is far more extensive than the floor-space apparently available. In this way they produce in the spectator a sense that the events are taking place out of time, in a miraculous space where the conditions of our everyday world do not prevail. One of the things which characterizes the designs of Poussin as Classic, in the age of High Baroque, is that he refused to abandon the logic of the floor. Indeed he developed it to the highest possible pitch. And it may very well be that without the experience of such Baroque design we should not have been able to accept the illogicalities of more primitive art.

Most of the Impressionists, van Gogh, and Gauguin, retain a tradi- 188 tional sense of floor as the main key to their construction of space. But part of Cézanne's great importance in the history of art rests upon the way he eliminates, in so many of his later drawings and paintings, all sense of floor. In fact he often chooses motifs which have, as it were, 120 only an elevation and no ground plan. He deliberately elides the stretch of ground which usually joins the spectator's feet to the bot-

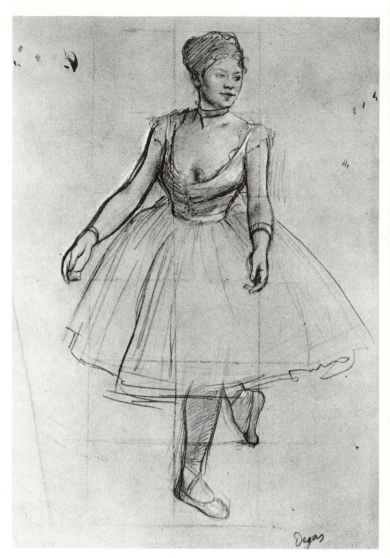

tom elements of the motif—which themselves may appear un-
explained above the lower edge of the format. He wishes to create a
ravine between spectator and picture, which helps him to weave the
massive, rounded volumes of his forms into a design as strong in the
flat sense as a playing-card. For Cézanne this had a special significance.
But modern art has seized upon this particular practice of his, and

elevated it into a principle. The floor has been exiled from most modernist design. And where recognizable ground has been admitted, it has been subjected to deliberate diffraction by means of contradictory clues; rhythmic sequences contradict each other and the logic of the floor, so that they expressly deny the validity of any consistent space-construct we might look for. This is combined with a deliberate discontinuity of bodies and a confusion of depth-clues among the 'feet' of objects, to produce that sense of dislocation in space which is said to be the 'new, cosmic space of the non-Euclidian geometries'. The old constructs are certainly negated, though it is difficult to discern yet what non-Euclidian orders are positively constructed. 'Movement' is not enough to explain such dislocations. For, as I have pointed out, all drawing must be kinetic in structure and significance.

It is perhaps worth mentioning here that the medieval convention, which seems to us so strange, of representing for example figures on memorial brasses as standing 'on tiptoe' is really an attempt to render the reality of the floor, as if we were in a face to face posture with the figure. For if, when we are confronting someone, we look them up and down we do see the whole top surface of their feet. To show feet thus is a means of bringing us closely into the presence of a two-dimensionally rendered person.

Conflict of spatial clues There are, however, styles of drawing in which the visual clues do contradict the logic of visual perception without the artist consciously intending this. Many works of art are valued today for this very fact among them early Siennese paintings, much medieval European drawing, and Indian drawing. Usually such dislocations of perceptual logic will be found to have happened in the interests of conceptual knowledge and clear explanation. For example the arm of a figure which is shown by the high standing-place of its feet to be distant may cross in front of a feature, say a pillar with a low standing-place in the foreground; the space-index of the overlapping thus conflicts with the space-index of the 'floor'. Or again a more distant figure may be much larger than a nearer one. Or a continuous architectural form which appears at one point concave has to be interpreted at another point as convex. It may have been essential to the draughtsman's intentions that we see the whole gesture of the first figure's arm, recognize the importance of the second figure, and understand the narrative continuity of the scenes in which the architecture features.

One very common instance is when the drawing of a flat rectangular feature which is seen end on—a table, say, or an ornamental pond—widens as it rises into depth. This conflicts expressly with the expectations inculcated by Western monocular box-perspective, which has established for us the theoretical norm that dimensions decrease in apparent size as they rise into depth towards the horizon. Here we may find that the reason for the 'incorrectness' is a formal one, not conceptual. The rectangle may, for example, widen into depth to establish a radial relationship between the outlines of two distinct human figures; each may relate to one of the diagonally drawn sides of the rectangle. Thus the 'incorrect' diagonal angle of each side may be structurally important, whereas a dogmatic assertion of 'correct' monocular perspective could only have been structurally injurious.

Depth-bands in graphic composition

Although, as I have indicated, the notional depths of a design are united in the flat sense by the rhythmic intervals, in most sophisticated styles of design there is usually a set of clearly separate notional bands 208 of depth. Both in Western Baroque academic art theory and in the art history of China these were usually limited to three, as in the diagram on this page, though occasionally four are used. In the first, nearest, lowest space-band usually appear the principal actors in the scene or the major features of the subject, perhaps framed by *repoussoir* wings. In the second are the features of the middle distance, whose function is to set off and relate to each other the elements in the first band. Finally there is the distance, the function of which is to relate the other elements to the infinitude of space, either by linking them into it or by isolating them from it. Between each of these space-bands a substantial 'jump-back' through space is understood to exist. An order of this type has been found most helpful by artists in dealing with deep space to strengthen their emotive effects. It can stimulate variety in the emotional responses which any rhythmic sequences evoke, and can open up a very wide variety of symbolic possibilities for the artist, for it suggests different qualities and realms of feeling implicit in degrees of the near and the far. 211

Fig. 30

One will, of course, encounter reductions, as well as occasional expansions, of this system of space-bands. Obviously many drawings, especially sculptors' drawings, will deal only with figures which lie within the nearest space-band. Sometimes the features of the nearest space-band will be set about and united with, say, architecture which is limited to the second band, and no third band appears. Occasionally

one finds a strange spatial effect used where a background is introduced which, although it seems to include remote figures that should belong in the third, distant band, nevertheless seems to lie within a shallow second band. This happens in the work of Uccello, for example, and it produces the effect of a stage back-cloth. It is known that where it occurs in Raphael's *Fire in the Borgo* fresco in the Vatican, the artist was intentionally producing the effect in direct imitation of stage design. It appears, of course, in the drawings of the great Baroque scene-designers, where the stage set is often drawn with figures in the front space-band and the second band contains careful monocular perspectives which nevertheless produce a sense of only limited theatrical space. Again a figure which is indicated as standing in the most remote space-band, and which may be no larger than a figure standing in the closest would be expected to be, will seem to be a Colossus. In Goya's famous painting *The Colossus* in the Prado this effect is reinforced by far smaller figures being set in the near space-band.

A particularly interesting use of the space-bands occurs in the long handscrolls made in Far Eastern countries. For such scrolls, as they are unrolled, are intended to suggest a vivid play of space. And so one finds the interest of successive sections varied by shifting the foci of the design to and fro from one space-band to another, and eliding one or more of the bands. Such a technique must depend upon a sophisticated attitude towards what is often called 'perspective'. For, obviously, a continuous handscroll can have no centred monocular perspective, since the observer's viewpoint upon the notional space is continually shifting.

Scale of touch in relation to distance A most important means of indicating true space in drawings which contain a considerable depth of space depends entirely upon our recognizing the actual elements of the notional subject and relating them to the scale and quality of the handling. In all drawings there is a basic minimum of stroke-scale—the 'touch' in fact—which the eye accepts as the irreducible unit of sense. This touch in the handling of 'near' objects will indicate only a small stretch of their surface; it will indicate vast stretches of space in the far distance. It may designate a mere inch of a near object, in the distance a stretch of far mountainside or a mile of remote cloud. Whether the touch corresponds with a small stretch or a large stretch of subject is one of the indices of depth, with all its emotional suggestiveness. There are all degrees of correspon-

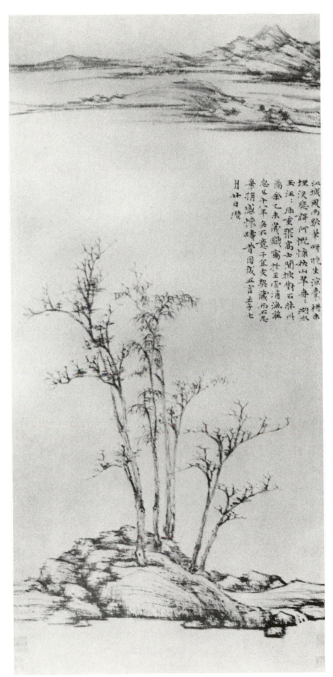

江城風雨歇筆硯生清寒
陳寫詩阿阽懷枕山軍舟之湖水
玉江：床重張高士開披對石林州
高余乙未歲戲寫於王雲浦漁莊
忽已十八年矣不意子宜友契藏而不忘
章拊感慨臨皆同戊五官去子七
月廿日瓚

Ni Tsan (1301–74),
FISHING VILLAGE WHEN
THE AUTUMN SKY IS
CLEARING UP; ink on
paper, 96 × 47 cm.
Shanghai Museum

dence. The touch in general may be fine and small, inviting the eye to look close and the hand to touch, as with Renoir; or it may be broad and compel the eye to a certain distance from the subject, as with Rembrandt. But its scale or key will be the same all over if the drawing is to have unity. In some styles this touch may accurately correspond with small details of objects which are near at hand, such as twigs, wrinkles of cloth, or the shadow of a pebble. This happens often in Chinese drawing. But in other styles small elements may need many touches to suggest them, so that the eye is forbidden to read the single touch alone. In styles like those of Cézanne and Renoir all small elements such as twigs and leaves are totally suppressed even in the foreground, and all objects are treated as 'bundles' or masses, the touch bearing a special relationship of scale to the units of mass in the foreground. Touch-scale is one of the principal means of indicating depth used by the draughtsmen of the Chinese handscrolls; and it is extremely important in all landscape drawing. It is a function of the natural observation that things which are near are larger than those which are far. But at the same time the unity of touch imposes a unity of focus on the whole.

Related to this method is atmospheric perspective. This was probably discovered for Europe by the Flemish painters of the fifteenth century, though it seems first to have been fully incorporated into drawing by Leonardo da Vinci in some of his landscapes. It was extensively used by many European landscape artists, especially by those accustomed to the damp atmosphere of the north. Chinese and Japanese artists used it with immense sophistication. Fundamentally, it consists of paling the tones and blurring the definition, both tonal and formal, of distant objects so as to suggest the layer of atmosphere which veils the distance. In a sense this technique is a function of chiaroscuro in the West; for it was first developed at the same time and by the same artists as chiaroscuro. But as it is used in the Far East independently of true chiaroscuro technique, it is seen more properly to be a function of touch, colour-tone, and distance. The further away objects are meant to be, the fewer tonal contrasts are used to indicate them and the paler are the tones. Whereas foreground rocks or trees may be executed with four or five tones, including the darkest, the most distant mountains will be rendered with one pale tone. Although the technique captures optically the occluding effect of deep atmosphere, and is usually reserved for the distance (as in Claude), one could say with some justice that Turner's later drawings bring atmo-

spheric perspective into the foreground. Those traditions of drawing which represent deep landscape yet do not use atmospheric perspective at all, are those from hot, usually dry countries such as India and Persia. Both near and far are treated with an almost equal stress of tone and definition. But the reason for this may not only be optical. For these drawing styles, among others, make a point of conveying all the ingredients in a drawing with equal emphasis in order to satisfy the traditional spectator's legitimate curiosity about everything in the picture.

Ambient space; a special technique
A further means of creating an ambient space for and uniting it with a close figure is to allow the ground or objects in the background to pick up the outlines of the figure itself so as to produce a halo or rhythmic band which emphasizes its total outline. This is very common in, for example, Munch and Renoir; and in tesselated and mosaic designs of late Roman and Byzantine times the ground tesserae follow the contours of the figures. Indian Basohli figures often have a dark band around them, derived no doubt from the halo of fine brushstrokes given to many Mogul figures. By this means such figures are given an enhanced plastic presence, which sets them off from the rest of the image and yet combines them with their space. Sometimes, in drawing, this device is used to intensify a close foreground feature by giving it reduplicated contours.

Implied motion creating a sense of space; left and right
In drawings that contain figures meant to be in motion another kind of space can be created. This is produced by our reading the implied motion of the figures and so mentally recognizing the field of movement within notional space that they require. The angel rising in the smoke above Rembrandt's *Manoah's Offering* drawings, Raphael's parading and gesticulating, or Michelangelo's running figures demand an arena in which their motion can be accomplished. And once again part of the artist's meaning is expressed by the manner in which 206 this implied arena is accommodated within the flat design. Rembrandt's angel may be flying up beyond the edge of the format. A single Tintoretto figure, a sketch for a composition, may suggest by 214 the implied gestures of its limbs that the space it claims extends far beyond the format; whilst Michelangelo may create a space so tightly knit that the movements of the exuberant bodies it contains, though not constrained, are enveloped in room so narrow that a special type of stress is generated.

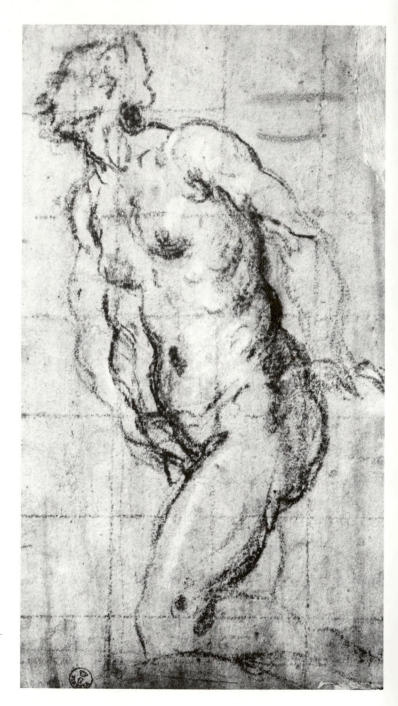

Jacopo Tintoretto (1518–
94), EVE; black chalk on
blue paper, 25 × 14 cm.
Uffizzi

Such notional movements in notional space can be read in relation to another factor. This is the psychological significance of left and right. There has been much speculation on this point, but little substantial can be asserted. We *can* only speculate. Nevertheless it is a very interesting question. Broadly speaking, the direction in which we read a drawing has something to do both with our habits of text-reading, and with the fact that the majority of the human race is right-handed. Generally, for Europeans the left is, as the etymology of the word implies, sinister. It is the region of uncertainty and mystery. The right is the region of confidence and objectivity. At the same time the 278 left is our point of entry into a design; the approaching glance travels in from the left, and the closure is at the right. Many designs are closed at the right by an emphatic feature, often vertical, at the feet of 234 which may lie the terminus of the rhythms of the design. It is well known that of two notional walls drawn running into the picture space at identical angles on each side of the composition, that on the left seems to run more parallel to the picture plane, whilst that on the right seems to oppose its face to the glance which travels from the left. Incidentally, the sense of unease one may feel in the presence of drawings by left-handed artists such as Leonardo must have something to do with a conflict not only in the implications of the reading of the graphic forms but also of notional space.

The movement of the notional figures and the way they address the spectator's attention relate to this psychological significance of the two sides. One may speculate as follows: figures which 'enter' the composition from the back left may be dangerous or threatening, such as invading armies. Those which leave towards the left may be going to somewhere mysterious or transcendent—perhaps paradise (Wat- 270 teau)—or may be pushed back into death (Goya) according to the mode of the design. Compliant, accessible nude ladies accept the approaching glance boldly, facing towards the left. If they face right, they may either by mysteriously divine, having entered from the left; or they may be sexually detached, like so many of Renoir's late nudes. Figures which leave the composition at the right-hand side are emphatically and finally departing. Christ may lift a sick woman up from the left towards himself at right (Rembrandt). Spiritual vulnerability tends to face left; aloofness to face away right. The figure with its back to the spectator, in the left foreground, invites the spectator to identify himself with it and enter the picture. The possibilities of sympathetic and introspective exploration along these lines are endless.

The situation is complicated when we come to the designs of art styles which are related to a script which runs from right to left (Islam) and even from above to below as well (China, Japan). The Chinese handscroll, which is read purely from right to left, will have a direction of structure entirely different from Western drawing. Thus if one wishes genuinely to appreciate such a work, with its figures, objects, and succession of distances, it can only be read in that direction. One should realize, as well, that Far Eastern vertical hanging scrolls, save for some recent inferior work, should be entered from the top; their final 'closures' may not necessarily be at the bottom, but somewhere towards one side, and in keeping with Chinese ideals of expression may not necessarily be actually defined closures so much as points where the attention finally moves out of the arena of the work.

The case with Islamic art is different again. For it seems that the psychological significance of the two sides is affected by three facts. First, the glance enters with the reading habit from the right so that the 'end' of a strict Islamic composition lies at the left-hand edge, in a row of profile figures, perhaps, or a tree. Second, the dominant profiles in an Islamic picture face to the right, and the dominant figures in any composition, such as kings or protagonists in a story, tend to preside from the left unless they are in motion. For motion in the figures is most commonly and vividly felt along with the reading glance. Something 'passed on' out of the picture, for example, a book, a cup of wine, tends to move out of the left-hand side following the dominant motion. Third, the narrative sequence—very strong in many Islamic paintings—is often to be read as a series of 'lines', i.e. a series of transverse movements across the page from top right, analogous to lines of script. These may be diagonally inflected; sometimes, however, the sequence moves in a long curvilinear track. It seems that Islamic art in general does not make so much of the psychological differences between the sides as Western art. Nevertheless the expression of its figures is still the result of the way in which they address themselves to a glance directed from the right, whether they advance to meet it, confront it, go along with it, or violently oppose it. Indian art of the post-Moslem epochs is strongly affected by this Islamic sense of direction.

Western perspective and the drawing-machine

I have called Western vanishing-point perspective 'monocular box-perspective'. This needs some elaboration. In fact the notion of opti-

cal perspective-structure which is universally accepted in the West, and which the camera seems to confirm, is valid only if it is based upon one strict assumption—that the eye which views the entire field of vision—from clouds to violently whirling figures in a foreground, say—is fixed to a single, theoretically unvarying viewpoint. In fact no eye but the eye of a machine ever sees nature in such a way. All human experience of visual reality, to which art ultimately appeals, has been gained through eyes which move continually in all directions, located in a head which constantly changes its height above ground and its angle of tilt. This constant movement also gives bodies their plastic isolation, since they seem to move in relation to each other with endless variation. It also produces that sense of life and the real which distinguishes truth from fantasy. An absolutely flat design lacks life also, in so far as it lacks bodies.

No human being has ever actually seen a fixed horizon-line or a vanishing-point to which all features in his field of vision are related. He can only come near to seeing in this way if he looks with one eye only through a peephole in something solidly fixed. And the peephole is the essential basis of those drawing machines which have been so widely used by Western artists since the late Middle Ages—and so seldom adequately acknowledged. Western perspective is functionally wedded to the peephole-machine, i.e. to mechanical seeing. And the peephole-machine has enabled countless Western artists to achieve that rigid 'optical' accuracy of contour which has been the joy of relatively unsophisticated patrons. The machine artists are not hard to identify. Holbein the Younger heads a list which includes Canaletto, Bellotto, and even Constable. It does not, however, include the major masters of imaginative painting like Titian, Rubens, or Delacroix. From our point of view we must realize that the pursuit of 'optical accuracy' as an artistic goal was an activity symbolic in itself—symbolic of an outlook upon the 'real world' which sought to fix the visual characteristics of that world according to a generally acceptable and immutably valid formula. In effect drawing machines were pieces of scientific equipment. And such science was imported into art, as science always is, for emotional reasons: to induce in the user and his public the satisfying self-confirmation that their activity is part of something irrefutable, durable, and far larger than themselves. In fact a sense of alienation from life, a sterilized reality, is also a result.

Both Leonardo and Dürer have left drawings of the typical peep-

hole machine. It consists of a low table supporting a flat pane of glass set in a frame at one end, at the other a stake to carry the peephole. The artist sits at the peephole end, peeping through it with one eye, viewing the subject he intends to draw through the pane of glass. He then traces the outline of the object with a suitable greasy medium on the glass. Then he takes a further tracing on to paper off the glass. A more complicated machine is also illustrated by Dürer, which involves cords, weights, and a pulley, enabling the artist to chart a set of points direct on to his paper without retracing. It is more than likely that the glass-pane drawing machine was in use in Italy by 1450. Holbein's famous portrait drawings of the English aristocracy, with their 'traced' outlines, bear all the marks of drawing machine products. His interest in optical tricks is amply attested by the famous optical anamorphosis of a death's head at the bottom of the painting called *The Ambassadors* in the National Gallery, London.

The camera obscura is another machine which has been widely used by artists to help them in tracing accurate 'perspectives'. Zanetti tells us that Canaletto used it; so did Bellotto. This machine was first described in print by Daniele Barbaro in 1568. Robert Hooke described a portable one used for drawing landscapes in 1668. Fundamentally it consists of a pinhole or, more sophisticated, a lens, opening into a dark box. Through this aperture an illuminated image of what lies opposite it is projected, inverted, on to a sheet of paper on the vertical opposite wall of the box. This can then be traced by the artist. A wide-angle image may extend around the other walls of the box. By having the aperture in the roof of the box and using a mirror to deflect the image through it a horizontal image may be projected on to the floor of the box; and the artist may thrust his head and shoulders into the box, screened by a blackout curtain, and easily trace such an image the right way up if the natural object is behind his back. The camera obscura was widely used in the seventeenth century; it even became a popular toy in the eighteenth century, featuring in amusement arcades. It is still used in technology, and by fashionable portrait-painters and other artists to help them in capturing likenesses. It is, of course, in principle identical with the photographic camera.

Needless to say, traced machine images are not themselves art, though they may become art if they are given artistic treatment by means of the conceptualizing processes I have been describing. It is, however, inconceivable that such processes would leave intact every aspect of the machine-image, although of course the very act of

tracing involves artistic methods. As I have pointed out, the machine's-eye view of the world is intimately linked with the by now traditional Western view of visual correctness, with its invisible 'box' side-walls, floor and roof running to meet at the 'vanishing-point'. Many kinds of artists, including topographers, have tried to fashion their styles on its effects. It is possible to imagine an image traced in true peephole-perspective which attempted to employ virtually none of the structural and rhythmical forms which I have been describing as the essence of drawing. And this would, for all its correctness, have no content of aesthetic form. So, conversely, it should be obvious that the optical peephole image has intrinsically nothing whatever to do with artistic form, though it may serve as 'tenor' to a work of art. Visual truth belongs to the constructive imagination, building its space out of rhythmical intervals between its graphic signs and notional bodies, offering its own repertory of reading-clues without regard to a mechanical optical image. The fact that the optical image came to be accepted in the West as the essential tenor for all designs is a historical phenomenon with a meaning of its own. But the peephole image itself does not belong to the category of artistic form.

Theme and variation Up to this point I have considered the nature of graphic forms, and
in drawing the general ways in which they can be related to each other. But the structure of a good drawing involves particularized relationships, and it is developed out of specific individual forms into a particular composition. The meaning of these terms 'specific forms' and 'develop' needs to be explored further. And in doing this an analogy with the established theory of musical composition will help. In the study of drawing the concepts of the graphic 'theme', the 'counter-subject', and the 'variation', can serve to open up a new field of ideas and interpretation.

To begin with I had better explain a few basic terms. By 'motive' I mean a small segment of form of a characteristic shape. It may be a stretch of contour, a patch of dark, a suggested enclosure or volume. By 'theme' I mean a characteristic motive or linked series of motives which is used as a basic visual idea for a composition. Motives may either serve as thematic material or build up thematic material of another kind. Thematic material of the first kind may, for example, consist of motives which are always treated as units, varied perhaps, but not actually broken up. Whereas thematic material of the second kind may consist of a chain of motives which can be broken up in

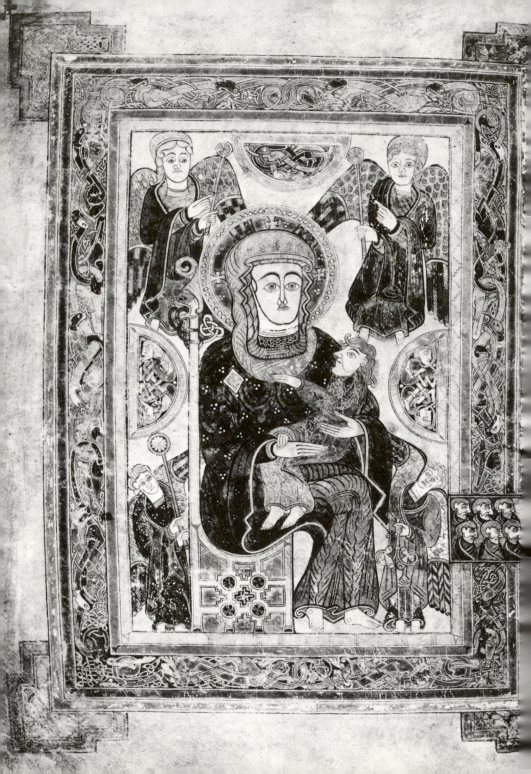

various ways without regard to the integrity of particular motives so as to produce what are in effect fresh motives. Such secondary motives are derived from themes, though the themes were not in the first place assembled from these motives, but from others. Endless permutations and combinations of material are thus possible.

All well-constructed drawings begin with a specific 'given' nuclear form or form-sequence. This may be any type of form, placed anywhere; but it is important to identify it at once; it is the key to the whole work. And it is the thing which is usually made first. For example, in the case of our illustrated Susa pot it is the pot-body itself, 229 which has both a circular section and a conic elevation. In the case of a Rembrandt drawing it may be a chain of shadow-lines running round the eyes, nose, and mouth in the centre of a face. In a Greek Lekythos picture it may be an undulant line of a certain rhythm that silhouettes a breast and belly. Against this given form will be set another visual idea. This will usually be in strong contrast to the primary theme. For example, it may be in the Lekythos drawing the strongly marked triplet motive in curved axial lines. In a Rembrandt it may be stated in the dark sweep of a hat-brim over the face. On a Susa pot or a Cretan ceramic it may be a volute-like form. The whole drawing consists of a reconciliation between these contrasted and even apparently irreconcilable forms. This is achieved by progressive 'variation' (in the musical sense) of the stated motives, resolving them into a unity through graphic symbolic forms, as I have described them, which are derived from aspects of the motives. The counterposing of the 220 motives, theme, and counter-subject sets up a kind of unresolved tension among them; the variation and reconciliation consists of a logical pursuit and heightening of this tension through a symbolic region of metaphorical forms expressed in drawing methods, in which a vital role may be played by the format itself. In drawings with a notional subject this subject provides a tenor which deploys the graphic forms rationally across the area of the format. Drawings of another recent kind may use a diagram as tenor, topic, and apparently as development too.[1]

[1] Many modern artists have failed to recognize and avail themselves of the powerful possibilities inherent in the distinction between tenor and form, so that they are stuck with a bald, diagrammatic tenor on their hands and cannot develop it as a formal structure (particularly true of architecture). This implies that because they still believe with the Victorian Academy that the subject is the substance of the work, they have to make their subject a diagram in order to produce a 'modern' work.

It often happens that in a finished work of painting or sculpture, the surface of which has been continuously worked over by the artist, this formal structure is obliterated. Drawings reveal such structure particularly clearly.

'Variation' of the counterposed motives is the key to structure. Various writers have classified the possible types of musical variation, and within limits such classification can be adapted to visual forms. In visual art, no less than in music, there is found 'false variation', what Schönberg used to call '*Rhabarber* [rhubarb] counterpoint'. (In the theatre an impression of a crowd of people all talking at once used to be given by a number of people offstage repeating 'Rhabarber, Rhabarber'.) This consists of many repetitions of the same motive transposed here and there to fill up the space, but not changed. In art we may be tempted to call this 'mere decoration'. Mannerist decorative painters like Vasari were much addicted to it. The imitation of a given motive may, however, be justified and create a powerful effect, if for example it is much enlarged or diminished in size or much displaced. The same motive-shape may be repeated with logic if it is applied to a completely different element of the notional subject, for example a motive invented for a facial contour may be applied to a mountain peak. But literal imitation in such cases is usually impossible. Instead there usually occurs the second type of thematic transformation, when the motive is repeated with minor changes which leave it still recognizable. For example, a curve may be flattened and two angles altered, though the motive remains recognizably the same. Through such continuous transformations disparate motives may be reconciled to each other gradually over the surface.

A further type of thematic transformation operates by inversion, or reversal, perhaps with slight modifications. Here graphic forms and sequences are made to run in the opposite direction, or are placed upside down so that the expression of their forms is radically altered; yet they remain manifestly related to their thematic matrix. As well, the forms may be applied to quite other elements of the notional subject, and may even become very difficult consciously to recognize; though one's visual intuition accepts them as valid transformations of the original thematic material.

The most important type of thematic transformation consists of dismantling each theme into its component elements and assembling these same elements in different ways so as to create fresh but related graphic symbols. We often find, if we read the order in which a draw-

222

ing was made, that as it progressed it came to be made with more and more broken-down elements of the themes, until it was concluded with loose strokes so generalized as to be scarcely recognizable as components of the motives. These will, however, retain a rhythmic disposition, and rhythms are valid forms. This often happens in Rembrandt's drawings, for example. Generally speaking, this kind of thematic transformation, applied through the forms and formal connectives I have described, is the mark of the greater artists.

A final type of transformation consists of inventing fresh forms, which have in some essential point a recognizable affinity with forms derived from the germinal themes. This affinity may not work through direct similarity with the actual forms of the thematic material, but by resemblance to forms built up out of such material. For example, a sequence of plastic volumes may be evolved in relation to a contour based upon a linear theme; and elsewhere in the composition a similar sequence of volumes might be developed, whilst the thematic contour does not itself appear. This happens frequently in large, extended compositions, different parts of which may be the subject of fresh design-cells. But it does also occur most often in the design of major 'machines' of large-scale painters who retain an over-all unity, such as Rubens, Veronese, or Poussin. In these works, where an opulence of forms laid over forms was expressly sought, and work would be sustained, with fresh starts, over a long period of time, initial inventions might be modified continuously by fresh thoughts which would be connected only, as it were, at their roots with the thematic structure of the whole. In drawings which are executed as a single creative act this type of variation is less common.

bematic development The basis of any development is what Schönberg called the given 'thematic imbalance'. The thematic ideas are inconclusive statements, full of implications. Development consists of amplifying, varying, combining, and resolving these ideas in relation to one another, using to the full the repertory of formal categories of relationship. For forms gain their expression from their relationship with other forms. The shape of the development and resolution of the initial imbalance into a coherent unity constitutes the real idea of the whole composition, and only the artistic process of development can in fact give access to that idea, which is itself a profound intuition that lies far beyond the reach of ordinary discursive thought.

There appear to be two basic ways in which development can take

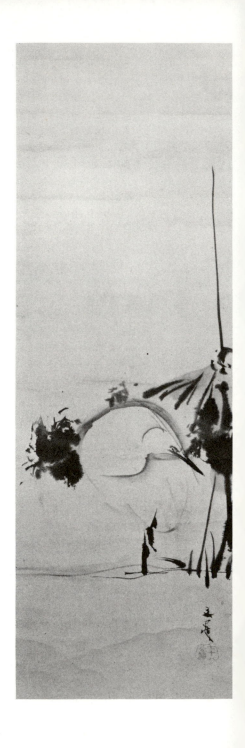

place. First, the most usual in Indian as well as most Western art, is that in which the idea of the whole composition is held in the forefront of the mind, and thematic material of a categorically simple or general character is 'used' to supply a reservoir of formal developments out of which the idea is assembled. There is a danger with this method that the graphic forms can be dissolved into uncharacteristic items none of which is functionally related to a genuine thematic motive. The second method is that in which complex and unique thematic motives are discovered and placed in apposition; to make their meaning plain they then require only a small amount of relation-building with fragmentary motives derived from the themes. The juxtaposition itself, provided it suggests implicit relations, is often sufficient. This is the method of some African art, and of Far Eastern 224 drawing of the 'abbreviated' or 'abrupt' type. Here the themes themselves may have a continuously linked structure of only a few very distinct and richly metaphorical motives, each of which shows a progressive modification towards the next; so that there is a kind of polarity of the motives at each end of the chain, without any passages of variation in the sense described above.

Generally speaking, the thematic material will be found in those aspects of the work to which the artist accords primary significance. In a purely linear art it will be found mainly in linear sequences. In an art based upon volumes it will be found in characteristic sequences of volume. In the work of artists much concerned with tonality, it may be found in a particular chain of darks. In enclosure art, in a set of positive or negative enclosures. It may be found in a quality of grouping, or in an especially complex rhythmic scheme. (Themes may also be found in particular patterns of colour relationships.) Whatever its character, however, the thematic material contains the germs from which the design is constructed. Its vitality and expressive potential is thus of the greatest importance. As is the case with music, only the simplest aspects of development-pattern can be described in words. One can, however, stipulate that variety of developmental combination and shape is the mark of the better art; genuine 'developing variation' is superior to mere repetition; and so it will naturally demand the widest and most original use of the categories of statement and combination.

In an important sense an artistic development is at one level an exercise in what is known to mathematics as topology. The problems with which it is faced, however, are not the purely abstract conceptual

problems of mathematical topology. Art must combine into formal catenae both the forms themselves and the emotionally charged experience-content signified by the analogical reference of the forms. It is the latter which promote and determine the combinations of form which the artist actually finds and which stimulate his invention of fresh combinations. If the forms merely denote the ordinary objects of experience without resonance or overtones of suggested meaning, or if the forms are general without benefit of much implied 'content', the art will achieve little. Forms must suggest the content of feeling-traces far beyond merely indicated fact, as Rubens's 'flesh' forms do or the Japanese Kaigetsudo's magnificent 'robe' constructions for his courtesans. They do this by virtue of their own subtlety, but also by virtue of their situation in a system of development.

The subtlety of its development is an index to the quality of a drawing's visual meaning. For though its initial general categories of form and relationship may be the same as those common to many works, the richness of reference available to its combined, categorically complex forms is great; and that available to integrated catenae of such forms is greater still. To construct such catenae, and to make it possible for the spectator to follow the artist into their region of significance and grasp his idea, thematic proposal and development may well be indispensable.

Location of themes The location of the thematic material in a drawing is usually related
and motives to the order in which the drawing was made. The spatial mode also influences the way in which the material is developed. In the mode of space as environment it is obvious that the initial statements of linear thematic material will lie at the preliminary focal nodes of the design which, as I have mentioned, the spectator needs first to identify. The variation-development will take place outwards into the open arena of the surface from these centres, maybe without invoking the specific shape of the format. In this mode, too, linear connections may appear which lead the eye actually beyond the edges of the format. Loops or junctions may be consummated only outside the arena of the sheet. This is especially visible in the long-format 'pillar' designs of the Ukiyo-e; but it was, in fact, common in much earlier Japanese drawing. In a drawing in the mode of space as limit the themes will probably take the form of distinctly formed enclosures, either one within the other or one against the other, with the format entering sometimes as the enclosing counter-subject itself, sometimes as a third party that

needs, as it were, to be 'satisfied'. The common combination of mode often found in Western drawing (for example in Rembrandt) consists of stating the themes as nuclei and relating them within the format as limit, so as to fill it 'satisfactorily' and enable it to become as it were a passive part of the thematic material. And because of the characteristic Western obsession with the face and its expression, the leading thematic material in a drawing in which the face is large enough to be worked will usually be found about the head and upper part of the body of the principal figure. By contrast, in the art of Japanese 282 Ukiyo-e, where the faces and the coiffures are essentially stereotypes, 20 though the draughtsman may have stated them first, they may play the role of conventional 'introduction'; the main linear themes appear extending from the ambience of the head or heads, which have served as it were to get the design under way. In the drawings of Poussin and even his paintings the face is confined to an ideal pattern on the same plane of emphasis as the bodily members.

Thematic material in the later drawings of Poussin is often obscured, and seems to be in the form of fragmentary motives which were overlaid with 'later' developments. However, from a study of his early drawings, and from his later comments on Junius on art, it is clear that he *was* accustomed to set down a leading contour first, a contour which indicated the principal characteristics of the bodily gesture of a leading person, and may have been quite long, covering even half the format. In some of his sketchiest late 'first thoughts' one can find this same procedure, with contours which are mere dividing lines without kinetic *brio* travelling the surface and giving rise to further contours.[1] Such material would normally become more or less invisible in a drawing completed with wash tones in which thematic material of a different kind was incorporated. It remains there; but the development of notional bodies over and out of it makes it hard to discern.

The conception of artistic order and structure proposed here is one which has its own built-in principle of anti-dogmatism and variety. Order in the sense I use it does not imply imposing any rigid patterns of form, rectangular, parametric, geometric, or otherwise. It involves heightening form through variation and relationship, and rejecting the ascendancy both of mere resemblance and of particular ideal patterns. In the first section of this book I pointed out that the forms of drawing used by an artist constitute, in some sense, a system of

[1] *Windsor Catalogue of French Paintings*, 221.

visual ontology. In a way one can say that, beyond the forms, the actual *system* of forms is itself symbolic of the nature of the artist's ontology. An artist who succeeds in exploiting an inexhaustible well of structural realizations through his intuitions and feelings has achieved something specific. We may call it an integration.

Structural analysis of examples In order to make clear what is meant here by structural development of thematic material I shall discuss in detail a few examples, in the manner of functional analysis of music. The first, in the mode of space as limit is the pot from Susa with the figure of an Ibex drawn on it in 22 manganese slip. Two essential given elements of this design are the circular plan of the pot, and its conical elevation within the form. The principal thematic statement within the stern, nearly rectangular frame, seems to be in the body of the animal, each end of which 'issues' from the rectangle; this is the place where the conical motive is taken up as enclosures, doubled end to end, made concave by combination with the segment of a circular hollow under the legs. This last is then taken up in the double, almost circular loop of the animal's horns, where the motive of doubling is repeated. The foliated disc inside the horns counterpoints the variation of the horns from the true circle. Auxiliary forms—the head of the beast, its beard, the cornstalk tail, repeated from the foliated disc—are general, and related, as it were, sequentially to the larger forms. For the head is derived from one of the body forms, its beard strokes parallel the main front-leg angle and front rectangular frame, the tail stroke is parallel to the beard strokes not to its own segment of frame; its angular brush repeats the motive of the angles at shoulder and haunch. Thus, in general terms, the idea of this composition is a fairly well-developed reconciliation of circular pot-form and rhomboid frame, by means of the interposition of the idea of the bi-cone ibex body with its lunate horns.

The drawing on the Cretan pot from Gurnia is more in the mode 2 of space as environment. It is less easy to dissect. First, the squab-like pot-body itself is of a contour which suggests that it is soft and swelling; it has two emergent spouts and a pair of eye-handles. The drawn thematic motive is based on the octopus body set deliberately at an angle which, by undulation, doubles the squamous body-form. The two eyes pick up the motive of the handles. The emergent spouts are recalled in the emergence of the limbs from the head by the eyes. The undulant limbs pick up the expression of the contour which gives the pot-body its form and, by free variation, intercede as it

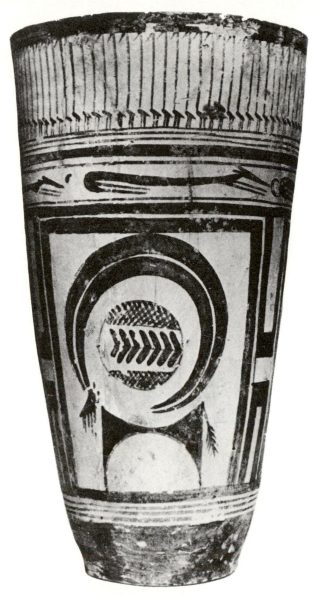

were between the skew-body of the octopus and the symmetrical
pot. Similarly, undulant seaweed and fish rationalize the handles and
spouts into the notional undersea environment—which is, be it noted,
three-dimensional by virtue of the curvature of its ground. Thus the
linear undulations of the limbs extended over the ground are also
three-dimensional, bonding graphic to plastic.

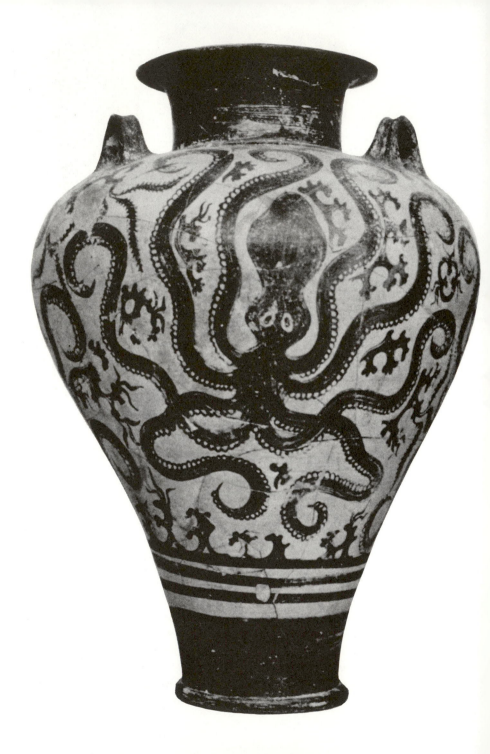

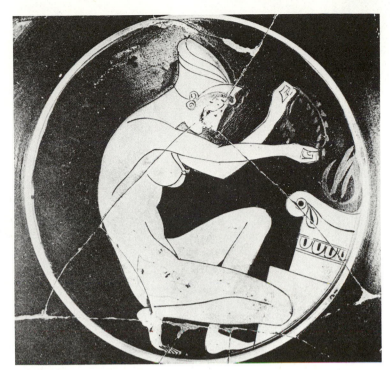

The early red-figure Greek cup drawing of a nude girl making an 231
offering on an altar is an example of the earliest phase of European art
where the thematic material is focused on the face. Although that par-
ticular part is slightly damaged, one can see that the main theme is
stated in the long angle of the nose, with a slight convex curve as one
of its sides; under it runs a triplet of loops, the lips and chin, the last
and lowest of which—the chin—has a very characteristic long curve,
straightening gradually to make a right-angle with the neck. The
contour of the head-dress is virtually an inversion and enlargement of
this chin-curve; the back line of neck and head-dress a negative inver-
sion, opened, combined with the neck-angle motive. Twin loops of
breasts repeat the twin lips, but with the concave upper inflexion of the
nose-ridge. Along the line of belly runs a triple, opened-out loop,
ending in an angle with the top of the near thigh, whose top-contour
repeats as an extended inversion the chin-curve. The contour of the far
thigh is a reversed variation on the head-dress form. The contour
of the back is another triplet of curves, even more opened out, ending
in a step to the heel. The angle between nearer shin and top of foot is

a variation of the underchin-neck angle; whilst the contour running over both knees is an inversion of the same underchin-neck angle. Along the upper edge of the nearer arm the curve-triplet appears again, with a concave sector at the wrist. And even in the little forms within the closed fingers derivatives of the motive appear. It should also be apparent that the over-curve of the now-missing eye plays a leading part in originating the overcurves at the tiara, on the shoulder, inverted under the breasts, and inverted on the altar-top. Most likely, too, the upper contour of the nearer calf is a derivative of it, combined, perhaps with a form from the nose-ridge, reversed. And so on. All this leaves out of consideration other forms of conceptual relationship between the contour elements, which are very strong in the drawing, such as the positive and negative enclosures, right-angles, and linear sequences.

Lest anyone might be tempted to say one could do this with any drawing, it must be pointed out most emphatically that one could do it only with a drawing which was originally drawn with well-conceptualized, specific, and varied forms. Inferior art only offers repetitions of general shapes or accidental differences. And one must remember, too, that this Greek pot illustrates one of the high-points of this type of structural clarity in the whole history of art; for its formal beauty has not been watered down by the need for superficial resemblance or the inclusion of all sorts of realistic detail. Later art presents us with more formidable problems of analysis, especially when original thematic material has actually been hidden.

In the Lekythos drawing the process of overloading has begun, and 232 the contours are used primarily to subtend notional volumes which lie within them; though they do still contain the main bulk of the developmental invention. The main thematic material is in: the inner angle of right-side eyebrow and nose, plus the nose tip leading into the volatile recurve of the nostril: against this is set the stern, angular, only lightly bowed contour of the cheek and chin. In fact this latter is a thematic derivative of the first. The sharply contrasted counter-subject is the looping contour of the hair, which is most clearly condensed into a linear form as the left-side contour of the chest-waist. There is, as well, a triplet motive which appears in many places, for example, eyelid and brow, waist-folds, fingers, neck-folds. The linear variations can be followed out in this drawing as they were in the last. Salient points to notice are that the outer elbow-angles repeat the eyebrow-nose theme; the volatile nostril supplies many of the drapery

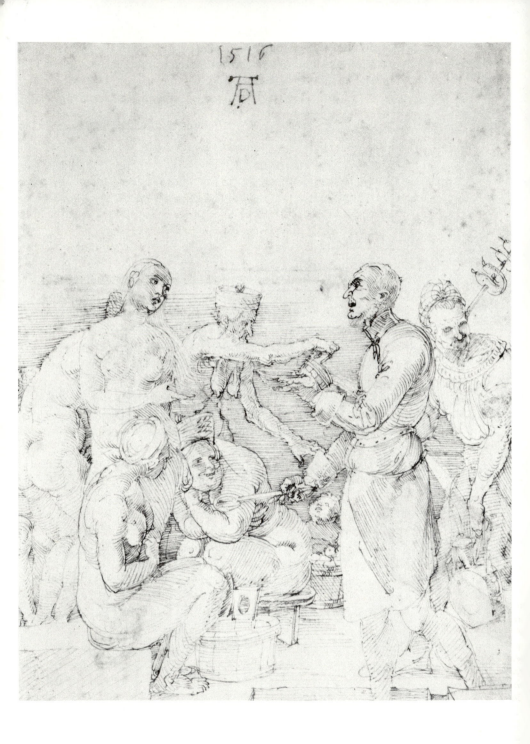

contours; the outer contours of shoulder and upper arm are, on the right side, a derivative of the chin-cheek contour and on the left side an extension, via the left-side chest-waist contour, which was probably drawn before it and after the right-side shoulder and arm, of the looping counter-subject, here extended into a specific undulation. Whilst the same trio of loops is compressed into overlaps of folds three times over at the waistline. And so on.

There are many later Western artists with whom the development of a drawing is primarily a matter of lines and their variations. We can apply very similar methods of analysis to the work of most of those *Trecento* and *Quattrocento* Italian artists whose drawing was based upon the outline. Even the early work of Raphael was based upon undulant and recurving linear sequences, which can be analysed in terms of—admittedly general and decorative—curves. These, of course, by no means follow the contours alone. In his later work they bury themselves very much into the directions of the shading carrying through the shadowy outlines of muscles and folds of flesh.

Northern art, especially German art around 1500, remained very firmly wedded to the line, and especially to the florid, generalized curve, which was modified relatively slightly according to the type of notional body to which it was attached. A sequential analysis of a drawing by Dürer will help to show what I mean. The style is linear, 234 and despite Dürer's pursuit of Classical ideals is not couched in terms of enclosure-shapes. It is fundamentally in the mode of space as environment.

The drawing represents a scene in a bath-house, and contains five naked women, one very old, one fat; a naked child; and two dressed male pedlars of food and drink. It is, in fact, as banal, unaesthetic, and even—in view of the unsavoury reputation of the medieval bath-house—as unappetizing a subject as could well be imagined. Its charm for Dürer, as for other artists, was that only in such a setting could he see nudes in free movement. One of the features of German art of this time was a tendency to heighten by its calligraphic exuberance images taken from life. This art found it almost impossible to adopt a purely aesthetic attitude towards an ideal and never-actualized nude.

The centre of this drawing is the face and head of the seated nude woman in the left foreground; they were drawn first. The whole of the rest of the design 'explodes slowly', as it were, out of this nucleus.

The mutually interlocked loops of the face and head are pursued like expanding ripples down that woman's body, line growing out from line, bracelet shadings picking up movements of undulation and recurve from the contour—though it is likely that the first batch of shading was very sparse. Her wooden basin was drawn next. None of the other figures or objects in the picture impinges on this figure or the basin, which shows that it was drawn first. For a similar reason one can say that next was drawn the female nude standing immediately behind the first figure, starting again most probably with the head and front arm, running down into the hips, belly, and thighs, the lines of which pick up and articulate by echoes and continuities those of the seated first figure. Pentimenti for the standing woman's arm, which pass through the rear-centre figures, show that the latter were not drawn yet. And the solution for the idle hand against the thigh was found before the seated fat woman's face was drawn. Next was drawn, beginning with the head again, down neck, chest, and arms, the standing, dressed male pedlar in the right foreground. One might have thought he was drawn as the second figure in the composition, before the second nude woman who stands, were it not that the glance of his eyes across the open space is directed at the face of the standing woman, and his hand profers the dish to her hand, implying that she was already there. His dish and ladle were both fully drawn before the rear figures. Next to be drawn, probably before the crouching fat nude woman at the centre, was the partial back view of a nude at the left-hand side of the drawing. Its lines take up lines from the two earlier female figures, but none from the fat woman. She represents a junction between the two earliest female nudes and the standing pedlar. She looks up at him. Her thighs and hip, and her shoulder, echo in parody those of the first seated woman.

Next, growing out of her and taking up the implied movement of the partial back view at the left, would be the old woman emptying out a stream of water from her bucket. All of her drawn parts vanish trimly behind the earlier pieces of drawing. The child looks up at her; so he in his tub is the last link between the women and the pedlar. The stream of water which the old woman throws out appears behind the pedlar's back, so it, presumably, was drawn before the second pedlar was drawn. He, with his sausages on sticks, must have been added, head first, to give the necessary final weight to the right-hand side of the picture; and he is drawn over the old woman's water. The leading characteristic of this style, in the mode of space as environ-

ment, is the way in which the contours, and the bracelet shadings, grow out of each other by continuity and virtual repetition.

One can analyse the sequence of almost any drawing in this way, provided it has not been too heavily overworked, and in so doing discover its thematic structure. It is, of course, easier to do with those drawings which were made for purely graphic purposes, and not to achieve the illusion of finish in another medium. The Poussin drawing of the capture of a Sabine woman is another excellent example of a 178 drawing readily amenable to analysis. Here, by reading the implications of the overlaps, we can see that the first things drawn were the shoulder and arm of the woman, her neck and pointed lower face; then her rear lifted arm, and the hand reaching forward over her head, the underpart of which was then completed, and the contour of her upper back taking up the contour of the outer part of her rear arm. Next her breast, and then the head, neck, shoulder, and arm of her captor. And so on, down the drawing. The final areas of wash capture extensions of the drawn contours and evolve from their plastic implications new sets of linked enclosures. But, of course, in Poussin's style the lines have no value in themselves *as* lines, as linear expression. They state simply locations—the locations of shaped enclosed volumes, which is where the thematic materials and its development resides. The reader may himself analyse the Poussin *Crucifixion* 182 along similar lines. It is a particularly rewarding example.

Further type of development At this point it may become very difficult for many people to recognize and follow out the development of material. For most people today are quite unaccustomed to reading and grasping notional bodies, i.e. volumes, with their idiosyncratic shapes which are subject, just as lines are, to variation and combination. Most art students have been trained purely on lines and outlined patches, following the tendencies of twentieth-century art—including, it must be said, sculpture, which is also based at present on linear functions extended into three dimensions by schematic development. The material of the Susa pot drawing was stated largely in terms of simple areas. The splendid drawing of the Virgin by Matthew Paris is couched mainly 238 in terms of interlocked enclosures defined by lines—not on linear themes, though it is drawn only with lines. Its thematic material is a round-ended long rectangle and the narrow rhomboid. This characteristically medieval type of thematic material survived in the work of many Italian draughtsmen of the *Quattrocento*—for example, F. R.

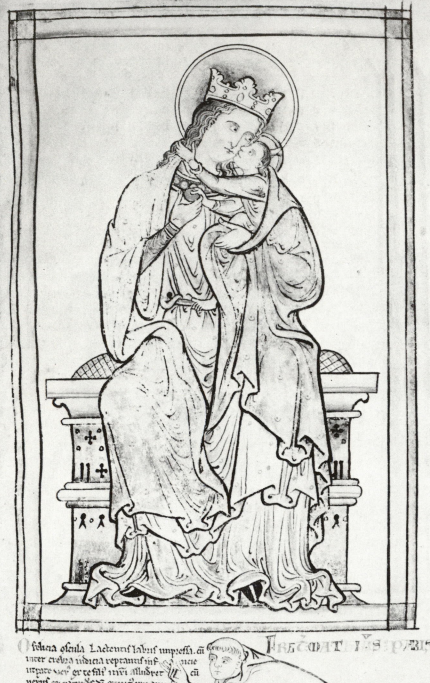

Osculata oscula Lactentis labris impressi. a̅u̅
inter crebra iudicia reptantis inf. ie
ut pare uer̅ er te fili̅ ni̅i illudret . . . cu̅
neuus er patre h̅c d̅i genit̅ imparer.

Francia. It was still at work in the drawing of Signorelli. But with him begins that tendency of one tradition among the European masters to subordinate the graphic symbols to the logic of the plastic bodies. The graphic forms remain vivid and varied, whilst it is the shaped bodies they indicate, by many means, which contain the substantial thought of the draughtsmen. Artists in this style think, as it were, between the lines, not along them. They begin to overlay and decorate with flourishes and multiplied small forms the essential elements of their graphic thought. And then those artists who adopt the logic of the ovoid enclosure (pp. 160–7, 239) begin to adopt a different attitude towards variation, and to look upon it from a different point of view —from the other end, as it were. One can find in the whole of European drawing in the epoch after about 1500 an often uneasy dialectic between the two attitudes towards theme and variation.

The linearists among the *Quattrocento* draughtsmen, and those of the *Cinquecento* like Pontormo, continued to evolve forms of combination, sequences, and varied enclosures out of fundamentally linear material. This is found also in artists of the shadow-path school 118 of seventeenth-century Holland. But with Botticelli and especially Mantegna and Signorelli we find that the thematic interest has departed from the linear forms and located itself in the shield-like shapes the lines designate. Botticelli's early pear-surfaces and tapered cylin- 240 ders have a unity of derivation amongst themselves. And one can find thematic types and developments in the flatter drapery enclosures of 116 his later work. But with Mantegna and Signorelli there is an inter- 159 weaving of lines and clearly conceptualized convexities which is extremely difficult to analyse. It seems, however, that both of these artists were finding their way, as well, into the world of ovoid masses where operated that method of formal variation which, for all their differences, was that of Michelangelo and Titian, of the later Raphael, of Veronese, Rubens, Delacroix, and Renoir. It was in this world that conceptions of variation were drastically revised, and inverted into a new method.

Simply stated the method is this: one starts with unity, which is represented by the undifferentiated ovoid form. All bodies are initially defined by means of general ovoid volumes suggesting a kind of generic stuff out of which everything is created. It symbolizes vital Being, in the abstract. Every artist starts with the same material, and each artist's skill consists of the way in which he extends, stretches, and modifies with endlessly varied inflexions, by grades of line and 180

Matthew Paris (d. 1259), VIRGIN AND CHILD (the author can be seen at the bottom of the picture), prefixed to the manuscript of his *Historia Anglorum*; pen, ink, and body-colour on vellum, 11 × 7 in. *British Museum*

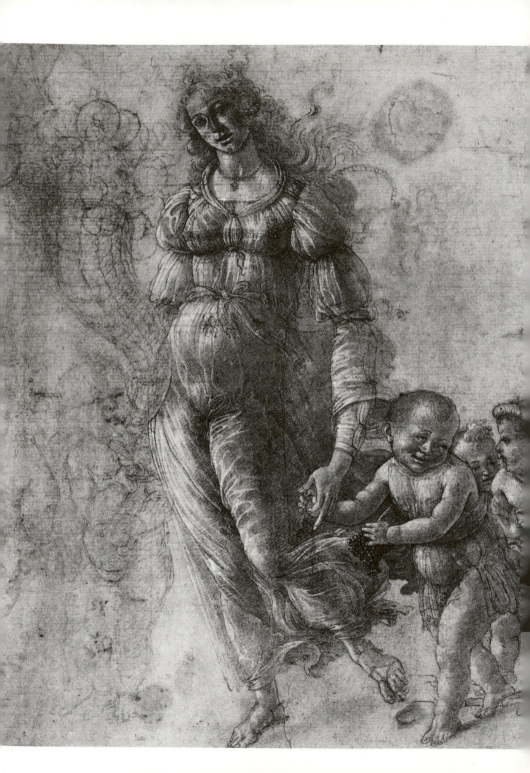

shades of tone, and in innumerable carefully devised contexts, this initial plastic body. Titian is perhaps the crucial draughtsman of this method. He has not yet been given the recognition as a draughtsman that he deserves, largely because of silly clichés about his drawing, comparing it unfavourably with Michelangelo's, which circulated in the Baroque academies. In his splendid sketch of two divine lovers 168 in Cambridge one can see the unitary ovoids almost in their pure, undifferentiated state. A master's skill is revealed in the way in which he can diversify his ovoids, and multiply them over facets, at many different sizes, so that they become different from each other— different enough to produce the continuous variety of life. Titian tended always to keep his ovoids relatively few, within not too wide a range of size, and his vital, unroutine touch helped the implicit surface to its variation. Michelangelo, as a sculptor, equating his ovoids with the volumes of fully contracted muscles, laid an undulating surface over them into three dimensions. In his drawings, however, especially in his later ones, can often be seen the same relatively undifferentiated ovoids of the primary substance. His more vivid pen drawings, such as this one in the Louvre, are not linear evolutions in the 242 Archaic Greek sense so much as notes combining locations and contexts for the ovoids with notes of how they are to be varied. Tintoretto's drawings serve a similar purpose. But the work of inferior men, such as Bandinelli, is vitiated by too banal a repetition of the ovoids, without much variation of scale, shape, or much invention in their location. Generally speaking, one recognizes the work of draughtsmen who develop their forms in this way by means of the repeated oval loops into which they tend to phrase their lines when they are working quickly or noting first thoughts.

What, then, does variation actually consist of in this type of art? Its precondition is that each plastic unit which defines any part of the surface shall be integrally contained within the solid notional body presented. No bits of one volume stick out, and no empty corners have to be packed with extra odd volumes. Each volume finds its maximum expansion, as it were, within the skin of the notional body. To some extent the variation will be supplied by the varied curvature natural to the different sized ovoids. But flattening, compression, elongation, so long as they do not breach the integrity of the volume, are the means; and it will be obvious how essential to this type of drawing is the extended tenor, the stimulating topic, one which challenges the artist to further and further variation. A drawing in this

Michelangelo Buonarroti
(1475–1564), MALE NUDE;
pen and ink,
335 × 168 mm.
Louvre, Cabinet des Dessins

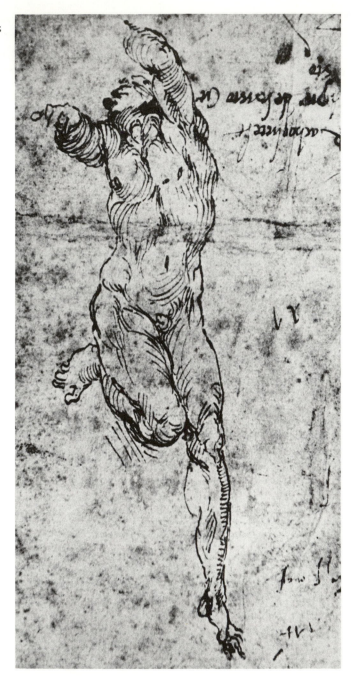

tradition generates lines, linear sequences, enclosures, patterns of darks, both as a system of unity over its variegated volumes and as a means towards variety. It thus follows that within this kind of variation there will also be detectable systems and patterns. So subtle and 'non-objective' are these that they are only accessible to an alert sensibility.

Obviously in a book of this scope it is not possible to analyse more than a sample handful of individual drawings. The reader will be able to develop his own analyses along similar lines; for there can be no doubt that many discoveries are to be made once this topic is fully opened out to discussion.

Iconography and form Early in the book I made a distinction between the iconography of the 'subject' and that of the forms, mentioning Berenson and Veronese's troubles with the Inquisition. Most of the book since then has dealt with questions of form and formal method, and the 'subject' has been mentioned from time to time only where it had a bearing on some aspect of form. Now I must say something in general about the subject in so far as it bears on the question of the meaning of any drawing.

It should by now be clear that the forms in which a subject is clothed are what matter. Drapery in itself is devoid of expression, only the forms with which an artist invests it give it expression and hence meaning. But I mentioned in the first section that a draughtsman's topic consists essentially of what he finds numinous in a given tenor—topic and tenor together helping to make up the 'subject', which his drawing is carried out to praise or celebrate. Thus the tenor, i.e. the collection of bare objects which serves to extend the design across the drawing surface, may have a significance in itself which is not merely iconologically apt. For within the frame of an orthodox drawing format the objects of the tenor may well seem to be engaging in a kind of drama of their own which does not depend quite solely on the way in which they are rendered by graphic symbols. This aspect of a drawing is the easy part which most academic critics and popular writers seize on when they describe and discourse on any drawing. It is the aspect on which poorer artists have concentrated. It is also the aspect of drawing on to which fastens the mind which is shut up within its everyday utilitarian perception conditioned by words. 'The Christ-child is plumper than in X's work; the sky is stormy', etc. Whilst the visual qualities of the forms which indicate the truly visual qualities of particular plumpness or storminess are overlooked, or taken for granted unexamined.

In fact any representational drawing has a descriptive element. That is to say part of the artist's effort is devoted to indicating the presence of significant parts of the everyday world. Of course any description seizes on aspects of the world which seem essential to the describer, and in visual art these are visual aspects. But described objects will carry a significance of their own; and this is where the art-

historical science of iconology begins. Perhaps we should expect that professional experts should look a little further into the meaning of forms than they have done hitherto. It would not be wrong to say that many iconological classics by academic scholars could have been written by blind men working from verbal descriptions of the figures and objects in pictures. Perhaps things will improve soon. For a few scholars are at work in the field of analytical morphology. Anyway, in view of the bulk of the work covering this ground I only intend in this book to devote a short section to the question of the subject as such.

The objects represented in a drawing, as I have pointed out, will provide both a tenor and a context for the forms used, as well as an indication to the spectator where his responses should begin. Since any artist's repertory of forms is limited, this context with its variety is as important to the draughtsman as it is to the spectator. Everyone approaches a drawing with sets of stock reactions in his mind to particular kinds of *objects* (not *forms*) and these stock reactions may constitute a major part of our apprehension of the subject. Everyone likes what *he* calls a pretty woman—and what *he* likes may not be what an artist centuries ago called a pretty woman. The beauties of ages long past may well seem repulsive to modern eyes—the moon-faced fat ladies of T'ang China for example. Therefore one may have to relearn, with great difficulty and purely intellectual effort, one's responses to objective things if one is to appreciate art of the past. And one may very well have to learn a repertory of meanings for objects in order to understand any given composition—what such a jar means in Poussin, such and such a pine tree in a Chinese drawing, what elaborate robes signified in the Middle Ages in Europe, what the orb or rabbit means in a Renaissance drawing, what a map meant to a Dutchman, a book or the postman to van Gogh, or what a certain sort of *putto* signifies, and so on. This can be taken further, by means of the psychological analysis of the symbolic significance of objects represented, and their archetypal values. Such interpretation belongs in the sphere of iconology. And this kind of knowledge can give keys to the regions of feeling to which the forms in which the objects are clothed refer. However, recent events in the arts have shown us that we should not remain satisfied with a conception of the 'subject' which accepts that it is somehow or other composed of straightforward 'objects', like those which our everyday world seems to contain. The situation is both more complex and more interesting than that.

The nature and
overwhelming
importance of the
graphic subject-type
in relation to the tenor

I have here to adopt a special term to indicate what I mean—the graphic 'type'. The subject of a drawing can best be explained as being composed of graphic types. At first sight it might seem that there are two possible ways in which 'type' appears in drawing. First, it can appear in the 'type' of *object* represented. For example, we know that Rubens seems to have been fascinated by a particular type of woman —blonde, pearly skinned, and plump, the volumes of her subcutaneous fat disposed in rhythmic creases and folds. Again, the Rajput draughtsmen of eighteenth-century India devoted themselves to a type of woman which was long-nosed, small-chinned, broad-hipped, small-waisted and had long deeply curved and outlined dark eyes. We find worn by many of Poussin's figures certain types of garments which are classical in appearance and suggest a kind of timeless Arcadian society. Renoir adored a certain 'type' of woman; Leonardo developed a 'type' of effeminate, beautiful youth, and a 'type' of bearded, violent sage with nutcracker nose and chin.

The other kind of 'type' is a type in the sense of pattern, a type constituted by the way in which an artist assembles his basic forms. This is the kind of conceptual type which distinguishes a draughtsman's style—his way of putting his chosen graphic symbols together which one can call his 'drawing-type'. Rubens, for example, runs undulating contours of very varied density over and around his figures; the old Rembrandt scratches and chops out sequences of broken contour and darks. In many relatively primitive arts we find a conceptual pattern serving as a 'type-representation' for all objects of a certain class—virtually a stereotype—so that all women or all birds or all trees look the same. For they are all repetitions of the same pattern of assembly.

On closer inspection, however, these two kinds of type are seen not really to be distinct at all, but to be functionally interdependent. The physical type of woman that Rubens creates is actually the product of an accumulation of graphic patterns, without which the type could not be defined. Similarly, when we see an Indian girl of whom we might say: 'She seems to have stepped out of a Kangra miniature', what we are really saying is that our graphic type-image based on the Kangra art is in many ways congruent with her optical image and imposes itself upon her. Only the existence in our mind of the Kangra graphic type enabled us to perceive the actual woman *as* a type. (There will always be ways in which any individual girl eludes congruence with any type.) For type in this sense is an optical construct, based

upon patterns of form assembled into groups which, because they are used repeatedly, become to some extent conventional. In the work of Rajput draughtsmen the conventions, the types, will have been accepted for a fairly long time unchanged. In the work of someone like Rembrandt the types will be modified year by year, partly because such an artist is continually at work challenging his types in confrontation with nature. In the work of Rubens, by comparison, the conventional types were progressively reinforced with fresh forms developed from natural observation. Thus types in the proper sense are *constructs of form*, based on the methods described above, which have shaped themselves into preliminary provisional unities which together will make up the whole. In this they resemble chapters in a book, or paragraphs in an essay. But in the case of visual art there is one additional factor.

On pp. 24ff. I referred to the analogizing faculty of the human mind, which is continually at work on the visual perceptions presented to the eye and brain. I pointed out that the fabric both of our world and of our art depends upon this continuous activity. One cannot and should not expect at any point to shut it off. Types in my sense represent the assemblage of basic forms which, because of their analogy with other forms of experience on a similar scale, will evoke chains of associated memories and responses. So that, like the lesser forms, they will synthesize emotional meanings which are beyond the reach of words. Because of the general scale and structure of our visual world, some of these provisional unities will tend to equate themselves with what we recognize as objects in the world. And the further assemblage of such unities will help to construct a whole composition. In primitive arts we can easily see that types do not merely indicate objects. But in relatively sophisticated arts types may seem to be much more 'descriptive'. For example, Rubens may seem to be designating with his types that special kind of woman which we call 'Rubensian'. In reality, however, he is actually assembling graphic forms and sub-types relating to our experience of flesh (plus fur and fabric), into structured units. These units can be types which may seem to describe everyday categories of the real. But the truth is that they are graphic constructs, which summarize and condense the psychological meaning of the graphic forms of which they are composed. Once we know an artist's work well, and his graphic types have become part of our mental apparatus, we begin to 'see' his types in the world. We 'see' Rubens's women. We 'see' Samuel Palmer or

Rembrandt landscapes. But this is because we are projecting an already formulated visual construct upon the stuff of the world. We project graphic types to give the world meaning. But what exactly we project the types on to is best described in terms of the 'tenor'.

The tenor can be defined as an objective correlative in the real world which gives the quality of truth to an evolved graphic type. To quote another example, certain kinds of actual girl have authenticated the Sihagiri graphic type. And because there is that graphic type charged with an emotional content ready in our minds to be projected upon it, we feel the given girl as tenor when we see her to be 'numinous'. Because of the way in which the analogizing faculty of the mind works, the graphic types the visual imagination evolves will always seek in our experience of the outer world for tenors upon which to project themselves. We will see in nature the images the artist has prepared us to see. At the same time such tenors can fulfil at least two important functions in art. First, for the artist, they can serve as emotional foci around which he can frame his graphic types, and assemble his lesser grades of form. Second, for the spectator, they can serve as essential keys to the artist's meaning; so that when the spectator recognizes them he can deduce the general region of feeling in which the artist is working, and gain a foothold in it.

I have repeatedly mentioned that the forms of drawing should, so far as possible, cut across the categories of everyday perception. Forms should not tally one for one with objects, or add up to mere descriptions of objects. Now that I have introduced the ideas of graphic type and objective tenor it may seem as if I am going back on what I have said earlier. In fact I am not. For however much it may seem to resemble an object, the artist's type is a purely graphic construct, though the mind's tendency to look for equations between graphic types and objective correlatives can not be stopped. For types need not correspond to ordinary objects, and their tenors may not be things. Certainly, as I explain below, many types may with benefit *seem* to correspond with bodily things. But in fact tenors are not only things, and types do not just refer to things. For example, there are types for representing three-dimensional depth in various ways. Many of the formal methods for indicating space described on pp. 199ff. have been associated with other forms and assembled into broader type-methods by different artists. One can easily distinguish Claude's types for indicating deep space from Rajput types; or Wang

Meng's type of 'dragon veins' from Huang Kung Wang's. Different artists have characteristic types of groups. They have different 'floor'-types, and so on. In fact one of the things that distinguishes primitive from more sophisticated arts is that the primitive *do* confine their types within the limits of what are accepted as specific notional objects. But, of course, they are objects characterized by qualities conveyed in the forms (cf. the Tiahuanaco bowl), and they may be objects which 307 can never be encountered in the *outside* world, at the same time, for there to be true visual metaphor, the memory-traces evoked by a form associated closely with a type-construct indicating, e.g. a feminine breast, must not refer only to experiences of breasts, but to experiences of other objective tenors.

This is the point at which much of the most recent non-figurative art (the names are legion—Morris Louis, Caro, etc.) parts company with traditional and twentieth-century figurative art. The former holds that it is both possible and desirable to abort the mind's direct equation between the graphic type and the objective tenor as an element of the recognizable real. It assumes that to make such an equation is banal, the mark of an inferior mind; and it is indignant at the bafflement of those who ask of non-figurative work: 'What does it represent?' The truth probably is that all graphic types are bound to find their tenor-correlatives. But in the case of non-figurative visual art the tenor-correlatives for each graphic type may not be *singular* but *multiple*. A graphic type may take its meaning, as forms on the lower scale do, not from objects falling within one single category of the objective real (human body; building; tree; cloth), but from those falling within two or more at once (i.e. the meaning of a metaphor lies in a metaphor). This kind of non-figurative art thus demands an act of mental inhibition from the spectator, and always looks for its tenors through, or past, the world of everyday categories of objects. Its objective world is real, but contains only forms of the kind discussed in Chapter 3, which are facts not recognized in the ontology of common speech and thought. Of course, this presents the beholder with terrible problems of approach. He may feel he has no keys to the meaning, no recognizable common ground between an artist of this kind and himself. In this field we may all be at a very primitive stage of evolution.

But even these considerations can lead us further still towards understanding the significance of the apparently figurative graphic type. For the truth is that even those graphic types which may *seem*

to have the closest correlation with single objective tenors (for example, portraits, or landscapes done before the motif) do not in fact refer to those tenors. No tenor is ever the final resting point of the meaning, its terminus. As I have indicated, the artistic tenor is never a single actual thing, nor even a recognized class of things. It is a fact of the world which is referred to for the sake of the sense of 'external reality' or 'positive truth' it can give to the image. For example, a spirit or god is given as tenor the shape of a man. This locates it in the realm of truth. But the essential thing about a spirit or god is that it is *not* human. And so the *type* must have attributes which can never be found among the optical features of any particular human being. This is true even of types which may seem most nearly to correspond with objects. For the type is purely a function of the artistic topic, a structure, not a mere derivative of cold optical fact. The tenor is simply *used* as a vehicle (essential in that role, no doubt) upon which the whole apparatus of artistic expression is projected, via the machinery of types. The point of the Rubens's woman is not any actual woman or class of women, but only the Rubens type with all its meaning in its various contexts; this is a major part of the artist's whole topic. The point of suggesting an apparently objective reality for certain types, as if they were 'things' (like the Rubens or Sihagiri women) is, first, to condense the component subordinate types into a unity; and, second, to supply three-dimensional bodies to the plane surface of the drawing. For, as I have mentioned, bodies are the only basis we have for defining space. In fact, the subject-matter of a very large number of the world's greatest drawings is something apparently objective, yet consisting of 'things' in various imaginary relations which have never been seen and never could be seen. Obvious examples are Chinese dragons hovering over mountain peaks and Hieronymus Bosch's demons doing nasty things in imaginary but convincing landscapes. In a subtler sense most of the extravagant figures in Mannerist and Baroque drawings are all obviously 'types'; yet they would be nothing without the conviction of bodily objectivity given to them by the tenors of human forms, space constructs, and action.

From all this it should be apparent that the whole idea of the type as an essential element in drawn structures runs utterly counter to the notion of art as a machine-like tracing of the optical field, the linear imitation of whatever is placed before the lens of the eye. Structure is everywhere of the essence; the type is an indispensable ingredient in

structure. The ground it covers may vary; there may be 'layers' of types in a composition. But without them semantic wholes are not made.

I should perhaps make one comment here on the way I use the word 'type', so as to relate it to another use which may seem more widely accepted. Type in my sense, the graphic type—i.e. a Watteau gallant, a Rembrandt landscape floor, a Chinese gorge, each in its drawn entity—may be either general or particularized. The normal usage of the word 'type', with which my usage may seem to be in conflict, suggests that every type is a 'typical' representative of a class, presenting the salient distinguishing characteristics of the whole class. For example, a 'typical fish' may be represented by a generalized drawing. And this typical (generic) fish will be distinct from any individual fish. The typical and the individual may seem to be in-evitably contrasted. However, in my use of the word 'type' in an artistic context individuality is not by any means excluded. Certainly an artistic type in my sense may refer to general categories of visual phenomena. Most primitive arts will refer by their type-construct only to general categories of objects like the generic fish. But there are also arts of drawing which include into their type-images indications of individuality, symbols which serve to represent the idea of unique-ness. Most Western art after about A.D. 1420 (earlier in some parts of Gothic Europe) includes in its type-constructs such indications. They are permitted by a kind of flexibility in the type, which allows latitude for variation within its construction. The type may not be strictly generic; but it is still a type. Whereas, say, an early Romanesque Christ in Glory is supposed accurately to repeat in all its lines a standardized pattern, a Baroque Christ may include into its type-image the concept of *ad libitum* variation among the terms of its formal language (as well as type-images for space and relationship). So that its Baroque drapery-forms are specifically required to differ from those of last year's Christ, and at the same time to suggest the infinite variety of the actual; its facial type must *not* resemble some other master's, and must incorporate the image of personal individuality as one of Christ's human traits. Furthermore, arts made according to metaphysical ideas which give a place of importance to the particular and individual will find symbols for particularity and individuality, defining the hexeity, the unique form of Being. Such symbols will consist of suggestions of the accidental, occasional, and idiosyncratic in persons, places, space, and light, along lines suggested below. The

danger in this, that not all draughtsmen have escaped, is of weakening form for the sake of the individual characteristic.

There arises here a further consideration, one which the great Chinese poet-painter Su Tung Po discussed. Amongst possible types there are those whose forms are relatively fixed, for example buildings and the human body—or if they are not actually fixed they may seem to be, because of the pressure of fashion. And then there are those whose forms, whilst still belonging recognizably to the type, are relatively free. A human arm must be about the 'right' length, and always have its muscle-lumps in similar places so as to 'look correct', i.e. norm-al. But a rock has no such norm, and a tree can proliferate in any direction, have broken branches, have bumps and twists virtually anywhere on its anatomy, and still remain—even scientifically—the same type of tree. Chinese art held that in fact the first kind, the fixed forms, were idealist illusions, and always recognized the second kind as the most interesting and aesthetically important, for it signified that the object was an actually unrepeatable event. The Chinese artist treated even human figures as if they were trees, valuing the eccentric far more highly than the narrowly typical. And so Chinese scholar-drawing—and after it the Japanese Bunjin-ga—being interested in the moving spirit of its forms, always avoided the assemblage of defined parts even whilst using the idea of the 'type' quite consciously. European drawing has almost always been dominated by the rigid type, and has even sought it expressly through the cult of Classicism. The closest it came to the Chinese idea was in some of the work of the great anti-classics, like Rembrandt and Goya, and in some of the drapery inventions of the later Gothic like Grünewald's; for drapery can more easily than most of the European notional realities come into that second class of 'free' forms.

Perhaps the most important thing to remember about the apparent subjects of drawings, their graphic types, is that they are not, and cannot be, an artist's sole property. Only scholars now usually remember that all the great masters of all countries in the past, until well on in the nineteenth century, relied heavily upon pattern books, and upon collections of copies or engravings for basic visual ideas, for example the Hercules, the leaning philosopher, the Bacchante, and hundreds of others. This, however, names only those thing-like types which can be named. Such types, and the others, they altered and adapted to their own purposes, using them as nuclear type-images into which to project their formal constructs. Only since the older Turner and the

Plein Air school of the 1860s and '70s has the use of patterns come to be frowned on. (At the end of the eighteenth century Choffard engraved, for the catalogues of the Vente Basan, the typical artist seated among his sources, chief of which were albums of old and modern prints.) We know well, for example, both from Michelangelo's jealousy about his drawings and the burglary of his studio, and from the scandal surrounding the theft of Guglielmo della Porta's *modelli*, that every artist needed and depended on a stock of ideas, and that some artists were willing to go to any lengths to acquire one. No artist ever expected to be the originator of all of the ideas he used; though his personal skill with forms would naturally modify any which he did take up. His own original inventions simply added to his available stock of types. Just as the types and topics of literature have continually changed, so too have those of art. The types of subject-matter vary, becoming more or less rigid, according to the fluctuations and revolutions of taste. Today once more we seem to be in an era of rigid and narrowly prescribed types. This question is deeply involved with the 'rules of drawing' as they were understood in the eighteenth-century Western academies, and with the different kinds of drawings, as they will be discussed in the last section of the book. The issue has been complicated for Western art theory by the intrusion of standards of optical truth set by the machine.

The type seems to be the most comfortable and appropriate unit of thought for most artists. One might say that the meaning of a drawing radiates both upwards and downwards from the graphic type: upwards, in that the composition as a whole is formed by combining graphic types; downwards, in that the clothing of expressive forms of the kind discussed in Chapter 3 can be varied according to the special context and meaning of each particular occurrence of the type. The essential point is that draughtsmen tend to work by composing the types which constitute their repertory. They embody and vary them, combine and re-combine them according to all the methods described above. They may amplify them by making detailed studies from nature. They may extend their repertory by learning from other artists. But at bottom an artist's drawings—and modern artists are far from exempt—are made up out of a limited number of type-elements, which are a vital part of the system of meaning and its communication.

In the realm of words no one, not even the greatest poet, ever creates the entire substance of what he has to say from scratch. He uses and extends established units of thought. The visual artist de-

pends upon his types in the same way. They identify his topic for him and provide a vehicle for his structure and invention. They are the means whereby the artist refers to meanings already implicit or formulated in previous works of art. The draughtsman may have inherited his stock of types from his tradition, and may use it timidly, repeating other men's thoughts. But if he is a major master, he will develop substantial modifications of his types and perhaps add substantial type-ideas of his own from his observation and synthesis of forms and meanings. His types define for each artist what to him is artistically present or valid. If there is no type for part of a subject which he feels demands expression, so that it does not yet exist artistically, a great artist will develop one. And generally the fact that a type exists indicates that correlative facts of the real world are the location for value and meaning. For example, Archaic Greek drawing has no types for landscape with its airy spaces, though it could represent river gods, and city deities. All its tenors were human. Medieval drawing emphasizes not the nude body, but its robe-types, which for the Middle Ages were symbols for a very special kind of glory, which was its topic. Michelangelo made an especially obvious use of the type; virtually every one of his figures, male or female, is a version of the same human bodily pattern.

One of the functions of a clearly recognized classification of types is to ensure variety. This can be seen very well in the technique of Chinese landscape drawing. We know that by the end of the seventeenth century sets of stereotypes for this tradition had been systematized in published woodblock-print books, such as the famous *Mustard-Seed Garden* and *Ten Bamboo Studio*. But it is obvious that these were merely fossilizations of what was, in fact, recognized practice among the artists. The types of tree were distinguished and classified, as were the types of rock, mountain, building, bridge. (So, too, were the techniques for executing them.) Following this procedure the draughtsman can be saved from falling victim to the single type (as, for example, Gainsborough did with his trees). The artist learns the different patterns, practises varying them; and when the time comes to execute a drawing he is able to range through a wide field of forms. And if he belongs to a society which attaches value to the observation of natural phenomena, an artist's familiarity with the inexhaustible modifications of nature may continually re-vitalize and vary his types. Each individual piece of drawing, in so far as it is a structure, involves a more or less intensely imagined combination of versions of the

秋
林
式

artist's types. It is also clear from the drawings which have survived
that throughout European history one of the functions of drawing
(and of engraving) was to record and transmit from one artist to
another the growing and changing repertory of available types. And
this makes the important point that such types are not a hindrance to
an artist, but an immense help. All artists down the ages have been

255

anxious to learn and assimilate fresh types which will be useful to them. If they do not, their work remains narrow. For the truth is that no one can work without them. The situation today is just the same.

It is, however, also true that certain types can become suffocating to artists as their social horizons and knowledge of art change. The history of the classically proportioned nude types in European art is a case in point. One can watch the Italians of the generation of Brunelleschi and Donatello attempting to fix them; then the Italianizing artists of post-Renaissance Europe making strenuous efforts to acquire them. Dürer's proportion system, on which he laboured so long and hard, was intended to help northern artists to assimilate them. For these types are a matter of a proportioned assembling of standardized bodily components. Engravings distributed all over Europe from Italy and Flanders during the sixteenth century enabled every artist to absorb classical ideals of 'Beauty', interpreted usually in Mannerist guise. Many great masters accepted them gratefully. Masters like Poussin extended them to the limit, purging them of their Mannerist extravagance, combining them with a vast collection of supporting classical detail and developing a huge variety of spatial and movement types with which to weave them together. During the eighteenth century the Academies canonized special forms of them, with the aid of archaeological research, into required rules of proportion and manner which would ensure beauty. Le Brun's *Traité des Passions* (1698) contained sets of engraved facial expressions for conveying the stereotyped passions, based supposedly upon Classical originals. These were widely distributed, copied, and used by hundreds of artists. But there were always a few masters who stood out against the imposition of these Classical types, preferring to create their own both by direct observation and by studying other, non-Classical arts. The chief of these was Rembrandt. His nudes, both drawn and etched, are violent rejections of the Classical types. The earlier ones are deliberately and passionately 'ugly'. The later ones are often quite wrongly called Classical. They are not Classical at all, though the composition of the designs is based upon the two-dimensional rectangular relationships used by many Italian artists and learned from them by Rembrandt. Velasquez and Caravaggio are others who avoided the Classical types. The eighteenth-century 'akalophils' ('lovers of the ugly') are supposed to have influenced Goya. These cultists went so far in their hatred of conventional 'beauty' as to wear on their own faces expressions adopted from

Leonardo da Vinci's drawings of grotseques—types of a different kind!

From this it will be clear that major masters tend to be masters of their own types, not servants. But even Rembrandt, Velasquez, and Goya created their own unmistakable types, physical types as well as those far more intangible formal ones. And other masters have done the same. The strength of a tradition, the rebellious individuality of the masters, and what the artist's public expects, all help to determine the *character* of an artist's types—but not whether he uses them or not. At the same time it is most important to remember what academic art, old or modern, always forgets: that what matters is not the mere 'possession' of dead types, but what is done with them in terms of expressive form, and how they are combined into a meaningful whole.

In this connection one has to question the role of natural observation. We know that innumerable draughtsmen have made direct studies from nature for a variety of different purposes. And the Plein Air school of late nineteenth-century France, with its later followers in other countries, even decreed that all drawing should be from the object. This, however, must rate as a special phenomenon, localized in time and place. At the same time it is quite clear that even this school, in its choice of subjects, came to adopt types which were in part of its members' own devising based upon transmitted patterns, in part an inheritance from their common language of form. Delacroix referred in his diary to nature as a dictionary. One does not write prose or verse by copying out the dictionary. One consults it to amplify one's resources. This certainly was how the majority of draughtsmen before the nineteenth century treated nature. They made drawings from models and landscape as an aid to their invention in their thorough-composed works. And usually the drawing from the natural object was made *after* the general pattern for the object's place in the final composition had been laid down. This is tantamount to saying that drawing always originates in the imagination, not in the object. The whole question will be referred to again in the last section.

Ontology and form There are, as it were, two ontological poles between which different arts can be placed. At one pole are the arts of closed societies, which have a strong sense of the numinous and take its reality for granted. Both artist and public readily accept the truth of their art, which refers to complexes of unanalysed feelings that are shared and accepted by everyone in the society. They are closely associated with

and repeatedly invoked by stereotypes related to single objects, of which no one doubts the 'reality' or truth. The tenor need not be stressed or discursively amplified. The forms in which each type is conveyed can thus be few, strong, and general, and still carry complete conviction. This is probably because early in human history natural objects were the original location of numen, and when humanity learned to portray its numen in graphic symbols, even though it did not delineate the object *qua* object, it remained attached to the conception of the single object-tenor as defining the only possible graphic type. Such types enshrined the magical function of art. In Indian drawing of all ages, in Persian and Japanese drawing, in European early medieval art, one finds types closest to separate things heavily predominant.

At the other pole the artists of sophisticated, multifarious, and open societies may have to work very hard at creating a conviction of reality for the numinous conceptions they recognize and are supposed to convey in their art. A simple, condensed type will not do. To be 'realized' for such a society the numinous subject must be invested with the highest possible degree of reality. The types of all kinds must continually appeal to many tenors in actual experience. The subject itself may even be a symbol for the 'ultimately real' (as in strictly religious icons). A wide range of types representing all the accepted existential ground needs to be evoked and clad in a large repertory of forms symbolic of the accepted extent of Being. This adds to the central numinous image a whole current apparatus of visual reality. It becomes necessary to create a visual image of the world which is itself a definition of its own existence.

All drawing styles which stand near to the second pole seek a highly developed system of visual ontology. Sir Russell Brain has pointed out that the world of perceptions a man gains through the sense of sight is not limited to purely visual apprehensions. The types which suggest a thorough-going objectivity in a work of visual art can arouse in a relatively wide audience responses belonging to other senses than the visual—kinetic, olfactory, tactile, even auditory—provided the objective suggestions are strong enough. We are meant to experience auditory echoes of the music in an Indian 'rāgamālā drawing, which is intended as an illustration of a scale and its characteristic expression, just as we are meant to intuit the sounds of Baroque angelic orchestras. We are also meant to experience the touch of skin, feathers, fur, and silks in Rubens, Boucher, and

Watteau; the smell of perfumes in some courtly works Western and ²⁷⁰ Eastern, more unpleasant smells in certain offensively suggestive Dutch drawings of the seventeenth century. Such amplified sensuous suggestion must be the prime reason for all thorough-going objectivity in subject-matter, as one finds it in Titian, Rubens, Poussin, Watteau, and Delacroix. Contrary to the commonly held critical fallacy that such masters were, like nineteenth-century academics, out to deceive the eye alone, they were in fact intent upon conveying vivid impressions of many sensuous kinds. An often quoted statement by a Marquesan (primitive) wood-carver illustrates the polarity of evocative suggestion very clearly. He is supposed to have asked (apropos of pictures of Western art) what was the purpose in making something that looked like a woman if it did not smell or feel like one. My point is that a good work of sophisticated art may very well suggest the smell and feel of a woman through its evocative forms—and many other sensuous aspects as well.

The pattern-types used in those arts which lie nearer the first pole may, as I have said, remain at the level of visual stereotype. Such types are often called 'conceptual presentations' as distinct from 'optical presentations'. They are predominantly profile images, or images of the object in its greatest *two*-dimensional extension. A Palaeolithic cave bison, for example, may even lack its two offside legs.

However, I must emphasize that the purely two-dimensional spread is always stressed even in the most sophisticated styles. For example, a chief characteristic of Ukiyo-e drawings is that it uses all ²⁰ its elements—limbs, bodies, clothing, heads—in their longest two-dimensional extension. It thus needs very interesting dislocations to carry through complicated figure-designs, as in the erotic Shunga. This, at the same time, places the bodies firmly in their own space, denying its link with ours. Moreover, even those drawing styles, like Michelangelo's, which do seek to emphasize the link between our space and the drawing's space, in fact spread out the members two-dimensionally, reserving their foreshortenings for features whose special function it is to display them. Except in the case of extravagant *sotto in su* effects, or in *tours de force* of foreshortening, formal invention can be reduced to banality by too much use of elements shown in their narrowest two-dimensional extent, rather than their broadest. Moving away from the first pole, most early Rajput or European medieval drawing uses pattern-types close to objects additively. The type for a male figure may be placed in apposition to a type for a

female, joined to it by a negative defined area, without any sustained attempt being made to reconcile the two by using further types for suggesting visual space. Such conceptual art remains in a way within range of the hieroglyph in that it depends on the spectator's having fully fledged stock responses ready to be evoked by the sight of the conceptual types. He will not demand to be convinced of the visual space in which the event takes place.

Between the two poles, the conceptual type and the thorough-going visual objectivity of the major European masters mentioned above, all degrees are possible. For the truth is that all representations are actually conceptual, i.e. types. But when artists and their publics are no longer content with their traditional types, they stretch them with sophisticated modifications, such as *contrapposto* or anatomical foreshortenings; combine them with others; adopt exotic types (for example, Picasso in 1907); or they may try in the face of nature to condense fresh types out of their repertory of forms. The wealth and character of the graphic forms in which the types and subject are clothed determine a drawing's place on the scale between the poles. Types of all kinds can serve as recognition signals and act as triggers or keys to groups of responses. In a conceptual style of drawing the conventionalized two-dimensional glyph is easily recognized and accepted by the public in an integrated society; whereas more diffuse and fragmented societies need continually to be persuaded of the truth and value of their types by means of an elaborated apparatus of optical devices.

There must be some correlation between the realism of drawing types and contemporary traditions of theatrical presentation. Historically there is a clear connection between those styles which devote themselves to a dense optical structure and traditions of tableau, masque, and drama in which living people play out the same sort of roles as human figure-types enact in the art, surrounded by the properties of everyday life. Likewise, traditions with strongly stylized theatre, especially puppet theatre, tend to frame their art in more stylized, conceptual terms to which the public has well-established stock responses. The connection between Baroque art and the Baroque theatre of machinery and miracle is well known. However, there is room for a great deal of further research on this matter.

One can summarize the relevance of these facts to the question of the subject in terms of significant types of human gesture, posture, facial expression, and implied movement. One learns the significance

of these as in the course of acquiring the mental stock of types, partly from theatrical and graphic art, and partly from our experience of encountering the expression-types used by actual people to express their actual feelings. The meaning of these types is a reflexion of past experience just as is the meaning of the lesser graphic forms. Of course it is natural that peoples with a wide repertory of 'theatrical' gesture, which they use in their everyday life as well, will make a feature of such expression in their art. The Italians are the most obvious example amongst European peoples. It is more than likely that modern northerners, who know nothing of the Italian language of gesture, do not understand the intended significance of Italian Mannerist drawing at all. On the other hand peoples who are accustomed only to a very restrained language of gesture and bodily expression in their daily life will create arts in which this element, the types of bodily expression, is absent. Nevertheless, as we have seen, such peoples, like the educated Chinese and Japanese, may very well have a highly developed sense of purely *graphic* gesture with the brush.

The 'address' of
subject-types to the
spectator

A related aspect of the notional subject can often be recognized in particular cases, but its role as a general principle is not usually understood (incidentally it is one of the major expressive resources of photography—still and moving—as well as drawing). It is this: the way in which any subject-type is drawn will suggest to the spectator that he occupies a particular stance or location in space in relation to that subject-type. For example, many of the religious or royal figures in Counter-Reformation Baroque art are drawn as it were from a low viewpoint, so that the spectator is reduced either to a lower 'floor', or at least to his knees in relation to them. He is made to feel small. This effect is greatly exaggerated when figures for a high-placed decorative scheme, or even a *sotto in su*, appear to stand on a floor whose surface is entirely hidden from us. In contrast certain intimate drawings by late nineteenth-century artists of domestic scenes, such as Mary Cassat, may show a group of a mother and child seen close and from slightly above, as if the spectator were standing intimately close looking down at them. In fact the draughtsman may have stood in such a position to make the drawing from an actual subject. We feel with the drawing of *Saint John the Evangelist* in Madrid by El Greco that, although technically we are face to face with the saint, he is 264 'seen', as it were, somewhat from below and elongated, so that he appears to be surveying us from a commanding height. In Goya's

261

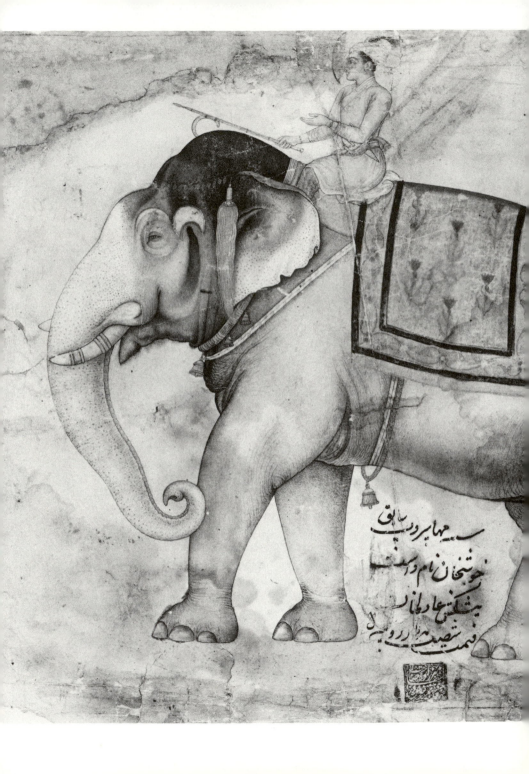

PRINCE DARA SHIKOH
ON THE IMPERIAL
ELEPHANT, NAMED
MAHABIR DEB, *c.* 1630;
brush drawing in Indian
ink tinted with gold and
watercolours, 16½ × 13 in.
Victoria and Albert
Museum. Crown Copyright

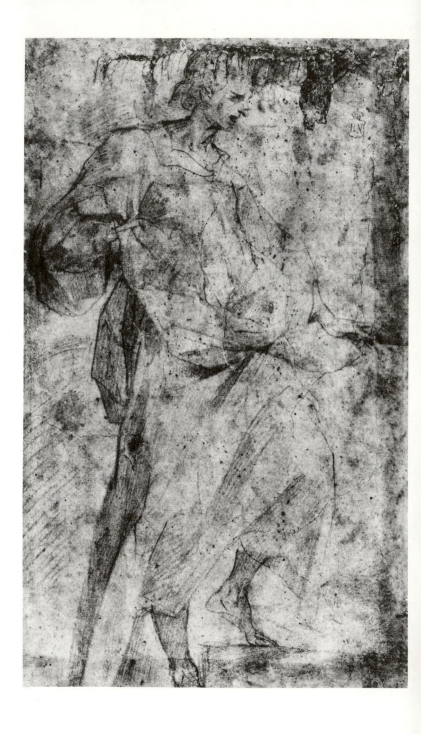

drawings we find a great variety of induced postures for the spectator, sometimes high, sometimes low, all within what may be called the possible range of normal vision, but nevertheless each meaning something. We should be aware in all drawings of the way our apparent posture *vis-à-vis* the figures affects our response. Depending on the relations of format and treatment we may seem to be intimately close or politely distant. And in certain notional situations there may be a very special significance in the attitude in which the figures of a notional subject allow us to catch them. For example in Pascin's subtly erotic drawings we are permitted to be 'standing over' or 'sitting on the floor' very close to girls with their legs casually parted, wearing almost nothing. Therefore we must always estimate carefully in our own minds what is the significance of our posture as spectator in relation to the subject as observed.

With landscape as subject there are also possibilities of expression by means of suggested posture for the observer. Usually in Western landscpe drawing the 'normal' eye-level viewpoint is so widely accepted that it seems natural and inevitable. This itself has a meaning. But even here the landscape location can suggest to us that we occupy a place in wild nature, for example, remote from city life and its tumult; or perhaps a pleasant spot in some tourist's paradise like the Roman Campagna (Paul Bril, Turner). However in some oriental drawing styles more pronounced effects are created. Very commonly in Chinese art the high horizon and the long vista of mountains and valleys can suggest that we occupy the posture of one of the 'shan-jen' ('mountain men'), Taoist hermits who seek immortality in the clear, cold air of the mountain-tops. Inscriptions on pictures make it quite clear that such an effect was consciously sought.

This brings in another important aspect of the figurative subject which it has long been fashionable to despise, or to pretend it doesn't exist. The figures in a drawing may seem to 'address themselves' to us in a particular way. One of those ways will be to treat us as if we were not there, as if the scene was going on in its own right and no 'observer' was present at all. But this is far rarer than we might imagine. It may occur in some Dutch or nineteenth-century drawings. Cézanne, as part of his purpose, eliminates completely any personal contact between his figures and the spectator; whilst Chinese and Japanese drawings may show 'scholars in nature' who are quite 'unaware' of the existence of an observer. But far more commonly we find in the work of all the great draughtsmen of the Renaissance,

Mannerist, and Baroque epochs—and, be it noted, in that of the draughtsmen of India and the Buddhist Far East—that the figures are in fact disposed over the ground so as to present themselves theatrically, as if they were participating in a spectacle produced by a careful director for the spectator's benefit. Spaces are thoughtfully opened to allow views of what goes on behind; legs and arms are extended in the picture plane so that their gestures can best be understood. All of this confirms that, as I have suggested, the arts of theatre and figural drawing were often closely linked.

There are, however, many drawing styles in which the figures definitely address themselves to the spectator as a person. We can explain it best by looking at work after 1850. For example, many figures in drawings of the late nineteenth and early twentieth century definitely look at the spectator almost as if they were speaking to him, or at least including him in their conversation. When the figures are undressed ladies this does have an unequivocal significance. And even when such ladies happen to be relaxing or asleep the style can often suggest that we are on intimate terms with them. It can also, by smooth, undeveloped finish, suggest 'don't touch, this isn't real'. It is interesting, and significant of his personal attitudes, that only very rarely indeed in Toulouse Lautrec's splendid nude drawings does one meet one of the subjects face to face. Even highly intimate subjects are treated very much as scenes in which the spectator is not actually involved but only present. On the other hand Pascin's and Modigliani's girls show themselves very much as if sexually involved with the spectator. Renoir's may be glad to be admired but otherwise self-sufficient. The figures in many of Constantin Guys's great later drawings display themselves at a reserved distance. Much work of Picasso, Léger, and Matisse is actually based on experiments with or fragmentation of this kind of 'presentation' of the observed to the observer.

It is possible, I believe, without solecism to carry this kind of interpretation back somewhat in time, and according to its degree and quality to appreciate the effects of almost all drawings. For example in Ingres's portrait drawings we are very often meant to be encountering the direct and social presence of the distinguished men and women whom he drew—and whose acquaintanceship he personally prized. Murillo's Virgins and Saints can almost be 'speaking' to us like visions. Many Baroque icons address us directly *de haut en bas*. We may be less closely involved personally with Rembrandt's sitters than is

[?] Pieter Brueghel the Elder (*c.* 1520–69), TWO RABBIS; pen and brown ink over black chalk, 152 × 195 mm. Colour notes: *gris bondt* (grey fur); *witte doeek* (white scarf); *rode strepen* (red stripes); *purpur-re rock* (purple dress); *nar het leven* (from life). *Städelsches Kunstinstitut, Frankfurt*

often imagined by the 'psychologizing' interpreter, for they usually seem to be wrapped in an intensely personal interior vision. But Byzantine icons are definitely meant to cow us by the unblinking direct stare of their emphatic eyes. And whilst late Hellenistic and Roman images may swim in the same sea of 'necessity' and 'being' as human beings, and thus be seen as presences engaged in their own affairs, Archaic Greek figures, so far as I am aware without exception, look only—and then not always—at each other. They are enclosed within the frieze-like eternity of their own world of legend. And so one can continue to speculate—but with adequate caution and care for *all* the expressive factors of any style.

Relation of graphic forms to subject-types A very large part of the meaning of any drawing derives from the relationship between the notional subject, and the garb of form and type in which it is clothed. Instances of this have cropped up throughout the book. The fact that it is a face, with eyes and mouth, which is treated *so* is an essential part of the total image. Whether the legs are combined into a single symmetrical enclosure, whether a drapery is taken as a block with surface lines (Giotto, etc.), as a three-dimensional surface (Leonardo da Vinci), or as rippling lines (Daumier), whether hair is a cap-like unit or an assemblage of positive and negative forms—all these determine the qualities of the spectator's experience. In Picasso's drawing one may see abrupt transitions from highly three-dimensional forms to flat areas, even within what is supposed to be the same notional body. Without the 'body' the effect would fail. The same is true of the multiple aspects of a subject, e.g. profiles from different viewpoints which Cubism is said to have woven together. Without the basic idea of a notional reality upon which they are focused—bodies—they would have lacked all conviction. For though the forms present the qualities without which no substance has any existence, formal qualities without an implicit substance given to them by the supposed tenor cannot be related to each other so as to condense an image. It is the notional substance of the subject which anchors heightened and fugitive qualities into the realm of meaning, giving them context and emotional force. This Klee has amply demonstrated by the way he adds clues, like a pair of eyes or feet, to his shapes, and gives objective titles to his works. In a sense this consideration amounts to a definition of 'the image' which is of so much concern to serious artists today. It provides, as it were, the

focus for the projection by the artist of all the essential qualities of his numinous icon.

The twentieth-century revolution in art seems primarily to be a matter of re-locating emotional qualities in notional subjects. In traditional drawing particular formal qualities have been restricted to particular segments of the notional subject. For example, in the past only draperies have been permitted to undulate and flutter, only lamps or the sun to cast shadow, only flesh to be roundly soft, only stone to be stereometrically hard, only things normally encountered together (within the limits of myth) to meet. In modern art, however, eyelids, cheeks, arms, bottles, and buildings have been permitted both to do irrational things and to encounter each other across the borders of the notional and the actual; a real tin may sit in a notional environment. The search for 'modern' subjects seems also to have been carried on partly in order to escape a too rigid and repetitive association between objects and their conventional qualities. However, in many modern attempts to associate qualities, which the older logic of substances would not allow to combine, the image has either been lost, or become itself the mere echo of a diagram of someone else's art—mathematical, photographic, or commercial.

The expression of details The details of the subject as such can convey powerful feelings and impressions, which are, of course, embodied in the forms. There is a huge range of possibilities for interpretation here, some of which have been the subject of statistical investigation by academic theoreticians. All I can do here is to indicate some of them. For example, if the ends of its draperies curve upwards instead of hanging downwards, this conveys the impression that a figure is floating (China, Japan, Grünewald), probably in the heavens, with a breeze rising beneath it. Most of the figures in Michelangelo's works suggest to the medical eye that their muscles are in a state of complete contraction, a fact which is responsible for a good deal of their effect. Important in European drawing of the post-Renaissance period are the expressions on faces, which convey intuitions to the spectator about the supposed psychological state of the subject; and it should be remembered that such observation is very much a local and limited one. Expressions have not mattered in this way to other people at other times. In much of the best European drawing of the same period the chains of bodies which I have described on pp. 178ff. have been linked across open space by gestures.

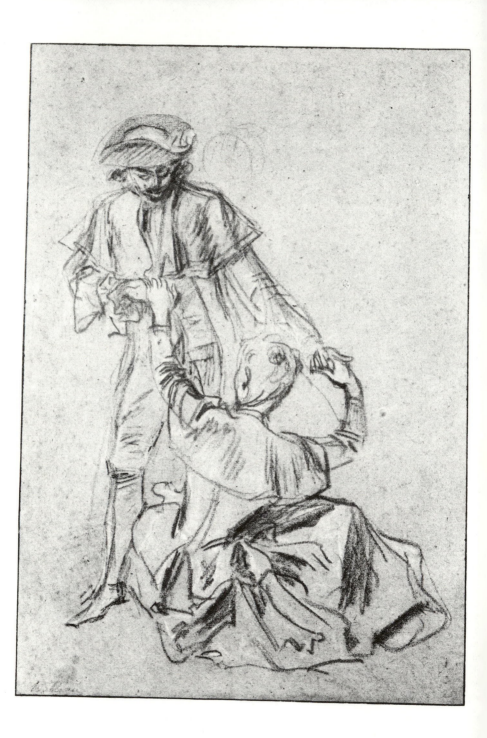

To come down to details. A solid object leaning against a vertical face will suggest a response in the spectator to a certain type of stress. So too will a mass reposing on a spreading, soft-looking volume. Objects or figures obviously out of balance can evoke uncomfortable feelings, with or without suggestions of probable collapse. Something freshly broken or cut, something eroded in shape suggesting a finished form eaten away by time, something heavy in relation to its support, or propped or twisted, something containing something else—all will convey their own impressions.

Movement, time, and It is in the sphere of time that most of these suggestions can have their
moment in the subject greatest effect. Quite apart from the question of the kinetic expression of lines there are other means whereby time and movement are conveyed in drawing. There are, of course, those 'swish lines', derived from photographs of moving objects, which are now universally employed in comics. One also reads the kinetic intent of whole figures, as I suggested in the chapter on space. And then there is the device common in Eastern and European medieval drawing of repeating the same figures several times in a single composition, engaged in different phases of an action or event. But most important is the 'Classical moment' and its many derivations.

This name comes from the sound observation made by Lessing that in Classical art (as he understood it) the figures were posed as it were at a moment of time between one preceding intelligible movement and another succeeding one. We are able to read these movements by means of our own sympathetic responses to the posture, the implied movements of drapery, musculature, and interrelation of the figures. This 'moment' is of immense importance in the whole of European art which came under the influence of Classical styles, and in art of the Renaissance and after. A drawn composition by Poussin is full of patterns of implied movement indicated by the 'moments' of the figures (which are nevertheless firmly combined into a flat conceptual design). In contrast Piero della Francesca's figures usually seem not to have moved recently or to be going to move at all soon—thus reinforcing the atmosphere of stillness and serenity. Again, it is possible for Baroque figures, which have all the appearance of violent movement, to convey nevertheless a frozen impression. This is either because the movements preceding and succeeding the moment they embody are unintelligible, or because the gesture is so extreme that there is no further point of expression to which we can imagine it

271

progressing. Such moments are to be found sometimes in Indian, Persian, and Far Eastern drawing as well; and here too it may well have been absorbed from the late Classical influence to which the art of those regions was subject. But it is not found in most primitive art. And to the eye accustomed to reading the significance of the 'moment' the special qualities of figures posed for all time in a single posture convey a very definite impression—especially where the posture, though static, is also highly expressive, as, say, in certain drawings by Grünewald.

It will be obvious that this whole phenomenon of the Classical moment is related to the anthropomorphic suggestions of the subject-matter. For the prime subject for such art is man. Since Neolithic times we men have nearly always been most interested aesthetically in ourselves, clothing our numinous concepts in anthropoid images. We read from the outward signs of the posture which each human figure in a design occupies the feeling by which the figure is supposed to be possessed. Before dramatic compositions filled with figures we react sympathetically to a whole sequence of attitudes and move-ments, and taste inwardly our own experience-traces of the emotions we recognize in the actors in the drama. A purely symmetrical single figure confronting us, a Buddha or Christ, invites us to experience the subjective content of that equable posture. Once again, to experience internal attitudes fully needs a good deal of time, as well as sym-pathetic effort.

With landscape drawing the situation seems to be different. We are not given moving figures which evoke memory-traces of our own felt experience, but we are offered the opportunity to occupy the posture of the artist, to look out upon a reality through his eyes, seeing it in the emotional tones which his forms give to it. It is interesting that many European landscape draughtsmen and nearly all Far Eastern artists include in their drawings a reminder of the human presence. In Western art this is usually in the form of people somewhere in the picture; in Far Eastern art it is usually a picture of the gazing poet-scholar himself, with whom we, as spectators of the magnificent land-scape, are meant to be identified. But in the work of the great Ni 21 Tsan there may be no trace of humanity, or at most a hut—a hut we are supposed to occupy. There is, however, an important difference between the Western outlook upon landscape and the oriental.

The Western view is apparently visual. That is to say, the emotion and meaning-content of the drawing are conveyed picturesquely.

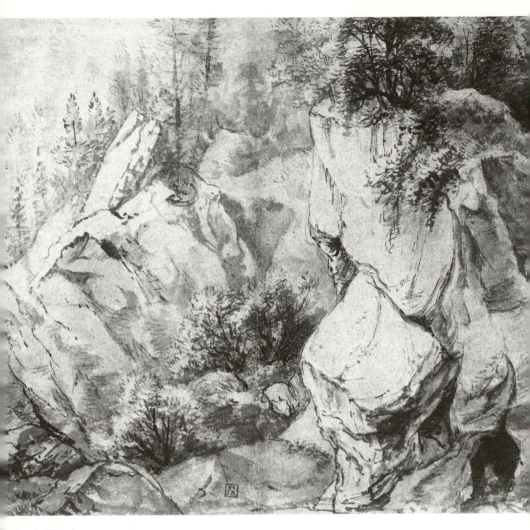

Anthonie Waterloo (1609?–1676?), A ROCKY, MOUNTAINOUS LANDSCAPE, 17th century; brush and black and grey washes on grey paper, 350 × 415 mm. Fogg Art Museum, Harvard University. Bequest of Charles Alexander Loeser

Usually we seem to be pure spectators of landscape, confining our emotional response to an outward appreciation of the visual symbols and structure. With Far Eastern landscape drawing there is a further element, similar in quality to the Classical moment. According to Chinese religious and medical belief the world and man are congruent, if not identical. The spiritual energies of man are identical with those of the outer universe. Therefore the artists have always expected that the spectator will be ready to attune the movements of

his spirit to the cosmic movements circulating through stones, mountains, clouds, and trees. Whereas the Western spectator identifies in himself traces of human feelings from the implied movements of human figures, the Far Eastern spectator of drawing experiences spiritual movements evoked by the forms given to mountains, rocks, trees, and flowers. These movements the artist is supposed to have captured from this cosmos; they are not merely human feelings. The slow impulses which formed and bedded earth and forced its plants, recorded by the drawing hand, will find their echoes in his own body. Thus he will be able to savour the processes of adaptation and change which govern the formation of the world and society, symbolized in types framed by the brush.

This, of course, raises the question: To what extent was this done in European drawing too? There can be no definite answer: the theoretical and documentary basis is lacking. Western art tended to personalize cosmic forces; in so far as the expression of such figures is personal, it seems that we must read their expression as allegory. But Romanticism of a Wordsworthian type may well have been present more often than is usually admitted in landscape drawing. We may well experience the expression of the forms in works by great landscape draughtsmen like Seghers, Rembrandt, and Leonardo not only as images of order, but also as images of spiritual movement in the outer world. But perhaps the most interesting issue arising is this: since cosmic forces such as the zodiacal signs and the deities of nature, including the seas, rivers, and woods, *were* personalized, and since in such art of classical inspiration we are bound to read what must seem to be the personal feelings of these anthropomorphic figures, are there not philosophical implications concerning the interrelationship of world and man to be drawn from art like that of Poussin and Titian which were never permitted to appear within the framework of orthodox European theology?

It is perhaps sad to realize that this Classical idea of the three-dimensional subject filled with intelligible 'moments', integrated into a taut flat design, degenerated into the mere 'story' of eighteenth-century history-painting and nineteenth-century *salon* art. It should not be impossible to rediscover and explore its potentialities in modern terms once its tone-scope is realized.

The value of figure-groups Another way in which the expression of the subject can contribute to the meaning of a drawing is by the close grouping together of human

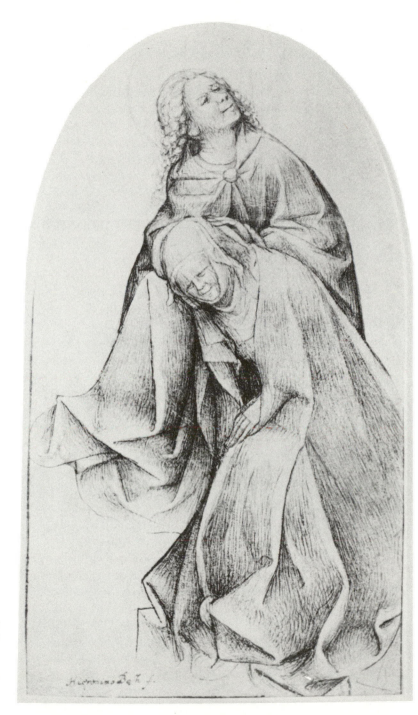

figures so that the expression of the group as a whole takes on a special force. In fact such a group of figures can be developed so as to express refined intuitions. At bottom it will be constituted and bound together by many of the methods I have discussed in Chapter 3. Yet the recognizable human types which go to make it up, and the types of graphic relationships set up within the group, will contribute very much to the expression of the drawing. Amongst our illustrations there are a number of human groups with very diverse expressions in which the meaning of the subject plays a very important part. In the Poussin drawing for *The Rape of the Sabines*, for example, the male and female bodies are intimately joined together by their contours and shadows, whilst the movements and gestures of the woman suggest the hopeless wish to escape. Virgil's story is that the Trojan seafarers who founded Rome needed wives to breed the great future Roman race; so they stole some Sabine women. Union was ultimate in spite of protest. Poussin's groups are always superbly structured in terms of type-expression. In Leonardo's *Virgin and Saint Anne* cartoon the spiral connectives involve the Holy Female progenitors into a condensed image. In the splendid Rubens *Garden of Love* the subsidiary groups of men and women are bonded into the whole major group largely through chains of bodies; and so as a group they display a kind of sensuous, organic, superhuman unity to which the erotic overtones of the subject contribute forcibly. In the late Michelangelo drawings for the *Deposition* one finds a very characteristic unity of body, tone, and implied undulant surface, creating a kind of 'super-type' out of the three typically Michelangelesque human types. None of these type-groups would convey the expression they do if we did not recognize the human emotional references of the human types, their gestures, movement, and graphic forms.

Emotional mode Perhaps the most elusive and interesting aspect of the subject is how it can serve as a key to the emotional mode, the particular quality of feeling in the expression of a drawing. It is well known from his famous letter to Fréart that Poussin was intellectually concerned with producing works in visual modes analogous to the recognized musical modes of classical antiquity, each of which was identified with a special emotional tone. The Doric was 'stable, grave, and stern', the Phrygian 'vehement, furious, most stern', breeding 'amazement in the beholder', and suitable for battle scenes, the Ionic cheerful, the Lyian sensuous, not admired, and the Hypolydian containing 'a

certain suavity and sweetness which fills the soul of the beholder with joy'. Certainly colour played a major part in his ideas. But so too did all the graphic forms, the types as well as the various postures and gestures of figures involved in the drama of the composition. Seurat's attempt to make Poussin's ideas on this topic 'scientific', and to reduce them to flat forms, cannot really be said to have led him very far in the varied expression of mode. To define, distinguish, and collect the formal qualities appropriate to a mode into a single composition is a task of immense difficulty, and can only be done by a master. In fact it is one of the marks of a master that his works should exhibit a clear, if elusive, modality. It was the classicist in Poussin which required that his works correspond with the classical modes. Not all arts or artists have such clear-cut ideas. A conception of mode is an aesthetic invention, a cultural achievement which only a few traditions have pursued. Some, however, do recognize a series of possible modes, even though they may not be easy to reduce to verbal categories; they have been recognized explicitly and defined in the aesthetic traditions of India, as well as those of the classical world.

Most artistically intuitive people can grasp the emotional mode of a modal work of art, although the mode may be impossible properly to define in words. One can feel very clearly what one cannot explain. But it is a great help to know that one is actually expected to discover a modality in a sophisticated work of art. This does not mean that one has to experience an *emotion* as such, but responses in the region of the emotion. There can be no mistaking the mode one might approximately define as heroic pathos in the drawing by Michelangelo, that of opulent sensuous sublimity in the drawing by Titian, or the idyllic, nostalgic eroticism in the Watteau. The still sublimity of the eternal informs Cézanne's drawing; a tormented, *mouvementé*, awesome sublimity that by Kuo Hsi. I cannot be too emphatic or precise on these points, because highly personal feeling-responses are involved. However, if we recognize the fact that modality exists as a recognized element in drawing, it will help us to ensure that our responses are as close as possible to what the artist intended and are not casually personal.

In our recognition of modes the subject-types will play an important part. This is not at all to say that they will dictate the modes. For they are no less servants of expression than forms. But the unitary images the types represent may most readily give us the key to the mode of the whole work, either directly or obliquely. Direct sug-

280

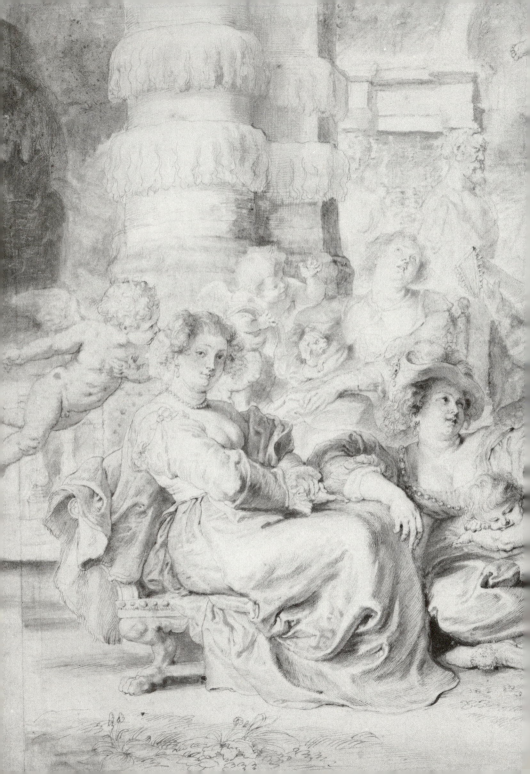

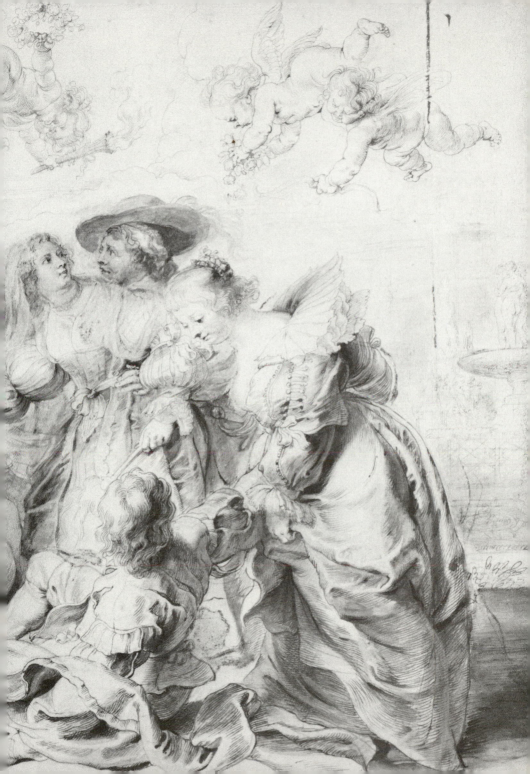

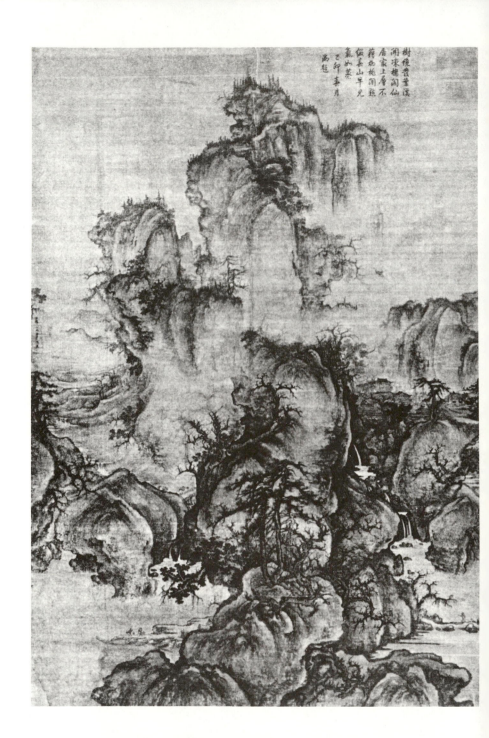

gestions are obviously given by subject-types with an emphatic emotional quality of their own, such as types of the Suffering Christ, sexually stimulating girls, austere philosophers, Herculean nudes. But there are cases where the very neutrality of subject-types which are invested with splendid forms produces an extraordinary effect. Cézanne's still lifes and landscapes, subjects belonging to the intimate environment, are invested with the dense, eternalizing structures of form appropriate to the sublime in 'Museum art'. And this is Cézanne's point. The sublime is to be seen in the here and now. In great works of art like this the mode may be a most rarefied one. Occasionally, too, it may be extremely complex, as in many of Poussin's works. In his painting *The Empire of Flora* in Leningrad the gay, springtime atmosphere of the picture is given a very subtle emotional twist by the fact that all the people in it, save Flora herself, are people who died tragically and were turned into flowers (according to the legends in Ovid's *Metamorphoses*). Here *only* knowledge of the subject can give the key to the mode and its extraordinarily subtle web of feeling-responses; likewise in Poussin's even subtler *The Blind Orion Travelling to the Shores of Ocean*.

We usually find that the modality can be defined in some way or other by a combination of the following categories which, like the named colours of the rainbow, merely pick out points of a whole spectrum of feeling: the erotic; the comic; the pathetic; the furious; the heroic; the terrifying; the disgusting; the sublime; the peaceful. And it is of the utmost importance to realize that, as I have pointed out before, one is expected to experience before a work of art responses in each of these modes, not an actual emotion. Critics often fail to make the distinction. We are not meant to experience actual fear, actual disgust, actual eros before a work of art, but responses in each mode. Actual emotions would destroy the essential artistic distance which separates the true symbol from raw event.

Pure signs Finally, among the types of subject-matter must be mentioned those pure signs, already conventional in their own right, which some arts employ. There are flags or monograms in many older works which help out the meaning. Klee was not the only artist to use arrows or exclamation marks in his pictures. Somewhat similar in purpose are the symbols found in many drawings which we can only read from purely intellectual knowledge. Most people know that the orb and sceptre indicate kingship. Many can read the attributes of the various

saints. But it may be harder to discover that certain kinds of costume or hair style indicate that a woman is a prostitute, or that a certain gesture had a standardized meaning at the time the drawing was made. Nevertheless we need to know such things when the symbols appear in drawings, if we are to understand them properly.

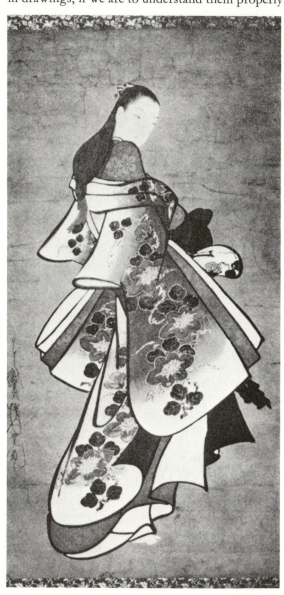

Kaigetsudo Ando (1671–1743), COURTESAN; ink and body-colour on paper, 88·5 × 45·5 cm. *National Museum, Tokyo*

In this final section I shall give a summary of the various kinds of drawing and their functions. For both in Europe and outside drawings have been used to do many different things. But the first point that has to be made is that drawings which are only an end in themselves are fewer than might be expected, whilst drawings done as subordinate accessories to a final work in another medium, such as sculpture or painting, are far more numerous. In fact, as I indicated at the very beginning of the book, drawing is an art in its own right, using a different kind of symbolism from the other arts. And so it should not be surprising that even drawings not made as ends in themselves should have their own special virtues and expression, which are not those of the final medium. I shall discuss drawings made as auxiliaries first, leaving those actually made as an end in themselves till last. And since this book will be read chiefly by readers of Western descent, Western attitudes to drawing need particular emphasis.

In fact the appreciation of drawings for their own sake is a relatively recent phenomenon in Europe. Nowadays everyone accepts that an artist's drawings are specially revealing, that they convey his thoughts in a particularly intimate way. It seems to me that this idea arose when it became generally realized that drawing was an art in its own right, as I have describe it above. It is usually said that only during the sixteenth century did drawings come to be valued in Europe by others than practising artists. And only during the fifteenth century did it gradually become usual for sculptors to be able to draw. However there can be no doubt that drawings *were* esteemed during the Middle Ages, in view of the abundance of pen-drawn decorations and fantasies in which dozens of medieval manuscripts abound. And since sculptors in the Middle Ages were very frequently goldsmiths as well who would need to be competent in flat linear design, it is perhaps wrong to be too rigid on these points. It is indeed true that fifteenth-century sculptors did often employ professional flat artists to draw the *modelli*, summary indications of what the finished work was to look like, which were shown to prospective patrons. And there can be little doubt that sculptors, working in three actual dimensions, have always been able to dispense with drawing more easily than painters, whose art is based upon drawing of one sort or another. But it is also true that real enthusiasm for drawings amongst collectors and

connoisseurs spread from the ranks of the artists during the sixteenth century. Then the first art-historians like Vasari, van Mander, and Sandrart began to register appreciation of drawings which artists earlier had considered to have no interest outside the workshop. During the seventeenth century, especially in France at the court of Louis XIV, enthusiasm for drawings reached such a peak that cabinets of drawings were assembled and a pure draughtsman like Lafage was able to make a career. The king commissioned engravers to produce versions of drawings which attempted to preserve the true drawing-quality. And during the eighteenth century the enthusiasm increased, so that the drawings of all the great Italians, and particularly those of Rembrandt, were eagerly collected and reproduced in engravings. The great eccentric the Comte de Caylus (1692–1765) made it part of his life's work to engrave and publish drawings. The nineteenth and the twentieth centuries have merely followed suit, different types and styles of drawings succeeding each other in favour with the connoisseurs in accordance with the vagaries of taste. Nowadays it is conventional for artists like, for example, Picasso to make drawings immediately available for graphic reproduction either by themselves or by craftsman-assistants.

In our appreciation of the qualities of the drawing we in the West have certainly lagged behind the connoisseurs of the Far East. There, since some uncertain period during the very early Middle Ages, pure monochrome calligraphy and drawing have been rated as the highest visual arts. As a consequence painting in the European sense has been much devalued in favour of immediately expressive drawing techniques. In particular, during the Southern Sung dynasty (1127–1279) and then again during the later seventeenth and early eighteenth century in China, and in Japan from about 1200 onwards, abrupt, aphoristic, and suggestive techniques of drawing were very much cultivated. Artists, especially those 'literary men' ('wen-jen') inspired by Taoist and Ch'an (Zen) Buddhist ideas, have taken particular pride in 'achieving the most by means of the least' in ink monochrome. And connoisseurs, often themselves artists, have been of the same mind.

European academic theory has evolved a schematic classification of drawing-types and their functions which has often been described. And no doubt very many European artists since the earliest days of the official Academies in the mid-sixteenth century have produced their drawings according to the standard scheme: first thoughts;

nature-studies; composition; cartoon. However, in view of the wider outlook on drawing adopted in this book, which includes the work of other ages and places, we must recognize that such a scheme is far too limited in its scope and significance. It leaves out of account many of the activities in which draughtsmen—even post-Renaissance European draughtsmen—have in fact engaged. I therefore suggest an ampler set of categories for the classification of drawings, and the functions they both can fulfil and have fulfilled. As I said above, the drawing executed for its own sake will be left till last. Of course these drawing types may shade into one another, as we shall see, especially in more recent art. And, most important, one can understand how the fact that an artist customarily practises one or other of the types of drawing will affect his whole style; and, conversely, how final techniques may condition the way in which the artist makes his preparatory drawings.

The first six categories are, as it were, preparatory; the next eight are phases in the creation of a work of art; the next two are special, independent functions; the last is drawing for itself.

1 Calligraphic exercise In many graphic traditions the draughtsman exercises his hand in the calligraphy upon which his drawing is founded. He learns a repertory of linear forms and shapes, which he practises until he can execute them as required. Such exercises constitute one kind of drawing. In traditional Persian draughtsmanship, for example, the artist learned to draw as perfectly as possible, without the least tremor or uncertainty, by means of a small brush, a repertory of single, double, and more complex curves of various inflexions, in various directions. These he used to compose his drawings—'perfection of line' being one of the Islamic ideals of art. In China and, following China, Japan, artists are first trained in a calligraphy which is based upon a given number of stroke-forms with their variants. These strokes are used for writing the complex Chinese characters, and the variety of styles of calligraphy ranges from the archaically severe to the vigorously cursive. Individuality of execution is much admired, so that artists become able to carry through sustained and expressive linear inventions. This skill is applied to representational drawing; and very much the same kind of expression is admired both in pure calligraphy and in representational art. It is not at all improbable—though I can quote no direct evidence save that of my eyes—that a similar, less highly developed attitude existed in some medieval monastic scriptoria in

Europe. The draughtsman may have developed there out of the skilled penman-calligrapher; and calligraphic flourishes formed an integral part of the style of a good deal of medieval draughtsmanship. The Utrecht psalter and Vienna *Genesis* are excellent examples, and one can find cases where calligraphic flourishes have even been carried over from drawings (presumably used as patterns) into stonework.

In the major drawing styles of post-medieval Europe one does not find the practice of purely calligraphic exercises playing any part in the education of the draughtsman. Nor did it, seemingly, in the education of the Hindu draughtsman—though during the sixteenth century Islamic customs in this respect were imported into the Moslem parts of India. However, during the present century a conception of 'free calligraphy' has been developed in Western art, largely as a result of the influence—overt or hidden—of Japanese versions of Chinese calligraphic ideas. Many Western artists, from Klee and Wols to Pollock and Mathieu, have adopted the technique. It is capable still of far greater development than it has yet received.

I do not think it would be wrong to see the graphic methods of Basic Design recently adopted in Western art schools as analogous to calligraphic exercises. As the child learning to talk indulges in babbling and mouth-play, so the young artist has to exercise his executive faculties in all sorts of directions as a prelude to finding his ultimate forms. So Basic Design exercises may belong to this category of drawing—though it must be recognized that there is a clear distinction of *intent* between the calligraphic drills of Eastern countries and the supposedly liberating exercises of Basic Design.

Such exercises in line and enclosure relationships are the first kind of drawing.

2 Pattern-types Pattern-types form the second category. We know for certain that in all the countries of the East, as well as in Europe, artists were accustomed to collect and make drawings for use as patterns in their art. Sometimes these drawings came to be copied as closely as possible, for instance, when an icon was being made in some final medium. In Buddhist Asia and Byzantine Europe exact fidelity of a new icon to a canonical pattern was required by religious belief. Where paintings have been made as artifacts and the same design has been used again and again—as in late medieval and modern India—a design and its component figures may actually be traced from a set of master-drawings. Such master-drawings may have been made

by the artist as his stock-in-trade, being traced off from similar draw-
ings owned by his own master. Or they may have been inherited or
received as a gift by pupil from master. Work executed in this tradi-
tional way may be of exceedingly high artistic quality.

Far the greater part of the European medieval drawings which sur-
vive independently, outside the pages of manuscripts, belong to this
category of pattern type. Villard d'Honnecourt's sketch-book began
as a collection of architectural and figural pattern-types collected by
the artist, who was a master-mason in the thirteenth century—
though it developed later into a kind of instruction manual. The book
would have travelled with him and been kept in his mason's lodge as
a basis for work he had to supervise and initiate. Other such books
are known to have existed; and many of the medieval single sheets of 111
drawing must have come from similar books. In them were included
patterns for saints, Virgins, beasts, birds, schemes for laying out the
proportions of human figures and faces, and architectural diagrams
such as ground-plans. Some figure drawings show a fairly complete
working out of the forms in terms of tone. Amongst Pisanello's
magnificent drawings are many which belong to this category, and 288
certainly Pisanello's famous drawings from objects seen, such as his
Hanged Men in the British Museum, must have been intended by the
artist as raw material for use in his Gothic compositions. He was
distinguished by his novel readiness to amplify his patterns by direct
observation.

The characteristics of pattern-type drawings are usually their
baldness and clarity, and their use of unbroken outlines. They are
intended to be worked up by each artist in his own medium and his
own way, and so they only represent a kind of lowest common de-
nominator of the subject. In post-Renaissance Europe, when artists
were claiming skill as draughtsmen, and collecting or stealing each
other's drawings, pattern-type drawings become hard to distinguish
from drawings of other kinds.

3 Record of fact The third type of drawing is the record of non-artistic fact. Many
artists who were draughtsmen with an otherwise highly developed
style made bald and direct drawings in order to record objective facts.
For example, Poussin made many drawings merely to note the details
of costume or armour represented in classical art. Rembrandt and
other Dutchmen made note-drawings to record the shapes of exotic
headgear, weapons, fruit, or shells. Other draughtsmen noted the

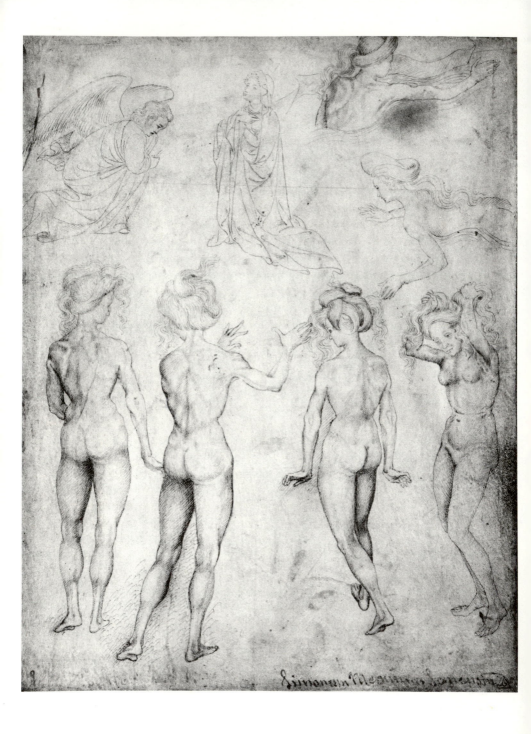

shapes of musical instruments, etc. Such drawings are usually cursory, and concentrate on outlining only those things the artist particularly wants to remember. Such outlining constitutes an act of isolation, distinguishing items of knowledge one from another and attributing to them a quality of neutral feeling.

Obviously architectural working-drawings, builders' handbooks in East and West, maps, and the many kinds of engineering drawing we know today belong in this category too. For what they convey is conceptual information, even though it be about facts not yet actual but only projected. There are splendid examples preserved amongst the drawings for medieval cathedrals.

We must recognize that four familiar kinds of drawing may belong, strictly speaking, to this category—anatomical studies, architectural and topographical drawings, botanical and zoological drawings, and records of classical works of art. Many of these, however, may be made with so clear a sense of the numinous value of the objects and the scientific activity involved, that they may achieve high standing as drawings. For example, Leonardo's drawings of anatomy are usually highly esteemed. So too are his drawn notes of scientific observation and of his inventions. The factual record which they contain was the subject of Leonardo's passionate concern—the locus of his sense of the numinous. And so they are lifted to a level above that of mere record. The same is true of Claude's and Poussin's recording 172 of the landscape of the Roman Campagna, of Francis Place's British topographies, Dürer's naturalist studies, and animal, bird, and flower studies by Indian Mogul artists—perhaps even Jan de Bisschop's 262 drawings of Classical sculptures. It is probably true as well of the drawings made by and for some of the early European explorers, which were often later engraved; and it is certainly true of the superb drawings of the American Indians done by John White in the sixteenth century and George Catlin in the nineteenth century. But there is an enormous number of documentary drawings in existence dealing with these topics whose artistic achievement does not extend beyond the mere record they convey. It is interesting that in many otherwise expressive Far Eastern drawings the architectural parts are often somewhat bald. It is necessary that numinous significance be given to the recorded fact by means of formal resonance if the drawings are to deserve a high aesthetic standing.

The drawings in the fourth category may seem at first sight to re-
semble those in category 3. In fact there is a substantial difference.
This category consists of drawings which set out to summarize as a
diagram substantial items of information, and are usually associated
somehow with an explanatory text. The example readiest to hand is
the isotype, which shows such economic facts as the Gross National
Products of different countries in the form of figures of different
sizes. It is worth noting that in some more primitive types of drawing
in other categories a similar principle is observed with regard to status,
a king being shown larger than his subjects, or Christ larger than mere
men. But the diagrammatic summary has an intermittent history of its
own. From ancient Egypt we have many copies of versions of the
Book of the Dead, which were meant to instruct the deceased in the
ritual conduct necessary in the Next World. The figures drawn on
many of these manuscripts often amount to instructive diagrams
showing the reader what post-mortem visions to expect. And then in
the schematic iconography of countries like India and Tibet we find
vast numbers of drawings of figures, often with many arms, dressed
in special garments, holding attributes of various kinds (conch shell,
goad, rosary, sword), all of which need explaining; so that the draw-
ing becomes a kind of shorthand diagram for a whole compendium

left and right
Illustration from an
Egyptian *Book of the Dead*;
ink, H. 2½ in.

of previously verbalized information or religious doctrine. In Europe similar drawings were made for religious purposes by Christians as well as by the Alchemists. It is worth mentioning that such drawings need not be figurative. They can be purely diagrammatic, summarizing abstract philosophical ideas.

As will easily be understood, this category of drawings sits uneasily in the present scheme of categories. For obviously drawings of this kind can, at various stages of their evolution, belong in many other categories. However it seems to me that the category is an essential one.

5 Theoretical diagrams This category is a relatively insignificant one in size, but its importance in the history of art has been immense. It contains those diagrammatic explorations of proportion (human and architectural), and of theoretical space which the Renaissance called the Geometry of art. Diagrammatic and prescriptive drawings were done in other cultures, notably in ancient Mesopotamia on clay and for building, sculptural, and cosmic schemes in India, the Far East, and Iran. In the West we know best such examples as Piero della Francesca's and Albrecht Dürer's, whilst Vasari has made Uccello famous for his absorption in such work.

6 Copies The sixth category consists of copies of other works of art—copies made not simply to record facts, as in category 3, but for the purpose of absorbing the types, methods, and atmosphere of another master's work. All good artists have done this, particularly during the early stages of their careers; and sometimes they have continued to do it until the end of their working lives. At the same time it must be remembered that it is possible for an artist to make a mere paraphrase of another artist's work, misunderstanding the 'language' completely, so that all the original virtues are lost.

In this category there are several subdivisions. First, and most important, are the drawings which copy drawings. We know that Rembrandt used to teach his pupils by getting them to copy, stroke for stroke, his own drawings. In this excellent fashion they would absorb the master's own way of scanning the world and his own vocabulary of graphic forms. Hoogstraten has left us a few details of his methods of instruction. Raphael and Primaticcio copied drawings by Leonardo. On the whole, however, this kind of drawing has not been done nearly so extensively in Europe as in the Far East. In China particularly, but in Japan too, generation after generation of artists have been brought up to copy, with the same stroke-for-stroke fidelity, the recognized masterpieces available in collections to which they had access (access matters a great deal—we tend to forget that artists even in the very recent past did not always have access to many real masterpieces, most of which were only to be seen by permission in the houses of the great or wealthy). In the Far East, however, a greater conscious emphasis was laid on capturing the 'spirit of the forms'; so that another kind of copying was practised, when a draughtsman worked 'in the spirit of' a certain earlier master, either after one of his actual compositions or only in his manner. Good copies of masterpieces, either close or free, were very highly valued, even when the copyists were not themselves major masters—so long as they captured something of the spirit of the original. It is still very much an open question how many of the much admired drawings attributed to major artists of the Southern Sung dynasty are 'originals' or inspired copies.

Although in the West drawn copies of drawings are relatively rare, engravings which copy drawings stroke for stroke are very common, especially from the later seventeenth century onwards. Very many such engravings were published, both single sheets and albums, which tried to capture both the essence and the texture of drawings

in the royal and private collections of England and France. These vary in quality. But some of the engravers were artists of a high order, who are not nowadays accorded the respect they deserve. Amongst them are, for example, Frans Ertinger (1640–*post* 1707), who worked after Lafage; Arthur Pond (*c.* 1705–58), who copied a variety of drawings; Demarteau, who worked mostly after Boucher drawings; and the Comte de Caylus. The earlier engravers, such as Giorgio Ghisi (1520–82), who worked after drawings by Giulio Romano, did not attempt to capture the essential drawn quality of the original but only used the original as a basis for a thorough-engraved design; for drawing as such was not yet in vogue.

Rembrandt, of course, was the principal artist who continued all his life to make copies of other people's drawings, and of engravings which were themselves works of graphic art, in order to absorb the essence of the original. He copied, amongst others, works from the schools of Raphael and Mantegna, as well as Indian Mogul miniatures. This seventeenth-century East-West artistic interchange went both ways. For we know of quite a few copies of European drawings and and engravings made in India under the Mogul emperors Akbar and Jehangir. Both parties were interested not only in what to each were exotic details of fact, but in what they could learn of types and methods. The same sort of exchange has taken place between Europe and Japan since the seventeenth century right down till today.

Copying by drawing from another artist's *paintings* demands slightly less intimacy between copyist and copied. For here a drawing amounts to a reduction into monochrome and lines of something which is not itself cast in those terms. At the same time the copyist's own conception of life can be given to his drawing, as, say, in Rubens's drawn copy of Titian's *Adam and Eve* painting. Nevertheless copying of this kind is still extremely useful as a means of studying and absorbing a painter's two-dimensional vocabulary of form, his 96 methods of composition and spatial construction. There exists an enormous number of drawings of this kind. For example, Michelangelo copied figures in Masaccio's Brancacci Chapel frescoes; Rubens copied Michelangelo; Delacroix copied Rubens; Cézanne copied Delacroix. And thus traditions have been formed.

Perhaps the most influential class of copies in Western art have been the drawings made of three-dimensional works of art, such as Classical sculptures, gems, coins, and of the sculptures of Michelangelo. This kind of copying covers a very wide range of method, and

the draughtsman is compelled to translate into his own *pictorial* graphic medium what is in fact a three-dimensional invention. And so what he assimilates does not lie in the sphere of *graphic method* so much as in that of the subject-type. And it has been precisely for the purpose of absorbing the qualities of subject-types that far the greatest number of drawn copies of sculpture have been made in Europe. In addition the clearly defined shapes of sculpture, which are already formulated into plastic concepts, can guide the copyist into formulating his own concepts clearly. From Poussin's drawings after the antique to the endless drawings after Classical casts made by generation after generation of academy students the aim has been for the copyist to learn the bodily partitioning, the proportions, and what used to be called the 'lines' of the ideal types. This was believed to be a good thing in itself, morally elevating and spiritually progressive, since it instilled into the mind of the copyist the exalted Platonic archetypes of the Beautiful, the Good, and the ultimately True in their highest form—the divinely human.

The kinds of drawing which follow are those associated with the production of elaborated works of art, and form part of a directly creative process.

7 First thoughts, or sketches

First thoughts, or 'sketches', are those drawings in which a graphic idea is set down at once as a unity. Details are avoided, and the draughtsman concentrates on capturing the essential characteristics of the whole design, recording an immediate vision. Such first thoughts usually attempt to give a summary of the aspects of a whole work which the artist regards as most important. They may represent the bones of the design which will later on be clothed in the flesh of forms. But even so the final, clothed forms will not violate the main ideas of the initial summary.

An enormous number of drawings which are first-thought sketches survives. Raphael, Veronese, Rembrandt, and especially those artists of China and Japan working in the 'abrupt' style such as 'Shih Ko' and Liang Kai, have left many of them. In practice many of these drawings also belong to the last category, drawings done for their own sakes. For they were never meant to be followed by 'second thoughts'. And one of the things many connoisseurs appreciate most in drawings is the immediacy and freshness of 'first thoughts'. In fact Rembrandt, for example, made many drawings which must rate as 'first thoughts' for pictures he never executed. In all such drawings

we recognize that the artist was working under the pressure of responsibility only to his own intelligence. His notes may well have been intended for none but his own eyes, so that he never found it necessary to include in such works the routine amplifications which were part of his everyday skill. Those he took for granted; so he laid down only the features which distinguished the current design from others, the individual characteristics of the particular invention. And to indicate the whole was always more important than the detailing of parts. So in many such drawings we may expect to find errors of placing brusquely corrected, overdrawing, rough strokes standing for inventions which are left to the spectator's imagination, and in some parts the sketchiest of indications of things which are to be worked out later, such as volumes without shading. It should, however, be realized that certain artists of great intellectual grasp and discipline, such as Poussin and Michelangelo in their later years, are able to draw their first thoughts with such a complete view of the 182 final result that even a sketch can look like a matured design.

There is a kind of second phase to this kind of drawing. Many artists, working under the impulse of inspiration, made first-thought 54 sketches in groups or batches. They often filled a whole sheet with variants of the idea, in which they tried to adjust the awkwardness of earlier drawings, to correct errors, and to include fresh thoughts. Again, Leonardo, Raphael, Titian, Veronese, Rubens, and hundreds of other artists, have left us such drawings. They belong to the realm of the sketch, and even rate as first thoughts; but they are first thoughts modified not by reworking but by exploration. Implications latent in the initial visual idea, but not expressed completely in any one of the sketches, are investigated. We know, as well, that Delacroix used to free his hand and imagination by making series of sketches from his head every day before he started to paint. Such sketches quite frequently served as the first thoughts for later, developed pictures.

Usually first thoughts are drawn directly from the artist's own head, from his fund of visual memories and ideas. But we must recognize that some artists of the Plein Air schools also produce 'first thoughts' in the presence of a motif. Such 'first thoughts' will get confused all too easily with drawings of other kinds, especially those of category 118 9. It may be difficult, but it will be rewarding, to determine which of the drawings of Constable, Degas, or Lautrec are actually first 171 thoughts, as distinct from studies after nature or drawings in their own right. It is one of the characteristics of nineteenth-century

left and above

Hans von Marées, NARCISSUS (study for a relief), *c.* 1884, verso and recto as shown; red chalk, 59.6 × 43.5 cm. *Staatliche Graphische Sammlung, Munich*

figurative art that the artists themselves were never quite sure whether a picture would emerge from any given drawing. The drawing might sustain further work; or it might not. In fact this is one of the ways of characterizing their methods.

8 Development of parts of a design The eighth category consists of drawings done from the imagination which represent developments of separate parts of invented designs. For example, single figures may be extracted from a design and drawn alone on a larger scale, so that the artist can clarify his ideas on particular points of form. Tintoretto and Rubens have left many drawings 214 of this kind. Such drawing may sometimes be found 'squared up' with a grid, so that the figure may be enlarged and transferred directly from sheet to painting.

9 Studies 'after nature' The ninth kind of drawing, studies after nature, is made for a variety of reasons. Many art styles have never produced them at all. But the 273 first thing to be remembered in connection with such drawings is that it is impossible to make *any* drawing after nature unless the draughtsman has first a clear image both of the types and of the visual language which will give form to his drawing. This is often forgotten by art teachers of the past and present, who set students to 'draw from the life' without equipping them first with an idea of what they can do. Nature is a chaos; to see forms one must first have formal ideas. If a good pattern-typology is not provided, the student will simply use a bad one from his experience of inferior popular imagery.

Thus it follows that drawing from nature represents the amplifica- 206 tion of visual forms by confronting them with parallels in nature. We know that very many artists have drawn from nature as a continuous 299 exercise to fill their minds with memories of the variety and individuality of reality. We know that Chinese draughtsmen of the Sung dynasty did this, noting the shapes of flowers, leaves, and mountains; and that artists in the West from late medieval times onwards have continuously done it. Rodin made hundreds of sketches from models moving about in the studio only to stock his mind with varieties of vividly undulant surfaces recorded as contours. Ingres, of course, made his famous tight, smooth studies recording the outlines of visual facts in detail. Renoir, who both drew and painted with the model there, seems to have used the model's mere physical presence as a stimulus, not as a visual fact to record. Art Nouveau draughtsmen made careful studies of natural floral forms which they stylized into undulant ornament. Rembrandt made endless drawings of the 198

life around him, many of which supplied him with material for further drawings or for paintings. Leonardo, as is well known, even recommended the artist to stimulate his inventive powers for landscape drawing, by drawing the irregular surface of an old wall. Cézanne made the majority of his drawings as studies of realization, from which the range of problems posed by colour was removed, and only those posed by tone were left.

However, in European art before the nineteenth century by far the commonest reason for making drawings from nature was to amplify 297

299

and give conviction to the figures in a previously invented design. Amongst the drawings of Raphael, for example, are instances where we can recognize that studio apprentices posed in the postures of figures in projected designs for the *Stanze* frescoes. Raphael drew the boys, either in groups or singly, in their everyday clothes, to absorb a dose of 'reality' into his ideal mental images. Grünewald and Leonardo, amongst many others, have made detailed studies of actual drapery, carefully noting variety of form and tone, as a prelude to painting pictures containing similar drapery. Innumerable drawings by artists of Renaissance Italy, of fifteenth-century Flanders, of seventeenth-century Holland, can be recognized as studies intended to vitalize a previously designed image with the variety of natural surface.

300

Perhaps we should include under the heading of studies after nature studies made from lay-figures and assemblies of wax models— for these are natural objects. Lay-figures wear draperies on behalf of absent sitters. And the wax models actualize images of miraculous assemblies, with floating figures hung on wires and effects of illumination, so that the draughtsman can see possible forms and groupings realized in three dimensions.

Another use of drawing after nature is made by portrait-painters— Rembrandt, Frans Hals, Goya, and Corot among them. Drawings can be done at one sitting from a busy or eminent sitter; and a painted likeness can be made from the drawing when the sitter is not there. Velasquez probably had to do this with his pictures of Spanish Royalty. And of course the artists of genre, painters, say, of peasant life, can do the same sort of thing. Daumier and Millet, for example, made drawings of scenes which caught their imaginations as material for paintings, and made the paintings from them. Such drawings may also rate as first thoughts. Many of Toulouse Lautrec's studies are probably of this kind. But van Gogh's early studies of peasant life were too intensely felt to be quite the same in intent.

112

The relationship between the visual pattern-type and the drawing after nature is extremely interesting. Graphic types are an essential element in any visual tradition. The types of the subject-matter are only part of the story. There are visual types which consist of groupings of basic graphic forms assembled in particular ways on the drawing surface. No artist can work without them, though masters make more of them than lesser artists. Even botanical drawing shows its typological evolution, and it is partly through the custom of con-

Raphael (Rafaello Sanzio) (1483–1520), Study for CHRIST GIVING THE KEYS TO SAINT PETER; 257 × 375 mm. *Windsor Castle, Royal Library. By permission of Her Majesty Queen Elizabeth II*

tinuously challenging the types with visual actuality by means of drawing after nature that Western drawing evolved in the way it did. The gradual erosion of types in the face of optical fact was one of the features of nineteenth-century drawing which only great masters succeeded in transcending. Variety came to be wrongly regarded as entirely the work of nature, not of artistic thought. An immense field of research lies waiting for future students of art history in the realm of such morphological analysis of style.

10 Drawn-up designs This category consists of fully drawn-up designs. These may be on a scale smaller than the final work, in the case of designs for mural paintings. Or in the case of designs for prints, such as a few of Rembrandt's for his own etchings, or Rubens's for his engravers, the 278 scales may be compatible. Some designs of this kind may be drawings in their own right, like Michelangelo's finished drawings.

Fully drawn-up designs generally include the results of work in the categories 7 to 9. The sketched design is filled out with detailed forms evolved to clothe its bare bones. It may even contain suggested patterns for brush-strokes (Delacroix). The detailed forms may be derived from variant drawings, nude studies, drapery studies, portraits, studies of landscape and foliage, so that a design by, say, Rubens, may contain all of these elements assembled together. Seurat followed a similar procedure. It may also happen that drawn-up designs in other traditions do not rest on any actual studies after nature. This is true of European medieval designs, of Indian designs, and of the designs made for paintings in Japan.

Designs of this kind may exist in several successive versions, for one frequently finds examples that have been traced from earlier versions. Some of Delacroix's designs show this, and Japanese Ukiyo-e print artists often made their final drawings in this way. It is usually done because the earlier versions have become smudged and unclear from too much overdrawing and redrawing. And it requires an exceptional artist to preserve the vitality in a traced-off design of this kind. Very often European examples of such designs have been squared-off in chalk for square-by-square enlargement on to the surface of a cartoon or larger painting. Here, again, in enlarging it is difficult to preserve the vitality of the original; and the question of the scale of the invention becomes urgent. For one cannot simply enlarge any graphic form without at the same time altering it drastically.

11 The cartoon The cartoon is a drawing the full and actual size of a projected large

work. Its figures may even be over life-size. It is done on large com-
posite sheets gummed in layers to give strength (hence the name). It
represents the artist's re-creation on a large scale of a design trans-
ferred from its original drawn scale. So cartoons usually bear the
squares which tallied with the squaring of the original smaller design.
There have been major works of art which never got beyond the stage
of cartoons, though they were originally meant to. Among these may
be the London *Virgin and Saint Anne* by Leonardo, and the famous
lost battle cartoon by Michelangelo for the Palazzo della Signoria in
Florence.

However, since cartoons were usually meant as prelude to large-
scale painting, usually wall-painting, they often bear another mark of
their purpose. Along the contours of their figures may be pin-holes.
The cartoon was meant to be laid against the surface to be painted;
charcoal dust was then to be pounced from a porous bag through the
holes on to the painting surface, thus recording the outlines of the
cartoon on the painting surface. Obviously cartoons have a very
special and limited purpose. It is possible, but not certain, that they
may have been used in the East by Buddhist wall-painters.

12 Large-scale drawing as basis for final work The twelfth category is the large-scale drawing, made directly on a
wall or another surface, either itself to serve as the public ornament of
a place, that is a rock-shrine or a building, or as the basis for a painting
in which the drawing is a major feature. There are many important
varieties of such drawing. The cave-drawings of Palaeolithic Europe 9
and Africa, the rock-drawings of India and of the Dogon in modern
Africa, are examples. We know from literary sources that the master
wall-painters of early medieval India prided themselves on being
able to draw, free-hand, complex scenes with many life-size figures.
Medieval wall drawings, and paintings with such underdrawing, sur- 165
vive in India and Ceylon.

One special form of this large-scale drawing is the method used by
Giotto and others (and described by Cennino Cennini) for designing
the series of frescoes which are attributed to him, as it has been
analysed by several art historians. Incidentally it helps to make the
difficulty of Giotto attributions more intelligible. It seems that the
master himself made original full-size drawings for a whole scheme,
with colour notes, on the next to last layer of plaster on the wall. He
drew free-hand with brush and ochre from original patterns and
designs. He, or more probably his chief assistants, then painted the

final fresco on a last thin layer of plaster, which was applied piecemeal so that the drawing disappeared only gradually under the painted layer. Thus the final executant retained continuous touch between his own work and the master's drawing. A large number of excellent instances can be seen in the Campo Santo at Pisa, where, owing to war damage, the underdrawing and overpainting of the same works have been separated, and both are preserved.

This kind of large-scale drawing, though it was always done more or less free-hand, perhaps needed the help of a few guide-lines. In one series of eighth-century wall-paintings in Ceylon at Mihintale centre verticals have not been eliminated. Cennino Cennini refers to horizontal and diagonal guide-lines being drawn in charcoal as well. The essential point about this kind of drawing is that it does not simply represent an enlargement of a smaller drawing, but is drawn itself in scale with its architectural environment. Its units of form, and the key of its emphasis, are thus entirely consistent with its place in relation to the spectator, to the proportions of its 'place' (*Ort*, in Heidegger's special sense of 'place'), and to the scale of the frames or panels in which it may fit. It was conceived from the beginning in terms of the environment in which it is set and does not conflict with it, demanding only a narrowing of the focus of attention. This all makes it a phenomenon distinct from designs elaborated up to cartoon scale and then transferred.

13 Underdrawing for subsequent painting
There are various kinds of underdrawing for actual paintings, which may or may not be meant to show in the final work. Many great painters never did an underdrawing. Titian began sometimes in his later years without any underdrawing. But in some pictures (notably the *Diana and Actaeon*, National Gallery, London) the underdrawing in charcoal can be seen to resemble his 'first thought' style. Most other European painters have begun with an underdrawing of some kind, at least to lay in the salient parts of the design. And, contrary to what is often believed, we have evidence that many of the major masters of Far Eastern brush-drawing used to lay out with charcoal the general design of their larger compositions. They were also accustomed to work a design up from a basis laid in with almost pure water or very pale ink on the surface. It is a common fallacy committed in many books on art techniques to say that all Far Eastern brush-drawing was done without any revision of strokes. In fact most work by the greatest masters was built up from pale to dark, with an accumulation of

strokes, often over a period of months or years. 'Instantaneous' drawing was a special and limited cult. It is also more than probable that many of those cursive designs which so impress us on Greek or European ceramics were also done with benefit of some kind of underdrawing either lightly incised or in a substance which would disappear in the firing. As well, the pencil or charcoal underdrawing used by the European masters of water-colour from Dürer down to the nineteenth century, even though it may have been obscured by the final colour surface, played an important part in the conception of the design. Such underdrawings are often clearly visible in un-finished works.

There are two principal kinds of preliminary drawing which were meant to contribute as part of the final effect of a work. The first of these is a scaffolding of lines and tone, of whatever kind, using any of the methods, which was completed by colour and meant to remain in the picture with its own value undiminished. Sometimes the main lines of the drawing need reinforcement on top of the colour. This, of course, is the case with the work of many great Japanese painters, 282 including Sesshu, the Kano genre masters, and Kaigetsudo Ando. So it is with the Europeans Dürer, Gauguin, and Pascin, to name only a few of the many possible names. Innumerable European medieval masters of manuscript illumination, and Indian miniature painters, 22 worked in the same way. In both these last two cases we know that it often happened that it was not necessarily the man who drew the design who added the colour. This kind of drawing, of course, was always done by the draughtsman with the thought in mind that colour was to come. Colour would condense the shape of otherwise feature-less areas; pure tonal values in the drawing would be altered by the differing tonal densities of the water-colour pigments used.

The second kind of preliminary drawing was meant to work in the final painting in quite a distinct way. It is characteristic of European painting after about 1300 and depends for its best effect on the inven-tion and use of transparent pigments carried in an oil-resin vehicle. It consists of a complete, shaded underpainting in tones of grey (grisaille), *terre verte*, or brown. The ground was usually of mid tone, and lights would be laid in with white. Over this preliminary drawing colour would be laid on in transparent tints and glazes, and free, opaque brushwork would complete the colour accents. The drawing, modified by the overlaid colours, and giving various qualities of half-tones, would serve as a scaffold for the whole picture. European oil-

painters worked in this way from the times of the van Eycks on, right down to the end of the eighteenth century and the beginning of the nineteenth. There were notable exceptions, such as Velasquez. And many artists, like Rubens in his sketches, or Rembrandt, made of the initial drawing something far more cursory than earlier painters had. Only the development of opaque, wet-in-wet painting, in the hands of Valesquez, the Tiepolos, Goya, and later Corot and Courbet, eliminated this technique in favour of *alla prima* painting with its worked impasto. Even through the nineteenth century it remained one of the principal resources of water-colour painters.

14 The modello One small class of drawings consists of those usually referred to by the Italian name '*modello*'. They were made for the benefit of patrons or prospective patrons, to give them some idea of what the finished work they were paying for would look like. Many of Rubens's oil-sketches, for example, belong to this category. They are also fine works of art. But many *modelli* are distinctly inferior works, since they were made only for the sake of recording details of iconography and a clear-cut arrangement, with very little of the true formal expression of developed drawings. Many late medieval examples survive. And, as I have mentioned, when the finished work was to be a sculpture, the artist often employed a hack to do the *modello* for him. And busy masters like Bernini, who were great draughtsmen perfectly capable of drawing such works, nevertheless employed senior studio hands to execute them; because, of course, from the creative point of view, a *modello* is always premature, a concession to the patron's lack of visual imagination.

15 Drawing as This category consists of drawings which are an enhancement of *enhancement of an* some other object, for example, a pot, a gate-post, or even a human 30 *object* body prepared, say, for some ritual. Indeed such drawn additions to objects do generally have a magical or apotropaic significance. Far the commonest of these drawings are on pottery, and I have mentioned earlier that they may very often be drawn in such a way as to take advantage of the three-dimensional curvature of the ground. 45 Amongst my analyses of drawings three are of drawings on pottery.

Because they are attached to the object such drawings usually have, along with their own expressive function, the function of exposing the nature of their ground. But here again there are degrees. Some pot drawings may be so intimately related to their support that they can

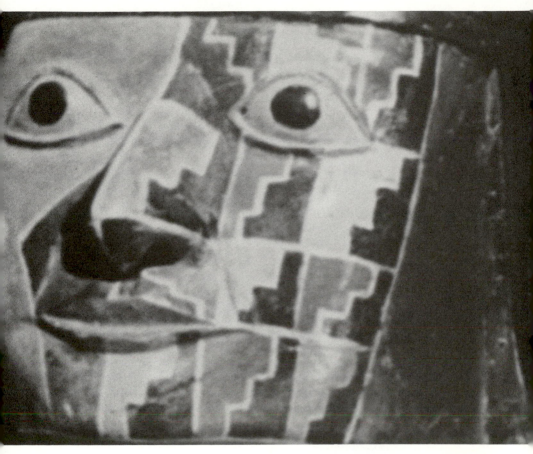

Effigy jar, coastal style,
Peru; white, reds, blue-
black, H. 19½ in.
National Museum of
Anthropology and
Archaeology, Lima

scarcely be conceived as other than they are—as, for example, on highly individual pieces of Japanese Raku tea-ware. On the other hand, with the drawing on much Greek pottery one feels that the artist could quite easily have executed any one of innumerable drawn 231 designs on the given panel of his standard type of pot. Of course it is true that the design still relates intimately to the shape of the pot. But there was a good deal of latitude in choosing. Such drawings must come very close to being purely independent works of art (category 16). And finally there is the case of most European decorated pottery, much of it aesthetically quite satisfactory, which was either painted or decorated with mass-produced transfer patterns, drawn, printed, and cut from paper, fired on to pots of many different shapes. Such designs are usually rather independent in character, the drawings

having no special connection with any particular three-dimensional shape.

Drawings meant expressly to be reproduced by mechanical means and to produce specific graphic effects are a very familiar feature of modern life. Such modern drawings may often be produced by a whole series of indirect techniques, such as cutting and montage, high-contrast photographic reprinting, stencilling, and subjection to a grid of shaped apertures. Such a drawing ready for reproduction may look like nothing so much as a multiple collage, inked here, whitened out there.

Leaving aside colour and colour-printing, and graphic techniques involving drawing directly on to a plate (for example in etching, engraving, and lithography), such drawings show a wide range of characteristics. A prime consideration is the fact that many of them may well be made much larger than the intended size of the final print (for example comic cartoons, comic strips). Thus many actual original drawings made for reproduction may seem very empty and the lines crude. The mechanical scaling-down process eliminates accidental irregularities or traces of corrections. The artist may have to produce on a large scale carefully contrived effects of abrupt, or easy, fluent drawing. To do this he may actually have to work on a mechanically blown-up print of one of his own drawings, carefully trimming, shaping with white and black the edges of strokes and drag marks. Thus there can be two, or even more, stages of mechanical re-scaling, as well as non-artistic tidying up, involved in such work. It is perhaps not surprising that drawings made in this way rarely achieve high artistic value.

There is, however, one type of limitation imposed by the exigencies of mechanical reproduction which has often been aesthetically most fruitful. This is consequent on the use of the so-called line block, which prints only in one tone, usually pure black on the white paper. Artists have thus been driven to conceive their forms purely in terms of a single unvaried tone, giving life to their drawing only by means of the vitality of their lines and their skilful disposition of areas of the same black. Probably the most successful Western examples of this kind of drawing all owe their origin to the Japanese monochrome wood-block prints of the seventeenth and early eighteenth centuries by such artists as Moronobu. Manet, under Japanese inspiration, made all-black drawings, though not for reproduction. But under the

same inspiration first-class commercial artists like Toulouse Lautrec, Steinlen, Bonnard, and the Beggarstaff Brothers made posters based on this technique; whilst Aubrey Beardsley centred his whole style upon it, and many other illustrators have followed him. Whereas earlier practitioners such as Beardsley based their work on a combination of outline and colour-tone stylized into a pure black-white contrast, in more recent examples the technique has added the stylization of the pattern of photographic shadows as an undulant continuity of black (for example, in comic strips and pop art).

7 Drawings in their own right This is the final category—that of drawings in their own right. By now it should be apparent how relatively few pure examples of such drawings there are, for earlier categories will have claimed many drawings usually believed to belong to this category alone.

In any discussion of drawings in their own right the issue of iconography must be resolved. Many of our earlier categories were defined by their iconic, that is fact-recording, function. But I define this last

AN ASSEMBLY (*c.* 1320), Persian style, showing the Mamluke kingdom of Syria; outline drawing in red for an illustration to al Harîrî's *Maqâmât*, 157 × 208 mm. *British Museum*

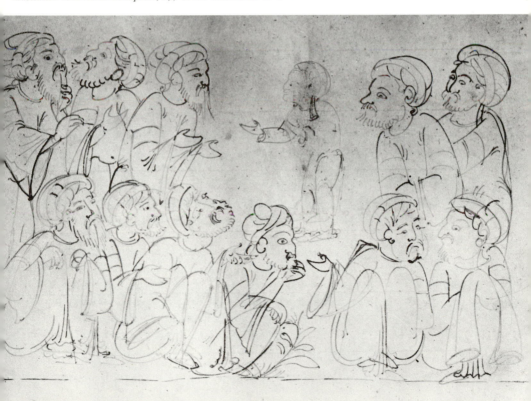

category by the *emotional* autonomy of its subject. For example, I consider that many manuscript illuminations which are added to poems, stories, and romances, must be regarded as drawings in their own right. This is because, although they are connected to the text or arise from it, what they do is to add something purely visual to the experience of the reader. They may record details given in the text; but they do not do so in order to summarize and convey those details, but to add something of their own. Examples of this kind of drawing are those of medieval European manuscripts of, say, *The Romance of the Rose*, the thirteenth-century Baghdad manuscripts (usually coloured) of the stories of al Harîrî, or later Persian illustrations to romances or collections like Khusraw and Chirin, the *Gulistan* of Sa'adi, or the poems of Hafiz. In contrast with this type of emotionally autonomous drawing there are the drawings which illustrate 'official' manuscripts, which may be bound to convey information concerning, for example, the layout of imperial palaces or to serve as a documentary record of a treaty. In some of these illustrations there may be so high a content of pure, summarized information that they must be classified under category 15. Amongst the illustrations to books, modern as well as old, one finds the same issue arising. And many of the 'fine editions' illustrated by twentieth-century artists such as Maillol (*Georgics*), Picasso (*Buffon*), and Matisse must rate as pure drawings (though one must allow for the intervention of the printing process).

In fact even for the most purely autonomous drawings there will be an iconography. The 'text' will have a prominence ranging all the way from the overt story which is illustrated, as I have described it above, through the independent additions to a text like the famous scenes of daily life drawn in the Luttrell Psalter, through drawings of well known classical myths, scenes of everyday incidents, drawings of noted saints or sages doing something (or nothing in particular in much European art), on to those generalized icons represented by landscape, which are justified only by emotional attitude, and those abstract images which are the projection of an aesthetic theory. Thus the drawing done for its own sake cannot be totally divorced from an iconography—no drawing can. Here it is defined by its *raison d'être*, its emotional autonomy.

Into this category must come drawings which are made purely for the sake of capturing and preserving likenesses of people and places. This includes portrait drawings made not as bases for pictures, but to be preserved as drawings. They usually show the artist's intention to

complete a static image of likeness by means of a carefully worked surface. In the West, especially during the eighteenth and nineteenth centuries, many miniaturists specialized in such likenesses, of the family and the famous, for albums. Silhouette draughtsmen did the same. Drawn likenesses of the prospective partners were used in earlier centuries for arranging marriages, especially among royalty and the higher aristocracy. In India we know that in the early Middle Ages the cultivated man about town took pride in his ability to limn the features of his lady-friends. During more recent centuries Rajput and Sikh families have ordered and preserved sets of likenesses of past and present members of their families, as a manifestation of dynastic pride and loyalty. It is quite likely that a similar genealogical motive has inspired European hoarders of family likenesses. In China every funeral has long required a drawn likeness of the deceased, though such likenesses usually tend to be stereotyped or even mass-produced. But the idea underlying all of this kind of drawing seems to be that the likeness contains something of the essence of the person. This is probably a popular adaptation of the almost universal religious conception that the icon contains a part of the essence of the divine prototype.

A similar motive seems to have inspired many European topographers, especially those who lived in Italy from the mid-seventeenth century on and supplied the touring aristocracy with landscapes of Rome and the Campagna, and those who specialized later in distinguished ruins both Classical and Gothic. Mere information or fact was not what was required. These likenesses of famous places were devoted to enshrining the numen of the place, just as portrait likenesses were supposed to carry something of the essence of a person. (Both functions have been largely taken over by the camera. But no camera can convey the formal *qualities* of the numinous as the first-class draughtsman can.)

However, far the most important drawings in this category are those made as deliberate works of art, solely for aesthetic purposes. Among the Western examples are: many of the drawings of Rembrandt, especially the landscapes; the carefully finished Platonic allegories made by Michelangelo as gifts for Tommasso Cavalieri and Vittoria Colonna; some of Dürer's drawings; drawings made for sale to early connoisseurs, by artists living in Italy such as the Carracci and Paul Bril, etc., which were often made to look like working drawings, but in fact were not; the drawings by Lafage made in emulation

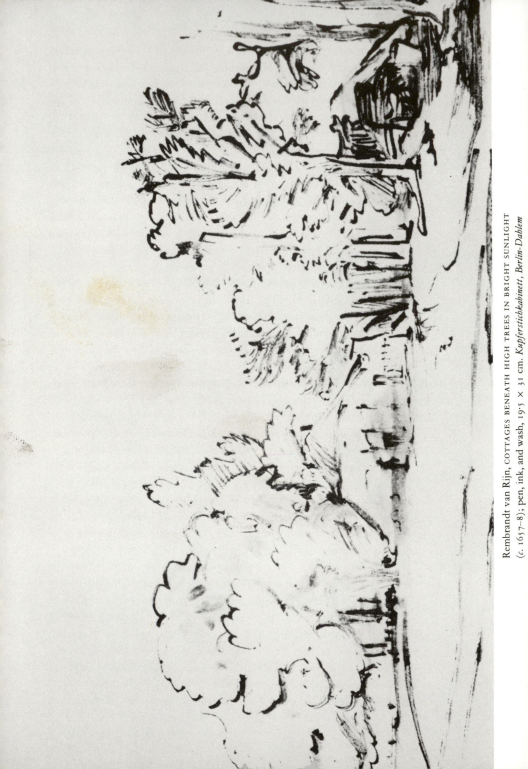

Rembrandt van Rijn, COTTAGES BENEATH HIGH TREES IN BRIGHT SUNLIGHT
(c. 1657–8); pen, ink, and wash, 19·5 × 31 cm. *Kupferstichkabinett, Berlin-Dahlem*

of the last kind; the drawings by nineteenth-century illustrators like Daumier and Forain, not necessarily preludes to later reproduction; the great late drawings of Constantin Guys, when he no longer envisaged his work as a basis for published illustrations; many drawings by van Gogh, especially those early ones of Borinage peasants, when he was struggling to express his love for them through drawings, and the later landscape drawings made often as substitutes for painting, 188 where a range of textures plays the roles of brushstroke and colour; drawings by Degas, Toulouse Lautrec, and other artists attempting to 'numenize' actual life. Now, of course, we know a range of drawings by modern artists which are a kind of surrogate for work in other media, to be made more easily and sold cheaper. In fact, many such drawings will reveal to the questioning eye that they either belong to earlier categories, make a commercial pretence of doing so, or do more or less the same things as the drawings mentioned earlier in this sixteenth category.

Then there are the drawings made in oriental countries for reasons which can only be called purely aesthetic. In seventeenth-century Persia drawings such as those made in the name of Riza-i-Abbasi were done for patrons who wished to savour the elegant expression of 86 calligraphy applied to appealing and often erotic subjects. Most important of all are drawings in that Far Eastern tradition, born in China around the fourth century A.D., developed for fifteen hundred years, then transmitted to Japan, and so eagerly adopted by European artists during the last hundred years that it is not too much to say that European art has become in many respects a provincial version of Far Eastern art. So deeply have the aesthetic ideas on which this art is based penetrated into our unconscious assumptions and aesthetic attitudes towards all art, that it is by no means impossible that some people tend to read the aesthetic expression of all other drawings in their light.

There are, of course, Far Eastern drawings belonging to many of the other categories mentioned in this section. But since the days of Ku K'ai Ch'ih (A.D. 345–c. 406), who wrote *On Drawing the Cloud Terrace Mountain*, artists brought up in a tradition founded jointly upon expressive literature and calligraphy have deliberately set out to produce drawings which were made solely for the aesthetic impression they could convey to the spectator. I have discussed many of their methods in earlier sections of this book. But we must realize that most of the 'immediate' works by wen-jen (Japanese 'Bunjin'), such

Tao Chi (Shih Tao)
(1641–*c*. 1717), A MAN IN
A HOUSE BENEATH A
CLIFF (album leaf); ink
and light colour on paper,
9½ × 11 in. *Nü Wa Chai
Collection*

as Su Tung Po, 'Shih Ko', Liang K'ai, Mu Ch'i, Sesshu, Tohaku, and others, using as subject mountains and rivers, poets, sages, or bamboos, were not made in subordination to any outside requirement, but only for the sake of communicating refined experiences. These were sometimes deemed in a very general sense religious. Ink monochrome was itself the most esteemed and dignified medium, enjoying a metaphysical significance as the root of all form and colour. Even the more elaborated works of recognized academic masters like Li Chen, Kuo Hsi, Hsia Kuei, and Wen Chen Ming were expected to stand or fall

by their success as communication. The authentic 'ch'i' (spirit) of the artist, corresponding with the moving spirit of the Universe, expressed by his inspired hand, was what was demanded. No other 12 criteria need enter into the situation, neither representation, iconography, record, nor moral elevation; whereas even in the purest drawings of the Western tradition one can always feel traces of the pressure of additional demands—of anatomical, canonical, and optical accuracy, and of ideal or moral value.

We recognize that the poet or even the musician must find some sort of 'external' equivalents for their internal experiences. So too must the draughtsman; but the strength of his position, or the difficulty he has to face, according to one's viewpoint, is that the draughtsman's external equivalents acquire an objectivity from the drawing surface and substance even whilst he is shaping them. They take on an independence which means that whenever he stops drawing they are already there to some degree. And this objectivity, in the case of representational drawings, will always compare itself with the objectivity of the overt subject-matter in the eyes of draughtsman and patron; and the subject's claim to external reality will always challenge the artist, requiring things of him which are not required of the poet or musician. The draughtsman has often been driven either by his own critical faculty or by the demands of his patrons to complete the conceptual realization of a motive in a way which can do—and has frequently done—violence to the truth of his inner feelings. This is why we value especially the first thoughts and studies which the artist meant for his own eyes alone. And this is why we find the 'free' art of the Far Eastern scholar-draughtsmen and Zen calligraphers so attractive, both as art and as example. For they were blessed in that they worked for the appreciation of their peers, of a few people who would look in their work only for what they themselves felt they needed to put into it. Everything else they just left out. This has become the ideal of the whole of non-figurative art in the west—to reach the 'essential' by omission of the 'inessential'.

Much Western drawing, however, has made a virtue of the necessity for thoroughgoing 'realization'. And for some artists 'completeness' has been the essence of what they had to say. The epitome is Poussin, who 'neglected nothing', and who was capable of carrying his final pictures to a density of structure unparalleled in other art. But even he, in his drawings, frequently captures a truth to feeling which is not present in a worked-out painting. We feel the same with

Michelangelo's personal, looser drawings, in comparison with his finished gift-drawings, or his polished sculptures. The visual artist in the West has often been obliged to drive himself beyond the point of diminishing feeling-returns when he has been working for an exigent or uncultured patron or has himself held rigid ideas. Others, like Rembrandt and Goya, more independent and perhaps in some ways more fortunate, did not.

Of course it is possible, as I suggested, to take another point of view, one less romantically individualist, and recognize that the notional subject, the objective correlative, required by a patron, or by the artist's own ideas of what is right (as for example with Chardin or Corot), can be a source of continual inspiration to the artist. But this in itself does not mean that he must be obliged to struggle to the limit of optical finish or even conceptual completeness—which is not the same thing anyway. In this, as in everything else, there are degrees; and the degrees have meaning. But the fact remains that the draughtsman's relationship to his topic, which is reflected in the varieties of drawing here discussed, is in general more uncompromising than that of other kinds of artist.

Conclusion We all feel the urge to transform our fugitive subjective experience of what we are into concrete, external symbols. The sum of feelings, images, and ideas in which is embedded our entire subjective experience of what makes us living beings has roots that reach into all sorts of corners of our perceptual and emotional life. We may make drawn images on pots or papyrus to go into the grave with the dead; for they need the consolation of crystallized images of their own identity. When we make them for walls or albums, they serve the living in a similar way. Fixed and externalized, they are there for us to visit them from time to time, to survey them, taste them, savour the projected quality of our own consummated nature.

Drawing can effect this transformation with the most modest resources but with great conviction. As we have seen, there are two sides to it. First is the imagery in which is embodied our existential experience and our ideas of what it means to live and die. This needs to be genuinely adequate to our dignity. Second is the fixing, the condensing of the imagery into forms of reality. This must measure up to our ontological vision. But they are two sides of the same coin.

Index

Anne & J